table C→

CW01072313

FRAUD, FAKERY AND FALSE BUSINESS

Fraud, Fakery and False Business

Rethinking the Shrager versus Dighton 'Old Furniture Case'

Abigail Harrison Moore

continuum

Continuum International Publishing Group
The Tower Building, 11 York Road, London SE1 7NX
80 Maiden Lane, Suite 704, New York, NY 10038

www.continuumbooks.com

Copyright © Abigail Harrison Moore 2011

All rights reserved. No part of this publication may be reproduced or transmitted
in any form or by any means, electronic or mechanical, including photocopying,
recording or any information storage or retrieval system, without prior permission
from the publishers.

First published 2011

British Library Cataloguing-in-Publication Data
A catalogue record for this book is available from the British Library.

ISBN: HB: 978-1-4411-1575-1

Typeset by Newgen Imaging Systems Pvt Ltd, Chennai, India
Printed and bound in Great Britain

In loving memory of Vanessa Elizabeth Moore.
For Tilly.

Contents

Acknowledgements

This book could not have been written without the kindness, patience and support of David Beevers and Frances and Robert Ludman. David Beevers, Keeper of the Royal Pavilion, Brighton, is the expert on Percy MacQuoid and has gathered together a wonderful archive which he generously allowed me to work through. I have enjoyed every trip to Brighton and have learned so much.

I was able to complete this book thanks to the award of research leave by the Arts and Humanities Research Council and the University of Leeds. My colleagues in the School of Fine Art, History of Art and Cultural Studies have always been supportive and I would particularly like to acknowledge the past and present heads of school, Martin McQuillan, David Jackson and Catherine Karkov. I am especially grateful to Mark Westgarth, whose knowledge of dealers and the art market is incredible, Kerry Bristol, the absolute proofing queen, and Emeritus Professor Fred Orton. Fred has mentored me through this project and his words of encouragement have been an inspiration. He read the text on numerous occasions and has helped me to develop as a writer. I would also like to acknowledge my doctoral, master's and undergraduate students who constantly help me refine my ideas as a researcher. A number of writers have particularly helped me formulate my ideas, including Lucy Wood and Stefan Muthesius, whose footnote in 'Why Do We Buy Old Furniture? Aspects of the Authentic Antique in Britain, 1870–1910' first drew my attention to the Shrager–Dighton case. I would also like to thank the staff in the Department of Furniture and Woodwork at the Victoria and Albert Museum and in the libraries at the University of Leeds, the archives at *Country Life* and at Brighton Royal Pavilion and Museums, particularly Stella Beddoe, the Furniture History Society, James Lomax and Helen Rees Leahy. Grateful thanks go to Continuum and particularly Michael Greenwood.

I have been thinking about this case throughout my daughter's first six years in the world and I could not have finally produced this book without the love and support of a great family, wonderful friends and my husband, Dean, who always believes in me.

List of Illustrations

Prologue: 'New Furniture for Old'

'New Furniture for Old' was the heading under which *The Manchester Guardian* inaugurated its coverage of a trial held at the Kings Bench Division in London from 14 November 1922 until 27 February 1923.[1] The case garnered daily coverage in all of the national newspapers, attracted much comment in editorials and drew the attention of publications on the other side of the Atlantic. And yet it has rarely been written about since, except as a footnote in the biographies of the people most intimately associated with the 'alleged antique furniture fraud'.[2] This book revisits Shrager v. Dighton, and reconsiders it as both an interesting and instructive example of the complexities of class, taste and identity in the 1920s, and as a case that offers us useful ways of thinking about how value in the antiques trade continues to be created by the marketplace today.

The case was complex, involving a large number of people and going on to appeal in June 1923. It is therefore important to introduce the *dramatis personae* involved in the courtroom drama before assessing its significance (see Figure P.1). The first hearing began on 23 January 1923, and went on for 26 days, ending on 27 February. The presiding Official Referee was Sir Edward Pollock. The plaintiff was Mr Adolph Shrager, who, with his wife, Adele,[3] had invested huge sums of money in a furniture collection, mainly purchased at the Savile Row shop of the defendants, Mr Harry Walton Lawrence and Mr Basil Lewis Dighton. Both were partners in Dighton and Co. The plaintiff was represented by a legal team that included W. J. Disturnal KC, and Roland Burrows, instructed by A. F. and R. W. Tweedie. On the side of the defence, Lawrence was represented by Alexander Neilson KC, instructed by Lawrence Jones and Co., and Dighton was represented by the Right Honourable Sir Ernest Pollock KC, MP and Mr Jowitt KC, instructed by Downing, Middleton and Lewis. Sir Ernest Pollock was the nephew of Sir Edward Pollock. A number of experts were called as witnesses for both sides. At the beginning of the case there was an unwarranted appearance by Sir Edward Marshall KC, who announced that he represented the British Antique Dealers Association, and that any member of the council of that large body was at the Official Referee's Disposal free if he required any assistance. The witnesses for the plaintiff, Shrager, included Reginald Matthews, the director of Tibbenham's Ltd of Ipswich, who had designed and supervised the making of 'the Royston Room', one of the key items purchased by Shrager; Herbert Cescinsky, a furniture maker and historian; and Frederick Litchfield, an antiques dealer and historian. The defence called on the evidence of Percy MacQuoid, a famous

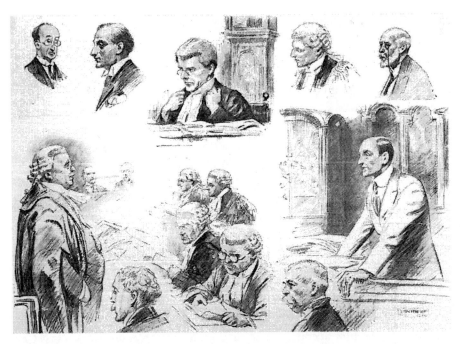

Figure P.1 'Vignettes in the Official Referee's Court During the Fascinating "Antique Furniture" Case', *The Sphere*, 3 March 1923, p. 216b. *From Top Left*: Usher, Adolph Shrager, Sir Edward Pollock, Cyril Asquith and Percy MacQuoid. *From Bottom Left*: W. Disturnal KC, J. Alan Bell, Sir Ernest Pollock, Alec Neilson KC and Basil Dighton in the Dock (drawn by D MacPherson). Reproduced by permission of David Beevers.

historian and collector of furniture, and Sir Charles Allom, the owner of a major decorating firm which sold both antique and reproduction furniture. There were a number of minor witnesses for the defence as well. These included Edward John Cooper, the London manager of the Coalport China Company; Edward Horace Benjamin, a partner in the Kent Gallery who sold to, or shared with, Dighton, 18 of the objects under consideration in court; Mr Herriot, who owned a business in Fitzroy Street, London, which cleaned antique furniture; Robert Sale, a cabinetmaker who made two cupboards purchased by Shrager; Lionel Harris, the owner of the Spanish Art Gallery and an associate of Dighton through the Kent Gallery, and Dighton's other business interest, the Cambridge Tapestry Company; and Frank Partridge, a dealer in antique furniture who went on to purchase a number of pieces from the Shrager collection when it was sold at Puttick and Simpson in June and August 1924 after the trial. The case went to appeal on 23, 24 and 26 July 1923, when it was heard by the high court judges, Lords Justice Bankes, Atkin and Younger.

The case was first heard before the Lord Chief Justice and a special jury on 14 November 1922. It soon became apparent that there were 'serious difficulties in the way of trying the case before a jury'.[4] Mr Disturnal KC, the leading counsel for the plaintiff, Shrager, made two attempts to confine the case within limits which would enable a jury to deal with it. The first was by taking the point that Shrager's purchases, although consisting of a number of items, were really one transaction for the purchase of a collection, and that proof of fraud in respect of a few items would entitle him to a verdict and judgement in respect of all. The Lord Chief Justice ruled against this contention. Mr Disturnal then said that, if the action continued before the jury, the plaintiff would content himself by relying on the 96 instances of alleged fraud mentioned in the particulars of the case, set out on 3 October in Shrager's original statement of claim. On 17 November, the Lord Chief Justice ruled the issues too complicated to be heard in front of a jury and the case was referred to the Official Referee's Court. On 28 November 1922, both parties met before the Lord Chief Justice to discuss the terms of the order of reference. Counsel for the defendants, Dighton and Co., asked that the Lord Chief Justice name the senior Official Referee to try the case. Instead, however, the Lord Chief Justice ruled that the case be taken by one of the Official Referees of the Supreme Court in the course of rotation. Unfortunately it seems that there was some confusion over who would be the Official Referee (a fact that became one of the key issues in Shrager's subsequent appeal), but on 21 December a clerk of the plaintiff's solicitor endorsed the order that 'Sir Edward Pollock is the Official Referee in rotation' and the case was allowed to proceed without a jury trial.[5] The few writers who have looked at the case have highlighted major discrepancies in the legal process, principally that the official rota of referees was doctored so that Dighton's QC, Sir Ernest Pollock's uncle, Sir Edward, was falsely entered in the register as the next in rotation as Official Referee.

The major tenets of the case, heard at the Official Referee's Court from 23 January until 27 February 1923, were clearly articulated by Shrager's lawyer, Roland Burrows, in his opening comments:

The action is brought by Mr Adolf Shrager . . . for damages for fraudulent misrepresentation; alternatively for breach of warranty, and he also puts the case in this way, that the goods sold to him upon certain representations and descriptions which are untrue and, therefore, he is entitled to resind this transaction. With regard to this case the story is not a particularly long one although the transactions are rather large . . . the total transactions between the parties, without making any distinction for the moment, amount to the sum of £111,193. The payments made by Mr Shrager to the parties amount to £88,200, leaving a balance of £22,000 outstanding. In point of fact the

other side say the amount is £25,000 odd but I do not think that anything material will turn upon the distinction.[6]

Shrager was sold approximately 500 items by Basil Dighton, to the value of £111,193.[7] The objects were intended to decorate his new home in Westgate-on-Sea, to establish a base that would allow him to launch himself into English society. Struggling to raise the last payment of £25,000, Shrager called in a local carpenter to value one of the pieces with a view to sale. The man judged that the item, purchased as an antique, was, in his opinion, of recent construction. Cescinsky was then consulted and pronounced that a fair proportion of the Dighton consignment was fake and much of the remainder had been grossly overpriced. At the conclusion of the case, Pollock ruled that Shrager's charge of fraud had been motivated by his outstanding debt to Dighton, hence his judgement for the defendant on the claim and counterclaim.[8]

In his article, 'Percy Macquoid and Others' for *Apollo Magazine* in 1974, Ralph Edwards offered a useful summary of the trial that points to many of the features that make both a fascinating historical incident and one still of significance today:

Two or three years before his death, Percy was beguiled, or beguiled himself, into participating in a deplorable affair which, after prolonged controversy and negotiations, ended up in the High Court. Basil Dighton, a prominent West End dealer, had disposed of a large quantity of furniture to a man named Shrager, a minor plutocrat of mid-European origin. He brought an action against Dighton for fraudulent misrepresentation in selling him spurious antiques. Such an action, in which expertise is involved, is notoriously beyond the competence of a judge and a jury without any claims to special knowledge to decide. Percy managed to convince himself – I think with no more than his wife's half-hearted approval – that the dealer was falsely charged and that he should enter the lists on his behalf. To those who saw and heard him in the witness box, as I did at one session – the trial lasted several days – it must have been obvious that Percy was enjoying himself: he flourished his eyeglass, looked jauntily around him and made expressive gestures of dissent or approbation. Shrager's chief witness was Herbert Cescinsky, who had published a large book on English furniture, reproducing many dubious specimens and a few with preposterous dates; nevertheless he had a considerable knowledge of cabinet making and was widely accepted as an authority. Some of the objects displayed in court went far to convince one that Percy must have had in full measure the will to believe. Personal consideration too may have biased his judgement: the plaintiff and

his chief witness did not, to put it mildly, evoke his sympathies. Shrager lost the case, but many of those present in the court must have seen in the trial conclusive proof that the matters at issue were far too technical to be left safely to an unqualified tribunal.[9]

What makes the case so interesting and instructive for both the social and furniture historian is the way that social prejudices and antique objects clashed together to reveal the dark underbelly of the trade as it developed in the early years of the twentieth century. The trial has become a *cause célèbre* in the discourse, featuring, on one side, Shrager and Cescinsky, and on the other, Dighton and his expert, Percy MacQuoid. The case, which can be tracked through a complete transcript commissioned by MacQuoid to celebrate his role in Dighton's triumph over Shrager, demands that we ask some important and relevant questions about the development of the discipline of furniture history in relation to the early twentieth-century rise of the furniture dealer and the furniture historian and the market for antiques. This book, then, is concerned with rethinking an important trial, ostensibly about furniture, but drawing in key contemporary themes including class, discrimination – against immigrants and Jews – and the politics of the 1920s. By revisiting and reconsidering the judgement we can also consider the implications of the case today. Much discussion of the world of antiques is still concerned primarily with notions of value. The key question on everyone's lips in the multitude of popular television programmes on the theme is '. . . but how much is it worth . . . ?' What the Shrager–Dighton case demonstrates is how value is created in the marketplace, and how ephemeral that value can be. As Herbert Cescinsky, drawing from his experience of the case and quoting Shakespeare, put it in the frontispiece of his later novel *The Antique Dealer*: 'ALL THAT GLISTERS IS NOT GOLD'.[10]

The Emperor's New Clothes: Adolph Shrager

The scenes in the courtroom during the Shrager–Dighton trial in early 1923 can be viewed as a microcosm for a much wider set of social and cultural distinctions that are key to our understanding of the period. The fact that Adolph Shrager lost both the first trial and the appeal, despite demonstrating on numerous occasions that he had a clear case against Dighton, raises questions about issues of race and class, where the establishment, in the form of the English gentleman dealer Dighton, of 'seemingly impeccable social credentials', backed up by the Marlborough-educated, well-married MacQuoid, closed ranks against Shrager, a European Jew, presented by the opposition as a war profiteer, supported by Cescinsky, the journeyman cabinetmaker.[1] Shrager acts as a cipher for the growing class of nouveaux riches, and their attempts to infiltrate the elite world that was so socially and culturally evident in Victorian and Edwardian England.[2] Joseph Mordaunt Crook sees the Victorian era as marking the beginning of a period when it seemed possible to 'buy' gentility more than ever before.[3] That said, as caricatured in Anthony Trollope's *The Way We Live Now* (1875), full social acceptance, despite wealth, was still slow. Trollope's Mr Longstaff is described as being:

Intensely proud of his position in life, thinking himself to be immensely superior to all those who earned their bread. There were no doubt gentlemen of different degrees, but the English gentleman of gentleman was he who had land, and family title-deeds and an old family place, and family portraits . . . and a family absence of any usual employment.[4]

These measures of status, which demanded more than wealth, were still applied in the 1920s and can clearly be seen to be at work in the condemnation of Shrager, 'a businessman all [his] life' who 'between 1914 and 1919 . . . prospered very much'[5] and in the comparison of Cescinsky, the cabinetmaker in his workshop, to MacQuoid, the gentleman historian, travelling from the country house of one friend to that of another. Despite a move, especially after the First World War, towards a new type of elite that looked beyond the rite of birth, Mordaunt Crook sees its acceptance as 'a slow-motion conjuring trick; the reinvention of the British aristocracy as a self-renewing plutocracy', and

certainly Shrager was taken in by the conjuring trick, believing that he could purchase his way to acceptance by 'taking a house and filling it with, say, £100,000 worth of furniture'.[6] As their personal wealth increased, the nouveaux riches turned pounds and guineas into more substantial things. In the trial, Ernest Pollock points out the tax benefits of such a practice:

> At the time when these things were bought, there was a tremendous boom in furniture . . . one of Mr Shrager's ideas was to invest in furniture, so he was to form a collection and the collection would be worth the same or more money as time went on. One has heard that during the period when excess profits tax was in operation and other items of high taxation people flew to diamonds and jewels and the like in which to invest their money in the hope that it would come out better – and at any rate such things were not the immediate subject of taxation – and that by no means illegitimate object was in Mr Shrager's mind.[7]

But beyond simple economics, the idea of collecting appealed because it offered a recognized system of social identification. *The Spectator* in 1872 commented, 'our millionaires are maniacs for collecting things'.[8] Mordaunt Crook in his examination of the nouveaux riches comments that 'often it was through the medium of collecting that the arriviste revealed his cultural identity'.[9] Cescinsky identifies this in *The Gentle Art of Faking Furniture* when considering the motivations of the collector:

> There are collectors and collectors – and yet again collectors. Some collect merely for profit, watching the rise in the market; others desire to possess things to which the average man cannot aspire. Yet others seek for unwritten history, some are led away by the lure of the antique, and they are satisfied with anything, however crude and ugly, as long as it is old.[10]

Consumption has been usefully analysed by many writers on the subject as the chief basis of social order and its internal classification systems.[11] This can help us understand why Adolf Shrager was drawn into the antiques market in 1919. Consumer objects constitute a classification system that can code behaviours and groups.[12] Examples in literature of the period, such as F. Scott Fitzgerald's *The Great Gatsby* (written in 1925 but set in 1922), demonstrate this palpably. Despite its American setting, Fitzgerald's depiction of the socially aware climber Gatsby's home in West Egg, 'a colossal affair by any standard . . . a factual imitation of some Hotel de Ville in Normandy, with a tower on one side' with its 'high Gothic library, panelled with carved English oak, and probably transported from some ruin overseas', is very pertinent to

our understanding of the attraction that the old, the antique, the 'historic' objects had for Shrager as he attempted to shift his way up the slippery social pole of England in the 1920s.[13] Other contemporary depictions, such as those in the novels of Henry James and Ford Maddox Ford, support the conclusion that conspicuous consumption was a key way of improving one's classification in the eyes of others, especially as an immigrant to England's shores. In *The Great Gatsby*, Fitzgerald paints a portrait in words of the new twentieth century, structured by consumerism, financial speculation and the rise of Veblen's 'leisure class'.[14] In 1920s London, the act of buying objects of supposed social recognition did not allow Shrager to break down the barriers of his birth, nationality, religion or race. These still conspired against him, not only in the way he was led by the unscrupulous dealer, but also in the ultimate outcome of the case.[15] Shrager attempted to purchase his way into a 'code of social standing', but what is clear from the start of the case, and from the moment he met Harry Lawrence, is that he had little or no understanding of the prevalent hierarchies of class that dominated British society, hierarchies that had even, perhaps, been exaggerated by the battles of the First World War. No amount of 'Chippendale' furniture could provide him with entry into a society whose social codes were so bound up in birth identity and class.[16]

H. G. Wells's *Tono-Bungay* (1909) continued the rant against the new, moneyed classes:

> We became part of . . . that multitude of economically ascendant people who are learning how to spend money . . . financial people, the owners of businesses, inventors of new sources of wealth . . . [and they all have one thing] in common; they are all moving and particularly their womenkind . . . towards a limitless expenditure . . . with an immense, astonished zest they begin shopping . . . as a class, they talk, think and dream possessions. . . . Acquisition becomes the substance of their lives . . .[At first] they join in the plunder of the eighteenth century . . . [but they end with] a jackdaw dream of . . . costly decrepit old things.[17]

The impulse to collect within a cultural situation is, according to Mieke Bal, hybridic – a mixture of capitalism and individualism.[18] Russell Belk has noted that the historic rise of consumer culture in Europe occurred at the same time as 'self'-prefixed words and phrases such as 'self-regard' and 'self-consciousness' entered the English vocabulary.[19] In his analysis of Western 'possessive individualism', C. B. MacPherson has traced the seventeenth-century emergence of an ideal self as owner, describing the individual surrounded by accumulated property and goods through the idea of the making and remaking of our cultural selves.[20] The collection is not natural or innocent as it is tied up

with social and political aims. All collections embody hierarchies of value, 'rule-generated territories of the self'.[21] The answer to the central question of why collecting was so important to the nouveaux riches born of the industrial revolution is, in James Clifford's view, to be found within notions of a developing capitalist 'system of objects', where collecting and display are viewed as a crucial process in the construction of identity, and within this a clear hierarchy of value is created, modelled mainly on the long-established patterns of the aristocratic collector.

In *Punch* of 1843, 'The Spangle-Lacquers', a nouveau riche family, are caricatured as socially rootless. It seems ironic for our purposes that the name chosen to designate this new class of people directly references one of the key furniture techniques that would be questioned throughout the Shrager–Dighton case. *Punch*'s Spangle-Lacquers had made their money from 'soap, gin, tallow, rags or something equally interesting, by a process of alchemy which leaves all the old philosophers far behind'. 'You can assign [them] no fixed position in society [since they are generally met with] in places where distinction was acquired by paying for it'.[22] Their trade is used to damn them, and in court Shrager's business activities were singled out for analysis and critique. In Shrager's own words, when examined by Burrows at the start of the trial, he stated that '[At the time of the transactions] I was interested in advising rubber syndicates and also in coal mines in India', although he described his occupation at the time of the trial as 'nothing'.[23] In 1901 an Adolph Shrager appeared in the *Proceedings of the Asiatic Society of Bengal* as being in Calcutta in 1900; in 1911 there is a report in the *Indian Law Reports* of a mortgage issue on the house of 'Adel and Adolphe [sic] Shrager and the Kirtikar Lease' on Old China Bazar Street, locating Shrager in India up to the start of the War, and indicating that his money troubles in the 1920s were not unusual.

> You know something, do you not, of what I will call the misfortunes of business? . . . You and your firm were bankrupt in 1905 . . . and were undischarged bankrupts until 1913?
>
> No . . . I was out in the East. When I came home I applied for my discharge and got it . . . in 1910 or 1911, but the order of discharge was granted on the 3rd July 1913.
>
> So that when you are making these charges against a number of persons you know quite well what it is to suffer the misfortunes of business. . . .
>
> The misfortunes of business, yes, fraud, no.[24]

As landed capital in England dwindled, around the time of the First World War, trading capital increased.[25] The move from primary income from

industrialization to secondary income through the financial markets saw the speed of capital accumulation accelerate.[26] Shrager's wealth belonged to this new type of speculation. His rise to wealth and the patterns of spending he adopted were not without clear precedent. Any number of case studies from the period can be cited to demonstrate how great sums of money could lead to social prestige. Mordaunt Crook, for example, provides the example of Carl Meyer, a Jewish banker and diamond magnate, who prospered in South Africa but then came to London, dying in 1922 a multimillionaire, a Tory Baronet and the owner of a mansion off Berkeley Square and a country house in Essex.[27] Clearly his wealth had allowed him to cross the social divide and enter into the most closed circle of political elitism. The Countess of Cardigan in 1911 sniffily summed up this significant change as 'nowadays money shouts and birth and breeding whisper'.[28] But assimilation upwards was not always easy and was fraught with social hazards, dramatically demonstrated by Shrager's fall from grace. When he entered Dighton's shop in 1919, he was welcomed as one of their own, his money acting as the simplest passport to acceptance in the elite world of antiques. By January 1920 Shrager had bought £17,000 worth of furniture and by July 1920 that had increased to about £24,000. In the following year, up to July 1921, the total was about £100,000. Throughout 1920 he was well able to pay for his substantial purchasing activity, but unfortunately for Shrager, unlike Meyer, the money did not last. In 1921 things became financially 'more difficult' and Shrager was rapidly reminded of the fact that those accepted for their financial means were just as quickly rejected.[29] Their entry into the elite was conditional. Having happily accepted his cash, Shrager was now dismissed as a war profiteer, an anathema in England in the early 1920s. Pollock, despite Shrager's objections, drew swift attention to this in his opening exchange with the plaintiff: 'You have been a businessman all your life, have you not?' Shrager agreed. 'And between 1914 and 1919 you prospered very much, did you not?' Shrager noted the significance of the dates and replied, 'Not very much in those periods but I prospered, yes'. Pollock continued, 'Have you been prosperous so as to justify in 1919 your taking a house and filling it with, say, £100,000 worth of furniture?' The plaintiff denied that he had purchased 'except very modestly' before the beginning of 1920.[30] By drawing attention to the role that the War had played in Shrager's wealth, Pollock both hinted that its sources were dubious and this, combined with the obvious fact of Shrager's Jewishness, left him open to the blatant anti-Semitism that stalked the corridors of power and the gilded drawing rooms of the English aristocracy in the early twentieth century. The novels of H. G. Wells remind us that this was an accepted feature of English political and social life at the time. In *Tono-Bungay* (1909) he

used the ultimate symbol of the English landed classes, the country house, to decry the new Jewish elite:

> The great houses stand in the parks still . . . [But] the hand of change rests on it all. . . . Bladesover House is now let furnished to Sir Reuben Lichtenstein, and has been since old Lady Drew died. . . . To borrow an image from my mineralogical days, these Jews were not so much a new British gentry as 'pseudomorphous' after the gentry.[31]

Shrager's Jewishness is clearly articulated in the trial through one of his purchases, commented on in his correspondence with Lawrence:

> 15 July 1921 . . . 'I have sent you an incense burner which will act until we can get something better. I have charged you £16.0.0. for this, but it is merely a book entry and of course you can send it back at any time.' I ought perhaps to complete the incense burner reference by telling you that there is a private Synagogue there [at Westgate]. Mr Shrager is a Jew by religion as well as by birth and the incense burner was wanted, I understand, for the purposes of Services in the Synagogue.[32]

Although social status rather than religious denomination seems to have remained the key factor in determining one's degree of acceptance, the growth of Jewish communities in England, especially in the last two decades of the nineteenth century when a new group of immigrants entered the country as a direct result of the Russian pogroms, resulted in a rise in anti-Semitic sentiment.[33] Texts published in England, such as J. Banister's *England under the Jews* (1901) had gone so far as to denounce all foreign Jews as 'thieves, sweaters, usurers, burglars, forgers, traitors, swindlers, blackmailers and perjurers'.[34] Such sentiment gained greater currency as the presence of visible Jewish communities increased. The Jewish population increased in size fourfold in the years between 1880 and 1910.[35] Mainly from the lower middle classes, they tended to settle in industrialized urban areas, particularly London, Manchester and Leeds, where their 'cultural individuality' was enhanced by 'their Yiddish language and Orthodox faith'.[36] As a result of perceived social difference and the threat to 'English' jobs, Conservatives and trade unionists joined together to demand tighter restrictions on immigration, and 'England for the English' began to be muttered in the meeting halls and parliamentary corridors.[37] The British Brothers League was founded in 1902 and attracted some 45,000 members from its base in the East End of London. Its language was all too familiar, accusing the Jews of 'being clannish, unwilling to abandon their identity and thus remaining a separate element in society'.[38] Despite

active lobbying by the anti-Semitic leagues, the Aliens Bill was passed in 1905, allowing active immigration to continue, supported by the right to asylum, at a rate of four to five thousand Jews per year until 1914. During the debates in Parliament around the passing of the bill, attitudes about the perceived separation of the Jews into states within states abounded. A. J. Balfour, for example, observed 'a state of things could easily be imagined in which . . . there should be an immense body of persons who, however patriotic, able, and industrious, however much they threw themselves into the national life, still, by their own action, remained a people apart'.[39] As a result of the War, anti-German fervour boosted the more traditional anti-Jewish arguments, citing, in 1917, 'a Jewish alliance with Old Testament Germany to regain temporal power on Earth'.[40]

Gisela Lebzelter has drawn attention to this 'hyper-sensitiveness' against Jews in high society after the First World War. Winston Churchill evoked this mood in a letter to David Lloyd George about forthcoming ministerial appointments, concluding that 'there is a point about Jews wh[ich] occurs to me – you must not have too many of them . . . three Jews amongst only seven Liberal cabinet ministers might I fear give rise to comment'.[41] Such a political and social climate, generated by domestic and international pressures after the War, 'proved prolific for the development of a mass hysteria' directed against the eternal scapegoat, leading to *The New Anti-Semitism* protested against by the Chief Rabbi in 1920.[42] As an example of the growing public accept-ance of anti-Semitic attitudes, Lebzelter cites the foundation of 'The Britons' in July 1919 as a 'society to protect the birthright of Britons and to eradicate alien influences from our politics and industries'.[43] The society was open to all 'Whites who can show that their ancestry is free from Jewish taint, and who are unallied with Jewry either by marriage, business association or control', and was in existence as a political movement until 1925.[44] It survived in name and literature into the 1940s, through the writing activities of its founder, Henry Beamish, and his associates.[45] Although a relatively small concern, 'The Britons' are interesting for our purposes in that, at exactly the same time as Shrager was going to court, it was propagating attitudes towards Jews and Germans that were consciously or unconsciously mirrored by many in the establishment, even if they did not express those feelings as extremely as did 'The Britons'. The group saved its greatest ire in the early 1920s for 'the Hidden Hand', those Jews who pretended to be Englishmen.[46] The peak of the group's activity came in early 1923, just as Shrager was entering the witness box, when they held an appeal to raise funds to 'fight the Hidden Hand'.[47] One can imag-ine that Shrager's Germanic name singled him out for further suspicion at a time when 'The Britons' were declaring that 'Germanism is a contagious disease like the plague, and the ubiquitous parasite which carries the germ

of it is the wandering Jew'.[48] Obviously the Britons represented the extreme end of anti-Semitic activity in the 1920s, but their sentiments were frequently rehearsed in the 'contemporary drawing-room anti-Semitism' of the far-right-wing press, such as the *Morning Post* and the Duke of Northumberland's weekly publication *The Patriot*.[49]

Having focused their attention on an imagined Judaeo-Germanic conspiracy, immediately after the War, however, Lebzelter reminds us that the Conservative press directed its invective to a wider international conspiracy, agitated by the Russian Revolution, and the fear of the 'Bolsheviks'. Fear of revolution was transferred to a rhetoric of anti-Jewishness: 'We must not lose sight of the fact that this movement is engineered and managed by astute Jews, many of them criminals'.[50] Many writers on Russia referred to the 'Jewish factor' in the Revolution, leading up to Churchill's statement that, while there was 'no need to exaggerate the part played in the creation of Bolshevism and in the actual bringing about of the Russian revolution by these international and for the most part atheistical Jews' . . . 'This movement among the Jews is not new . . . this world wide conspiracy for the overthrow of civilisation and for the reconstitution of society on the basis of arrested development, of envious malevolence, and impossible equality, has been steadily growing'.[51] Thus, the blame for the Revolution was placed squarely in the hands of 'international Jewry', denounced by many in England as 'wirepullers behind the scenes' who had come to 'rule the roost' in Downing Street.[52] 'Upper-class anti-Semitism not only manifested itself in the context of the reaction against' Bolshevism, 'but in the numerous passing remarks' which indicated a latent resentment and fear of the Jewish people. Lady Astor responded to a political opponent, 'Only a Jew like you would dare to be rude to me'; Sir Horace Rumbold stated 'I hate Jews'; and Lady Angela Forbes warned, 'the Jewish pest is a microbe that is multiplying in strength more rapidly than any known bacilli'.[53]

As an arriviste Jewish businessman, Shrager, therefore, seemed to have had little hope of social acceptance in 1919 among the titled classes that he was attempting to emulate with his purchases from Dighton's. Shrager's assimilation was not only limited by his identification as a Jewish businessman, but also as one who had made a significant portion of his wealth in India. The fact that any Jew was seen as a potential ally of anti-British behaviour was, according to Lebzelter, particularly apparent with regard to India. The knowledge that two Jews were in charge of the Government's Indian policy at this time, E. Montagu as Secretary of State for India, and Lord Reading as Viceroy, provoked many to blame the fall of the Raj on a 'Jewish conspiracy':

The British Empire rests on retention of India. To hold India it is necessary that the English race should hold all prominent appointments. The

proportion of roles now held by Jews is somewhat excessive, and . . . constitutes a possible danger to British prestige, because the Jews, being pure Asiatics, are regarded by our Indian fellow subjects without awe and frequently without respect'.[54]

Jewish financiers and businessmen working in India were treated with suspicion, with a sense that their activities were not aimed at the benefit of the English cause. Although it was never commented on explicitly, Shrager, a Jewish immigrant from Germany who had made his money in India during the War, presented a challenge to the likely prejudices of the lawyers, witnesses and official referee attendant on the case in the courtroom. Percy MacQuoid, for example, has been shown to have subscribed to this form of accepted anti-Semitism, and was unafraid to voice thoughts that seem shocking today. In a letter dated 17 November 1924 to C. B. Marriot of 25 Berkeley Square, London, from his house, Hoove Lea, as an addendum to his thanks for a gift of persimmons and walnuts he commented that:

By way of improving the day (Sunday) I am reading the Plague of London by Bell a harrowing book . . . the inhabitants of London numbered 500 000 only. 100 000 died of the plague. Here is the solution of everything. Start a good plague and go out of town, for the better class people all left the city and did not die and let's remember there were hardly any Jews in Charles II time.[55]

In England, anti-Semitism was most apparent at times of economic crisis, particularly in the 1920s, as the political landscape was reassessed after the War. As the population struggled to reestablish itself, and unemployment soared, a 'them and us' attitude inevitably developed, mixing racial and/or religious prejudice with economic jealousy, as many railed against the 'International Jewish profiteers'. It was against this landscape that Shrager attempted to sue the establishment, and inevitably failed.[56]

As we have glimpsed, there were Jews who succeeded to the highest echelons of power and maintained their position. The longevity of the Rothschild family in positions of social and political power seems to have allowed them, although critiqued widely, to maintain their position of influence in England throughout the second half of the nineteenth century and into the twentieth. A French journalist reportedly said in 1841, 'There is but one power in Europe and that is Rothschild'.[57] From its founding in Frankfurt in 1743, to the multinational merchant bank of the nineteenth century, they used their wealth and influence to advance the business, but also to advance themselves politically and socially. Their identity as 'Jewish' is a constant throughout, from the

description by Otto von Bismarck, the first Chancellor of the German Empire of Amschel Mayer Rothschild as a 'real old Jew pedlar' to Surtees rechristening the Vale of Aylesbury, in the early twentieth century, 'Jewdaea'.[58] The family's wealth, valued at 4.4 million pounds in 1828, meant that they were dealing with the European aristocracy on an almost equal social basis. That said, their loyalty to Judaism was noted in almost all dispatches, including a comment by Edward Hamilton, William Gladstone's private secretary, that his friend Ferdinand de Rothschild was 'proud of his race and his family and liked talking about his predecessors as if he had an illustrious history of the bluest of bloods'.[59] Ferdinand's father, Nathan Mayer, is credited with having established the family's stronghold in England. By taking on their pastimes and joining their clubs, his wealth allowed him to rapidly become a part of the elite in his adopted country. In 1841, probably as a result of connections made at Cambridge University, he was elected a member of Brooks, long the club of aristocratic Whigs. He became High Sheriff of his county, Buckinghamshire, in 1847, no longer an office of significant power, but an emblem of acceptance within the county elite. The financial difficulties of several landowners in the country, most notably the second Duke of Buckingham, allowed him to amass the requisite acreage in a relatively short time.[60] His sons continued this rise to power, through astute social connections. Most notable of all was their close relationship with Edward, Prince of Wales, who became a frequent visitor to the family's estate of Waddesdon Manor; 'The Prince's business instinct enabled him to appreciate the financial acumen of the Rothschild clan, but he was more effectively drawn to its members by their profuse charity, their range of political information, their hospitalities, their patronage of sport, and their assiduity in collecting works of art'.[61] Their wealth allowed them to purchase their way in the political ascendancy, helped by the more liberal attitude in England to the Jewish community than in other European countries, where they continued to be ghettoized. One particularly influential figure in their rise was the Prime Minister, Benjamin Disraeli, the first and only person of Jewish heritage to hold the position. Disraeli, however, had converted to Anglicanism in his teenage years, thereby avoiding the ban on practising Jews entering higher positions in public life, a ban that was not lifted until 1858.[62] This undoubtedly aided Lionel Nathan de Rothschild's ambition to become the first elected Jew to enter the House of Commons. He had originally been elected in 1849, but could not take up his position until 1858 when the law changed:

> The Jews . . . rising to the top in Disraeli's day tended to be silent, prudent, high principled people of impeccable integrity, who acquired vast wealth, became masters of hounds and bought up the Vale of Aylesbury. Their

quintessence is represented by Disraeli's later friend Baron Rothschild, who on the grounds of principle stood again and again for Parliament until the ban on Jews was removed, and then having at last got there, sat for fifteen years without opening his mouth.[63]

The move to bring selected Jewish members into the houses of power was politically astute. Lord Glanville, for example, advised Queen Victoria to 'attach them to the aristocracy rather than drive them into the democratic camp'.[64]

Thus, the Rothschilds move into the elite was a considered one, mapped out carefully on patterns of aristocratic living:

> Participation in British political life reflected an increasing social identifi-
> cation of British Jews with the analogous groups of the wider society. The
> wealthiest of the Jewish community continued to acquire country estates,
> even if only for weekend and holiday residence and their members aspired to
> play a part in country society. In Buckinghamshire, where Lord Rothschild
> was lord-lieutenant, the family, with five estates in or adjoining the county,
> exercised considerable influence in local Conservative politics. Elsewhere
> the entry of Jews might have been less accepted but their presence was a
> fact; the short stories of "Saki" (H. H. Munro) testify to the entry of Jews,
> identifiable by their Teutonic names, into Victorian and Edwardian coun-
> try house society.[65]

These houses became the focus for the Rothschilds' politicking, none so more than Ferdinand's creation, Waddesdon Manor. Born in 1839, Ferdinand was the first generation of the family to enjoy their wealth without working for it. After the death of his father in 1874, he liquidated his share in the bank and bought a run-down estate from the Duke of Marlborough in the family's home county of Buckinghamshire. The old aristocrat's loss was Rothschild's gain, as he embarked on the traditional landowner's game of constructing a country house on top of a hill near the local village of Waddesdon.[66] Rothschild had a very particular attitude to collecting. As outlined in his 1897 essay on the sub- ject, 'Bric-a-Brac', he had what Michael Hall has described as 'a Whig vision of history, seeing it as an inevitable progression from autocracy to democracy'.[67] Rothschild believed that he and his plutocratic peers were positioned at the midpoint in this Hegelian progression and that acquiring the works of art originally made for monarchs, and then assembling them in their own homes, would ensure their eventual transition to public museums and therefore the wider public. Ferdinand's essay is interesting for our purposes as it not only indicates the types of object of interest to the wealthy Jewish collector, but

also depicts the world in which he collected. It reveals, unsurprisingly, his suspicion and curiosity about dealers, 'la bande noir', and portrays his and his friends' dealings with men such as Frederic Spitzer and Alexander Barker as a battle of wits; 'In every country private collections are formed of all styles of old art from antique statues to buttons and shoes, for the discovery of which the palace and the cottage is explored and ransacked, and for the acquisition of which unimaginable extravagances are committed. The mania lends itself to satire'.[68] Rothschild's wealth and position, and his ability to pay expert advisors, protected him from the excesses of the dealers that we witness in the Shrager case, but 'Bric-a-Brac' usefully depicts the market and its pitfalls for the unwary purchaser at the turn of the century. 'In the earlier years of this century buyers were few . . . now the collector need only sit in his chair, open his purse-strings and the mountain will come to him'.[69] The growth of the market for goods and dealers will be explored in Chapter 2 in more detail, but, suffice it to say, Rothschild was aware of the dangers of seeming too rich and too acquisitive when in the dealer's shop, and warned that the sometimes 'vulgar traffic' of customers led to the dealers turning from 'pauper Germans' to 'French Swells'.[70] The fruits of the Rothschilds' purchases of antique furnishings were not always well received, however, and were often condemned using the familiar anti-Semitic rhetoric of excess and ostentation. The notion of a 'vulgar traffic' in goods was turned back onto them. Lord Crawford, who stayed at the home of Lionel Nathan de Rothschild, Tring Park, as a young man, declared himself so appalled by the 'overpowering ostentation and vulgarity' that he vowed 'never again [to] stay in one of the big Jewish houses'.[71] When he returned in 1939, he declared that he

> [w]as horrified by the whole mis-en-scene [sic]. Though many of the pictures have been removed and furniture has been collected in various rooms according to categories, one has a very good idea of what the house was like. . . . In one of the rooms was a group of clocks . . . horrors. Another room seemed to have twenty to thirty sideboards ornamented with modern Sevres plaques. Awful inlaid chairs and tables were classified, huge costly fitments, vast china vases of the worst period. . . . I passed from one monstrous apartment to another, with ever growing consternation.[72]

One wonders what he would have made of Shrager's house, Kent Lodge, in 1922 filled with what would have seemed like the mismatched and multiple contents of an antiques shop! The association of Jewish wealth with conspicuous ostentation imbued the court case. T. H. S. Escott noted in 1903 that the 'social centre' of England was divided between 'the Semite and the Yankee',[73] describing the Jews as 'the salt of smart society' without whose patronage 'English art and

music could scarcely live in the English capital . . . to talk of Jewish influence materialising society in London is silly blague . . . the Israelite might rather claim to be a spiritualising force'.[74] Despite Escott's words of support, the visibility of this wealthy social segment, displaying all of its manifest success, was sure to attract hostility. Anti-Semitic views were often cited among the gossiping circles of the older generation of aristocrats. In 1900, for example, Lord Balcarres' diarized that 'in the afternoon Connie and I went to Hertford House, where a large party invited by Arthur Rothschild and Roseberry assembled to meet the Prince of Wales. The number of Jews in the place was past belief. I have studied the anti-semite question with some attention, always hoping to stem an ignoble movement; but when confronted with a herd of Ickleheimers and Puppenbergs, Raphaels, Sassoons and the rest of the breed, my emotions gain the better of logic and justice, while I feel some sympathy for Lüger and Drumont – John Burns, by the way, says the Jew is the tapeworm of civilisation'.[75] Two years later he noted that these 'ignoble' feelings were widespread: 'At Aldershot they called out "King of the Jews" [Edward VII] . . . there is much dormant anti-semitism, especially against [Royal patronage] in Park Lane and Grosvenor Square'.[76] The figures go in some way to account for the dissent among the landed classes, who saw their assets being reduced at a time when a fifth of all non-landed millionaires were Jews, although the Jewish population of London just before the start of the First World War was no more than 3 per cent of the total, and the Jewish proportion of the British population was only 0.03 per cent.[77] As Mordaunt Crook reminds us, such figures were seen to be upsetting the norms of political life, with Hillaire Belloc protesting that the House of Lords had been turned into 'a committee for the protection of the Anglo-Judaic plutocracy' and *The Spectator* commenting that 'These over-civilised orientals . . . go to bed in satin and live upon izes and water biscuits'.[78]

Against this background we need to place Adolph Shrager's story, as a newly enriched Jewish businessman living in England after the War. By the end of 1919, Shrager was a 'man of means', considering the purchase of 'old' furniture for the house he was planning to buy in Kent. Ernest Pollock, in his cross-examination, told the story of Shrager's buying activity:

> By January 1920 you had bought £17,000 worth of furniture . . . and by June or July 1920 that had been increased to about £24,000 . . . then in the following year, up to July 1921, the total was about £100,000 . . . throughout 1920 you were well able to pay this £100,000 . . . but in 1921 things became more difficult for you, did they not? [79]

The case hinges on, and was ultimately won or lost on, the image of the dealer. 'You said, you were going to buy old furniture and . . . you had been told that

dealers were dangerous people . . . did you not say to Lawrence that he was a man from whom you were going to buy because he would keep you right?'.[80] The Official Referee was asked to decide between Shrager and his dealers, Dighton and Co. Much of the plaintiff's evidence relied on his understanding of the dealers and their practices. According to Shrager's evidence, Harry Lawrence had presented himself as a 'friend', a 'very intimate' acquaintance of 'two or three years' who happened to know a great deal about furniture through his association with Dighton.[81] Lawrence took the opportunity to tell him that he had been connected with Basil Dighton before the War without explaining any difference between Basil Dighton, the company, and Basil Dighton, the man, and now had rejoined the company, 'and a question arose about getting some antique furniture'.[82] Realizing that he would require advice if he were going to buy antique furniture, Shrager, 'not unnaturally leapt at the opportunity of dealing with a firm where a personal friend of his was concerned. The position, therefore, arose that Mr Shrager was dealing with Basil Dighton mainly through Lawrence relying upon him as an expert, relying upon his honest advice and assistance. Mr Lawrence assured him that they were experts, they were absolutely reliable, and he would see he got the right things'.[83]

The 'right things' in 1919 were very much mapped out by the market and its tastes. Customers such as the Shragers wished to emulate the elite, and so, with the guidance of firms such as Dighton and Co., embraced a highly conventional aesthetic which had strong social connotations.[84] The model of the domestic interior derived from the houses of the eighteenth-century aristocracy in both Britain and France, the 'mansions', as they were frequently referred to, provided the aspirational style for these newly monied, middle-class consumers. The familiar language of the eighteenth century provided the starting point for the development of a language of interior decoration that denoted social standing and upward mobility, and offered a sense of security through its historical references at a time of social turbulence. By the late nineteenth century, Mark Jones has noted, society desired 'almost anything that spoke to them of the calm certainties of the vanished past'.[85] This was a subtle language that decorators and dealers, like Dighton and Francis Lenygon, used knowingly. According to Penny Sparke and Susie McKellar, the design and decoration of the domestic interior provided a locus for a dialogue between class, race and gender identities, material culture and the languages of interior decoration. They position the domestic interior as a key factor in the formation of personal and collective identities.[86] At this time, the aesthetic of the domestic interior came to play an increasingly important function as representing one's status or class, genuine or assumed. Clients such as the nouveau riche arriviste Shrager had little confidence in their own taste and sought confirmation

of their position in society, as a result of increased wealth, through the owner-
ship of an interior decoration that had proved its social acceptability, such as
the Georgian style of furnishing.[87] Following the decline of the country house
after the First World War, subsequent country house sales made it possible for
decorators to obtain for their clients 'real things', things which had a history,
to allow them to access the inherited splendour of aristocratic England and
imbue the schemes with a certain 'authenticity'.[88] They were looking to buy an
illusion, 'the illusion of status, of belonging, of success'.[89]

This was the world that Mr and Mrs Shrager were looking to enter when,
on 19 November 1919, they paid their first visit to Dighton's premises at 3
Savile Row. They were shown pieces of furniture by Lawrence, and 'they
admired them, he told them what they were, which they did not know,
and they selected some to purchase'.[90] In a letter of the same day Lawrence
began his task of convincing the couple of the worth of their purchases: 'I
think you have chosen extremely well all the pieces being of the finest qual-
ity and in every case what I should term "collectors pieces"'.[91] Mrs Shrager
from the beginning was an active participant in the hunt for 'antiques' to
furnish her home. She often visited Dighton's on her own and was used by
Lawrence to encourage her husband's collecting. For example, on 5 March
1920, Lawrence wrote to Mr Shrager, 'Mrs Shrager is very anxious for you
to see three Chippendale chairs and a baby Queen Anne chair, and also an
important piece of red lacquer. If you have time you might come and see these
things and we could discuss them'.[92] Because consumption was seen as both
important yet frivolous at this time, it was frequently located in the domestic
sphere where women were expected to consume to express the status of the
family. The private sphere was just as important as the public sphere, and men
required their wives to assist them in engaging in the public, social, economic
and political activity that was focused on the activity of 'buying'.[93] A number
of authors have examined the role of the female middle-class consumer in the
development of a modern commercial world and, particularly at this point
in time, in the development of the department store.[94] Mica Nava, for exam-
ple, has commented on 'women's massive participation in the exploding cul-
ture of consumption and spectacle'.[95] Erika Rappaport has highlighted the
importance of the 'mass market of married women' to the growing market,
and the influence they had on the spectacle of the institutions of commerce.[96]
Certainly, for Lawrence, Mrs Shrager was key to the selling relationship that he
aimed to establish at 3 Savile Row, and she frequently visited the shop on her
own, leaving Lawrence to later write to her husband to confirm (in his words)
those objects in which she was interested. Although the department store,
with its more anonymous retail practices, was expanding as a key commercial
site throughout this period, the traditional shop environment, represented by

Dighton and Co., was still a vital space for purchasing transactions, particularly at the 'high end' of the market. As late as 1915, department stores only accounted for 2 per cent of all retail activity in fixed shops.[97] The experience that the Shragers had at Dighton and Co. was still very much the norm, and Lawrence and Dighton's retail methods harked back to the original dealers' shops of the early nineteenth century. The growth of this type of business will be explored further in Chapter 2, whereas here we will focus specifically on the types of encounters the Shragers had at Dighton and Co. and the retail relationship that would ultimately lead to their downfall.

Basil Dighton had been in the antique trade for 30 years when Shrager first entered his shop. Starting with the sale of prints, he established his shop at 3 Savile Row in 1917. Shrager's solicitor, Neilson, told the court the story of the friendship between Dighton and Lawrence, in order to outline how entwined their business lives were and had been, and to indicate how, by buying from Lawrence, Shrager was essentially making a purchase from Dighton and Co., a fact of which Shrager claimed to have been unaware throughout.

> Mr Lawrence's position was that of an extremely old friend of Mr Dighton's. They had been at school together and had known each other practically all their lives and ever since 1911 when Mr Lawrence came in contact with Mr Dighton he assisted him first when he was at Gower Street, which was the place he had before the war, and after the war when he went to Savile Row. When the war came along Mr Lawrence went into the service of the Admiralty and in 1919 he rejoined Mr Dighton. Between these two dates Mr Lawrence had met the Plaintiff, Mr Shrager, and Mr Lawrence will tell you that it was entirely on his own motion that Mr Shrager came to him and asked him if he would sell some articles of furniture as he wanted at some time to furnish his house at Westgate and he wanted to begin collecting the furniture for his house.[98]

Lawrence was key to luring Shrager into making his purchases from Dighton and Co.:

> This is perhaps a convenient period at which I can tell you something about the relationship between Mr Lawrence and Dightons. Dighton's position is managing director of Basil Dighton Ltd. And Mr Lawrence's position at that time was that of director. Apparently he is paid on salary and commission. There are a number of transactions which the plaintiff had with Mr Lawrence which he says were on his own account. I ought perhaps now tell you as this is a matter which has to be dealt with separately that payments were made to Mr Lawrence or Mr Dighton. In making payments no

distinction was drawn between Basil Dighton and H. W. Lawrence and you will find that cheques were drawn in favour of Mr Lawrence and acknowledged by Basil Dighton. The two people were dealt with by Mr Shrager as interchangeable units, that is to say, they both represented Basil Dighton, Basil Dighton being an individual, or a partnership, with which he thought he was dealing.[99]

The tone of the selling relationship was established from the start. This harked back to the commercial practices of the nineteenth century, where the seller developed a 'personal' relationship with his client, and where the financial transaction was rarely recorded, except when things began to go wrong. Shrager seems to have developed such a close and trusting relationship with Lawrence that, after a very short period, the dealer took over the purchasing decisions, to the point that he would send objects to the Shragers' house 'on approval' and select items without the Shragers needing to visit the shop. The key to their relationship was the conviction that Lawrence was a 'friend' rather than a mere dealer. Lawrence then worked to convince Shrager of Dighton's credentials:

He said that he had known Mr Basil Dighton for I think thirty years ... that they were great friends, that Mr Dighton had been in the antique furniture business, and that he had a very good name, that he dealt in articles of the finest quality ... he said Mr Dighton's prices were perhaps a bit stiff, but having the name he had, I could rely on the finest things and that it would be better, in fact, to go to a firm of standing than to try and pick up things here and there and especially as Mr Lawrence was my friend, he would see that I was treated very fairly, and that he would advise and undertake the supervision – well undertake the purchasing of things for me.[100]

I told him that I would be wanting to acquire furniture and he said well, that is very simple. I told him what our tastes were and he said it would be simple as he was an expert in antique furniture and was my friend, and would see that I got the right things at a reasonable price. He also told me that there was a good deal of swindling, as he put it, in his business, and that it would not be wise to go and buy in all sorts of places, and that I would need expert advice, and he was an expert ... he told me that in purchasing antique furniture, we should only go for the very best, and also it would be advantageous to get in a collection, as if ever we wished to dispose of the pieces, having a collection of good things, the one enhances, so to speak, the value of the other, and that if at any time I wished to dispose of it, having a collection would be a better investment than buying the odd pieces here and there.[101]

Shrager's naivety and lack of knowledge of the antiques business played into the hands of the dealer, 'As regards [to] whether a thing was of a certain period or whether it was a genuine piece or a good piece or a valuable piece I had no idea whatsoever, and that is why Mr Lawrence offered to keep me right to avoid my purchasing spurious articles which he said abounded in the trade'.[102] Lawrence's identity as a friend was key to their commercial relationship. He dealt principally with the Shragers, with Dighton only joining in to convince Shrager of the taste and shrewdness of his purchasing decisions:

> The one who showed me most of the things at Savile Row was Lawrence. Dighton showed me things, and joined in when conversations were taking place about the things. On many occasions Dighton told me that I was buying extremely well, and getting the pick of their stuff. He also told me that he had been dealing in antique furniture for about thirty five years; that at the beginning he used to roam the country and buy pieces and send them to Christies and sell them and on one or two occasions he showed me photographs of some very wonderful things which he had brought and sold. Everything that I purchased was at Savile Row without exception. I was shown everything at Savile Row in the various rooms.[103]

The full transcript of the court case, commissioned by Percy MacQuoid, and still owned by the descendants of his wife, Theresa, offers us a useful précis of the story of the Shragers rise and fall in the antiques world. Throughout the trial the letters that passed between Lawrence and Shrager were used to examine what was purchased and how the purchases had been made. They are helpful not only in allowing us to track the objects that were bought, but also to examine in intimate detail the buyer/seller relationship in the furniture trade, a relationship that has altered very little since the 1800s. During Shrager's examination, both the lawyers for the prosecution and defence reviewed the letters relating to the purchases, starting with one written on 14 November 1919, from Lawrence: 'I have just seen a very wonderful red lac clock – unique as far as I know and the price is £170 which I think is extremely reasonable. It is in the possession of a competitor of mine who is also a friend'.[104] The clock was never purchased, but Burrows, Shrager's lawyer, drew attention to the last two sentences, 'I am really anxious that if you buy you should get the right thing at a reasonable price'.[105] Shrager is shown to have been led by Lawrence from the start in his purchasing activity:

> The idea was suggested by Lawrence to form a collection of antique furniture which would consist of fine pieces, because Lawrence explained to Shrager that a collection sold better than pieces. I ought to say . . . that one

of Mr Shrager's ideas was to invest in furniture, so he was to form a collection and the collection would be worth the same or more money as time went on. It was important for him as the purpose was well known to the Defendants that he should not purchase stuff which was not properly and readily saleable under the description which was sold to him.[106]

Obviously Lawrence did an excellent job of convincing Shrager of the 'rightness' of the objects for sale at Dighton's, and their value, as he immediately 'decided that he should begin purchasing without waiting for a house'.[107] At the time when the Shragers first visited the London shop they were living in a rented house at 31 Circus Road, in the City. When they eventually moved to Westgate, Lawrence took over the lease on the Circus Road house, although he claimed, 'it has nothing whatever to do with this case'.[108]

On the Shragers' first visit to Dighton's shop, they bought, according to Lawrence's account:

[a] Walnut bureau bookcase of early eighteenth century with inlaid doors and pediment; English eighteenth century bracket clock with elaborate brass mounts; two carved walnut Charles II chairs with caned seats and oval carved backs; eighteenth century mahogany Carlton House writing table; silver inkstand by Cripps, 1750; elaborate carved Chippendale chest of drawers with carved corners and serpentine front; inlaid Adam chest of drawers on legs with shaped front; five chairs and two settees of the early eighteenth century with elaborate carved legs and original water gilding; Chippendale jardinière on carved stand (. . .). That is the first piece which was produced.[109]

Unfortunately for Shrager, according to his lawyer, these purchases marked the beginning of his encounter with the insalubrious world of the furniture trade. . . .

I might perhaps indicate to you generally at this stage what is said about these pieces of the finest quality which might be true collectors pieces. It is said with regard to the first item of all, the first purchase, that it is a made up piece, 'Lower part [of the bureau] old but fall re-veneered, central box behind fall with door and secret drawers, modern. Fitting behind fall (central box) made from new American oak; upper part entirely "made up". They are so modern that they smell of American oak'. They will be produced to you and you will have the opportunity of testing that. 'Doors made from solid slabs of wood instead of being framed veneered on both sides'. The result of that is that the doors have warped and are warping. It

stands to reason that if they were eighteenth century they would not be warping now. In point of fact they have further warped since this case was started. That is the first piece which was produced.[110]

They started by selling him something which can only properly be described as a fake; throughout the transactions they sold him what can only properly be described as fakes; and they finished up by selling to him fakes. I cannot tell you the exact percentage of what really can be called genuine antique furniture, apart from those which are either reproductions or fakes, or made up of altered things, but the percentage of furniture which can be taken up, without attack at all is either one or two percent.[111]

On the surface, the whole of the case appears to rest on this crucial debate; was Shrager sold a collection of which 98 per cent could not be described as 'fake' or was he sold the 'collector's pieces' as described by Lawrence and Dighton?

Fakes 'are, above all else, a response to demand, an ever changing portrait of human desires. Each society, each generation, fakes the thing it covets the most'.[112] The role of antiques in the desire for cultural capital at this time led to the growth in ways to fake them. As Cescinsky would later comment, 'If the genuine article does not command a price on the market which will pay for its reproduction, then faking it is out of the question. It must be remembered that the fake, if it is to be worthy of the name is much more . . . than a mere modern copy'.[113] Fakes delineate the evolution of taste, 'where there are fakes it is clear that there was a booming market in the things thus imitated. . . . If the market concerned is in antiques, however broadly defined, the fakes produced for it will reflect its demands more accurately than the genuine work traded in it. The former mirror the perceived desires of collectors; the latter may pass unchanged through their hands'.[114] As Cescinsky commented in *The Gentle Art of Faking Furniture*, 'the term fake must be an elastic one and difficult to define. It would almost appear that the faking element belongs as much to the method of selling as to the making'.[115] Certainly the market is all important and is often the conduit of a definition. The focus is not on the object itself, but on its meaning to the buyer. Mark Jones, reflecting on the major exhibition, 'Fake, The Art of Deception', held at the British Museum in 1990, attempted to define the term as 'objects proven to be made to deceive the buyer'.[116] Without this interaction, without the label that is applied to the object at the point of consumption, no object can enter into the realm of the fake. Bound into this are theories of provenance and authenticity. The seller takes the object and places a value upon it according to his/her perception of history and the seller's confirmation through these that the object is 'real'. It is this 'moral force of the real thing', that persuades the buyer to part with more money than a simple functional, modern object would command.[117] 'Only the

idea is consumed', just as we are prepared to spend double, triple or even more on a designer handbag or pair of shoes, which fulfil the same function as much cheaper items but have a name or aura of significant value attached, so we are prepared to spend more on the old, the antique, the authentic piece.[118] This implied/applied value does not operate at the time of one purchase, but continues to impact upon the value of an object, unless this system is broken by an accusation of fakery. The idea that we could re-sell the object for more money in the future also explains the attraction of the antique and therefore its propensity to be faked. Cescinsky also considered this an important factor when assessing the value of the authentic object over the well-done fake:

> It may be asked, if the differences between the genuine and the spurious be so slight, why not collect the fake? The answer is, why not, PROVIDING THAT ONE KNOWS THE DIFFERENCE BETWEEN THE TWO. Without entering into the question that inability to discern the difference between a real pearl and an imitation does not alter the fact that the one is real and the other imitation, it is of some importance that one should not pay pearl-price for the substitute, especially if one comes to sell again. The matter goes deeper even than this, in the case of antique furniture. Genuine old pieces are a part of the social history of bygone times, be that history ever so unknown or unwritten. To weave romances round a thing of only yesterday – and one the natural life of which has been seriously shortened in the attempt to give it the spurious appearance of age, and to do this through sheer ignorance – is neither satisfactory nor clever. To pay Queen Anne price for Mary Anne is still more stupid.[119]

The market in fakes was (and is) driven by the commodification of culture. When the notion of the original piece of applied art was not so valued, when the copy and the cast were considered worthy alternatives, the faker had little to do. It was only with the rise of the market, the ability to select one's purchases from a wide array of alternatives, did the antique become valued and thus its careful reproduction become a worthwhile activity. As David Lowenthal commented in his essay supporting the exhibition of fakes at the British Museum, 'the global tendency to treat art and antiquity as market commodities, augments the value of originals, thereby encouraging their faking. Fame, rarity and uniqueness boost their monetary worth and investment value. Because past masterpieces are a non-renewable resource, the expanding market always needs more originals and seeks new sources'.[120] It is important to establish at this point a caveat to my use of the word 'original' and how it was defined in court. The idea of an 'original' is a complex one as its definition changes not only in history but also according to the object under

consideration. For example, it is accepted that a bronze sculpture will be one of a series of casts, due to the process of manufacture. Likewise, in the art market, the limited edition print has a value above that of a large edition print or reproduction, but is not as valuable as the test print, or first etching, but all can be described as 'original'. The definition of 'original' is slippery when applied to the sale of antiques. It is recognized that there is a difference in value between an object linked by known provenance to a named maker/firm, an object that was made at a particular time in history but not linked to a named maker/firm, an object that has been reproduced in the past, but now is 'historical' (i.e. a Victorian reproduction of an eighteenth-century chair sold in 2010), a recent reproduction and a modern piece styled in an historic way. But it is often difficult to place an object within this hierarchy, particularly when one considers the nature of the manufacturing process. An object styled as 'Chippendale' can never be precisely linked to an actual individual historical Thomas Chippendale, as we do not have any evidence of his unique hand in the making of furniture produced by his firm. There is no such thing, therefore, as a 'real' Chippendale, but only a name given to a range of simulacra of varying value according to the history and provenance – a kind of Foucauldian 'author function' without an originary author. The *Oxford English Dictionary* defines 'original' in the sense of a 'work of art' as 'created or done by a person directly; produced first hand; not imitated or copied from another', and it is interesting that this definition was not cited in the courtroom as the experts argued whether an object could be defined as 'original' and 'unique'. Using this definition, it would be very difficult to define any piece of Chippendale furniture as 'original'.

The value of the antique rose in the nineteenth century as historians and dealers began to define which objects were worthy of the title and which were not. It was no longer good enough for a piece of furniture to reproduce ancient forms; its construction and materials had to be confirmed as *old*.[121] The growing literature on what 'antique' meant when applied to old furniture also influenced the development of legal definitions of the antique for tax and import and export purposes. This rule was also applied in the Shrager case, with Cescinsky confirming in court in response to the question, 'Suppose it is early nineteenth century, would it not be an antique? Not in the sense I was using the term – that is to say, a thing which acquires something more than a second-hand value by reason of its antiquity'.[122] Once the definition of 'antique' had settled on the idea of 100 years as the key legal indicator, the market began to develop rapidly and desire for the old generated an increased role for those capable of falsifying the patina of age. As the market for antiques developed and specialized so the faker's activities mutated. At the beginning of the nineteenth century, faking old furniture consisted chiefly of making new pieces

by joining together old bits of timber, culled from a wide range of objects and interiors, or by adding decoration to and/or recarving old objects. By the 1870s, Charles Eastlake, in his *Hints on Household Taste in Furniture and Upholstery and Other Details* (1868) – among others – was condemning such practices and revealing the tricks of the faker's trade, such as the use of thick varnish to disguise the variety of timbers and joins or the creation of worm holes, a practice much discussed in the Shrager–Dighton trial. As the historian, and hence the trade, became more aware of such techniques, the faker had to develop more sophisticated practices to fool the customer. A hierarchy of fakes even developed: 'We can divide fakes into two classes, those made to deceive a real expert, and those made to satisfy others whose sole criterion of antiquity is dirt or the presence of worm'.[123] The 'creation' of the most effective fakes involved both manufacturer and dealer, the object and its aura, created by the catalogue, the shop and even faked provenances.[124] As Walter Benjamin would later confirm in his celebration of his own and others' collecting practices, 'The period, the region, the craftsmanship, the former ownership – for a true collector, the whole background of an item adds up to a magic encyclopaedia whose quintessence is the fate of his object'.[125] The collector of antique furniture was equally as entranced by the 'magic encyclopaedia' that a detailed provenance could provide, and thus this became the most useful of tools for the faker determined to market the products of his workshop.

Discussions in the courtroom about the definition of the fake reflected a more general discussion outside about the definition of a fake and specifically a fake's relationship to the reproduction pieces that were a popular part of the market, and frequently featured alongside 'genuine' antiques in the dealer's shop. Mark Jones's comment in the 1990s on this subject, 'The history of restoration is . . . inextricably linked to that of fakes'[126] shows that the problems of defining the fake as distinct from the reproduction have not altered much since Cecinsky considered this dichotomy at the beginning of the century: '"Fake" and "reproduction" are often loosely used as if they were interchangeable terms, which is, emphatically, not the case. A reproduction, in its best sense, reproduces everything but the appearance of antiquity, and, as a rule, it falls far short even of this. . . . The reproduction will aim only at producing a modern copy. . . . No attempt will have been made to produce even the effect of age'.[127] In the courtroom all of the expert witnesses were asked to define the range of terms used in the trade to describe the legitimate and illegitimate processes used to treat old furniture. When examined on the difference between a repair and a restoration, Cescinsky, for example, declared:

> 'Restoration' is so much wider a term. Restoration, I understand, in its literal interpretation, means bringing back a piece to its original state. That

may be done by sticking back a piece of veneer which has fallen off. It may be by making a new chest of drawers to an old handle. It is a question of restoration to a degree, justifiable or unjustifiable restoration. . . .

There is also a process whereby a piece of furniture is made which resembles old furniture is there not?

Yes.

Is there any difference between what is called a 'reproduction' and a 'fake'?

Yes, there is . . . a reproduction copied an old model. A fake not only copies an old model, but there is a deliberate attempt made to deceive somebody that it is the old model.

How far is the use or employment of old wood to be taken into account in considering whether a thing is a fake or not? . . . Where a genuine piece has been dealt with, does the question of degree come in? . . .

It may depend on the character of the piece. You may admit a larger degree of restoration in one piece than you would conceivably admit in another.

With regard to a reproduction, does the question of degree come in at all?

No. A reproduction is a modern piece of furniture which copies an old piece in style and may copy it in general effect. There are reproductions sold today which are catalogued as possessing what they call an antique rubbed finish.

With regard to the articles in which old material has been used in modern times to make a piece of furniture, does the question of degree enter into it there?

Yes, because if old wood is used it can be a reproduction guiltless of deception; it may be a fake which could be put to very, very guilty uses.

If there has been restoration or repair to any extent, should it or should it not be mentioned when the article is being dealt with?

When it gets beyond a certain slight degree it should always be mentioned.

The degree, then, is slight?

Yes, quite slight.[128]

Cescinsky therefore concluded that it was the label applied to the object, rather than the object itself, that was key and that these labels were mainly applied in the dealer's shop. 'Economic exchange creates value'; the fake only operates once it is sold.[129] Its meaning is bound up in its ability to be

exchanged. They play on/operate through the idea that the antique is a unique[130] and therefore scarce object – it is this notion of scarcity that creates value. As George Simmel concluded in *The Philosophy of Money* (1907), 'the difficulty of acquisition, the sacrifice offered in exchange, is the unique constitutive element of value',[131] or, in Arjun Appadurai's words, 'exchange is not a by-product of the mutual valuation of objects, but its source'.[132] Just as Cescinsky confirmed, a fake only becomes a fake once it passes through the market and is defined only when it 'is used for the purpose of deceiving somebody'.[133] As such, the success of a fake, its very creation, depends on the specific cultural and historical milieu in which it is produced: 'If the genuine article does not command a price on the market which will pay for its reproduction, then faking it is out of the question. It must be remembered that the fake, if it is to be worthy of the name is much more . . . than a mere modern copy'.[134] 'Desire and demand . . . interact to create economic value in specific social situations'.[135]

It is only through the process of purchase that the fake obtains its value. Therefore there was much to lose if Shrager had won his case – both for the dealer and his supplier. The success of a fake relies on it being deemed 'right' and, in order for this to happen, it must enter into the cycle of purchase and collection. It only really works once it leaves the dealer's shop. As Jean Baudrillard has highlighted in his consideration of the art auction, the market for art and antiques and thus the inherent structures of value go 'well beyond economic calculation and concern all the processes of the transmutation of values, from one logic to another logic of value which may be noted in determinate places and institutions'.[136] He goes on to note that, 'contrary to [normal] commercial operations, which institute a relation of economic *rivalry* between individuals on the footing of formal *equality*', the antiques market, just like its close cousin, the auction house, 'institutes a concrete community of the privileged who define themselves as such by agnostic speculation upon a restricted corpus of signs. Competition of the aristocratic sort seals their *parity* (which has nothing to do with the formal equality of economic competition) and thus their collective caste privilege with respect to all others, from whom they are no longer separated merely by their purchasing power, but by the sumptuary and collective act of the production and exchange of sign values'.[137] These sign values feed the forger's profession, as to question the faked object displayed in the dealer's shop window, and celebrated by the expert's prose, is to evidence one's removal from the 'community of the privileged'. Certainly Lawrence's and Dighton's descriptions of the objects in their shop left little room for questioning: 'He used to go into very elaborate phraseology as to the fineness of the articles'.[138] The etymology of their praise was and remains familiar to those who visit the antiques shop or read the auction

catalogue, featuring the familiar terms; 'so rare', 'unique', 'a very fine piece of antique', 'a little darling', 'so very fine that you really are lucky', 'probably the most wonderful piece of oak in the kingdom', 'something extraordinary', 'in charming condition', 'a gem'. 'He pointed to the painting and pointed to the whole thing and dilated on its beauties and its variety, and its quality. . . . "It is a piece that many people will be after as soon as they know it is here"'.[139] The hyperbole of the dealer's descriptions reminds us of the capacity that language has to generate desire. Lawrence's success depended not on the quality of the object itself but his ability to invent a convincing narrative about it. This narrative is the basis of the structure of desire that underlines and supports the practice of the antique dealer. This structure 'both invents and distances its object and thereby inscribes again and again the gap between signifier and signified that is the place of generation for the symbolic'.[140] 'Lawrence pointed these tables out to me when I was there and described them as eighteenth century, and he said that he had never seen in his life such a perfect pair. It was the inlay and the condition which were absolutely magnificent and the whole conception of the tables he said was perfection, and it was perfectional work, that was the expression. I bought them for £800'.[141] It is the narrative, the talk of 'perfectional work' and the like, that generates the object and hence generated Shrager's longing for these objects. In the gap between the object and its representation in language, we find the key to understanding how the bourgeois milieu created a certain system of desire for old furniture. The arbitrary nature of the sign allows it to be transformed through the language of the sale. In her analysis of 'longing', Susan Stewart compares this to the arbitrariness of exchange value.[142] The exchange value bears no intrinsic relation to either the value of the materials out of which the object has been fabricated or the value of the labour that has fabricated it. Its abstraction from the reality of its production through the process of exchange and desire means that the sign (rather than the object itself) is consumed and thus its value is imposed by its description, a description that maps onto certain social patterns and beliefs. This 'language of consumption' is apparent in the dealer's parlance of the 1920s.[143] Throughout the case, Harry Lawrence's words are repeated, drawn from his letters to Shrager, emphasizing the key linguistic games that the dealer used to convince his buyer to purchase:

At a visit there [a small Chippendale love seat with carved legs and underframe] was shown to me by Lawrence and he dilated on it. To use his expression, he called it a 'gem' or a 'darling'. He said, 'It is a small one and small seats are really quite rare'. He said 'this is a beautiful specimen'. I said 'All right, send it along'.[144]

Lawrence pointed these out to me and told me that in the ordinary way he would not let me buy anything that had modern painting, that the stands of these cabinets usually somehow got damaged and so forth, and if it were not that the cabinet itself was not so exceptionally fine, he would not dream of letting me buy it but the cabinet itself was so exceptionally fine, he would make an exception and he said 'you ought to take it'. I bought it.[145]

Shrager was not buying a seat or a cabinet, he was buying the narrative that Lawrence had woven around them, a narrative that is supported and repeated by the rest of the trade. For Jean Baudrillard, in the late 1960s, the 'psychological restructuration of the consumer is performed' through single words such as 'Philips' and 'General Motors', words capable of 'summing up both the diversity of objects and a host of diffuse meanings'. These 'words of synthesis', 'psychological labels' in the antiques market of the 1920s, were not individual brands, but key terms that suggested quality, age and value. Repeatedly we hear the words 'genuine', 'fine', 'unique', 'gem' and so forth used to describe the objects in the dealer's shop. This is 'undoubtedly the most impoverished of languages: full of signification and empty of meaning'.[146] This 'language of signals' is carefully debated in the courtroom. The direct relationship between the language applied to the object and its price is also demonstrated by Cescinsky's assessment of the value of the pieces under consideration:

> I have taken values to be first of all 1920 values; secondly I have taken those values and calculated, as far as possible, a rate of profit which I consider is proper to the person selling that particular class of article. That means that in the case of a fine antique piece, presumably sold by a fine firm in expensive premises, I should assess that proportionally much bigger than I should assess a second-hand dealer in a piece of furniture which might be sold by any . . . dealer in a back street.[147]

In his attempt to accuse Dighton's of spurious business practices, Cescinsky returned again and again to the idea that the objects were not 'antique', but 'second-hand'. Both labels imply age but the difference between them is measured in pounds and pence, and signalled by their circumstances of sale. In simple terms, the difference in price for an 'antique' bureau and a 'second-hand' one was £209 according to Cescinsky.[148] Pollock, for the defence, attempted to locate the processes of valuation – 'who shall say what is the right price?' – firmly at the door of the purchaser rather than the dealer and he laid the blame for the change in signification of any given piece on those willing to 'pay almost any sum' for 'artistic furniture'.[149] 'If you go from

one dealer to another, you may find prices varying in the most remarkable degree for these pieces. It depends very much on how keen the person is to possess the piece, and so on and so on. There is no market value for them'.[150] Reflecting upon the contrast that was constantly drawn between the pieces discussed in court 'and what is called an article of commerce', he concluded that:

> Articles of commerce have their value, a known value and a value which you can estimate, but when dealing with pieces of furniture of the character and quality which are being dealt with in this case, we are dealing with pieces of furniture in respect of which there is no commercial value or market value in that sense, and any man who acquires the possession of them may be prepared to pay, and might gladly be prepared to pay a sum which many people who stand outside the matter may be thought to be a ridiculous sum.[151]

As evidence he drew the court's attention to the auction sale, where a price may go up 'by leaps and bounds to a very high value indeed and the winner is glad to think that he has bought it'.[152]

> Can it be said that the fact that he has paid that large sum is an indication that an excessive value has been paid? On the basis, of course, that these are genuine pieces, there is no test of value that you can apply to them. Let me take one illustration. Do you remember the two side tables which were bought at Melchet Court? As to those, they were sold at the sale for £1,100 or guineas, whichever it may be. 'If genuine', said Mr Cescinsky, 'their value would be £2,000'. They were sold for £1,100, and you have a case there where experts might differ and where what I call the interest, the incentive to purchase, would be so great that in the case of some persons, I daresay £2,000 would gladly be paid. But are you able to say from that that it is any evidence of breach of warranty, because they have been sold at a particular figure when another price might have been paid, or would have been paid by some people? The very illustration that I give is perhaps as conclusive an illustration that I can give as showing that the money paid for a particular piece, if it is genuine, is really no guide at all.[153]

Yet within his summation, Pollock returned to the crux of the case, the question of authenticity, and whether the objects sold as 'genuine' and thus paid for as 'genuine' were, in fact, 'genuine'. On this point, Cescinsky, like the other experts, was asked for his definition.

My definition of the word 'genuine' as applied to furniture is furniture which has not been altered, only restored and legitimately repaired.

Have you altered your definition of the word 'genuine' recently?

No, it is a loose term in any case . . . it is still a loose word in my mind, as well as in other people's.[154]

The 'looseness' of the term is its very success. It allows the dealer to re-invent the object without suggesting anything in particular. The objects themselves are arbitrary; description in the dealer's game is everything. We can see this in the court's attempts to define 'genuine' and how they drew together the gamut of terms used to 'invent' the object in the dealer's shop; 'antique', 'restoration', 'legitimate' and 'quality'.

It is antique in the sense of age?

Yes.

It is antique in the sense that it has nothing to do with age? In the sense of rarity value, because of its antiquity?

No, it has no value from that point of view. It is purely a second-hand, roughly made piece of furniture.

Do you suggest this thing has been greatly restored. Or do you say that it is not worth restoring?

. . . Restoration to a certain point we never quarrel about . . .

Up to a certain point it is quite legitimate is it not?

Yes.

That is a question of degree. Has that point been passed . . . has the restoration gone so far, if you like, as to change the identity of the piece or to make it substantially a different piece?

In a piece as rough as this, you could keep on restoring it, and make it entirely new, and it would not affect its value.

I daresay that is so, but in this particular piece have the restorations been so great as to substantially change the character of the piece?

No.

We all know the story of the knife, that you can get a new blade and a new handle and so on, and it is difficult to know where the old knife stops?

Quite.

But in this particular chest of drawers, you agree, do you not, that the restorations have not been so drastic as to prevent it remaining antique in the sense of antiquity?

No, I do not.

It would be true to say, then, that it is too much restored to be classed as genuine?

... I should not put it that way ... that, again, is a matter of opinion. My opinion is that I should never apply the term 'genuine' to this. Genuineness applies to quality as well as to age. I should not call it anything but a roughly made, second-hand piece of furniture, with no pretensions to good workmanship or quality.[155]

Once the prosecution had their say, Percy MacQuoid, for the defence, also attempted to fix the term's meaning:

Now I want to know something about the standard that you apply when you are advising clients. You have used a number of terms here in the course of your evidence; sometimes you have said 'genuine', sometimes 'perfectly genuine', sometimes 'utterly genuine' and I think there are others, but I need not mention them. Do you mean the same thing by those various phrases?

That is simply a different method of using English to me ... Certainly ...

What do you mean by 'genuine'? We ought to have a dictionary.[156]

'Genuine' is, shall we call it, what it purports to be ... if you say that table is a Queen Anne table and it is a Queen Anne table, it is genuine. That means that it should be a table of the time of Queen Anne. On the other hand, you might say; 'Is that table genuine?' without dating it at all, and then you must definitely feel for its date.

May I put it this way; 'true to its genus'?

Yes, I suppose so.

Pure and unadulterated?

No, Not unadulterated.

Would you regard it as a genuine piece of furniture if some part of it was made in the time of Queen Anne but some of it had modern pieces put into it?

Yes.

And would you so advise your clients ... ?

I should point out that certain pieces, if I saw them, had been restored. You do not always see it.

Would you advise your clients without any qualification that a piece the main part of which was made in the time of Queen Anne and which had some new parts in it was a genuine Queen Anne piece?

No, because I should employ a reservation . . . if I saw that it had been very much restored I should mention the fact. I should say; 'This is a genuine piece of Anne furniture, but it has been restored here and it has been restored there.'

Then do you think it necessary to make that reservation and that special statement and qualification of the word 'genuine' do you?

If I saw these restorations.[157]

One of the most interesting tests of the idea of the genuine object in the court-room comes from MacQuoid's own publishing activity, and shows how closely the antique shop and history book were tied, despite MacQuoid's claims to the contrary. One of MacQuoid's first articles for *Country Life,* published in 1911, concerned a chair in his own collection (see Figure 1.1).

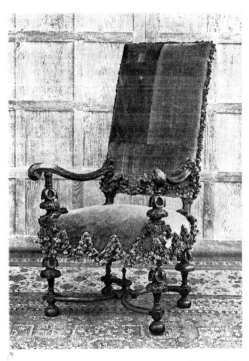

Figure 1.1 'Armchair belonging to Percy MacQuoid', published in *Country Life,* 29 April 1911, pp. 610–11.

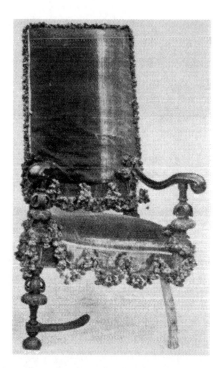

Figure 1.2 Walnut Armchair, Figure 26 in Percy MacQuoid, *A History of English Furniture: The Age of Walnut, 1660–1720* (London: Lawrence and Bullen, 1905).

On 1 April 1911 *Country Life* had announced that 'so great is the present interest in the history of furniture', the magazine, taking full advantage of recent advances in colour printing, would 'week to week present a picture of a piece of furniture so exactly capturing its characteristics ... that the very thing itself will appear before us'.[158] MacQuoid's chair was one of this series.[159] It had originally been featured in his volume, *Age of Walnut*, of 1905 as an 'interesting ruin',[160] but was shown as having been restored and, thus, became the focus of an interesting debate about how we define a reproduction as opposed to a 'genuine antique' (see Figure 1.2).[161]

Do you call that a genuine chair. It is one of your own?

It was a genuine chair.

When it was printed in your book was it a genuine chair?

Yes ... it was not put in the book. That is not a book on furniture. That is an article upon an individual chair.

When it was reproduced for that article, was it a genuine chair?

Certainly it was a genuine chair, and if you read the article you will see it was in a terribly dilapidated condition. . . .

At that period it was a genuine chair of the Charles [II] period?

With restorations, as I mentioned in the book. . . .

I only want to get an understanding of the meaning of your words. This is your own book upon furniture, *The Age of Walnut* page 25. Look at the chair on the right. Is that the chair you called an interesting ruin?

Yes. . . .

Then the picture which is there, an interesting ruin, was taken before this one, was it not?

Certainly. . . .

So that the ruin which has been made up, three legs and a stretcher, becomes a genuine chair of the Charles II period in your vocabulary?

There were more than three legs and a stretcher.

Wait a moment. Remind yourself of the book. There are three legs missing are there not?

There were portions tied on to the legs when the chair was sold. . . .

In your vocabulary does the chair made up from the ruin of that sort become a genuine chair of Charles II period?

It all depends how you describe the chair and what you mean by the word 'genuine'.

I want to know how you describe it to your clients?

If I describe a chair to my clients, if I wanted to sell the chair, I should say 'I bought the chair and I restored this leg and I restored that leg'.

How would you describe it in giving evidence here? Would you say it was genuine in the sense you have been using the word in the witness box?

Yes, I should say it is an old genuine chair.

Restored?

Restored.

Then it is not genuine is it?

Yes, certainly.

Not genuine without qualification?

I have told you that there are many genuine things which are restored. . . .

Is a chair which is whole and intact as it was at the time it was made of the same value or more value than a chair which has been a ruin and restored?

Of course, as it was made.

In a chair of that kind, what sort of percentage would you add on to the price of the restored ruin if it were a genuine chair?

I do not understand such things. I do not sell furniture. I do not keep a shop.

But you advise clients about price. Assume you have your client here and a piece is put before him which you know and are satisfied is absolutely genuine, intact, in the same condition as it was except for age when it left the manufacturer's place. You would advise your client to give a very much higher price than if the thing you saw was a restored ruin, would you not?

No. . . .

Are they the same value?

Practically in my idea, and they ought to be. . . . A client has never asked me about the ruin or what the value of a ruin is.

Have you never advised your clients to purchase restored ruins?

No, I do not think that has ever occurred to me.

When does it begin to affect the price? Let us take the one within your own experience. Would this chair in your view restored in that way be of the same value as this chair if it had never become a ruin and was in the condition it was when it left the manufacturers?

It is rather difficult to get at its value in the first instance, but I should say it would be the same value plus the simple expense of the restoration.[162]

On cross-examination MacQuoid stated that he would point out the restorations to a potential client but would not advise them to give a higher price for an unrestored piece.[163] The incredulous examiner retorted, 'You really tell us without hesitation that you would advise a client to give the same price for a restored ruin as for a piece of furniture that was intact and complete as it was when it left the manufacturer's place? Yes, I should', replied MacQuoid, concluding that the difference between a restored ruin and an original piece 'would be the same value plus the simple expense of restoration'.[164] This is in direct contrast to the advice he gave Lady Stamford in 1907 regarding the purchase of a table for the hall at Dunham Massey: 'I am anxious . . . to get one really good table for your Hall . . . the less modern work is put in the more interesting and valuable your table becomes'.[165] Also interesting was MacQuoid's claim that, as he did 'not keep a shop', he could not comment on anything as base as price. At the trial the 'experts', with no sense of the inherent irony of their practice, consistently attempted to distance themselves

from the commodification of the antiques under discussion. The term 'a collector's piece' was frequently applied to the objects purchased by Shrager, who was keen to be seen as something more than a customer. The distinction between these terms maps onto a similar distinction that has been proposed in the attempt to differentiate collecting from simple consumption. Krzysztof Pomian, for example, defines a collection as 'a group of objects maintained outside economic activity'.[166] The use of the term 'collector's piece' therefore aims to confer an 'aesthetic status' above the market. Susan Pearce, in her exploration of the object as viewed in the museum, has highlighted '[t]he traditional separation of the aesthetic and economic dimensions, which confers a "sacred dimension" on cultural objects, versus those objects with commodity status'.[167] In using the term 'collector's piece', Lawrence and Dighton hoped to raise their furniture out of the commercial zone and into the sacred space of the antique, to create an aura that disguised the base activity of financial exchange. This definition became vital to the defence and the prosecution lawyers as they attempted to demonstrate whether or not Shrager had been misled into thinking that he was purchasing something more than furniture. Pollock attempted to convince the court that Shrager was mistaken when he claimed that Lawrence first used the term in November 1919: 'I just wanted to understand when it was first a term used to help you to buy. . . . In conversation first of all before I bought, Mr Lawrence told me to go in for only the best and the finest . . . collector's pieces'.[168] Cescinsky claimed that 'a collector's piece implies a piece the character of which has not been altered in any way and the additions or restorations are not of a material character. For instance, take a chest of drawers on a stand where the whole of the stand has been made up. In my opinion the stand is not a collector's piece',[169] whereas Pollock argued, in his summation of the prosecution's case, that

The standard put forward by Mr Cescinsky is that it must be a 'collector's piece', and he says that this and that and the other is not a collector's piece as if that were the one and only standard. Mr Litchfield dealt with that matter in a very fair way. He said it depends very much upon the collector, upon what he is collecting, and the wide range his collection covers, yet time after time 'collector's piece' has been used in this Court as if it were the standard. The curious thing is that it is after a number of pieces have been bought that you first find the word – that Mr Lawrence said 'This is what I should call a collector's piece'. It is not put as an original part of the representation, but it falls into line with this expression 'collector's piece'. . . . 'Museum pieces' and 'collector's pieces' and so on are all uncertain standards.[170]

They may have been 'uncertain standards' but they certainly worked to convince Shrager, and so his story became the story of the Emperor's new clothes; his parade of faked objects resulted from his unwillingness/inability to question/disrupt the 'tournaments of value' until failing financial circumstances forced him to do so.[171]

By 1920, instead of buying pieces of antique furniture for the purpose of putting into a house when bought, it was a case of buying antique furniture for the purpose of putting into a specific house, for the Shragers had finally purchased their house in Kent. At this point Lawrence took charge and the house was furnished throughout under his advice and supervision.

> He not only advised Mr Shrager and had charge of the selling of antique furniture which he put into the house but he also took over the question of modern furniture and the decoration and things to go into it and he also undertook and had already started the supply of French prints and so on for the purpose of decorating the house. As the house was occupied eventually the contents and design of the house were Mr Lawrence's idea. He took over the whole thing. Mr Shrager was acting entirely on his advice and it led to this result; that a great many things were bought by Mr Shrager which he had never seen and had only acquired by the simple process of Mr Lawrence sending them down to Westgate and sending in a note for them. A great many items Mr Shrager not merely purchased on the advice and on the representations of Mr Lawrence but he actually purchased because he trusted Mr Lawrence to supply him with the right thing without ever having seen them and knowing nothing whatsoever about them.[172]

Lawrence, as a dealer working for Dighton and Co., therefore, had a significant role, a role commented on by Mrs Shrager when things began to go wrong in December 1921: 'I can assure you that had we known that we would have anybody else besides yourself and Mr Lawrence to deal with, I should long ago have stopped my husband from spending such huge sums'.[173] As we have seen, Shrager's perception of him as a 'trusted friend' allowed Lawrence to take full control of creating a house that would be suitable for the Shragers' current, and much hoped for, future social standing. They had the financial wherewithal but needed guidance as to what to purchase to ensure that their financial capital would be turned into cultural capital. Lawrence was even consulted by Shrager on the few purchases the latter made elsewhere.[174] Of course, the defence presented this relationship somewhat differently:

> Mr Lawrence will tell you that it was entirely on his own motion that Mr Shrager came to him and asked him if he would sell some articles of

furniture as he wanted at some time to furnish his house at Westgate and he wanted to begin collecting the furniture for his house. There was no question of any collection of collector's pieces; it was merely a question of the furnishing of his house, not the furnishing of a museum – and Mr Shrager bought these articles for that purpose. There was nothing in the shape of Mr Lawrence being the guiding hand in the matter. Mr Shrager and Mrs Shrager used to come to Savile Row and say: 'I like this thing; how much is it?' and the price was named, and they either had it or they did not have it. They picked the things out that they wanted. In some cases things were submitted and after inspection sometimes they bought them and sometimes they did not. But these two, the Plaintiff and his wife, were the persons who were in direct control of what they bought and did not buy.[175]

Whichever version of events one believes, if circumstances had not meant that Shrager needed to rapidly re-sell the objects quickly in order to meet his debts, perhaps their 'genuine quality' as 'collector's pieces' would never have been in question. Ironically, in 1920 and 1921, the economic depression had allowed Shrager, at least if Lawrence was to be believed, to take advantage of the penury of others:

I went into number 3 Savile Row, and Lawrence told me, 'Something wonderful has just come in. These are bad times, people have got to sell, and here is a very wonderful pair of lacquer cabinets.' He said something about William and Mary or Queen Anne period, one or the other. He said 'The bother is this, the people are selling because they must have cash. I said 'Are they very wonderful, because we have got a lot' and he said, 'Oh yes, they are'. He said, 'If it were not for the bad times, they would be worth about £4,000'. I said 'Should we really buy them?' He said 'Yes, rather'. I said 'Well, it means getting cash. Well alright, I shall do it', I got the cash and bought them.[176]

It was not long afterwards, however, that Shrager was also a victim of the downturn in the markets. By June 1921 he was under severe financial pressure and beginning to realize all was not as it had first appeared.

Had I known all along, which I did not, that our very pleasant and large dealings were subject to the control of others than yourself and Lawrence and myself, and I might at any time have to enter into discussions with anybody but your two selves, I should never have continued purchasing from you for cash things. . . . I would also never have taken from your stock lying at the place, thousands of pounds worth of prints, which, but that I

took them, would in all probability be still lying there and I would thus have been owing nothing or next to nothing.[177]

He was beginning to see how he had been persuaded to purchase by Lawrence's presentation as an disinterested friend showing him around a shop that was largely presented as a home. Lawrence and Dighton's were also struggling as boom turned to bust. 'I know that your unfortunate illness has interfered with your business arrangements. Unfortunately, however, this does not ease the situation here as I must find a large sum before the end of the year, and my other directors absolutely insist on the money being paid in order to avoid a collapse and consequent increase of unpleasantness for both of us'.[178] Dighton was careful at first to couch his demands with reference to the general economic downturn: 'Do not for a moment think that I do not appreciate the large business you have done with me for the past two years, nor yet the considerable payments you have made, but we cannot afford to carry the large amount in our books. Had times been normal none of us would have been worried, and I am extremely sorry that the necessities of the case can be overcome only in one way'.[179] Shrager had been ill since November 1921, and his wife was left trying to deal with his accounts at Dighton's, deciding that as her husband could not 'attend to affairs at present . . . I must therefore try and do the best I can for all concerned. I can send you by next week £1,000. . . . I am also quite agreeable if you dispose of the suite of furniture for which my husband paid £3,000 cash, if not I shall arrange through Mr Weir, our solicitor to send it up to Christie's for sale'.[180] But Dighton's were pessimistic in their reply, claiming 'there is little chance of selling your suite of Chippendale furniture as there is practically no business. I am afraid they [the Directors] will not allow the account to stand any longer unpaid'.[181] According to the prosecution, from this point

> Until the date at which the experts were brought in, Mr Shrager was under the impression that the furniture and effects he had bought from Messrs Dighton were well worth the money he had paid for them, and that the amount of the outstanding account could easily be dealt with in case of need, if he found he was not able to raise sufficient cash from other sources, it could easily be made up by selling this genuine antique furniture. There might possibly be a difference of a few hundreds, but the things were still worth the money and he had no suspicion that what he had was not genuine.[182]

Dighton and Co. attempted to use the current state of the market to dissuade him from doing so, writing on 31 December that, 'there is very little chance

etc. . . . practically no bidding'.[183] Burrows concluded that, 'It is just as well that Mr Shrager did not sell the suite of Chippendale furniture or he would probably have had an action brought against him for selling as Chippendale furniture something which was not'.[184] Pushed to settle his accounts, Shrager 'made up his mind that the simplest way of paying would be to sell some of the furniture, and he called in an expert connected with the trade to advise him, not whether the pieces were genuine or not, but as to which pieces he could dispense with, so as not to spoil the house, and to realize those – so as not to spoil the collection which was housed in his house, but which pieces could best be dispensed with leaving his collection as untouched as possible'.[185] Unfortunately, this expert, later revealed to be Frederick Litchfield, did not give Shrager the news he was hoping for, disclosing that, to Shrager's 'shock', 'ninety-eight or ninety-nine percent' of the 'antique' furniture could not be described as the 'genuine pieces' of Lawrence's prose.

> That was the first time that he had any suspicion that in these friendly deal-ings with Messrs Dighton, extending over so long a period and involving such large sums he was not getting what was purported to be sold to him. Upon that he consulted experts upon the question of how much was or was not genuine. The examination of the experts disclosed this fact, that the vast bulk of the antique furniture which had been sold to Mr Shrager could not possibly be supported by the descriptions given by Messrs Dighton, and, speaking generally, one might say that they were faked in this sense, either that they never were antiques or that they were made up from antiques, miscellaneous pieces of antiques put together, or that they had been genuine antiques so made up as not to be saleable as genuine antiques, and certainly with very few exceptions in the hundreds of pieces that were bought, some ninety-eight or ninety-nine percent of them could not be described as genuine antique pieces of furniture of the highest class. That is the position he found himself in with regard to the antique furniture. With regard to the modern furniture which he had bought from them, he bought from them on the faith of the dealings that he had with them as to the antique furniture, and upon the faith of their standing and he finds that he has been grievously overcharged to the extent of thousands of pounds, a bill which he never would have incurred had he not relied upon them and upon what they told him.[186]

In the opening comments in court, Burrows summed up the case:

> The position therefore is this, that Mr Shrager, being a friend of Mr Lawrence, was introduced to Messrs Dighton by whom Lawrence was employed. He

went to them to buy things relying on their advice and judgement and their skill as experts . . . if they were in fact experts then they knew perfectly well that the stuff that they were selling Mr Shrager was not what they were representing it to be . . . if they were not experts then they lied when they said they were . . . Mr Shrager relied on the strength of his belief in their good faith and reputation . . . he was induced to spend a sum of no less than £111,000. What he got was not what he was told he was getting. . . . He has been planted with a lot of stuff which cannot possibly be sold except with a description of a kind which must damn the sale of practically every article. If he sells them honestly his loss is prodigious. It is that loss that he seeks to recover in this action.[187]

Having had the 'greatest trouble to get things expertised by independent experts', Shrager finally persuaded Cescinsky to go to Westgate in February 1922, where he spent two days examining all the articles purchased from Dighton's. In all Cescinsky visited the house in Kent five times before he drew up his report for the solicitors.[188] Litchfield had also visited in February, having taken much persuasion to do so, and Percy MacQuoid was sent there once the writ had been issued, in October 1922, to examine the 'pieces of furniture very carefully'.[189] MacQuoid not only claimed to have examined them in daylight but 'took all the furniture outside into the open air, which is the most severe test that you can put old furniture to'.[190] Despite Macquoid's claims to the contrary, the first two 'experts' concluded that the objects were not as they had been sold, and in January 1922 Shrager was told that he had been swindled, 'and the action was started'.[191]

From then on, until the case was concluded in the Court of Appeal in 1924, the public were transfixed by the tales of fraud, fakery and false business dealings. But the case was most closely watched by the trade, the men who stood to lose the most if Shrager won his charge of fraud, 'a serious charge against men who have stood at the forefront of the business or profession . . . of dealing in antique furniture'.[192]

'Make Us Rich': Dighton and Co. and the Market for Furniture

There have always been dealers of all sorts, dishonest as well as honest . . . but many of the dealers of the past generation were devoted to the profession for its own merits and not merely for the profit it brought . . . the Old Curiosity Shop with its dingy recesses and its picturesque assemblage of motley articles is now transformed into a garish 'fine art gallery', the dealer into a gentleman who makes it a favour to show one of his goods . . . now the collector need only sit in his chair, open his purse-strings and the mountain will come to him.[1]

Mr Dighton had been in the antique furniture business, and that he had a very good name, that he dealt in articles of the finest quality . . . he said Mr Dighton's prices were perhaps a bit stiff, but having the name he had, I could rely on the finest things and that it would be better, in fact, to go to a firm of standing than to try and pick up things here and there and especially as Mr Lawrence was my friend, he would see that I was treated very fairly, and that he would advise and undertake the supervision – well undertake the purchasing of things for me.[2]

The success or failure of Shrager's accusation of fraud centred on the notion of the dealer. Dighton and Co.'s defence relied upon them seeming to rise above the popular caricature of the profession as sinister and on the make, as seen in the famous portrayal of Daniel Quilp, the moneylender in Charles Dickens's *The Old Curiosity Shop* (1841). As such, this chapter places Dighton and Co., and the dealers who worked in the partnership – Basil Dighton and Harry Lawrence – within the wider context of the antiques market in England, mapping their practices, as described in the trial, onto the history of the dealer's shop.

The growth of the market for antique goods in England, and the dealers' shops to display them, has been the subject of relatively few studies. John Cornforth bemoaned this fact in his essay, 'Dealing in History; The Rise of the Taste for English Furniture' (1983), declaring that little been written about the relationship between dealing and collecting, and that there was no British equivalent of Elizabeth Stillinger's *The Antiquers* (1980) on the changing taste in American antiques from 1850 to 1930.[3] He comments that little was

known about furniture dealers in late nineteenth and early twentieth centuries and that apart from the work done on the firm of Baldock, most were just names, and that no one had written about nineteenth-century attitudes to eighteenth-century furniture.[4] Many of these absences have been addressed, particularly by Stefan Muthesius in his groundbreaking essay 'Why do we buy old furniture? Aspects of the Authentic Antique in Britain, 1870–1910',[5] and, more recently, in Mark Westgarth's work, which tracks dealers' activities even further back, locating the rise of the practice of selling antiques in the early nineteenth century.[6]

According to David Beevers, old furniture was not actively collected until the late eighteenth century, when dilettanti such as Horace Walpole, Richard Bateman and William Beckford began to acquire mainly Gothick [sic]objects for their 'romantic, historical associations'.[7] In 1776, Adam Smith had commented that 'in countries that have long been rich, you will frequently find the inferior ranks of people in possession both of houses and furniture perfectly good and entire, but of which neither one could have been built, nor the other have been made for their use . . . the marriage bed of James I of Great Britain, which his queen brought from Denmark, as a present fit for a sovereign . . . was, a few years ago the ornament of an alehouse in Dunfermline'.[8] It was only with the development of a romantic interest in the past, fired by novels such as Walpole's *The Castle of Otranto*, that such objects began to move back up the social scale to become 'antiques'. Such a move was summarized in an article on 'Ancient Domestic Furniture' in *Gentleman's Magazine* of 1842:

> The prevalence, at the present period, of a taste for Antique Furniture is most decidedly manifested, not only by the examples which everyone may happen to know of either ancient mansions, or modern houses in the 'Elizabethan' style, filled with collections of this description, but by the multitude of warehouses which now display their attractive stores, not merely in Wardour Street, but in almost every quarter of the metropolis . . . larger importations . . . not only entire pieces of furniture have been brought to supply the demand, but great quantities of detached portions.[9]

This observation was echoed by J. C. Loudon in his *Encyclopedia of Cottage, Farm and Villa Architecture and Furniture* of 1833: 'We now have upholsterers in London who collect . . . whatever they can find of curious and ancient furniture'.[10]

By the 1830s books began to appear aimed at the connoisseur-collector, such as T. F. Hunt's *Examples of Tudor Architecture Adapted to Modern Habitations* (1830) and Shaw and Meyrick's *Specimens of Ancient Furniture Drawn from Existing Authorities* (1836). At the same time sales of both antique and

reproduction eighteenth-century furniture began to increase. Simultaneously the market was supported by the aristocracy and the new industrial capitalists who were appropriating the signs of the old hierarchies in their wish to identify themselves as part of the elite. For example, Dolphin tables in the style of William Kent were made for the Picture Gallery at Bridgewater House in about 1805, and the sixth Duke of Devonshire bought not only Kentian furniture but also had it made for Chatsworth. Therefore, as John Cornforth points out, the market for old English furniture seems to have preceded the literature on it and indeed stimulated it.[11] Horace Walpole collected country chairs and Samuel Rush Meyrick fitted up the breakfast room at Goodrich Court, designed by Blore, in 1828, 'in the gorgeous style of Queen Anne's time'.[12] Much of Meyrick's historical ephemera gathered together at Goodrich Court was purchased from the early antiquarian and curiosity dealers who were starting to trade out of premises in Wardour Street.[13] His use of 'period' rooms in which to display his finds was a very early articulation of a display device that would become key to the interpretation of historic furniture in spaces such as the Victoria and Albert Museum.[14]

In *The Economics of Taste* Gerald Reitlinger pointed out that 'the 1850s and 1860s, which saw such an impressive advance in the value of painting of the English eighteenth-century school, produced nothing that was comparable in the English furniture field'.[15] That said, Reitlinger's theories have been challenged by more recent studies of the growth of the number of curiosity and antiquarian shops before this time. In his *Dictionary of Antique and Curiosity Dealers*, Mark Westgarth has revealed that, during the period 1820–40, the numbers of dealers in London multiplied by more than 1500 per cent, rising from less than ten dealers in 1820 to at least 155 by 1840, and this number was supplemented by considerable expansion outside the capital.[16] At the same time the image of the dealer and his shop entered into the wider social consciousness, and this image was rarely a positive one. As Westgarth has pointed out, Charles Dickens's *Old Curiosity Shop* (1841) was preceded by other literary portrayals most notably in Honoré de Balzac's *The Wild Ass's Skin* (1831) and *Cousin Pons* (1848).[17] In all three novels, the dealer is portrayed as a problematic character surrounded by an inauthentic miscellany of objects that many had begun to treat with suspicion. In 1850, for example, A. W. Franks wrote, 'The value of objects is frequently lost when they pass through a dealer's hands; their authenticity is destroyed and their history mutilated', and, as we will see, this image of the dealer was still strong when Shrager accused Dighton and Co. of false practice.[18]

Hungerford Pollen's introduction to the first catalogue of *Ancient and Modern Furniture in the South Kensington Museum* (1874) cited a number of key events for the growing popularity of antique furniture in the second

half of the century: 'We are now, perhaps, returning to a renaissance art in furniture, and it is certain that collections such as those lately exhibited by Sir Richard Wallace; the Exposition Retrospective in Paris in 1865; the loan exhibitions of 1862 in London, and that of Gore House at an earlier period; and above all the great permanent collection at South Kensington, must contribute to form the public taste'.[19] In 1896 it was Pollen who, with Purdon Clarke, organized at the Bethnal Green Museum what was probably the first proper exhibition of English furniture and silks. Exhibits ranged from the late seventeenth century to George IV, and drew on 70 historic collections.[20] By the mid-nineteenth century antiquarian interiors furnished largely or exclusively with old furniture were commonplace. Charles Eastlake's *Hints on Household Taste in Furniture and Upholstery and Other Details* (1868) is characteristic of the period.[21] So popular that a second edition was published within one year of the initial publication, Eastlake's treatise aimed to

> [s]uggest some fixed principles of taste for the popular guidance of those not accustomed to hear such principles defined . . . [although] the question of style and design in art-manufacture has been from time to time treated in various works after a technical, a theoretical and an historical fashion . . . I am not aware that it has yet been discussed in a manner sufficiently practical and familiar to ensure the attention of the general public, without whose support, as every artist knows, all attempts at aesthetical reform are hopeless.[22]

Eastlake's book, therefore, was not directed at the 'virtuoso . . . wanting antiquarian research' or the 'scientific man . . . [wanting] technical information', but instead he saw his audience as those who wished to 'furnish their homes in accordance with a sense of the picturesque which shall not interfere with modern notions of comfort and convenience'.[23] Eastlake aimed to attract the type of reader who was dabbling in the 'picturesque' world of the antique at mid century, those who were beginning also to venture into the 'old curiosity shops' of the antiquarian dealers. His book marked the significant increase in interest in 'old furniture' so interestingly explored in Muthesius's article. The writers and designers of the Arts and Crafts movement and the vernacular revival had begun to argue for a home furnished gradually and cumulatively with objects that had been individually made, deeming this aesthetically and morally superior to the kind of instant furnishing schemes perpetrated by professional upholsterers.[24] In the same spirit, George Eliot, in her review of Owen Jones's *The Grammar of Ornament*, railed against the modern decorator and upholster, 'Who shall say that the ugliness of our streets, the falsity of our ornamentation, the vulgarity of our upholstery have not something

to do with those bad tempers which breed false conclusions',[25] and Eastlake moaned, 'When did people adopt the monstrous notion that the last pattern out must be the best?'[26] Old English furniture appealed to all the instincts of the vernacular revival as 'purely English design and execution'[27] and Eastlake called for his readers to celebrate again the indigenous craft 'of the minor articles of household use ... the common "Windsor" chair and the bed-room towel-horse. A careful examination of these humble specimens of home man-ufacture will show that they are really superior in point of design to many pretentious elegancies of fashionable make'.[28] But in their search for such examples of 'old' furniture, Eastlake was careful to

> [c]aution my readers against the contemptible specimens of that would-be Gothic joinery which is manufactured in the back-shops of Soho. No doubt good examples of medieval furniture and cabinet-work are occasionally to be met with in the curiosity shops of Wardour Street; but, as a rule, the 'Glastonbury' chairs and 'antique' bookcases which are sold in that vener-able thoroughfare will prove on examination to be nothing but gross libels on the style of art which they are supposed to represent.[29]

Eastlake here employs a geographical and historical lexicon that had begun to symbolize all that was feared by the cautious purchase in the dealer's shop. Street names such as Wardour and Tottenham Court Road, and the Soho dis-trict, had become signifiers of the 'inauthentic' antique, and would feature strongly in commentaries on the trade.[30] Mark Westgarth has drawn atten-tion to the role of these 'less prestigious locations' for the curiosities market in the nineteenth century, cited in the Shrager–Dighton case as ciphers for a dubious trade.[31] Cescinsky made knowing reference to this when describing a small hanging cabinet as being 'quite fashionable in Tottenham Court Road' when he was a boy.[32] MacQuoid also uses geography to rebuke this comment, declaring that, 'I should say the cabinet was made when the Tottenham Court Road was called the Hampstead Road. It is a very beautiful little piece of work, exquisitely touched, very finely put together'.[33] Despite the growth of the mar-ket in the more fashionable areas of the West End, such as Regent Street and New Bond Street,[34] the trade in antiques and curiosities was still expanding in less salubrious areas in response to consumer demand. Westgarth notes that Wardour Street was synonymous with the antique and curiosity trade as early at the late 1820s, and his work on one of the dealers located there, John Coleman Isaac, demonstrates the significance of the site, physically and psychologically at the centre of the trade in both good and not so good objects.[35] The location soon became 'convenient shorthand for a host of prob-lematic responses' to the trade in historical objects, as illustrated by Eastlake's

comment and, as we will see, in the trial.[36] Throughout the Shrager case, such sites were cited knowingly and critically by the lawyers and witnesses: 'You might have a Jacobean chair made tomorrow in the Tottenham Court Road, might you not?'[37] Likewise, the lawyer's reference to 'Jacobean' chairs and the focus throughout the case on such historical terms as 'Georgian', 'William and Mary', 'Glastonbury' and so forth remind us of the importance of such labels as signifiers of the 'old' and the 'antique' so vital for the unscrupulous dealer and the needy customer.

The attraction of 'old stuff' was a theme that ran through the many published guides to the decoration of the home in the late nineteenth century. One of the most influential, particularly as it was addressed to the mistress of the house, and therefore recognized the growing power of women as consumers, was Rhoda and Agnes Garrett's *Suggestions for House Decoration in Painting, Woodwork and Furniture* (1877). In it they addressed the 'charge of "Backward Ho!"' brought against them when it came to their recommendations for furniture. 'How often is the question asked, "Why do you admire this old stuff?" and how often do we feel we are being accused (silently perhaps) of liking a thing just because it is old'.[38] The Garretts consciously aimed their advice at the rising middle-class audience, 'who require the aid of a cultivated and yet not extravagant decorator' rather than those 'who have lived in houses built by Inigo Jones, and whose walls are rich in paintings by the old masters' for whom their book might 'appear rudimentary and perhaps uncalled for'.[39] Their audience consisted of the same growing group of consumers in Wardour Street and Tottenham Court Road who were looking to improve their homes and (potentially) their social standing. To this new audience, the Garretts issued the same warnings that we have read in earlier books on old furniture, 'It may be emphatically stated that by no means *all* old pieces of furniture, even those which have survived us, are worthy of admiration or imitation either for their design or usefulness. . . . There can be no doubt that even in the days of Queen Anne (by which, courteous reader, you surely will not compel us to mean strictly the years between 1702 and 1714) a great deal of rubbish was made, as it is now'.[40] Their case for old furniture paralleled the Arts and Crafts aesthetic. Despite admitting that their calls for historic styles and objects could sound like 'rankest Toryism', they focused their admiration on the age of objects and their survival as a result of being made by 'men (and often designed and made by the same man) who were thorough masters of their work and understood the construction of every part of it', unlike the 'cheap and showy furniture' demanded by the modern market.[41] Stefan Muthesius has explored the rapid growth of this move in the second half of the nineteenth century towards collecting 'old' furniture for the 'ordinary' home.[42] He links this move to the interests of the Victorian revivalists. The

1850s onward saw an interest develop in the collecting of 'antique' furniture, inspired by Ruskin's invective of 1854 against 'fatal newness'.[43] The idea that environment could affect morality, invoked by a number of writers including Pugin, Ruskin and Morris, developed into a passion for the antique. This was reflected in the development of the amateur collector, Rossetti leading the way with the decoration of his home in Chelsea. An article in *Cornhill Magazine* of 1875 concluded that modern furniture was intolerably ugly and declared that 'the art of furnishing must be closely connected with the judicious buying of old furniture'.[44] The books of Eastlake and the Garretts were typical of the move against the dealer that was already apparent in the literature of the 1870s. The established antique and curiosity trade in Wardour Street had already fallen into disrepute, and the amateur collector was encouraged to bypass the trade. Eastlake issued dire warnings of the less than honest practices of the trade:

> A fragment of Jacobean wood-carving, or a single 'linen-fold' pane, is frequently considered a sufficient authority for the construction of a massive sideboard, which bears no more relation to the genuine work of the Middle Ages than the diaphanous paper of recent invention does to the stained glass of our old cathedrals. In other words, these elaborate fittings for the hall and library are forgeries, made up of odds and ends grafted on modern carpentry of a weak and paltry description. Not only is the rudeness of the old carving parodied without an atom of its real spirit, but the very construction of the articles in question is defective. Nails and screws are substituted for the stout wooden pins and tenon-joints used in medieval framing; mouldings, instead of being worked in solid wood, are 'run' in separate strips, and only glued into their places; clocks and fissures are filled up with putty, and the whole surface is often smeared thickly over with a dark varnish, partly to conceal these flaws and partly to give that appearance of age which the mere virtuoso will always regard with interest.[45]

While exhorting the homeowner to buy 'old work', they directed him to act as his own expert in seeking out objects 'found in the rough', guided of course by the authors' text and illustrations.[46] Percy MacQuoid's collection at his own London home, The Yellow House was praised in the popular press as deriving from vernacular sources (see Figure 2.1). The drawing room panelling, for example, was described as coming from 'an old house called Foulescombe in Devonshire . . . a desolate mansion, on the edge of the moor and 15 miles from the nearest town',[47] and it was this fashion that led Shrager to accept Lawrence's advice to include panelling from the nonexistent 'Royston Hall' in his house at Westgate, which, as we will see, became a key point of discussion

in the trial. The Ruskinian call for evidence of 'visible wear' as an essential sign of age was one that would come to dominate the market once authenticity came into question. Along with this came the nationalistic call to embrace English styles over the continental ones that had dominated fashion and the homes of the elite, such as Wallace's Hertford House: 'Be national in your taste and you cannot go wrong'.[48] Until the 1870s, the focus was on the periods from the Gothic to the seventeenth century, following the doctrine of Pugin and the celebration of the medieval as the one, true, Christian style. Eastlake, for example, illustrated no furniture later than 1700. Georgian furniture was considered 'clumsy' by most observers.[49] Nevertheless the 1880s saw a moderate revival of interest in Chippendale and carved wood furniture in general. Famous names such as Chippendale, Sheraton and Hepplewhite had never been forgotten because of the survival of their pattern books, and some of Chippendale's plates were reissued in a bastardized form by Weale in 1830; Sheraton and Hepplewhite's books were reprinted in 1895 and 1897.[50] By 1877 the Garrett sisters were clear about the best period for furnishing the 'modern home', promoting the 'Queen Anne' style over the Gothic revival so 'that the fashionable world of London may one day return and live in the houses which were built in the solid and unpretentious style so much in accordance with the best characteristics of the English people'.[51] The term 'Queen Anne' contained a 'mysterious sanctity', despite being recognizably derived from the Italian Renaissance, and was sold as the best style for the 'English home'.[52] Of all styles, 'Chippendale' came to rule the dealer's patter and the collector's ambition, a focus that remained throughout the period of the Shrager case, and is still evident today. The importance of the 'Chippendale' name will be discussed further when we look to the specific practices of Dighton and Co., but suffice it to say here that it rapidly became the signifier of note in the late nineteenth century, with even 'John Bull' being 'greatly gratified by the recent revolution in favour of Chippendale' in 1877.[53]

The rise of the market for eighteenth-century furniture ran hand in hand at the end of the century with the rise in publications on the history of the objects. This will be the focus of Chapter 3 when we examine the role of the 'expert witnesses' in court, all of whom were drawn from this growing caucus. It is to this point in time that Muthesius has tracked a change in attitude to objects of the past and how they were valued that is pertinent for our subject today and its timing. With the turn of the century it began to no longer be sufficient for an object's design to simply evoke the past; its materials and construction had to be 'old'. 'In one word: it had to be "authentic"'.[54] As such, the notion of an 'antique' moved away from that of a 'curiosity', which, in turn, led to an increased interest in specialization, identification and, most importantly, authentication, and the development of the antiques business as we recognize

it today. Prices for eighteenth-century furniture were rising fast, witnessed by the '£1,050 paid for a set of two Chippendale chairs at Christie's in 1902'.[55] By then Frederick Litchfield, well known as a dealer on Wardour Street, had written his *Illustrated History of Furniture* (1892), tapping into the growing move among collectors to focus on the quality of individual pieces rather than a general effect.[56] Muthesius draws attention to the fact that, in the increasing number of texts on the subject, there was a clear 'emphasis on construction and materials, on colour and texture'.[57] The knowledge of 'patina' was considered to be 'the collector's greatest asset . . . because it is the best safeguard'.[58] This focus grew as the early twentieth-century debates on genuineness in the light of the growing market prices for 'authentic' objects became more important to the dealer and collector alike, and the books published in the 1920s, such as R. W. Symond's *The Present State of English Furniture* (1921), Frederick Litchfield's *Antiques, Genuine and Spurious; An Art Expert's Recollections and Cautions* (1921) and Cescinsky's own books, concentrated even more on workmanship and surface. Cescinky's evidence, given as a cabinetmaker, makes explicit such a debate, which is why it is ironic that in the end MacQuoid's expertise won. Throughout the trial, Cescinsky referred to the materials and the construction of the objects as evidence of their inauthenticity, referencing the types of tool used, such as the difference between the marks made by the fret saw and a power band saw; the use of varnishes and their different effects; the quality of carving; and the age of the wood, all as signs of the 'spurious'.[59] His own claim that, 'Only a trained expert can differentiate between the original and the old copy. A first rate knowledge of timbers, details and methods of construction is indispensable . . .' referred to a wider move in the literature to stress the need for an expert to have 'experience'.[60] Ironically, many of these authors were also dealers in their own right, although most, for obvious reasons, would attempt to distance themselves in their literature from this role, as Litchfield and MacQuoid indeed did.

By 1900 the market value for furniture had caught up with fine art.[61] It was at this time that certain major collectors, such as Percival Griffiths, who would be cited in the trial, began to make inroads into the market for old furniture. Griffiths went on to form one of 'the most comprehensive collections of early-Georgian furniture' in the country, which he kept at his substantial country house, Sandridgebury, near St Albans.[62] Griffiths was typical of the new breed of collectors, having made his money as a partner in the accountancy firm of Deloitte, Plender, Griffiths and Co. R. W. Symonds, who first met Griffiths in 1911, wrote *English Furniture from Charles II to George III* (1929) as 'virtually a catalogue of the Sandridgebury Collection' and Griffiths wrote in the foreword, 'No collector can ever be perfect. The collector who knows this, and has the heart to part with one possession in order to acquire another,

and does so deliberately and with discrimination, is still collecting, and is exercising his taste and mind well'.[63] Griffiths's activity as a collector mirrors the developments in the literature of furniture history. He described how, in the years around 1910, the wealthy collector 'would have nothing to do with English furniture', although 'oak, satinwood and mahogany were appreciated by a tiny minority'.[64] The publication of MacQuoid's four volumes of *The History of English Furniture* was particularly influential. Griffiths wrote in retrospect on how *The Age of Walnut*, in particular, was a revelation, 'Walnut pieces that today [1929] run into four figures could easily have been purchased in 1910 for £80 or £100'.[65] Following the publication of Macquoid's book, early collectors encouraged their dealers to find intricately carved pieces of eighteenth-century furniture, and Griffiths was no exception. Before the First World War he was credited with having the finest 'collection of lion mask furniture' in existence.[66] Unfortunately for Griffiths, he had been a victim of the less salubrious market practices that were a direct result of the increase of interest in (and consequently the value of) such objects. As the story is told by Simon Houfe, when stopping by chance in a London backstreet, Griffiths saw a finely carved, tripod table identical to one he had bought recently. On entering the shop and speaking with the dealer, he found to his horror that the piece was of very recent manufacture.[67] The dealer added, with a wink, 'I've made in the last few years a large number of such pieces of Chippendale for an old buffer who lives at St Albans!' Most likely as a result of this incident Griffiths turned to the furniture historian R. W. Symonds, who acted as his advisor from that point on. At the same time, the national museum collections started to reflect these changing tastes. Ironically it was the dealers who supplied these objects. For example, Sir George Donaldson, a well-known dealer in Bond Street, gave a collection of old English furniture to the Victoria and Albert Museum in 1900. The relationship between the historians, the museum and the market will be explored further in Chapter 4.

After 1900 the numbers of firms and men listed as 'Antique Dealers' grew rapidly to about two hundred in London. The year 1918 witnessed the foundation of the British Antique Dealers' Association. One of the most significant moves made by this group was to insist that dealers mark reproductions as such if they were displayed alongside originals. Additionally, members of the Association were strictly vetted and their numbers were limited.[68] As would be expected, BADA were 'naturally much interested in th[e] case . . . [which] has gained a great deal of notoriety' and from the outset Sir Edward Marshall Hall, KC represented their interests in the courtroom.[69] For obvious reasons the organization and its dealers were keenly interested in the idea of authenticity, and took seriously any threat to their trade. The activities of fakers had grown

at the same rate as the prices paid. 'I knew of one workshop . . . which sent one vanload, at least, regularly every week to one firm not a thousand miles from Baker Street'.[70] The boundaries between the distinguished side of the trade – the historian and BADA-approved dealer – and the modern manufacturers of 'old' objects, were less clear-cut than would first appear, as was clearly demonstrated by the Shrager–Dighton case. As Cescinsky highlighted in his 1931 text, *The Gentle Art of Faking Furniture*, virtually no one entering the market could avoid purchasing faked objects in the early 1900s: 'Remember that, in the world, there are thousands of really clever people engaged in forging any of these objects which are high-priced enough to make the game worthwhile. . . . Yet we expect the dealer to know more than the whole army of these fakers put together. The collector who really imagines such a thing must put his thinking out with his washing'.[71] Christopher Hussey's *Country Life* review at the conclusion of 'The Furniture Case' in 1923, summed up the problems in the market and the dealers' internal solution:

The prevailing taste for old furniture, to the exclusion of all other, must inevitably result in a great mass of work being executed in old styles. English cabinet making, moreover, has reached so high a level of craftsmanship that the difference between old and new work is often very difficult of detection. It is not for lack of designers that modern furniture is little known; it is for lack of intelligent demand. The majority of those who buy furniture in old styles do so in order to be in fashion, not for any reasonable preference for it. It is an unhealthy condition of things and one which the true dealer in antique furniture deplores as much as the modern designer; for the best antique furniture will always command high prices, however the fashions change. Moreover, if the highly trained craftsmen were allowed to work on original, instead of copied, designs dealers would be freed from the suspicion of selling reproductions as genuine pieces.

The suspicion is felt so keenly by dealers that there exists a powerful organisation to dispel it – the Antiques Dealers Association, similar to the legal societies to which barristers and solicitors can only belong if of assured probity. The Antique Dealers Association comprises all the best and most reliable dealers, and any dishonourable action involves dismissal – the censure of the masters of the trade. It fulfils the public protecting functions of old guilds.[72]

As Hussey cites, the market for old furniture was also a market ripe for the sale of 'genuine' reproductions. The Garrett sisters had indicated the move towards a new breed of decorator, in 1877, calling for a change in the

profession, from 'simply a man who hangs paper and knows mechanically how to paint wood' to

> [s]omeone who can do more than this; he should be able to design and arrange all the internal fittings in the house, the chimney pieces, grates and door-heads, as well as the wallhangings, curtains, carpets and furniture. All of these it has hitherto been customary to entrust to different people, none of whom has had any part in the deliberations of the other. The consequence of such a disjointed approach has been that in modern houses one seldom finds a room which makes a harmonious whole. A well-intentioned beginning is spoiled by an incongruous end; or the effect of carefully designed drapery and furniture is lost through proximity with glaring wallpaper and hideous wood-fittings . . . only those who are able to judge beforehand the effect of the whole can give a trustworthy opinion upon details.[73]

The tradition of dealers writing and publishing continued, especially with the growth of the new, great firms of decorators such as Lenygon and Co., established in 1904.[74] In 1909, this firm moved its business premises to a Georgian house at 31 Old Burlington Street, and in same year brought out *The Decoration and Furniture of English Mansions during the Seventeenth and Eighteenth Centuries*. The book was aimed at establishing their reputation as the experts to go to for anyone planning a new scheme of decoration in the antique style, and was principally illustrated with objects and rooms from the arrangement of Lenygon and Co.'s own premises. In this they stated that:

> So much has recently been written on the subject [of the brothers Adam, or of Chippendale, or his successors Locke and Copeland, Ince and Mayhew, Johnson, Manwaring, Shearer, Hepplewhite or Sheraton] that it would seem unnecessary to repeat any details respecting their personality or their methods of working. Apart from the excellent book by Miss Constance Simon (to whose researches we are indebted for so many of the important known facts respecting these furniture designers of the latter half of the eighteenth century) much of the recent literature on the subject consists of conjecture based on the prefaces, descriptions and designs which they each issued; indeed without these published designs and fashion plates it is probable that we should have heard little of these craftsmen, as their names can only include a fraction of the furniture makers who worked in London alone during this half century.[75]

As such, they claimed to be returning to the 'real' spirit of the pattern books. Five years later they embarked on the much more ambitious Library of

Decorative Art, of which the first two volumes, *Decoration in England* and *Furniture in England* were published in 1914. They are assumed to be the work of the furniture historian, Margaret Jourdain. Such books were written with an eye on the American market where there was considerable and growing demand for antiques from the eighteenth century.[76] Lenygon and Co. made the most of the fact that many rich Americans looked to Europe to provide suitable objects for their new homes. Once merged in 1912, the even more powerful firm of Lenygon and Morant operated as a conduit between the aristocracy in England, looking to sell their heirlooms to generate much needed income during the War, and the nouveaux riches across the Atlantic looking to create interiors with an established provenance and history.[77] Companies such as Lenygon and Co. aimed, through their publishing activity and their choice of advisors, to rise above the criticisms that were being directed at the large furniture salerooms, where one could select from a huge range of ages and styles. Shirley Wainwright, writing in 'The Studio Year Book of Decorative Art' for 1923, the year of the trial, commented that:

> In relation to the treatment of interiors the state of affairs in this country is less satisfactory. This in part is due no doubt to the system prevailing whereby the householder turns for advice and inspiration to the salesman in a furnishing establishment – too often, it is feared, to an individual without any real qualification to direct the aesthetic treatment of the home . . . no alternative practice seems to be contemplated except in a few cases where an architect is commissioned to decorate or an expert called in to advise.[78]

In order to distinguish themselves, the firms that were aiming at the upper-class market turned to the furniture historians to add credence to their work. Margaret Jourdain was retained by Lenygon and Co. from 1911. Percy MacQuoid also advised Morant, the long-established firm of upholsterers that would eventually merge with Lenygon and Co.,[79] and, as we have seen, R. W. Symonds was an 'advisor' on the development of private collections as well as a writer.[80] There was a strong sense of discovery, backed by the increasing potential of the American market, which prompted a number of English decorators and dealers to open in New York around 1910.[81] The growth of the American market was much commented on and welcomed. It encouraged the forgers to up their game, however, leading to Cescinsky's comment that, 'One does not require an expert, but an actuary, to tell the collector of English furniture that, in one year, more is shipped to America than could have been made in the whole of the eighteenth century'.[82] As is well documented in the novels of Henry James, many an English family in financial decline looked to America. James's novel *The Outcry* (1911), caricatures the sale of Britain's art treasures

overseas. The young aristocrat at the centre of the story fears the loss of family heirlooms: 'we don't want any more of our national treasures . . . to be scattered around the world'.[83] They even used firms such as Lenygon and Morant or White Allom and Co., to copy pieces so that they could be sold in the States without appearing to have disappeared from their own homes. For example, in a letter to Sir Arthur Crosfield from Sir Charles Allom in 1918, it is apparent that Lady Crosfield complained that she regarded the sideboard in question 'as one of the three great pieces of old English workmanship we shall have in the house when finished, the other two being the red lacquer cabinet and the Elizabethan or Queen Mary cabinet. It is not as if we were going to purchase other great pieces of the same kind, our scheme of decorative work does not necessitate our doing so' and she was 'far from anxious to sell the treasure, at any price, but I have persuaded her to agree to part with it for £1200 if your friends in America care to take it at that price on the understanding that one copy of it should be made for us in place of it'.[84] Conversely, many of the American brides whose money was brought in to prop up old aristocratic lines turned to these firms to provide them with appropriately tasteful homes. For example, the wife of the eighth Duke of Roxburghe, the American heiress Mary Goelet, daughter of Ogden Goelet of New York, employed Lenygon and Morant to refit the rooms at Floors Castle, Roxburghshire, in an appropriate style as a setting for her collection of eighteenth-century furniture.[85] Lenygon and Morant also decorated their London town house at 2 Carlton House Terrace, leased in 1921, and by 1923 the bill for their neo-Georgian decorations had reached £19,865 for the London house alone. 'With an American grasp of the importance of provenance, what began as a need to furnish Carlton House Terrace soon developed into a more serious form of collecting as the Duchess took advantage of the opportunities presented by the dispersal of contents from country houses less fortunate than Floors'.[86] On her commission, for example, Lenygon purchased for £514 gilt pier tables with dragon-headed legs from a suite made by James Pascall for the gallery at the Temple Newsam sale in 1922 and repaired them for £18.[87] As a finishing touch, the English furniture at Carlton House Terrace was described by Margaret Jourdain in two articles in *Country Life* in April and June 1931.[88]

Percy MacQuoid also acted as an advisor, on the payroll of Lenygon and Morant. He was employed, via the firm, by Lord Curzon in 1917. Curzon was another beneficiary of American money, having married Mary Leiter, a Chicago heiress, in 1895. At Kedleston Hall, Derbyshire, the house he inherited in 1916, he undertook a major redecoration, described in correspondence with MacQuoid in 1914.[89] MacQuoid advised Curzon on curtains and fabrics as well as interior decorative schemes. A watercolour by MacQuoid, entitled 'A late Chippendale bed for Lord Curzon', signed and dated 1917,

indicates that he was also designing furniture for the house.[90] Macquoid spent much of his career acting as an advisor on period interiors and the requisite antique furniture, and he specialized in period work.[91] He seems to have had a fairly extensive country house practice and described himself as 'a decorative artist, professional decorator and advisor to clients who are purchasing furniture'.[92] From 1906 to 1908 Macquoid also remodelled and redecorated the staterooms at Dunham Massey for the ninth Earl of Stamford, who was related to MacQuoid's wife, Theresa. The curtains and fabric were supplied by Morant and Co.[93] In 1925 MacQuoid was commissioned by Lord Leverhulme to design an Adam Room for the Lady Lever Art Gallery in Port Sunlight, based on panelling in Adam's Music Room at Harewood House, Yorkshire. The work was executed by Charles Allom, another fashionable London decorating firm. Both commissions will be considered further when we look at MacQuoid's career as an advisor and expert in Chapter 4.[94]

Most interestingly for our purposes, some of MacQuoid's books were published by the defendant, Harry Lawrence. When Shrager first met Lawrence, the relationship between historian and dealer was carefully woven:

He told me that before the War he had been interested with Mr Dighton in a big furniture business, that he had been a publisher and had published books on furniture written by a great friend of his, Mr MacQuoid, that he had written in collaboration with Mr Dighton a book on prints or line engravings, and that generally he had an intimate knowledge of antique furniture and works of art. . . . He said that he had known Mr Basil Dighton for I think thirty years . . . that they were great friends, that Mr Dighton had been in the antique furniture business, and that he had a very good name, that he dealt in articles of the finest quality . . . he said Mr Dighton's prices were perhaps a bit stiff, but having the name he had, I could rely on the finest things and that it would be better, in fact, to go to a firm of standing than to try and pick up things here and there and especially as Mr Lawrence was my friend, he would see that I was treated very fairly, and that he would advise and undertake the supervision – well undertake the purchasing of things for me.[95]

In the opening examination of Shrager at the trial we get insight into his relationship with the dealers, one which bears many of the hallmarks of the trade as it can be understood in the late nineteenth and early twentieth century. Lawrence, as we have seen in Chapter 1, promised that, as an expert in antique furniture, he could help Shrager avoid being 'swindled'.[96] The etymology of Lawrence's sales pitch will be considered later in this chapter, but what needs to be pointed out here is that the dealer acknowledged the commonly

held view of the trade as rife with sharp practice. When Shrager discovered
that he had, indeed, been swindled, he tried to get expert advice, and it is at
this point that we become aware of how integrated the 'closed shop' of the
trade had become in its need to maintain the illusion of authenticity. 'I had
the greatest trouble to get things expertised by independent experts'.[97] It took
the lawyer a number of questions before Shrager revealed his source of expert-
ise, as he feared that he should not disclose their name:

> The stringency of your business continued and so in December 1921 and
> January 1922 you turned about to see whether you could realise some of
> the furniture?
>
> Yes.
>
> Then you got somebody down to advise you?
>
> Yes.
>
> And you had difficulty in getting an expert to say anything against Messrs
> Dighton?
>
> I did not say that. . . . At that period I had this gentleman who came down.
> After that I had experts who advised . . . I never asked them things about
> Messrs Dighton and I never mentioned where I got the furniture. . . . I
> said that I had difficulty getting experts to give me advice, experts in the
> trade . . . the difficulty was that many people came down and told me things
> were wrong, but they said they were not going to court to give evidence
> because it would hurt them very badly in their own trade. . . . He was a gen-
> tleman connected with the selling of things and I undertook not to men-
> tion who he was, because he said it would hurt him very much . . . it is on
> his advice that I got the experts.
>
> Did you get your solicitors to come down with the experts?
>
> Yes, they came down with the first expert.
>
> What was the name of the first expert?
>
> I do not know whether I can disclose that.
>
> I want to know. This is a very serious charge of fraud. Please tell me the
> name of the expert who came with the solicitors.
>
> Mr Litchfield.
>
> Was that the only advice you had up to the time of the issue of the writ, the
> advice of Mr Litchfield?
>
> The only written advice.
>
> I am speaking of the furniture expert's advice.
>
> Yes.

So upon Mr Litchfield's advice you instructed your solicitors to issue the writ?

Yes.

You realised that this was a very serious charge against Messrs Dighton and Mr Lawrence?

I realised that this was a very serious charge, and I realised that I had been very seriously swindled.

Did you think it would be fair to your quoted friends to write some letter to them before the action?

I do not think so having regard to the way I had been treated. My eyes had been opened.[98]

Frederick Litchfield, author of an *Illustrated History of Furniture* of 1892, had made some clear comments in his own books on furniture history about the trade, declaring in his *How to Collect Old Furniture* (1904) that one should 'Be prepared to pay a good price to a man of good reputation for a really good article'.[99] Litchfield's *Illustrated History of Furniture* had not been primarily directed towards the collector and decorator, although Muthesius suggests that this was because he was trying to disguise the fact that he was one of the Wardour Street dealers, and that this reticence to acknowledge the professional trade in antiques reflected a more general trope in the field.[100]

Litchfield's comments on how to select a dealer, similar in tone to Lawrence's ironic advice to Shrager to 'go to a firm of standing' and be prepared to 'only go for the very best' despite 'Mr Dighton's prices [being] perhaps a bit stiff', highlights the terms 'authenticity' and 'genuineness', both described by Muthesius as 'polite formulations of what had become the chief issue, the chief problem of collecting antiques: how to avoid fakes'.[101] The 1923 trial was hinged on this key idea. The word 'authentic' governed the furniture trade and dominated the sales pitch and the writ issued against Dighton which cited Shrager's purchases as 'altered and made up and spurious'. This was the ultimate threat one could make to an object's value, and to the reputation of the trade. Sir Ernest Pollock iterated this fact in his comment that:

The case was originally opened by my learned friend before the Chief Justice on Tuesday 14th November. . . . From the 14 November, the first moment at which this charge was brought in public, until the present time, there has been no opportunity of laying before either Court definitely the answer to what the answer is to this very serious charge of fraud. From the 14th November to the present time is not far short of three months, and during the whole of that time Mr Dighton or Mr Lawrence have lain under

the most serious charge that can be brought against business men, a charge
so serious that of course it involves, as Mr Dighton will tell you, practi-
cally the immediate paralysis of his business. No one is going to Savile
Row while the head of the firm lies under this charge, and he will tell you,
when I call him, that the effect of this charge has been a complete stagna-
tion of his business; and, Sir, if I am right that this charge which has no just
foundation and which ought never to have been brought, I think I am not
going beyond the mark when I say that this has proved and is a very cruel
charge.[102]

The accusations in the courtroom created shock waves in a market that was
reliant upon the public perception and expectation that its systems were nat-
ural, truthful and correct. As a self-perpetuating system, any interruption,
whether it be to question or accuse, would cause an immediate breakdown of
value. The methods used to value objects in this system were not 'natural' or
'revealed', they were constructed in the interests of specific social groups by
the trade, in order to enhance their domination.[103] The dealers had long been
in the position of power, deciding which pieces were authentic and which
were not, and fixing market value. This system was (and remains) incred-
ibly vulnerable. This has been brought to light in recent times, with the
spectacular fall from grace of employees of the major international auction
houses under a cloud of accusations of price-fixing and disingenuous sell-
ing practices. The press coverage of these events has focused on the accusa-
tion that some dealers and auctioneers have knowingly passed off fakes as
important eighteenth-century pieces of furniture, including many reminis-
cent of the pieces under discussion in the 1923 trial. Even more striking are
recent legal debates which feature the direct descendants of one of the wit-
nesses in our trial. John and Frank Partridge are the current owners of the
bankrupt business, Partridge Fine Arts, begun by Frank Partridge, who not
only offered evidence for the defence in 1923, but was also the purchaser of
some of the items featured in the case when they were sold off in 1924. The
company, which went into administration in 2009 after 107 years of trad-
ing, were accused of doctoring furniture to increase its value, in a case eerily
reminiscent of ours. They were accused of 'systematic fraud' and 'counterfeit-
ing' by a former director of the business, the former Conservative minister,
David Mellor.[104] The terms of the writ were reminiscent of Shrager's, citing
particular pieces, such as a pair of eighteenth-century Boulle chests, which
were claimed to have been significantly altered to increase their value from
the £150,000 paid by Partridge, to the £600,000 paid by their current owner,
the American chief executive of Limited Brands, Leslie H. Wexner. Partridge
challenged the claims, stating that the furniture had been 'restored'. Mellor's

statement on the case transports us back to Shrager: 'Partridge blatantly used their reputation, their authority and their prestige to say certain things were unique or original or genuine when they weren't'.[105] Interestingly, the same article refers to BADA's rules on restoration, just as they had been in 1923. The use of vocabulary of accusation such as 'fake', 'systematic fraudulent trading practices', 'grotesque . . . recreations', set against a defence that states the objects were subject to 'painstaking restoration' and are 'rare pieces' is a reminder that the whole construction of the market for old furniture revolves around convincing the purchaser of the 'rightness' of the objects. Dighton and Lawrence's key role was to convince Shrager that they were the guardians of decisions on 'rightness'. This was key to their selling practice. 'As regards whether a thing was of a certain period or whether it was a genuine piece or a good piece or a valuable piece I had no idea whatsoever, and that is why Mr Lawrence offered to keep me right to avoid my purchasing spurious articles which he said abounded in the trade'.[106] Their ability to judge was often cited as founded in experience, a guarantee that Cescinsky later ridiculed in *The Gentle Art of Faking Furniture*:

> Consider an average dealer's stock, and see what he offers for sale, and guarantees as genuine. Furniture of all periods and nationalities, tapestries, needlework, Oriental, European and English porcelains. . . . Now remember that, in the world, there are thousands of really clever people engaged in forging any of these objects which are high-priced enough to make the game worth while, and who each specialise in one particular field. Yet we expect the dealer to know more than the whole army of these fakers put together. The collector who really imagines such a thing must put his thinking out with his washing.[107]

Basil Dighton had had a varied career before Basil Dighton Ltd was incorporated in November 1917 at 3 Savile Row, London where he employed Harry Walton Lawrence. He started out selling engravings at Christie's and then branched into dealing in 'antique' furniture. He was also well known as a dealer of reproductions, some of which were made by Frederick Tibbenham and Co. in Ipswich, which, together with Dighton, was associated with the Cambridge Tapestry Company, listed at the same business address, 3 Savile Row, as Dighton's. The Cambridge Tapestry Co. was set up by Dighton to copy antique needlework. In court, Dighton claimed that he always sold reproductions as reproductions. For example, he explained that he had had Tibbenham make furniture for Lord Kitchener which was marketed as a copy. Dighton did earn a good name for himself in the trade, as demonstrated by the fact that he was selected to serve on the furniture committee of the British Empire

Exhibition in 1924. Throughout the case, much of the evidence was focused on attempting to establish the nature of Dighton, and specifically Lawrence's relationship with Shrager, to demonstrate for the prosecution case how they had led their client to buy his 'spurious' collection. Each of the dealers had their own legal representation and at times they were actively pitted against each other in an attempt to establish blame.

> I want you to tell me generally what your dealings were with Lawrence and what with Dighton distinguishing between the two. Who did you deal with principally?
>
> The one who showed me most of the things at Savile Row was Lawrence. Dighton showed me things, and joined in when conversations were taking place about the things. On many occasions Dighton told me that I was buying extremely well, and getting the pick of their stuff. He also told me that he had been dealing in antique furniture for about thirty five years; that at the beginning he used to roam the country and buy pieces and send them to Christies and sell them and on one or two occasions he showed me photographs of some very wonderful things which he had bought and sold. Everything that I purchased was at Savile Row without exception. I was shown everything at Savile Row in the various rooms.
>
> Did you purchase everything which was in the list in the sense that you saw the things and said that you would have them?
>
> Not everything. With regard to modern furniture, for instance, I did not see those pieces. They were sent down to Kent Lodge. I never saw them before they were down at Kent Lodge. There were some specific items which stand out in my mind which were *delayed* [sic] on by Mr Dighton. They were such extraordinary pieces that he said he would have to satisfy himself as to their genuiness before he would let me have them. At a later visit he satisfied himself and Lawrence too apparently, because I was told by them both that they were satisfied and I could get it. It was sent down and put in the bill.[108]

Throughout we are made all too aware of the games that the dealers had played in order to convince their client to purchase, including delaying the sale of an object in order to guarantee its 'genuiness'.

Dighton and Co.'s practice was very much part of the wider commercial world of the 1920s, where there had been huge changes in market practice as a result of the Industrial Revolution and the concurrent growth of the metropolis. At the point of the conclusion of the trial, as its effects were still reverberating, Walter Benjamin was beginning his Arcades Project (1927–40). This

significant attempt to analyse the commercial world of nineteenth-century Paris occupied the philosopher until he fled the German army's approach on Paris in 1940. In its examination of the history of commerce in the Parisian arcades his project was a product of its time of writing, bringing together fragments from key theorists, writers and historians, including Marx and Baudelaire, to create a twentieth-century review of the nineteenth-century world of capital as it was presented in the arcades, which he linked to a number of phenomena seen as characteristic of the century's major preoccupations in literature, philosophy, politics, economics and technology. This he described as the *Urgeschichte* or 'primal list' of the nineteenth century, which he created in opposition to the traditional historiography of 'great men and celebrated events'.[109] By looking at the traces of everyday life he aimed to reveal the wider practices and preoccupations of the century, just as in the microcosm of the trial we can see reflected many of the key ideas and issues of the 1920s. As such, the shops in the arcades are described by Benjamin as 'worlds in miniature', where the 'consumers occupy the space of the display itself, and thus become an integral part of it'.[110] Dighton and Co. also produced a 'world in miniature' that recreated the worlds of the upper-class home and thus presented an ideal environment for the aspirant consumer.[111]

Interestingly, Marx (a major resource for Benjamin in the Arcades Project) left this general description not of the arcades in London but of the shops in London: 'The busiest streets of London are crowded with shops whose showcases display all the riches of the world: Indian shawls, American revolvers, Chinese porcelain, Parisian corsets, furs from Russia and spices from the tropics; but all of these worldly things bear odious white paper labels with Arabic numerals and then laconic symbols £SD. This is how commodities are presented in circulation'.[112] More specifically this late nineteenth century (1859) description maps out an environment of commerce into which Dighton's shop fits neatly. His 'odious white paper labels' reflect Shrager's purchasing experience, except for the fact that the 'Arabic numerals' and 'laconic symbols' were replaced by an even more odious labelling system based on the code 'make us rich'. The letters in the code represented specific numbers, allowing Dighton to remind himself and his team of the price of the object but offering no clues to the purchaser.[113]

This still remains the practice of the antiques dealer today, where nothing so base as the actual price can diminish the beauty and experience of the antique object, and 'if you have to ask the price, you can't afford it!' remains a truism. As was reported in the *The Manchester Guardian* under the heading 'Antique Dealer's Profits; High Figures Admitted' Dighton stated that his 'private pricing code . . . had caused the defendants a good deal of trouble' in court.[114] From Shrager and his wife's first visit, the pricing structure for

the objects selected by Lawrence was controlled by Lawrence. Only he knew what the code on the tickets meant. 'You went round these showrooms and you saw a piece that attracted you and you said that you liked it, and then asked the price? . . . On these individual pieces there were tickets, were there not? . . . and when you asked the price the ticket was looked at and you were told what the price was?' 'On some occasions tickets were looked at and on others Mr Lawrence told me the price.' 'If you wanted a piece and approved of the price you bought it? . . . So much for the ordinary course of business'.[115]

The antique dealers' shops were reminiscent of Benjamin's utopian, 'fairy-tale world' of the arcades, existing in parallel to the world outside, offering an escape to gentility and the trappings of wealth unmarred by any overt symbol of commercial culture. The shops offered up illusions, just like the 'houses . . . having no outside'. Like a dream' of Benjamin's Paris.[116] Dighton's shop, just like Lenygon's, was designed to simulate the utopian Georgian home. The trial demonstrated Shrager was consistently taken in by this device, 'On a visit there I was taken to the front drawing room and Lawrence pointed out this piece of furniture and said "look at that". I said "Hullo, that looks very nice" '.[117] On 19 November 1919, Mr and Mrs Shrager paid their first visit to Dighton's premises at 3 Savile Row. 'I understand they are like old houses, somewhat dark, lit by electric light, and as it was furnished, that is to say, it does not look like a shop at all but like a house'.[118] They were shown pieces of furniture by Lawrence, 'they admired them, he told them what they were, which they did not know, and they selected some to purchase'.[119] The presentation of the shop as a series of period rooms was aimed at diverting the customer from the base process of simple consumption. Shrager was not buying a single object but a lifestyle. This technique of selling is still deemed effective today; from Habitat to Ikea, we are sold the idea of how our rooms might look and a lifestyle to which we might aspire. Within the display spaces of Dighton's shop, Shrager was being offered a range of select and complementary objects. This arrangement was aimed at evoking a 'psychological chain reaction in the consumer who peruses it, inventories it and grasps it as a total category'.[120] Objects were not meant to speak individually to the purchaser but, through their context, to the other objects in the rooms. As Baudrillard commented on the display window, the antiques took on a different and more specific meaning when they were grouped together, the ensemble playing an essential role in impos-ing a coherent and collective vision. Each object 'signif[ied] the other in a more complex super-object' leading the consumer to a series of more com-plex choices. By mimicking the casually created home of the man of taste, the objects for sale could 'better seduce'; 'the arrangement directs the purchas-ing impulse towards *networks* of objects in order to seduce it and elicit, in accordance with its own logic, a maximal investment, reaching the limits of

economic potential'.[121] Such 'object paths' encouraged Shrager's purchasing ambitions, identifying the potential to purchase not only a set of furnishings, but a lifestyle which could evoke class and influence.[122]

Thus Dighton and Co., Lenygon and Co. and the other dealers' shops presented as ideal Georgian homes became a utopian space for the hungry purchaser, providing a perfect version of an establishment space to be translated wholesale to the new homes of the nouveau riche.[123] In this context the concept of authenticity becomes redundant as the simulation, for example the period room in the dealer's shop, bears no connection to the thing it simulates and instead becomes an entity in itself.[124] The reconstructed historic interior is a real entity but it has no origin in reality, in a real domestic interior of any period. It is a simulacrum. Simulation is no longer a point of reference to an original being, 'it is the generation of models of a real without origin or reality; a hyperreal'.[125] Such hyperreal spaces, however, were (and are) very convincing. A visitor to the Victoria and Albert Museum in the early 1900s would have been presented with a range of period rooms, each constructed to be convincingly 'real', to persuade the viewer that they were seeing a room translated in its entirety from its original location, be that Clifford's Inn or Norfolk House. The museum, however, could only present an 'authentic' experience up to the point that the viewer moved on to the next display. Within the dealer's shop or home (as in the case of dealers and collectors such as James Orrock), the visitor was engulfed by the environment, with very few reminders that they were not a genuine guest in a friend's house. The period room 'constitutes the most literal of messages'.[126] Orrock's use of a complete period house for the display of his collections has been cited as highly influential for the date, and perhaps it influenced Lenygon and Dighton in their display choices.[127] Lucy Wood also sees him as one of the most important figures in raising the profile of British art, and particularly English furniture, in the last 30 years of the nineteenth century. 'His own collection was allegedly launched with the impulse purchase by himself and a friend of the entire contents of a coaching inn, The King's Head in Coventry, which were being auctioned as he passed through the town'. Here he acquired 'some exceeding rare and valuable specimens of Queen Anne, Chippendale, Sheraton and Hepplewhite, for the Old Inn had been filled with the very finest work in several different styles'.[128] Although this smacks of the typical story of 'chance encounters' with important historic objects offered by a dealer, it did mean that he changed trades from 'surgeon dentist' to collector and dealer, encouraged by his friendship with William Lockwood, who was 'a generous and discriminative patron of English art, and one of the earliest collectors of the English furniture upon which the name of Chippendale, with a lack of differentiation that does injustice to other masters of the craft, has been popularly placed'.[129] Once established in London, in a

house in Bedford Square, Orrock became a leading collector of English furniture, and his home attracted visits from many like-minded collectors, particularly from America. By 1905, it was solidly on the map for the tourist-collector: 'Not an American millionaire now who does not regularly make a pilgrimage to 48 Bedford Square, one of the great artistic sights of London for thirty years and more'.[130] Visitors were encouraged to view the collection at Bedford Square after it was first publicized in 1892, via several engraved illustrations in an article for the *Art Journal* entitled 'A connoisseur and his surroundings'.[131] His biography by Byron Webber published in 1903 included numerous photographs of the objects and interiors in Orrock's house and further photos were published in books on English furniture, such as W Shaw Sparrow's *The British Home of Today* (1904) and Frederick Fenn and B Wyllie's *Old English Furniture* (1904). Constance Simon's *English Furniture Designers* devoted several pages to the 'Opinions of an expert . . . who for half a century has made a study of the renaissance period of British art in all its many branches'.[132] As such, Orrock was celebrated in print as an 'expert' and 'connoisseur' and was called upon to comment on the methods of distinguishing antique furniture from 'fraudulent imitations'.[133] But ultimately, behind the guise of the expert, Orrock's main business was as a dealer, selling his own objects and acting as the middleman in order to furnish the homes of his wealthy clients and visitors. Most famously, Lever, who first met Orrock in 1896, purchased Orrock's whole collection on three separate occasions, in 1904–5, 1910–11 and 1912–13. Interestingly, although Lever purchased from the same dealers as Shrager, and took advice from the same experts, the extent of his collecting and the scale of his single purchases were never commented upon except in the most glowing terms. He was protected by his status and influence, as, despite his background as a newly moneyed industrialist born and bred in Bolton, his knighthood and political power, and his continuing supplies of funds protected him from the sort of critique that other nouveaus attracted. It did not protect him from the 'spurious' antique however, and Cescinsky commented in the *Gentle Art of Faking Furniture* on Lever's 'positive genius for buying fakes' including a pair of cream lacquer cabinets from the Shrager collection (see Figure 5.1).[134] This was despite the 'enormous amount of furniture which he bought (he had three or four houses simply packed with pieces)'.[135]

Lever himself purchased a number of period rooms, both for his own houses and for the Lady Lever Art Gallery at the centre of his model village at Port Sunlight. One of the first rooms was adapted and installed by the company of Shrager's 'expert', Frederick Litchfield. In 1904, the firm installed panelling in Hall I'th' Wood, near Bolton, and the following year supplied dining room panelling at The Hill, Hampstead. Thus began a long relationship with the firm of Litchfield and Co., established in 1834 in Bruton Street, London.

Lever purchased both a Tudor and Stuart Room and the William and Mary Room for the Lady Lever Gallery from Litchfield and both were radically altered.[136] The former, purchased in 1917, came from Lambourne Hall Farm, Chigwell, Essex, and was made up of plain panelling interspersed with fluted Doric pilasters, accompanied by an 'English Renaissance fireplace overmantel' later described in Percy MacQuoid's 1928 catalogue, *The Leverhulme Art Collections*, Volume III; *Furniture, Tapestry and Needlework*.[137] As was fairly standard when purchasing period rooms, the panelling was rearranged to fit the space and extended in length. The late-seventeenth-century oak-panelled William and Mary Room acquired in May 1919 for £765 had been illustrated in Litchfield's 1913 sale catalogue, and was said to come from a house near Southowram, Halifax, the now demolished Walterclough Hall. It was also 'extensively rearranged and augmented'.[138] Lever also purchased an early eighteenth century painted and panelled room from a house near Chatham, Kent, which was originally thought to have been designed by William Kent.[139] Lever had bought it from Arthur Evans, a dealer in Wigmore Street in June 1919 for £950, but it arrived in the North 'badly chipped after being sent in an open railway carriage and included some pieces clearly not belonging to the rest'. When it was assembled, the room was five feet shorter than Lever expected. When Edwards refused to take it back, Lever raged, 'Even if I had a case against you which would be worth taking into the Law Courts . . . the matter is not worth the time it would take'.[140] Perhaps Lever had a sense of the potential pain and expense taking a dealer to court would mean. One of Lever's last acts of patronage before his death was to commission MacQuoid himself to design an Adam room for the Lady Lever Gallery. The room was subject to a great deal of debate and correspondence but was finally completed by Charles Allom's firm in 1925.

Most notable dealers and fashionable decorators were in the business of selling period rooms by the beginning of the twentieth century, as their popularity increased for the tasteful private home. Litchfield's was also commissioned to install and adapt 'genuine French boiseries' for a house in Grosvenor Street, London, for the American, Robert Emmet, and numerous West End firms became involved in the flourishing interiors business.[141] The period room, with its 'authentique' panelling, was not without its critics, however. As early as 1868 Charles Lock Eastlake deplored this type of treatment: 'It is scarcely possible to imagine any system of house furnishing more absurd and mischievous in its effect upon uneducated taste than this',[142] but high-profile period schemes, such as at the World's Fair of 1893 in Chicago, brought about the rehabilitation of the period room as a device for interior decoration.[143] The vogue for the period room was at its height in the first two decades of the twentieth century. MacQuoid not only was involved in designing such spaces

for others, but by 1902 had installed period rooms at his home, the Yellow House, in Bayswater, London. The MacQuoids' home was described in *The King* on 19 April 1902, and praised as 'few houses in London can offer greater interest to lovers of antiquity and the romantic.[144] The Hall of this 'extremely interesting house' was 'panelled in old oak, collected from various parts of England' and the walls in 'Mrs MacQuoid's boudoir' were 'lined to within two feet or three feet of the ceiling with carved walnut panelling from a labourer's cottage at Didcot'.[145] The pièce de résistance was,

> The Drawing Room, which occupies the whole of the first floor . . . here, reunited once more are all the vanished splendours of a bygone age. The oak beams that support the ceiling, though of modern workmanship, carry out the old feudal plan of construction . . . the panelling of the walls was brought from an old house called Foulescombe in Devonshire. This was a desolate mansion, on the edge of the moor and 15 miles from the nearest town, discovered one day by accident whilst Mr MacQuoid was driving in the neighbourhood. The place had fallen into such a state of dilapidation that the panelling had dropped from the walls and was lying across the marble floors; ferns were growing in the fireplace and the grass sprang up between the slabs of marble. At that time there was no possibility of purchasing any of the treasures that were thus being allowed to fall into ruin and decay; but later, when disputes over the property had been settled, Mr MacQuoid happened to be on the spot and had the good fortune to procure the fine panelling which is now fixed up round this room (see Figure 2.1).[146]

The romantic notion of the 'discovered' old room was often a vital aspect of the period room and was a useful foil for the dealer. Not only was a client purchasing a set of panelling, they were purchasing 'history'. For the newly moneyed classes, without the benefit of the inherited history that was part of the pedigree of 'aristocratic' landed capitalists, the period room offered the valuable cultural capital of heritage. The fact that many of these rooms came from 'peasant cottages' and the like did not seem to matter too much, particularly with the vernacular revival, although a room linked to an old hall or castle had the ultimate cachet. When writing about the *King* magazine, 'a short-lived metropolitan off-shoot of *Country Life*', John Cornforth commented that even the great Percy MacQuoid's drawing room was 'better described as the "Robber Baron style" of Park Avenue or Long Island'.[147] Perhaps to contemporaries this room – 'an apartment one's imagination might conjure up whilst wandering round some ruined castle. Here all the vanished splendours of a bygone age' – was a greater reflection of MacQuoid's entry into high society than his wife's establishment credentials. One of the

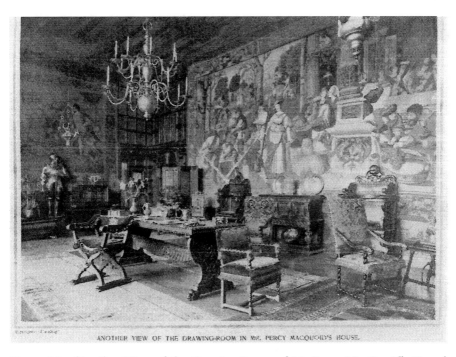

ANOTHER VIEW OF THE DRAWING-ROOM IN MR. PERCY MACQUOID'S HOUSE.

Figure 2.1 'Another View of the Drawing Room of Mr Percy MacQuoid's House', published in 'Of London Houses: The Yellow House, 8 Palace Court, the Residence of Mr Percy MacQuoid, RI', *The King*, 19 April 1902. Reproduced with kind permission of David Beevers.

pioneers of the period-room style was the ultimate champion of new money's acceptance into high society, Baron Ferdinand de Rothschild, who incorporated eighteenth century French panelling into most of the principal reception rooms at Waddesdon Manor. In 'Bric a Brac' (1896) he laid claim as an innovator when he reminisced that '[My family] first revived the decoration of the eighteenth century in its purity, reconstructing rooms out of old material, reproducing them as they had been during the reigns of the Louis, while at the same time adapting them to modern requirements'.[148] As their popularity increased, the domestic treatment of period rooms became a popular subject for a number of books published in the early twentieth century. One of the curious results of this was that such authors came to advocate the use of reproduction furniture: 'To furnish a room entirely with genuine antiques is for the man of average means an impossibility . . . and genuine examples of furniture . . . by their very age and costliness are impractical for use, and their possession is more in keeping with the foundation of a museum than

the forming of a home'.[149] This was not the case in the homes of MacQuoid
or Rothschild, but it encouraged the growth of the large furniture salerooms,
and saw to it that companies such as Lenygon's and Allom's sold reproduc-
tions alongside antiques and even offered the service of copying antiques to
allow the originals to be sold abroad when families in England found them-
selves in need of ready cash.

Nine English rooms were installed in the Victoria and Albert Museum
between 1891 and 1955. Collectively known as 'the English Primary Galleries'
after 1951, Julius Bryant suggests that these 'satisfied a patriotic need for nostal-
gic escape from post-war austerity'.[150] This fits with the idea that the nostalgic
drive to recreate the past is at its highest when there is a keen sense of loss.[151] As
many of the sons of the country house owners did not return from the battle-
fields of the First World War, the houses themselves were threatened, both from
demolition but also from a new type of owner among the wealthy American
incomers. Period rooms became a signifier of a great history of design, one that
many feared had gone forever. John Harris has described this period as 'hey-
days for demolition contractors and antique dealers'.[152] Virtually anything sal-
vageable was saleable, especially the panelled rooms, but also chimney pieces,
a whole range of architectural elements and staircases. The willing recipient for
much of this material was the United States, where hungry consumers wished
to 'manufacture stylistic history'.[153] The catalyst for much of this transatlantic
activity was the making of Colonial Williamsburg in the mid 1920s. Often such
transactions were handled by dealers based in London, increasingly with off-
shoots in New York. As a result, a number of such rooms installed in American
museums have been the subject of scrutiny and dispute in recent times. John
Harris, for example, has cited the case of the Woodcote Park Room installed
in the Museum of Fine Arts, Boston, in 1927. Then called the 'Chippendale
Room', the Museum's director, Eben Howard Gay, was passionate in his belief
that it had been designed by the master of English furnituremakers, who had
enthralled him since the publication of A Chippendale Romance (1915), the
story of his own Boston House.[154] The Chippendale Room's donor had com-
missioned it from Charles Roberson of London, probably in partnership with
Harold G. Lancaster, 'specialist in architectural interiors' who also supplied the
fabricated 'Kempshott Park Saloon' to the Saint Louis Art Museum, donated
in 1929.[155] Charles Roberson had himself been involved in a court case in 1925,
but, unlike Shrager, the plaintiff, a Norwegian shipowner named Jens Gabriel
Lund, won. He had sued Roberson over 'alleged fraudulent representation in
connection with the purchase of the lease and contents of 14, Stratton Street,
Piccadilly', described as the Stratton Street Collection.[156] Lund also accused
Roberson of removing panelling illegally from one of the rooms at his house,
Nun's Acre, and he was ordered to return it.

The history of period rooms is littered with such tales of fakery and 'making up'. They offered the unscrupulous dealer and his naive customer the ultimate in Foucauldian mirrors, 'a utopian place as it is a placeless place, despite its appearance of reality'.[157] As placeless places, period rooms were ripe for adoption and re-creation, but purchasers were sold utopian fables, sucked in by the fairy tales of bygone days and medieval halls. One of the firms that made a good living from creating these rooms was Tibbenham's Ltd of Ipswich. Tibbenham's were legitimate makers of reproduction furniture, who supplied a number of the West End dealers. The firm had an account with Basil Dighton from around 1917 until 1923. In the witness box, Reginald Tibbenham stated that he did not sell furniture made in imitation of the antique to Dighton and Co., but instead mostly decorated items sent to Suffolk by Basil Dighton. Under further cross-examination he then stated that he had sold about 'nine pieces' of furniture that Tibbenham's had made to Basil Dighton Ltd, including six mahogany chairs from a 'pattern chair' sent by Dighton, although these were presented as legitimate reproductions rather than attempted fakery.[158] Other pieces mentioned in court as supplied to Dighton were a mahogany Sheraton bed, dressing table and triple mirror; two black lacquer chairs; four red lacquer armchairs; and two painted satinwood chairs. When asked whether the furniture was made like antiques, Tibbenham replied, 'No, none of Mr Dighton's were ever made like antiques'.[159] Both Dighton and Tibbenham were also involved in the Cambridge Tapestry Company, which supplied modern reproductions of historic upholstery. A number of the exhibits in court that featured embroidered elements were proposed by the prosecution to have come from this source. The most significant piece of work carried out by Tibbenham's for Dighton and Co., however, was the infamous Royston Room, which became a central feature of the Shrager case.

The Royston Room provides us with the ultimate symbol of the utopian world that Dighton and Co. were offering Shrager (see Figure 2.2).[160] Drawing on the popularity of the period room in interior schemes, Lawrence suggested that Shrager 'ought to have one room panelled' at Kent Lodge.[161] Shrager was obviously aware of the status symbol that such rooms had become, replying, 'Yes, I like the idea'.[162] Unsurprisingly, once the seed had been planted, Lawrence very quickly came up with the goods, calling Shrager to London 'as he had heard of some old oak panelling'.[163] Shrager continued the story in court of Lawrence's and his own 'good luck':

He had been to Ipswich and Cambridge, and said he had found a room, but it would just about fit, or have to be slightly altered to fit, but the idea was to get the architect to inspect the matter and see what could be done. It was finally decided to knock away one side of the room entirely and build up

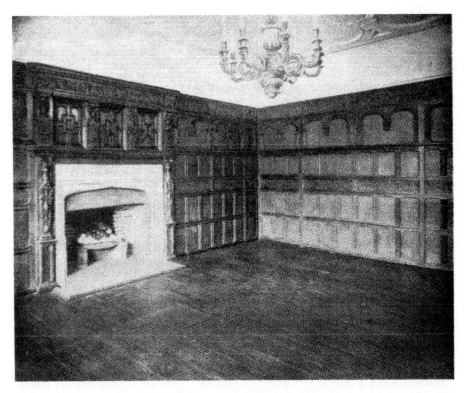

Figure 2.2 'The "Royston Hall" Oak Room', illustrated in Herbert Cescinsky, *The Gentle Art of Faking Furniture* (London: Chapman and Hall Limited, 1931), plate no. 86. Cescinsky claimed that the photograph showed a view 'of the "celebrated" oak room from the mythical "Royston hall" which figured in the English Courts of Law in 1923–4'.

mullion windows to set the panelling which he told me was Elizabethan. . . . Lawrence told me he would get an adaption of some ceiling to match this panelling which he did. He attended to the plaster ceiling. . . . When I saw him about the panelling, he said "I have found a room which comes from Royston Hall". I said "All right, get on with the job". He got on with the job and the room is there and when he came down to visits to Kent Lodge he was always raving about the beauty of this room. I pointed out the special frieze, and just below the frieze the arches in the woodwork. He also drew my attention to the perfect state of the room, the preservation of the whole room, and chaffed me about my usual luck in getting these wonderful things together.[164]

But, as was the case with the majority of Lawrence's lucky finds, all was not as Shrager believed it to be. Lawrence had managed to convince Shrager first that he needed to panel the drawing room; 'the suggestion was that Mr Rose, a local builder, should do the panelling', and then 'that matter was taken out of his hands because he was not thought to be good enough. Mr Lawrence . . . employed Mr Norman Evill, an architect, to supervise the matter and he himself went forth to get the panelling'.[165] As such, 'First of all, it was modern panelling, then old panelling, and then it came to be a room, an old oak room from Royston. Mr Lawrence described it to the plaintiff as an old oak room from Royston Hall'.[166] The sales process involved in the Royston Room reflected wider cultural demands. Not only would the room be panelled, but it would be panelled using an 'old oak room from Royston Hall'. The romantic tale of an old interior salvaged from an old hall added to its value and Shrager's desire to own it. 'A home is not simply a house. It is an image of how we dwell, how we inhabit the world, how we view ourselves in the world'.[167] Shrager wanted the world to view him as a cultured man of taste and the romantic myth of the period room had become a trophy which he coveted. Unfortunately, 'there is, I understand, no such place as Royston Hall. Some of the panelling, not all of it, came from a place used as a dairy in the High Street at Royston in Hertfordshire'.[168] Reginald Matthews, the director of Tibbenham's, confirmed when examined that the panelling had been purchased 'from a house in the High Street of Royston, Hertfordshire . . . at that time . . . used as a dairy'.[169] Lawrence's 'great find', described by the dealer as 'an old oak room from Royston Hall which would exactly fit the room but having regard to the age and character of the panelling a good deal of reconstruction would have to be done with regard to the shape of the room and the windows so as to get the windows in keeping'. As a result, 'Shrager spent on that room £3,220 16s 9d'.[170] For the lawyers, the key arguments were focused on the authenticity of the Royston Room: 'we can tell you exactly the history of that room. . . .' The case for the defence depended on proving that the room had its origin in reality, in a real, historic, domestic interior.[171] As presented by the case for the prosecution, this was patently not the case. They claimed to know:

> [w]here the room came from . . . it was a room used as a dairy in High Street, Royston. It was purchased from a firm named Tibbenham of Ipswich, from a dealer in great Yarmouth. It was then in situ. What Mr Burwood of Yarmouth gave for it we do not know, nor do we think it is material. Messrs Tibbenham gave £225 for it. Tibbenhams removed the panelling from this room to their place at Ipswich and at the place

at Ipswich it was stored as a mass of panelling and we have now a blue print showing the design . . . some of it was original panelling although I think resurfaced and then there were parts of the old panelling which had got broken or damaged and could not be used which were remade and pieced together so as to make other panelling. That amounts alto-gether, roughly speaking, to a half of the old room which was supplied by Messrs Dighton to Mr Shrager. The balance of it and the most important feature of it, namely the frieze, was made by Mee'srs [sic] Tibbenham and I understand was sold to Messrs Dighton for what it is. It could be honestly described as a reconstructed room and not as an old room from Royston, Herts. It had ceased to be the old oak room from Royston, Herts; it was a redesigned room of the same style but manifestly increased in size. About half the material was new . . . it was resold to Dightons by Messrs Tibbenham for the sum of £1,050. You must add to that the £272 6s 9d, which is alterations at cost so what they charged Messrs Dighton was £1,322 6s 9d. The resale to Mr Shrager was for £1,972 6s 9d, their profit being £650.[172]

The debates about the Royston Room rested on its name. 'Mr Shrager will tell you that Mr Lawrence told him that it came from Royston Hall'.[173] Despite Lawrence claiming that he never used this description, it is clear from the evi-dence that Lawrence used the expression knowingly, inventing a history in order to sell Shrager a 'genuine' old oak room from Royston, Hertfordshire, 'in spits [sic] of their knowing the facts they sold it to Mr Shrager as genu-ine knowing perfectly well it had been so reconstructed as to entirely alter its description and they induced him to incur an expenditure of £3,200 on a representation of something which one could demonstrate they knew it was not'.[174] The antiques business is built on such names. By providing a history, a provenance, whether spurious or not, the dealer can induce customers to part with far more money than they would if they were knowingly installing modern or reconstructed panelling. This is the pivot upon which the defin-ition of a fake sits. The dealer's shop is where the object is altered, not in its materiality but in its definition, and, as Cescinsky would later conclude, 'the faking element belongs as much to the method of selling as to the making'.[175] But, in the end, such methods only work if the customer is willing to believe: 'To weave romances round a thing of only yesterday – and one the natural life of which has been seriously shortened in the attempt to give it the spuri-ous appearance of age, and to do this through sheer ignorance – is neither satisfactory nor clever. To pay Queen Anne price for Mary Anne is still more stupid'.[176]

Sir Ernest Pollock's concluding comments rested upon the naming of the room:

> Now, Sir, just one final word on what has been called the Royston Room. I shall call it the Royston Room because it is a convenient way of identifying it. My recollection of it is that at the start originally there is no reference to the Royston Room at all, merely to some panelling from two sources. Ultimately part of it having come from the Royston Room it gets to be called the Royston Room, but Mr Shrager says he does not care a bit whether it came from the Royston Room or not, that Royston Room had no effect upon his mind at all. Yet the expert says; 'You were selling him a room and it ought to be a complete room; it ought to fit', and the like. The answer of Mr Shrager himself was; 'I wanted some old panelling whether from the Royston Room or any other room did not matter a bit to me'. So that we can leave out Mr Cescinsky's sentimental references to this history, because in this case it is immaterial. There is no doubt there was a large quantity of beautiful panel work, and Mr Cescinsky himself was unable to find which was new and which was old. . . . That I submit again is an item which, though it bulked somewhat large at one time, falls into line with all the other pieces.[177]

But as we have seen from the evidence, the process of naming the room increased its price from the £275 that Tibbenham paid to the £3,200 that Shrager parted with in order to have it enhance his home. Roland Barthes famously declared that, 'Writing is the destruction of every voice, of every point of origin. Writing is that neutral, composite, oblique space where our subject slips away. . . . As soon as a fact is narrated . . . the voice loses its origin'.[178] Once the name 'Royston Hall' had been suggested by Lawrence, the origin of the panelled room was allowed to slip away, and its value was predicated on the historical provenance he created. The creation of such myths was key to the market for 'old things'. In naming the objects, they moved from their original 'closed, silent existence to an oral state, open to appropriation', by the dealers and the society in which they traded.[179] These myths, as such, were not defined by the object of their message but by the way in which the market 'utter[ed] this message'.[180]

Reginald Matthews, the director of Tibbenham's Ltd, as witness for the plaintiff, provided the court with the 'real' history of the room that resonated with a number of cases surrounding so-called 'period rooms' sold at this time. John Harris has written about a number of these, but what is interesting here is the timing of the Shrager case.[181] Despite the nationwide, and worldwide, publicity surrounding the trial – including *The Times* recording Matthew's evidence that the panelling, 'did not come from Royston Hall, Hertfordshire . . . it had

come from a house used as a dairy in High Street, Royston . . . [and] his firm made about one-third of the whole of the panelling'[182] – such rooms remained popular. Questions about their origin and 'authenticity' only really began to be raised in the 1950s, as such themes became more important for their owners, particularly public museums. In his article about the new British Galleries at the Victoria and Albert Museum, Julius Bryant concluded that many of the period rooms purchased before and after the trial[183] had been removed from display in the museum by the 1980s because many of the curators 'had lost . . . faith in their rooms as entities, having discovered them to be of mixed origin. Assembled by dealers in the early twentieth century, prior to purchase by museums, period rooms came to be dismantled as fakes'.[184] Certainly, given the evidence presented in court, the Royston Room should have served as a cautionary tale for any potential purchaser of an 'old room'.

Where did the panelling come from originally?

From a house in the High Street of Royston, Hertfordshire.

What was the house used as?

At that time it was used as a dairy.

Did it come from Royston Hall?

No it came from a house in the High Street at Royston.

Where did Messrs Tibbenham buy that panelling from?

The person was a Mr Burwood of Great Yarmouth.

What is he by occupation?

A merchant in builders materials.

What money did you pay Mr Burwood for this stuff?

£275.

To whom did your firm supply the panelling for Kent Lodge?

To Messrs Basil Dighton.

Did you supply panelling other than what you got from Royston?

Yes, we restored the Royston Room. . .

Would you mind explaining to the learned referee what is original, what is made up and what is new? [blueprint handed to the witness]

These parts which are left in blue upon the blueprint were added by ourselves. The parts that are washed in colour were those portions which we had from Royston . . . we sent our man over to Royston and took it down, brought it back to our factory in Ipswich, measured it all up and made this reconstruction.

You made the design?

Yes.

That was before you had a purchaser in view?

Yes.[185]

Matthews did make the case that his work on this room was perfectly normal for this type of antique, however. He thought the original wood to be 'the genuine old article and fine quality in addition', and commented that 'from the lay point of view, when [old panelling is] taken out it looks a heap of rubbish'.[186] As such 'in ninety nine cases out of one hundred having taken out panelling from an old room you have to reconstruct it'.[187] The third of the room which Tibbenham made was claimed to be of 'Only old wood . . . carefully collected. . . . Seventeenth century wood' and as such 'Mr Shrager himself . . . found it impossible to distinguish the old from the new in the sense of the word new!'[188] As we have seen already, however, this was no indication of accuracy. Matthews concluded that 'it was the most scholarly reconstruction we could make of it'.[189]

Cescinsky confirmed in 1931,

The 'genuine oak room' was a very profitable field for the faker until a few years ago, and his efforts, of that time, still exist to confound the expert. A complete room which will sell for thousands of pounds is much more lucrative to make and sell than, say, a Gothic chair about which some awkward questions as to origin may be asked. The provenance of an oak room can be so easily manufactured.[190]

Reflecting on 'the famous Shrager panelled room which came from "Royston Hall"', he claimed that he

[k]new of another house – or rather a yeoman's cottage – in the Midlands from which no less than six rooms came – including a Long Gallery – but where no single apartment was anything like large enough to have contained a single one, not even the smallest. One is reminded of Mark Twain's tunnel which ran through a mountain and stuck out one hundred feet at the top and four hundred feet at each end, or many of the secret passages 'which led to the neighbouring Abbey'.[191]

While reflecting on this trend for the period room, he concluded that,

The difference between an old room which has been taken down and stripped and another which has been juggled together from indiscriminate

scraps is often very little indeed . . . some rooms have been made outright from old wood; there was quite a flourishing industry in these some twenty years ago, which still persists, I believe, and here the faker is not fettered by existing old materials. The modern tool, however, is still his pitfall, if he is to make commercially, and, it must be repeated here, the faker rolls up no fortune; it is the dealer who basks in the thousand-per-cent patch.[192]

About 'the celebrated "Royston Room"', Cescinsky remarked both in court and in his later book that the dealer's profit was more than half the total price of the room, and he concluded as such that the maker could not be described as a faker, 'as I understand the term to imply deceiver'. Instead,

> The dealer who sold it as a genuine 'Elizabethan' room (which it could never have been, in any event) to the unfortunate Adolph Shrager could have had no delusions on the subject, as he saw it being made, and on more than one occasion. So much for the rewards of faking, which I define here as a sale under false pretences which may have little or nothing to do with the actual making of the fake thus sold.[193]

In court, Cescinsky's evidence on the subject of the Royston Room made clear reference to the fact that, in the end, Shrager was not purchasing the room as made by Tibbenham's Ltd, but the description as sold by Dighton and Co.

> If I sell somebody some Jacobean panelling which is perfectly genuine I make it up to fit their room; I cut away pieces and I add pieces, and that is perfectly legitimate. But if I sell him that as Oliver Cromwell's own room, then it is quite another matter, because I am charging him for the historical association, and if I begin to materially alter it, add to it or subtract from it, it is a very different matter, as long as I am charging for the historical association. . . .
>
> If it is sold as from Royston Hall why is it that you would think it would have its value enhanced?
>
> Because I should expect a place like Royston Hall to have historical associations, and in buying a room from Royston Hall I should expect to buy a complete room. . . . I would want to be quite convinced about Royston Hall and this panelling before I charged money for history, and I should not want old wives tales either.
>
> What is the money that you would charge for the history. Let us have a percentage?
>
> I do not know. I am not in the habit of charging for history.

So I thought; then you cannot give the difference in value between what might be called common history and the Oliver Cromwell sort of history?

Yes, I can, because I know sometimes what these rooms have fetched. I have one in mind now, the Star Room at Yarmouth, the Nelson Room. . . .

That was a large room that brought in a large sum of money, did it not?

Yes, a very large sum of money.

You said that Mr Dighton bought it at some period or another.

So far as I know it was in the hands of Messrs Greenwood of Hereford. If you want to know anything about it you had better ask them.

What was the Nelson Room sold for?

Charging my memory, it is many years since it was bought, I think it was about £6,000 or £7,000. . . .

Did you satisfy yourself that it was truly and rightly called the Nelson room because Nelson had been there?

I did not attach any importance to that, because the room itself was much older than Nelson and its history was well-known.

The mere fact it was called the Nelson Room did not make any difference?

Not in the least. . . .

Official referee: But I gather that as regards the earlier history there was a considerable charge made on that account?

Considerable; and a very interesting history, too. That was a room that belonged to one of the old merchant adventurers at Yarmouth . . . William Burton. . . . [194]

When purchasing a period room one was buying its 'pedigree', but such pedigrees were notoriously slippery.

I have learned to distrust these pedigrees [not substantiated by exact evidence] thoroughly, and the more plausible they are the more I become suspicious. I have found, in some forty years' experience, that they are easier to fabricate than the pieces they purport to be. The latter do require skill, taste, facilities and opportunities; a lively, if dishonest, imagination is all that is necessary with the former. [195]

'The period room constitutes the most literal of messages, diminished only by the knowledge that some of its aspects are not necessarily original or authentic'. [196] Key to their value is the idea of the 'authentic historical experience' and, once this is in question for the owner and museum curator alike,

the room is diminished in value and status. Provenance was and remains key to such places, and to their survival.

> A caution here may be necessary. Distrust all local legends and 'old wives' tales'. I have seen so many oak and deal rooms which I have been assured, ostensibly on the best authority, are in original *situ*, but where the signs of later cutting and adaption are obvious. There is one in Sparrowe's House in the Buttermarket at Ipswich which has evidently been very largely altered, and two mantels and some of the panelling in the 'Feathers' Hotel at Ludlow are also not original to the house.[197]

Despite Matthews's evidence to the contrary, however carefully couched, the Official Referee dismissed the evidence against Dighton's, leading Cescinsky to caution:

> My advice to those who seek the aid of the law in their 'bargains' is the same as that given by *Punch* to those about to marry. The law demands proof, and even the placing of the actual make in the box is not 'proof' to many judges, as they may hold that the faker has been bribed to make false statements. I have always that famous 'Royston Hall Room' in mind, where not only the maker, but the drawings also, were produced in court, yet where the plaintiff failed on this point and on every other. To be able to produce the actual maker of a fake is almost impossible, especially in a case against the antiques trade, as fakers live by the trade and not by the private collector, and bread and butter is thicker than sentiment.[198]

Ultimately, as Cescinsky concluded, the market was a self-fulfilling space, and one in which no one dared step out of place for fear of upsetting the carefully modulated system of buying and selling. The ringmaster within this space was the dealer. The dealer worked the market in order to generate the highest prices for the goods they had to sell. Key to the circle of the market was the naive customer, ready to be directed in their purchasing choices, exposed by their desire to purchase objects according to a culturally dictated plan that ultimately they did not understand because they were only on the edges of the social life that they coveted.[199] Lawrence knew his business when he 'hooked [his] fish'; 'you want to get him firmly on the hook beyond the possibility of getting off again, you offer him a profit on his bargain. If he takes it, well, it is only some £50 or £60 out of pocket, and you have got him as a customer, and you can easily make it up elsewhere'.[200] Once hooked, Shrager was open to direction, as he had come to the shop already convinced that it would offer him the objects required for a 'gentleman's home'. 'Perception is determined

by the structure of expectations that underpins it'.[201] The dealer created value by indicating a demand in the market, thus demand created further demand. This is a key aspect of Lawrence's sales technique.

> Just after you left this morning, a client came in and expressed 'great anxiety' to buy a fine mahogany chest of drawers which you will remember is in the lobby outside our back drawing room here. I told him that there was no chance of getting it, be he was so insistent that I said I would write to my client who had bought it, to see if he would part with it. He has made an offer of £400 for it, and he says if it can't be got for that, what can it be got for? So I told him I would do my best for him, and it is not up to you to do anything you like in this matter. It is no doubt rather boring to offer you a profit on things that you have bought, on the other hand it is not unpleasant, and I feel bound to submit them to you if I receive them. That offer was not accepted. Mr Shrager's confidence in the defendants was made, if possible, greater than before.[202]

As highlighted in George Simmel's book on the philosophy of money, value is never the inherent property of objects, rather it is 'a judgement made about them by subjects'. Arjun Appadurai took up Simmel's arguments when he asserted that 'economic exchange creates value'.[203] The price a purchaser is prepared to pay to the vendor determines the value of the thing that is purchased. The movement of the objects through the dealer's shop, and the desires of their clients, gave the objects their values. If eighteenth-century furniture was perceived as the ultimate goal for the collector in the early twentieth century, then the desire for such objects would increase, thus not only increasing their market value but also their propensity to being faked. The more 'unique' an object, the rarer the opportunity to purchase, the more valuable it became; 'We call these objects valuable that resist our desire to possess them'.[204] 'The economic object does not have an absolute value as a result of the demand for it, but the demand, as the basis of a real or imagined exchange, endows the object with value. It is exchange that sets the parameters of utility and scarcity, rather than the other way round, and exchange that is the source of value'.[205] Lawrence's key role was to create the aura of demand, and to inflate his prices by building on the obvious demand for such objects in the London market at that time. The market was being driven by the nouveaux riches purchasers, particularly from America, as we see in Lawrence's letter of the 30 July 1920:

> 'I find that those tapestry chairs are under offer to an American but I don't think they will have them. Dighton arranged this but I did not know as I told

our secretary to reserve them'. Those chairs which that letter relates to are some William and Mary chairs. There are four William and Mary chairs and four stools ensuite with original English needlework and a set of six William and Mary chairs covered with needlework seats. Some have carved open backs and some have stuffed backs. They resemble one another very curiously. The fact of the matter is that they are not William and Mary chairs and the needlework is only original in this sense, that somebody in quite recent days has embroidered on an altar cloth a pattern and that has been used to upholster these chairs. The price of those between them was £2,400.[206]

The price is striking, particularly given the comment on the objects made by the prosecution lawyer, Burrows, but Shrager could look at the auction prices for such 'William and Mary' suites in the 1920s to confirm Lawrence's offer.

The auction house sat, and continues to sit, at the apex of these structures of exchange. It is the main influencer in the move from a culture of production to a culture of commodity exchange, value, price and profit, and is the space where the object, through commodification, becomes fetish. Throughout the trial we see the auction house not only offered as a guarantee of value but also as a source of provenance; both are problematic given its role as a subjective space for the creation of value. The auction house was often cited by dealers and their lawyers alike as offering the sought-after historical guarantee of authenticity. Through the passing of objects through sales and the accompanying catalogues, the buyer was supposedly provided with the evidence needed to support an object's valuation. As Walter Benjamin claimed in his seminal text, 'The Work of Art in the Age of Mechanical Reproduction', 'The authenticity of a thing is the essence of all that is transmissible from its beginning, ranging from its substantive duration to its testimony to the history which it has experienced'.[207] The auction catalogue was a key part of such 'testimony'. Frequently the defence team referred to an object's journey as evidence of its authenticity, for example, during Cescinsky's cross-examination:

Now let me take No. 44, a pair of Queen Anne walnut long seats . . . you say they are made up, but the framing is made from old wood. You say they are really of no age at all. . . .

They are of no age, a few years at most; they have been made with intent to masquerade as antique pieces.

They are what is called in the trade, fakes?

Quite right. First of all the framework is of pine; I do not know of pine ever being used for that purpose in the 18th century; they purport to belong to the eighteenth century; they are faced up with walnut; they are coloured. . . .

Would it help you to know that these were bought at Christie's. . . . Does it help you to know that they came from Ashley Park and were sold in Mr J. S. Sasson's sale from Ashley Park on the 11th June 1918?

A sale by whom? Would you tell me the auctioneer and I might be able to recognise the sale?

It is item 71, the auctioneers are Messrs Christie, Manson and Woods. Were you at the sale?

No, I do not think I was.

Lot 71 was bought at Christie's by the Defendants and they were sold to Lady Northcliffe, who covered them with the Genoese velvet, and subsequently Mr Dighton, at Lady Northcliffe's request, bought them back from her, as they were not suitable for the place she wanted them for. Does that help you at all as to whether they are genuine or not?

No, not as to their genuineness; it helps me in another way. Were they at Sutton Place? . . . Did Lady Northcliffe have them at Sutton Place; if so I ought to have seen them.

They came from Ashley Park?

But where did Lady Northcliffe have them; she must have had them in one of her houses at some time.

Then you must enquire from her, as I have no information with regard to that.

Very well. Answering your question, these are walnut unmistakably, not a possibility of their being anything else; and what you have read to me does not affect my opinion in the least.

I am saying that it was Lady Northcliffe who covered them in the Genoese velvet.

Then Lady Northcliffe put the best part on the stools.

I want you to be quite clear that I am not suggesting they were bought at Christie's with that particular velvet upon them.

No; it is a surprise to me that they were bought at Christie's at all.[208]

Cescinsky was to make his feelings clear about the use of the auction house as provenance:

It is necessary to offer a caution here, when the provenance of a well-known auction room is cited. 'I bought that at _____'s auction room, and it came from the _____ collection. Here is the catalogue and the illustration of that piece." Apparently nothing could be more convincing, yet, in a Court of

Law, not so many years ago, I was shown a piece which was covered by a catalogue description and illustration, the original of which I had actually bought myself at that sale, and had in my possession at the time. It is well to regard all pedigrees in a sceptical spirit until some more convincing evidence than the auctioneer's catalogue is forthcoming. It is a wicked world, and he who would make a fortune out of high priced goods bought at public auctions (where his prices are known to everyone who is interested) must both buy and sell an enormous amount in the year. It does not require an expert but an actuary to prove this point.[209]

Since the inception of the public auction in the final decade of the seventeenth century in Amsterdam, at the beginning of the eighteenth century in London and in the 1730s in Paris, it has dominated the market as the favoured method of purchase and as a key site for dealer activity.[210] Here dealers and buyers alike were made aware of the prices for their objects, while at the same time the passage of such objects through the auction room had an explicit impact on their value. But does the auction house sell objects or does it create objects through the act of selling?[211] The notion of value permeates intellectual, aesthetic and historical appreciation in a complex relationship where financial value is intimately tied to cultural value, and the auction room is tied closely into this network. This was clearly illustrated from the start, when auctions began to emerge not only as a place to buy and sell objects but as a site which guaranteed an audience for those wishing to publicly celebrate their cultural and financial capital. The public auction gave free reign to combative behaviour, where each bidder simultaneously exposed his taste, his capacity to sacrifice wealth in order to satisfy it and the exact extent of that wealth.[212] As the sales began to play an ever-increasing role and the sums paid increased, the idea of the professional expert began to gain prestige, both in the form of the dealer and the auctioneer, who often worked together to guarantee the best possible returns for their efforts.[213] Such persons were responsible for delivering the items for sale, conducting the sale and drawing up the catalogue, and making the purchases either on a speculation for their shops or on behalf of clients, thereby creating a clear link between the writing of histories, the gathering of provenance for the catalogue, the market and the saleroom. The rise of the auction house brought about the rise of the profession of auctioneer, closely allied to the idea of the expert. The role of the auctioneer consisted of identifying objects, the attribution of a specific author/designer when necessary, composing a concise but accurate description and calculating their artistic and monetary value.

Within these markets the role of 'expert and connoisseur' was often bound up with the role of dealer and auctioneer, leading to clear difficulties in teasing

out what motivated their pronouncements on an individual object's value. We will look at the role of the 'expert' in Chapter 3 when we consider the witnesses in the trial, but it is important here to consider how the professions of dealer and expert merged in the auction room, despite the experts often attempting to distance themselves from market processes. For example, Ralph Edwards in his article, 'Percy MacQuoid and Others', for *Apollo* magazine, described how the furniture expert 'advised . . . rich folk with pretensions to taste . . . [who] collected old furniture to equip their houses; and at long intervals effected a profitable sale from the abundance of valuable objects he had accumulated – though to suggest he was a dealer would be entirely misleading'.[214] His letters to clients, such as Sir Arthur Crosfield, suggest otherwise. Despite his own and others desire to separate his profession from the more explicit market practices, MacQuoid, like many of the other historians writing in the early twentieth century, was often called upon to advise the auction house (just as they continue to be today), blurring the distinction between historian and the object expert brought in to guarantee authenticity in the auction house. The idea that the historian/expert will exercise objective and scientific knowledge is vital to the image of his/her role in the auction process. The myth of objectivity has allowed certain historians and connoisseurs to dominate the process of assigning value within the self-fulfilling cycle of discourse/market. The auctioneer, dealer and connoisseur are all deemed able to assess the validity of an object as a result of daily contact with similar items, but the auctioneer and dealers, by title, are identified directly with the financial aspect of object decisions, whereas the connoisseur benefits from a perceived separation which credits him/her with the ability to make intellectual pronunciations upon objects that affect value obliquely. MacQuoid himself highlighted the fallibility of the auction house:

Do you think that they are genuine Charles II chairs?

Perfectly genuine, only they are made of oak and naturally look much coarser than if they were made of walnut. . . . A certain number of these chairs were made in oak and Christie's persisted for years, until about five years ago, in calling every walnut Charles II chair that came into their place an 'oak chair of Charles II'. No matter what you said to them, they only laughed and went on describing them as oak but at last they have changed . . . you cannot call them valuable.[215]

Cescinsky, risking biting the hand that fed him, critiqued the auction house while admitting his role as 'expert' when attending sales on behalf of clients:

In your profession, do you make a practice of attending auction sales?

Yes, very frequently.

On behalf of clients?

Yes.

And in advising clients in respect of them?

Yes.

Do you personally rely upon your own judgement in buying things?

As to their authenticity? . . . Yes, on my own judgement entirely.

Or do you rely on the auctioneer's particulars.

No, I put no reliance on them.

This is the Burghard sale on January 7th, 1920, by Messrs Christie, Manson and Wood. Condition 5 is: 'The lots to be taken away and paid for whether genuine authentic or not, with all faults and errors of description at the buyer's expense and risk within two days of the sale, description, genuineness or authenticity, or any fault or defect in any lot and making no warranty whatever'. Are you aware that the auctioneer's Messrs Christie, Manson and Woods, protect themselves in that way?

Yes.

Is that the practice of all auctioneers dealing with these matters?

Yes, the clause is in every auctioneer's catalogue to my knowledge.

Is it a well understood thing amongst the trade, people who buy furniture in business. I do not mean private people, because they may be different, that auctioneers do that?

Yes, that is why the auctioneers give view days so that you can examine prior to the sale.[216]

From the eighteenth century onwards, the connoisseur by dint of his 'expertise' and first-hand experience of the objects, has been judged able to comment on fine art and decorative objects. The methodological study of works of art that made the connoisseur less dependent on subjective criteria coincided with the emergence and growth of public galleries in England and on the Continent. According to Frank Herrmann, the custodians of these institutions turned to the connoisseur in order to obtain a guarantee of authenticity when spending public funds on highly priced, well-known Old Master paintings. Herrmann describes the connoisseur as 'intelligent and highly educated', with 'outstanding ability and judgement', supported by 'the methodological compilation of documentary evidence by the building up of excellent libraries of books and magazines on the arts and photographic reproductions'.[217] As the disciplines of art history and furniture history developed, much focus was placed on these libraries of documented knowledge, but, as E. H. Carr evidenced in the

lectures that formed the basis of *What Is History* (1978), such histories are predicated on the subjective reader.[218] Cescinsky goes even further to warn of the deliberate manipulation of historical evidence:

> There is another pitfall, in this sifting of evidence, which should be mentioned here, the relation of documents to the pieces themselves . . . if one find a mention in an inventory of a certain piece of furniture, and one exists which corresponds, roughly, to the description, that, in itself, is no evidence that it is the actual piece. The original may have disappeared and its place be taken by another. I have found this quite frequently. Once any historical furniture has passed through an auction-room, the greatest care is necessary in its subsequent identification. I have known, on more than one occasion, of a genuine piece, bought at auction, which has been copied, and then sold as original under the cloak of the catalogue description and provenance.[219]

With the rise of furniture history, and the corresponding rise of prices in the auction house and dealer's shop in the late nineteenth century, historians began to focus on a set of defined factors when assessing an object's worth: the maker, style, materials, technique and provenance. A crucial dichotomy developed at the heart of the market and the discourse, recognized by Herrmann as 'something of a tug of war between aesthetic and commercial considerations'.[220] Critical comment on an object placed for sale by an 'expert' could prove highly damaging, or highly beneficial, as historic furniture became negotiable property. 'Inevitably this gives the art historian/expert who is the recognized authority on a specialized period . . . a good deal of power, and it makes it essential that scholarship in this field should be combined with complete integrity'.[221] The history of connoisseurship, intrinsically bound by such demand for perceptible integrity, was based upon notions such as truth, honesty and hard work. These are themes that ran throughout the trial, where Dighton was frequently quoted as telling Shrager that he had been dealing in antique furniture for 35 years, and often bought and sold through Christie's.[222] As we have seen, experience and the involvement of the auction house were often bound together to demonstrate the expertise of the dealer and/or historian.

Connoisseurial approaches had come to dominate the discourse of furniture history since the 1890s, when dealers such as Frederick Litchfield began to create chronologies of the history of furniture at a time when the furniture trade was witnessing an expanding commercialization. As objects were identified as collectible, a hierarchy developed and the object was no longer seen in isolation, only in relation to similar objects. Once this system had developed, the assessment of old furniture was subsumed into a commercial sphere that, inevitably,

led to a desire by collectors such as Shrager to have their objects' aesthetic and historical value validated by their commercial exchange value. Above all, the market reflects the position of the discourse at a particular point in time.[223] In his 1970 lecture, 'The Order of Discourse', Michel Foucault showed how the rules of formation of discourses are linked to the operation of a particular kind of social power.[224] Furniture history, as such, can be seen as intimately tied to the development of the auction, and particularly of the dealer, in the late nineteenth and early twentieth centuries. Through the commodification process, objects become representative of the mechanization of society and the public illustration of a particular type of discernment linked to a certain, well-defined, *habitus*. Therefore, the discourse is bound by the same regulations as the commercial practice, enforced through the social actions of appropriation, control and 'policing'.[225] 'It is the meaning of collection pieces that determines their exchange value', the object, once commodified, changes its meaning.[226] 'It is value . . . that converts every product into a social hieroglyphic'.[227] Since the late sixteenth century, society has constructed and reconstructed itself through possessions, and particularly the spectacle of these possessions. 'The same object can exist in a number of situations, or social discourses, through the course of its physical life, and may therefore figure in a number of inter-pretive patterns, as it attracts different notions of value and significance'.[228] Ultimately, the objects purchased in the auction houses were signifiers of the commodification process in a scheme of social self-creation. The auction catalogues themselves could be seen as signifiers of the cultural and hence financial worth of an object, as Cescinsky's cross-examination indicates:

> With regard to the question which we have discussed on various occasions as to the descriptions in illustrated auctioneer's catalogues, is there any particular value in those descriptions?
>
> None, whatever . . . an auctioneer has to put the best things in his catalogue that he can in capitals which indicates that he probably has no better. He describes them as well as he can. He is not necessarily particular about being accurate, and to safeguard himself against implying any warranty they always put in the front a condition of sale which bars that out. . . .
>
> With regard to Messrs Christie's, it was put to you that Messrs Christie's were not the sort of persons who would sell things which were not right?
>
> Yes, it was certainly suggested that the fact of it being sold at Christie's was some sort of warranty that they were presumably genuine, and presumably what they describe them to be. I will not go so far as to say that it was a warranty and I never suggested it. . . .

Official Referee: The presumption is as everybody knows that Christie's are a firm of the very highest standing not willing to deceive anybody.

I do not think so for a moment. They are as a rule very accurate in their descriptions.

Has it happened that Messrs Christie's descriptions have been found to be incorrect?

Yes, it has been found with every auctioneer.

Was the Dickens' sale for example at Christie's?

Yes.

Official Referee: I take it that the auctioneer gets his description to almost the entire extent from the persons who give him the objects to sell?

Not necessarily. . . . In some cases he sends his representatives to lot and to describe. That is done in the case of Christie's and in the case of Sotheby's and Puttick and Simpson. . . .

With regard to the question of auctioneer's description, would a man who was an expert be justified in selling a thing on the description of an auctioneer's catalogue?

No, certainly not.

What could a dealer or expert do if he has bought a thing on an auctioneer's catalogue and desires to sell it again?

He should examine it first of all, if he has trusted to the auctioneer's description, but very few dealers do. They go down a few days prior and carefully look at the things to see what they are. If he fails to do that and walks into the auction room and bids of course he takes the chance for whatever he might get.

What happens if a dealer by accident buys a piece which is not a genuine piece?

The usual custom as far as I have discovered it is to put it back in another auction room and hope that some other dealer or somebody will fall into it.

If there are pieces which are either made up or restored or spurious, can they be shown to be spurious or false with equal ease or is it easy or difficult?

It depends, it is a matter of degree, and the example.

When care has been taken to give an appearance of age, is it easy to show that a thing is not genuine.

One may know it and be utterly unable to say why and utterly unable to demonstrate it.[229]

The process of purchase, display and sale demonstrates how objects become signs of a person's location in a particular hierarchy the moment those objects become commodities. The auction house, as such, serves as a rite of passage for these objects. Despite all the warnings, in the trial, it also was held up by the case for the defence as an authentic space, the ultimate signifier of a genuine piece. Edward Pollock concluded as much when he declared:

> I am entitled to ask you to consider one point. Of course, if with the wicked design of fraudulently deceiving a client Mr Dighton and Mr Lawrence had laid their heads together for the purpose of concocting a fraud, it would be unlikely, I think, that they would choose to sell pieces which had a history. I do not care what the history is, but I mean pieces that are sold at Christie's, or which are sold at the Ravensworth sale, or are sold at the Wentworth sale and so on, are known and must have been known throughout the trade. If this sinister design was entered upon surely it would be with regard to pieces which have suddenly turned up in some dealer's place from a country house, which is not named and not known. That is what you would probably find, but when you find that pieces which are sold are pieces which in many cases – I do not know whether I may say many, but in some cases – are pieces which form the feature of the sale and well known sales, it is remarkable that those pieces are passed on as genuine, when in truth and in fact they are fakes. I really do not care what Mr Cescinsky or anybody else may think as to whether or not the piece that is sold is ultimately held to be genuine or not; it really matters not. What matters is this, that the persons who are selling that piece think it of such importance that they illustrate it, they put it into the catalogue in big type as an attractive feature, and they are going to do it in the faces of all those who come to the sale. . . . I do not care whether it is a Slough auctioneer or whether it is Messrs Knight, Frank and Rutley's representative or Messrs Christie, Manson and Wood's representative, no-one is going to get up on to the rostrum and produce a piece of furniture which is so obviously a fake, so stupid and fraudulent a piece, that it has really no character at all, and he is going to say, 'Now I am going to sell you a lovely Queen Anne piece'. He would have been met with shouts of laughter and it would have been said to him, 'If that is the way you prepare your catalogues, how can you expect anybody to come to your sales – to describe as beautiful Charles II seats and William and Mary stools and so on, rubbish that comes from the Tottenham Court Road?' People who care for their reputation care for their characters quite as much as Mr Shrager, and to say, because these pieces appear in a catalogue and that Mr Cescinsky withholds his admiration or approval, that therefore they are all base and spurious is to carry the matter far beyond what even

the great authority of Mr Cescinsky can vouch for . . . the real guarantee
that you have there is that at a public sale by well-known persons, by well
known auctioneers, before a company which is gathered together because
of their appreciation of the integrity and acumen of the auctioneers who
are holding the sale.[230]

Disregarding the commercial role of the auction house, the auctioned object's
function, style and meaning are bound up in a specific social ritual. The object
does not stand alone as a representative of a designer's *oeuvre*, but becomes
dynamically involved in a much wider pattern of consumption and desire.
Commodification allows the object to operate as a sign within the social and
commercial discourses that value the slippery concepts of 'genius' and 'origi-
nality'. 'All value is symbolic value . . . societies need principles of valuation
and a range of values in order to be able to function'.[231] If the authority of
the auctioneer was allowed to be questioned, then the system would cease to
work, and ultimately it was this fact that determined Shrager's fate from the
start.

Ironically, the movement of the objects through the auction rooms of
Christie's and the like became part of their vital provenance.

I will take just one more item that I need not be long over, the pair of 17th
century walnut armchairs. . . . 'These chairs are practically remade and
they are reupholstered'. I think these are the chairs they suggested were
made by the same hand or the factory that are No. 14 in the Particulars . . .
because they are gouged out in a particular way, the chisel or gouge was
used in a particular way and so on?

Yes.

Does it affect your mind that these chairs were sold at Christie's and were
subsequently bought from the purchaser from there by Mr Dighton – they
were bought first of all by Messrs Stare and Andrew. Do you know the
name?

Yes, Soho Square.

Are they dealers in furniture?

Yes.

Dealers in antique furniture?

Yes, they bought the Nelson Room out of Great Yarmouth, one of the finest
oak rooms that has ever come into the market.

Are you right about that?

No, I beg your pardon, it was Fenner's house. There were two rooms.

Mr Dighton bought the Nelson Room from Great Yarmouth, did he not, 'the finest room' and so and so?

No, there were two rooms there.

You have referred to the Nelson Room and that is what Mr Dighton bought, is it not?

Is the Nelson Room the one from the Star Hotel . . . that was bought by Messrs Greenwood? . . . Then shall we leave all the Nelson Rooms for the moment and who they were bought by and go back to what I was asking you before. . . . Do you know that these chairs were sold by them to Mr Benjamin . . . and ultimately to Messrs Dighton, through all that sequence, after their sale at Christie's . . . and then sold to Mr Shrager. . . . Does that affect your mind at all?

Well it is rather a merry-go-round, when they could have gone to Christie's themselves. There are profits each time Sir.

I do not quite follow what you mean by that. Do you mean to say that Mr Dighton was not entitled to sell to Mr Shrager anything unless he bought it originally himself?

I do not say he was not entitled to, but I say that it is not giving good service to his client to let so many profits come on chairs on that description.

Do you mean it was Mr Dighton's duty only to buy from the original house where the furniture was?

No, not in the faintest, but these chairs were bought especially, as I understand, for Mr Shrager. . . .

Then do you suggest that it is an improper thing for him to have bought after a sequence of buyers from Christie's or anywhere else. . . .

If I were buying for you I should call it grossly improper to pay all those profits.

Do you suggest that it was an improper thing for Messrs Dighton to buy from a person from whom he could get goods of the right quality?

Yes, it is bad to do it in that way; it is bad service to their clients.

What ought they to have done?

They ought to have gone to Christie's and bought them themselves.[232]

Meaning is in a continuous process of alteration and therefore provenance is a complex measure, often mediated through contemporary concerns, with the fragments of history being joined together according to the historian's desires. E. H. Carr drew our attention most firmly to this: 'The historian is necessarily selective . . . the belief in a hard core of historical facts existing objectively and

independently of the interpretation of the historian is a preposterous fallacy, but one which is very hard to eradicate'.[233] He goes on to call history 'an enormous jigsaw with a lot of missing parts'.[234] Throughout the case the experts and their lawyers attempted to piece together this jigsaw in order to meet the ambitions of their side of the courtroom. For example, Percy MacQuoid took his opponent's evidence and attempted to defeat it using provenance:

> Now, we pass to the next item, a pair of old lacquer stools . . . [Cescinsky says] 'they are modern forgeries, as coarse as they possibly can be, and the lacquer is not lacquer. It is common red paint' . . . I then asked him whether his opinion would be modified by knowing that Lord Zouche had at one time been the owner of them . . . I have seen these stools before. I fancy I saw them at Parham, at Lord Zouche's. I think I went there when I was writing my book, but I did not want them for this period of furniture when I was there, because I had already dealt with the period, and therefore they did not particularly interest me at the time, having done with that period. I have never seen this sort of furniture coloured with what you may call true spirit lacquer; it is nearly always done with a form of paint, I suppose because they found it would stick better to the curves of the furniture. You do not find lacquer employed upon curved furniture, and my only theory is that they found that paint was better to get into the interstices . . . they are perfectly genuine, late James II, early William III stools.[235]

As Carr concludes, 'All history is contemporary history', as it consists mainly in seeing the past through the eyes of the present.[236] In *The Archaeology of Knowledge* (1974), Foucault highlights the fact that knowledge is socially constructed and history can only ever be interpreted through the lens of the time in which it is produced. And yet MacQuoid presents history as evidence, as a set of facts. But his evidence relies on simple interpretation. What remains interesting, beyond the facts or fictions of the case, is the drivers behind them. What made an expert such as MacQuoid stand up on behalf of Dighton? Within the circle of the market, his livelihood – which would never be founded on the writing of books on furniture – depended on Shrager losing the case. The value of his own collection was at risk if Shrager won. Objects and their values were and remain exceedingly fragile, dependent on a majority belief in the rightness of the objects and their histories. The definition of an object as 'genuine' remained key, as Cescinsky was reminded when considering a 'Sheraton semi-circular sideboard':

> It was a genuine sideboard of the period named but several things have happened to it . . . do you regard it now as a perfectly genuine sideboard?

From my definition of the word 'genuine' no.

I think we have all got more or less an idea of the meaning of the word 'genuine' but perhaps you would give us your idea of it.

My definition of the word 'genuine' as applied to furniture is furniture which has not been altered, only restored and legitimately repaired.

Have you altered your definition of the word 'genuine' recently?

No, it is a loose term in any case.

So as far as you are concerned, I am sure you are never guilty of using words in a loose sense. Have you stuck to your view of what 'genuine' means?

Yes, it is still a loose word in my mind, as well as in other people's. . . .

Did you regard it . . . as it then stood, as a perfectly genuine sideboard or not?

Yes, but with a 'but'. . . .

I thought a few moments ago, before I called your attention to that, you did not regard it as a perfectly genuine sideboard, even with a lot of 'buts'. . . . Then we will see if we cannot get rid of the "buts". Should it help you at all if I told you where it came from? . . . If you knew that that sideboard came from Wentworth Castle – you will remember the photograph from Wentworth Castle?

Yes.

. . . and was sold at Christie's in 1919 and was bought by Mr Dighton there, would that assist you?

No it gives me information which I had not before.

It does not aid you adversely to Mr Dighton this time?

It does not alter my criticisms of that sideboard one iota; they are questions of fact.[237]

The movement through the auction room was seen by Dighton's solicitors as an important rite of passage for the object, but Cescinsky stuck firm to his wariness of this measure, stating in 1931 that:

There are public sale rooms of very high and very low repute, but one and all they put a clause in their conditions of sale by which they exempt them-selves from any liability, due to miss [sic]-description or other cause. Why do they do this? Why, when they catalogue a piece as 'Chippendale' do they not guarantee it and stand by their description? Because, first, to do so is not business, and secondly, they are not infallible, and they know it. Therefore the buyer at an auction purchases with all the faults and errors of description

and must stand by his bargain. There is no such thing as the 'guarantee of an auction room'. . . . Has anyone, outside the closed ring of dealers and auctioneers, any idea of the appetite of a modern auction room? . . . In a good season the turnover of Christie's may run into millions. Think of the insatiable maw which can swallow and regurgitate goods to this amount in a single year. Think also what it would mean if they guaranteed each lot and stood behind their guarantee, prepared to refund if necessary.[238]

Ironically the 'closed ring of the dealers' cited was actually given as evidence in favour of Dighton and Co., although it was rapidly dismissed by Cescinsky:

You were asked yesterday about . . . a pair of seventeenth century walnut armchairs. It was put to you that it was purchased by one firm, Messrs Stare and Andrew and then sold by them to . . . Mr Benjamin, by Mr Benjamin to Messrs Dighton and by Messrs Dighton to Mr Shrager . . . is it common practice when a gentleman in the trade is furnishing and supplying a gentleman's house for him to collect pieces in this sort of way through an agent of dealers and auctions?

I am not acquainted with it being a practice. If it be it is a very objectionable one.[239]

Sir Ernest Pollock concluded for the defence that this was a perfectly normal market practice:

I do not know in how many cases, but in a considerable number of cases I have given the source from which these things were purchased. No doubt they were purchased and they passed through various hands, but ultimately they come to Mr Dighton who sells them to Mr Shrager, or they may be obtained direct for Mr Shrager, it really matters not, but the way in which the dealer makes his profit is by buying cheaply at a sale something which perhaps others have not realised what its true value was, and he makes his profit by selling on when he has the opportunity of seeing how good the piece is, and so on and so on. Here we come to the fact once more that the original cost, as I say, is of no importance as a badge or test of fraud. The point that I am making here is that I think in most cases Mr Dighton or Mr Lawrence will be able to tell you the source from which they got those pieces, many of them sources which are so patent to all the public and to all the known art critics that they negate the desire or the effort to fraudulently put forward a piece which they did not believe to be genuine.[240]

Despite the source being another dealer, provenance ultimately is held up as measure of the quality of an object. From the origin of the antique dealer's business in the curiosity shops of the early nineteenth century, dealers, auction houses and experts worked together closely to ensure that the circle of the market would not be broken by the revelation of the myths, fakes and forgeries upon which it was often founded. Cescinsky was very aware of this and referred to it when retrospectively considering the Case in 1931:

> Many will remember the famous – or infamous – Shrager furniture case which figured in the English courts in 1923, where furniture was sold to the unfortunate plaintiff, in this action, at massive price, but which afterwards realised the prices of bad second-hand goods at a well-known London auction-room, with the trade in attendance and in force. I was principal witness for the unfortunate Shrager in this action, and my evidence was rebutted by the leading lights of the antique world, whose testimony in turn was contradicted in an unmistakeable manner by the subsequent auction prices. I mention this nauseous affair here only for one reason. I was accused, at the time, of 'putting the cat among the pigeons' and 'giving the show away,' but, actually, the first suspicions were aroused in the mind of Adolph Shrager by a local carpenter at Westgate, who pointed out that many of the pieces were so obviously made up that they could not be all that Shrager (or the vending dealer) represented them to be. The points which the seaside carpenter made were fully upheld at the trial, and especially after. Actually he knew more than all the defendants' experts or he was more unbiased – which may be nearer the truth, perhaps.[241]

3

'The Faker's Bible': Percy MacQuoid, Herbert Cescinsky and the Role of the 'Expert'

The Official Referee, while giving judgement in the antique furniture case yesterday, had some hard things to say of the experts and their 'terrible mistakes'. The world at the moment is a fairly comfortable place for the approved expert. So many branches of science, and of learning in general, are expanding rapidly in the presence of a public that wants names and ideas to play with that a man who can give the public some evidence of research and information is usually welcomed with an almost pathetic confidence. Nor is the public much perplexed if the various specialists in any subject stand with rock-like tenacity by obviously conflicting theories and apply themselves with vigour to controversies which certainly prove one thing – namely, that claims to certainty had better be deferred. The weakness of the public attitude lies in its failure to realise that the possession of voluminous knowledge is not much use unless it is accompanied by a sound grip of the laws of evidence. The Greek distinction between 'prudence' – which some might call common sense – and 'wisdom' – which is more akin to learning – is a thoroughly sound one and needs strong emphasis today. The highly specialised professor of some high sounding science who fails in the comparatively simple job of putting two and two together is not unknown. A good instance is often afforded by the literary controversialists whose specialised study has given them a detailed knowledge of an author's text, letter by letter, while their methods of argument and their ideas of the proper evidence needed as the foundation for their judgements may be as such to make one blush for one's kind. Of course the community that tried to do without its experts would soon get into as much trouble, as if it tried to follow the advice of all of its experts at once. The lay mind in search of knowledge worth having has to sift the various brands of specialism through the sieve of common sense.[1]

The *Manchester Guardian*'s leader column on 28 February 1923, reflecting on the Official Referee's judgement of the Shrager–Dighton case, commented on the increasing and problematic role of the 'expert'. With developments in the

technologies of communication, the general public was more than ever before able to access a mass of information on history and science, philosophy, religion and the law, but frequently obtained such information through the intermediary figure of the 'approved expert'. Theirs was a powerful role, able to cast judgement that could mean the difference, in our case, of hundreds, or even thousands, of pounds. Cescinsky warned, although too late for Shrager to benefit, that 'Experts are rare, that is, those who have any real right to the title. It pays, therefore, to ignore them, in a general way, or to regard them as a justifiable business risk'.[2] Despite such fears, the Shrager–Dighton case rested on the opinions of some of the most important experts on the history of furniture in England, whose work had been published both at home and in the burgeoning markets in America, and of whom Sir Ernest Pollock commented, 'Now, Sir, I have a body of very expensive expert witnesses here. . . .'[3] Cescinsky, Percy MacQuoid and Frederick Litchfield had all established a leading role in the discourse, through publications such as *The History of English Furniture* (1904–8), *English Furniture in the Eighteenth Century* (1909–11) and *How to Collect Old Furniture* (1904) respectively. Such books were cited in the courtroom, not only to establish the experts' credentials but also to demonstrate their ability to judge what was 'right' in Shrager's collection. But they stood on opposite sides of the room, and their ability to offer opposing views of the same object indicated the fallibility of the discourse, its 'experts' and its tomes. As Cescinsky was later to comment:

> I know of no single historical work on the subject of English furniture and woodwork which does not illustrate fakes, my own among the number. It requires, very often, a long and close acquaintance with certain pieces to be convinced that they are later copies, or outright fakes of a high order, and when one has to write a book illustrated with upwards of a thousand examples, scattered all over England, this close association with each is, manifestly, impossible.[4]

As such, he warned, 'beware of the expert who professes a knowledge in too many branches; as a rule he is ignorant in all of them. It takes a lifetime to know enough of English furniture to become an expert'.[5]

Despite such fears, the early twentieth century saw a rapid number of books on English furniture published, as demand for 'knowledge' grew alongside the rise in the market for 'genuine' pieces. These history books still relied upon, and drew from, the earliest publications on furniture, the sheets of designs and pattern books of the sixteenth, seventeenth and eighteenth centuries. In the sixteenth and seventeenth centuries, plates of perspectival instruction had been used extensively by furniture craftsmen and designers. Joseph Moxton's

Practical Perspective, or Perspective Made Easie, published in London in 1670, for example, included designs for chairs, tables and a linen press.[6] These plates provided ideas but little detail for furniture makers. Sheets of flat ornament were another source of inspiration. They were widely available on the Continent and many were for sale in London, including those by the French architect, designer and engraver, Jean Berain. Architectural pattern books were also popular among furniture makers and their clients, and were used to gain knowledge of popular and fashionable motifs. One of the most successful was Daniel Marot's *Works*, published in Amsterdam and The Hague in 1703 and 1713, and widely available in England at the beginning of the eighteenth century. Marot included designs for chairs, tables, mirror frames and candle stands, as well as designs for the arrangement of whole interiors, that could be understood by craftsman and customer alike. By the beginning of the eighteenth century, the pattern book had become a commodified object, seen as vital for the process of selling furniture to the fashion-conscious client. They facilitated the movement of designs from the Continent to Britain, particularly from France and Holland, the most popular being the designs of Marot and the Dutchman, Hans Vredeman de Vries.

It was not until the middle years of the eighteenth century that English furniture designers began to publish the pattern books that would be so influential on the furniture historian of the twentieth century and the descriptions in the auction catalogues and dealers' shops. During the 1720s and 1730s, most furniture designs were supplied in books on architecture and the pieces were nearly always of an architectural nature, as seen in the designs for chimney pieces, pier tables and mirror frames in William Jones's *Gentleman or Builder's Companion* (1739). During the 1740s, more books devoted in their entirety to furniture began to appear.[7] Mathias Lock, a carver and designer, and the engravers H. Copeland and Mathias Darly, all published furniture and ornamental design books between 1744 and 1752. By the middle of the 1750s, an average of two to three furniture pattern books appeared in print each year. The size and complexity of these texts grew, particularly after the publication of the most famous eighteenth-century pattern book, Thomas Chippendale's *Gentleman and Cabinet Maker's Director* (1754), which proved so successful that a second edition was needed within 12 months. From the 1760s onwards, a wide range of pattern books was available, including Ince and Mayhew's *Universal System of Houshold Furniture*, a third edition of Chippendale's *Director* and smaller volumes devoted to single object types or patterns, such as John Crunden's *Joyner and Cabinet Maker's Darling* (1765).[8]

Many designs were issued initially as single sheets, as *cahiers* of approximately six sheets, or as 'parts', all of which could be bound subsequently into a single volume. Many books went into a number of editions, or had

their plates reissued under different titles at a later date by publishers such as Robert Sayer. Important pattern books for the furniture historian of the late eighteenth century include William Hepplewhite's *Cabinet Maker and Upholsterer's Guide*, published posthumously by his widow, Alice, in 1788; Thomas Sheraton's *The Cabinet Maker and Upholsterer's Drawing Book*, (published in four parts, 1791–4); *The Cabinet Dictionary, etc.*, of 1803; and the first volume of *The Encylopaedia* (1805). In the early nineteenth century, Thomas Hope's *Household Furniture and Interior Decoration* (1807), which illustrated designs made specially for the author's Duchess Street town house, and George Smith's *A Collection of Designs for Household Furniture and Interior Decoration* of 1808 were both influential. The latter, containing 158 plates in colour, some showing designs for approved schemes of decoration for whole rooms, was advertised with the byline, 'Upholder Extraordinary to His Royal Highness the Prince of Wales'. This was followed by Smith's *Cabinet Maker and Upholsterer's Guide* in 1826 and R. Ackermann's *Repository of Arts*, published in monthly parts from 1809 to 1828.

These pattern books helped form the foundations of the development of a distinctive discourse of furniture history at the end of the nineteenth century, providing the burgeoning subject area with 'evidence' and 'provenance'.[9] Viollet-le-Duc's *Dictionnaire du Mobilier Français* began to appear in the 1850s, leading to a typically British response, both in Parliament, where many discussions were held on how to compete with design and production from across the Channel, and in the literature. Nationalistic agendas meant that English furniture began to play a greater role in the Victoria and Albert Museum from the 1870s, often displayed to compare favourably with objects from other nations, as tracked by John Hungerford Pollen's catalogue of *Ancient and Modern Furniture and Woodwork* (1876, 2nd edn 1877).[10] Pollen's approach was still in the antiquarian tradition of Shaw and Meyrick's *Specimens* published 40 years earlier; he commends the study of the objects because 'a careful examination of them carries us back to the days in which they were made and to the taste and manners, the habits and requirements, of bygone ages'.[11] In this way, Pollen used contemporary woodcuts, inventories and wills to write his history, but did not attempt to relate individual pieces to documentary evidence. There seemed no particular need for detailed art historical information. He did, however, suggest a chronological ordering that would both influence the writing of the history of furniture and the way antique objects were described:

In order to take a general review of the kinds, forms and changes of personal and secular woodwork and furniture, as manners and fashions have influenced the wants of different nations and times, it will be well to divide

the subject in chronological order into antique; early and late medieval; renaissance; seventeenth and eighteenth century work; to be followed by an inquiry into the changes that some pieces of furniture in most frequent use have undergone.[12]

Likewise, he suggested the use of monarchs' reigns as a useful way of classifying furniture, 'The lists of reigns supplies more convenient dates than the beginning and end of a century for marking changes of national tastes in such matters as furniture. The names of kings and queens are justly given to denote styles, whether of architecture, dress or personal ornaments and utensils of the household. Society in most countries adopts those habits that are first taken up by the sovereign'.[13] In his codification of the history of furniture, he offered the dealer and the expert a methodology for 'naming' objects, one which we see rehearsed throughout the trial by witnesses and accused alike.

Despite the political drive to celebrate the histories of English 'fine' furniture, it would be another 20 to 30 years before any significant publishing activity took place in the field. The driver for the rush of publications at the turn of the century seems to have been the revival of eighteenth-century furniture styles, and their subsequent desirability in the marketplace. The roots of this can be seen in the 1874 edition of *The Builder*, when the execution of furniture in the previous century was described as 'first rate'.[14] The new nationalistic nostalgia for the period, both in the history book and the dealer's shop, was celebrated in an article in *All the Year Round* on 'John Bull's New House', and his pleasure at being surrounded by examples of Chippendale's *oeuvre*.[15] From the start of this revival, the labels 'Chippendale' and 'eighteenth century furniture' were conflated when authors described the most sought-after period in the market. From the 1890s, the eighteenth century was viewed as a period when English workmanship was 'the best in the world' and, as we saw in Chapter 2, the dealer was ideally positioned to benefit from this opinion.[16] Hermann Muthesius, in 1905, declared that 'the English interior under Adam and Sheraton had reached a peak of artistic achievement . . . not yet reached again today'.[17] The historians and the marketplace began to move in sync, when Litchfield published the first major book on the history of English furniture, his *Illustrated History of Furniture* in 1892.[18] Litchfield's book used examples from museums and country houses to establish 'authenticity' and illustrated interiors to show how the furniture was arranged. Like Pollen, his approach was that of connoisseur and antiquarian; as David Beevers has highlighted, association was important to Litchfield.[19] He imagines some mid-sixteenth-century oak paneling in the South Kensington Museum, for example, 'arranged as if it was fitted originally in the house of one of Elizabeth's subjects . . . we should then have an object lesson of value and be able to picture a Drake or a Raleigh

in his West of England home'.[20] Litchfield was more interested in documents than Pollen, using the 'heirloom' book from Knole to date the furniture in the King's bedchambers, and quotes from eighteenth-century newspaper articles to establish correct furniture terminology, but even this book did not yet fully respond to the new methods developing in collecting. Some illustrations did not show authenticated pieces from the past but objects 'in the style of. . . .'[21] Litchfield himself wrote that the book was not primarily directed towards the collector and decorator, although Muthesius suggests that this was because he was trying to deflect from the fact that he was one of the Wardour Street dealers.[22] Litchfield was the 'gentleman connected with the selling of things' whose identity Shrager had tried to protect in court, acknowledging that to reveal him as the expert who identified the fraudulent furniture would be to 'hurt him very much'. Litchfield offered 'the only written advice' from a 'furniture expert' prior to the issue of the writ against Dighton, and it was on his advice that Shrager 'realised that [he] had been very seriously swindled'.[23] Litchfield's, and hence Shrager and his lawyer's, fear of revealing his name in court underlines how dangerous the case was for the trade and for all those involved in it, and draws our attention to the close links between the founding fathers of the discipline and the market.

Ten years after Litchfield published his *Illustrated History*, the production of books on English furniture began in earnest and remained pretty much constant from this point on until the 1950s.[24] Texts by Frederick Roe, Arthur Hayden, Edwin Foley and our experts, Litchfield, MacQuoid and Cescinsky, among others, began to define the discourse. Many of these texts used social history as a means of establishing dates, and increasingly they included sections on construction, materials, colour and texture, but social history was clearly perceived as distinct from the academic discipline of 'history' or even function, and was used only as a means of typological identification.[25] It was usually stressed that only through experience would the collector be able to identify the peculiarities of construction and surface treatment, hence it is from this date that we can begin to see the establishment of the idea of the 'expert', uniquely placed, usually through collecting experience, to make judgements. These experts soon found themselves much sought after by the potential collector, who, heeding the warnings in the literature, found themselves searching for the right sort of guidance, a fact satirized by Cescinsky when he declared that he knew of 'one American collector who told me the rarest thing he had was his expert. It took more trouble to "collect" him than all the works of art he ever possessed'.[26] Much discussion in the growing body of literature concerned itself with the notion of authenticity. It was often emphasized that only with the help of the experienced expert would a collector be able to find his way through the peculiarities of construction,

hence avoid unsafe purchases. Dates written on the furniture were to be distrusted,[27] and in 1921 Symonds claimed that patina was more important than construction because 'it is the best safeguard'.[28] Provenance and historic documentation still remained key indicators of history and, therefore, quality. The focus on source material and its translation was a vital aspect of the historian's work. This can be seen clearly in a review in the *Burlington Magazine for Connoisseurs* in May 1905 of Constance Simon's *English Furniture Designers of the Eighteenth Century*. This commented:

> It is impossible to commend too highly the painstaking research which has been given to the personal history of some of the old furniture makers. Registers and dry-as-dust documents in almost countless numbers must have been examined to furnish the facts arrived at. Sometimes these are stated rather baldly, while at others there is a leaning to the picturesque which leads to trouble. The story of the quarrel between Chippendale and the rest of the trade, though originally the merest guess, has been largely copied by other writers. Miss Simon now furnishes us with another – quite as imaginary – between Hepplewhite and Sheraton.[29]

While she was offered the back-handed praise that she had at least not copied her 'faults . . . parrot-like from other utterances', the *Burlington* drew attention to a wider issue in the discipline, where the rapid growth of books on the history of English furniture early in the century had led to much reproduction of similar material, and the development of specific myths, re-translated through a variety of texts.

Many authors enjoyed scouring the archives in order to expose the 'myths' in their competitors' work, culminating in 'The Myth Exploded' of 1958, an article by R. W. Symonds in *The Country Life Annual*, which claimed to offer proof that Chippendale was the master of his own designs, rather than a follower of Adam, and offering a letter from the archives at Nostell Priory, West Yorkshire, as evidence.

In the same issue of the *Burlington Magazine* as the critique of Simon's book, there appeared a review for Volume I of MacQuoid's *A History of English Furniture: The Age of Oak*. The reviewer, probably R. S. Clouston, who would himself publish *English Furniture and Furniture Makers of the Eighteenth Century* in the following year, praised MacQuoid's *History*,

> From an artistic point of view the book can be unreservedly praised. The illustrations alone . . . make it indispensable to the collector of furniture, and for the trouble and time that he must have spent on discovering and selecting the pieces to be illustrated, Mr MacQuoid deserves the gratitude

of everyone interested in the subject. Only a connoisseur as keen and well-informed as he is could have pictured the furniture of the past as it is here pictured for us, or have described it with so true an artistic appreciation.[30]

Although the review concluded that 'the book is not fully adequate from the archaeological and historical points of view, and the definitive history of furniture remains to be written', MacQuoid's four-volume publication went on to become one of the most significant reference books on the subject.[31] In it the major periods of furniture history were divided according to the different timbers, oak, walnut, mahogany and satinwood, in line with the idea (supposedly to protect the collector from a regretful purchase) that the materials themselves accounted for many of the changes in the history of furniture. The books written at this time on old furniture were judged according to their trustworthiness,[32] indicating their major role as guides to the prospective purchaser, a fact made clear by a number of their titles: *How to Collect Old Furniture*; *Chats on Old Furniture, A Practical Guide to Collectors*; *Old English Furniture of the Seventeenth and Eighteenth Centuries, A Guide for the Collector.*[33] Ironically, according to the evidence presented at the trial, MacQuoid's *History* had 'been greatly used by people who desire to make imitations of old furniture' and Cescinsky claimed that the book was 'known as the faker's bible . . . there is not a single thing [in it] that has not been copied over and over again'.[34] The book was even used 'by the American Custom Houses in order to guide them as to the antique furniture which is sent across the world' and to authenticate antique furniture imported into the country as modern furniture rather than antique as this attracted a custom's levy.[35] In the trial it was confirmed that the book had 'a very large circulation'.[36] It also offers evidence of the close links between the discourse and the market, where the growing number of publications on the history of furniture undoubtedly influenced the rapid increase in furniture prices in the salerooms. Gerald Reitlinger, in *The Economics of Taste* (1963), cites the example of a Chippendale settee that had been illustrated in MacQuoid's *Age of Mahoghany* (1906, Fig. 121) that sold at the H Percy Dean sale in 1909 for the then enormous price of 1,950 guineas. An amboyna and rosewood cabinet, also illustrated in the volume (plate XI), fetched 1,400 guineas in same sale.[37]

Certainly the publication of MacQuoid's *History* had a significant impact upon the discourse, as detailed by Ralph Edwards in his celebration of 'Percy MacQuoid and Others' which was published in *Apollo* magazine in 1974:

As a work on English furniture it was then unrivalled, and it may be said to be the point of departure for the copious and seeming unending literature on the subject . . . predating the really intensive cultivation of this field,

MacQuoid's *History* (much of the research was carried out by his wife) is still valued for the literary references and quotations from diaries, correspondence and memoirs which distinguished it from the gossipy treatises lacking any socio-historical background that had gone before. All this material was good to steal from by compilers of catch-penny books. Moreover it contains admirable illustrations of fine furniture in historic houses. . . .[38]

Edwards went on to concede that,

Along with the varnished gold so effectively displayed . . . there is an appreciable measure of dross – objects in the hands of dealers and in private collections too readily taken on trust . . . in those primitive, unscientific days nearly all the fine furniture of the period 1750–75 was supposed, with what now seems amazing incredulity, to have been made by Chippendale. Acanthus ornament on the knees was held to provide a test: according to MacQuoid it should be 'narrow, concise and long'.[39]

As Edwards indicated, MacQuoid's test of authenticity was 'the design, the appearance of the thing, and the beauty of the structure'.[40] He claimed not to be interested in carpenters' and joiners' techniques and did not 'know so much about knives and saws and things of this kind. I look at furniture, and how it is sawn or cut, I do not really mind'.[41] In the end, the test within the courtroom did not seem to be the trustworthiness of the object. Instead, it appears that the experts were on trial and their ability to judge was measured against the perception of their worthiness as historians, not their writing, or even their knowledge, but via a class-biased image of how an academic should operate. The trial emphasized MacQuoid's role as an artist and connoisseur while Cescinsky represented the rival approach, that of the practical cabinet-maker. Cescinsky claimed to be unimpressed by such details as provenance: 'Let me hear if it came from Wentworth Castle, let me hear if it came from Burleigh House, I care nothing for those original sources; you may tell me that it stood there in the days of Lord Burleigh; I do not care. I have written a book, and in my book you will see what I say about it, and you must believe it'.[42] MacQuoid, on the other hand, was portrayed as a gentleman connoisseur, a view no doubt backed up by his personal relationship with a large number of aristocratic collectors across England: 'he goes about and has for many years stayed in a number of houses as an expert and goes about in the circles which own these pieces and have them in their houses'.[43] MacQuoid founded his opinions on these trips, and condemned those without the same level of access: 'I . . . say that anyone who is not in the habit of seeing these

things in these houses would naturally consider that they might not be of the time, but I assure you I have seen them, they do not surprise me in the least and I have seen them several times. . . . Then that is Mr Cescinsky's ignorance? . . . I do not know that, he may have passed them by'.[44] Cescinsky's dismissal of provenance failed to impress the court and on one occasion he was described as a 'cabinetmaker without a trade, an architect without qualification, and, I suggest, an expert without knowledge; his arguments having been 'maintained with that venom and animus which has characterised Mr Cescinsky throughout this case'.[45] Thus MacQuoid set himself up as the academic, the historian, the connoisseur and collector, against Cescinsky's portrayal as the journeyman maker. Class differences were being played out at every level in the courtroom.

Edward's review of MacQuoid's *History* unconsciously draws us to the key aspects of MacQuoid's reputation as played out in court, for instance his good marriage that allowed him access to 'the varnished gold so effectively displayed' in the country houses of England.[46] Despite being educated at Marlborough School,[47] it was MacQuoid's marriage to Theresa, daughter of Thomas Dent and Sabine Ellen Roberts, on 3 September 1891, that secured his place in society and guaranteed him access to the best drawing rooms. Theresa's father was the founder of a firm of China merchants, Dent, Palmer and Co, who held a virtual monopoly on the sale of opium and other commodities in China.[48] MacQuoid himself was not wealthy, but his wife's ample resources sustained her husband's collecting activities and enabled him to pursue his interest in furniture. She also supported him intellectually and carried out much of his research, finishing his publications after his death. MacQuoid began his career as an artist, studying at Heatherley's School before going on to the Royal Academy Schools and then training in France. He exhibited at the Royal Academy between 1875 and 1887, where he specialized in genre and history painting. He first properly came to the public's attention, however, through his theatre designs. In 1900, MacQuoid became artistic advisor to Sir George Alexander, manager of the St James Theatre and 'a great lover of the furnishings of the eighteenth century'.[49] From 1900 until 1922, MacQuoid designed sets and properties for a wide variety of theatre productions, and David Beevers considers it likely that his interest in the history of furniture was derived from attempts at historical authenticity in his work for theatre.[50]

In his own testimony in 1923, MacQuoid described himself as 'an artist . . . an expert on old furniture . . . [and] a decorator', finally declaring that his 'profession is that of decorative artist'.[51] He also acted as 'an advisor to the furniture department of the Victoria and Albert Museum', claiming in the trial to have 'only heard from them the day before yesterday' and to 'advise as to the purchase or acceptation of pieces of [English] furniture'.[52] Each of these

roles relied upon the perception of MacQuoid as an 'expert', and much of this seems to have been attributed to the success of his activities in self-promotion after his marriage and the connections he gained as a result of his move up the social ladder. After their marriage, the MacQuoids moved to the Yellow House, 8 Palace Court, Bayswater, built for the couple by Ernest George and Harold Peto in 1892. Peto, an architect mostly famed for his country house designs, was best man at their wedding.[53] Peto himself was known for having boosted the success of his company's reputation by establishing and publicizing their contacts with aristocratic patrons. Their friendship also enabled MacQuoid to examine many famous collections, to establish himself as a fashionable decorator and to take advantage of the increasing number of sales from country houses in the first 20 years of the century.[54] MacQuoid used these advantages to begin to collect on a large scale and furnish the Yellow House, as photographed for *The King* in April 1902 (see Figure 2.1).

Each room in their home was devoted to a particular period of English or continental furniture and decorative art. For example, the dining room was designated as representing the best of eighteenth-century English design, 'the style has been rigorously kept throughout, from the Sheraton and Chippendale chairs to the mezzotints and drawings on the walls'.[55] The house contained a typical antiquarian's collection, divided into periods mirroring those used in the literature, supporting the image of MacQuoid as a connoisseur and knowledgeable historian. MacQuoid was not only collecting for his own home at this period but was also beginning to act as an advisor on period interiors. He supplied furniture to a number of aristocratic clients, including the ninth Earl of Stamford at his home, Dunham Massey (1906–8). The Earl was distantly related to Theresa MacQuoid, adding to the conclusion that his marriage had been a vital moment for his business success.[56]

Gervase Jackson Stops has described MacQuoid's work at Dunham Massey as wedding 'together the layers of history without overwhelming them in a consciously Edwardian décor', creating an illusion of continuity.[57] In order to do this, he organized 'an Edwardian rearrangement of the family heirlooms', demonstrating his 'antiquarian approach to the past' that characterized his own home, the Yellow House.[58] Keen to recognize the 'spirit of the house' rather than rely on 'historical accuracy', his interiors were interpretive rather than archaeological. We can see this in his own descriptions of the work: 'The hall . . . has quoted an early eighteenth century appearance and is a stately room'.[59] MacQuoid was not interested in what we would think of as an authentic restoration, but preferred to create a style and character for the hall.[60]

As such, he was working in the spirit of the discourse of furniture history of the time, enacting the idea that objects and interiors formed 'in the style of . . .' an historical period were as valid as those that were authentically

historical. He recommended that the existing hall furniture, consisting of late-seventeenth-century armchairs and high-backed chairs be restored by Morant and Co., and brought in furniture from other rooms, while suggesting pieces for reproduction. For example, the large oak hall table was a MacQuoid confection, made up from two antique tables, with a new carved rail and carved mouldings on one side and a new top. Costing £35 10s, and made by Morant and Co., MacQuoid assured the Stamfords that the new carving would not be detectable. This is interesting in light of the later conversations he would have in the courtroom about the differing values of an antique and a reproduction. On cross-examination about the 'upholstered Stuart Armchair' discussed in Chapter 2, MacQuoid had confirmed that he would point out the restorations to a potential client but would not advise them to give a higher price for an unrestored piece.[61] His conclusion, then, that the difference between a restored ruin and an original piece 'would be the same value plus the simple expense of restoration'[62] was in direct contrast to the advice he gave Lady Stamford about her table, 'I am anxious . . . to get one really good table for your hall . . . the less modern work is put in the more interesting and valuable your table becomes'.[63] In *The Morant Collection of Old Velvets, Damasks, Brocades etc.*, Margaret Jourdain's catalogue for the firm that supplied the restored piece, she added another dimension to the argument when she confirmed that,

> It has always been a rule of Morants never to supply material from modern designs; they have only furnished their customers with reproductions from their own models . . . and as their reproductions have been exact, not only in design and colouring, but in quality, their reputation as the premier firm has remained for over a century, and this without their having to resort to the aid of advertisements.[64]

Here she made a virtue of the idea that, although reproductions, these were reproductions of the highest accuracy, modelled on historic precedents. MacQuoid's analysis of the two tables illustrates a certain amount of 'fudging' when he discusses their historical relevance. He claimed that he believed them to have once been 'made out of one', proposing that the two should be joined together and the table restored to its original length of '12 feet long, 3 broad . . . there will be a certain amount of carving to make good but I will see this is done so that it cannot be detected'.[65] Interestingly, as Jane Morrison has pointed out, the 1912 inventories of Dunham Massey describe 'a massive c17th oak table . . . 1650', hinting at the quality of the reproduction and the problems of authenticating historic furniture. The inventories also demonstrate the difficulties of relying on documentary 'evidence' that may be flawed from the start, and inject a hint of caution into the celebration of the use of archives

by early furniture historians, MacQuoid included. Although MacQuoid felt that the hall should be consistent with the 'character' of the house, his comments revealed that while he appreciated the history of the building, he was less preoccupied with historical accuracy than with a desire to recognize and work with the prevailing spirit of the house, a fact that also emerges in his correspondence with Lord Curzon about his later restorations at Kedleston. This does not mean that he was unconcerned with historical correctness, and in the realm of furniture his approach was certainly scholarly by the standards of the day. In the creation of the 'period' interior, however, he seems to have aimed at re-creating an impression of the period by evoking its mood and atmosphere.[66] MacQuoid seems to have developed a fairly extensive country house practice, particularly after he began to act as an historical advisor for Morant and Co., and his business would have suffered had Shrager won the trial, as it was founded as much on the perception of his rightness as an advisor as it was on anything else.[67]

Aside from detailing the work MacQuoid did at Dunham Massey, family archives at the house also reveal that he undertook unspecified work for Lord Harewood in 1907[68] and from 1914 to 1922 he advised Lord Curzon on curtains and fabrics for Kedleston Hall.[69] A watercolour by him entitled 'A late Chippendale bed for Lord Curzon', signed and dated 1917, and now in Hove Museum, indicated that MacQuoid was also designing furniture for the house. This bed may now be at Hackwood Park, Hampshire, which was let to Lord Curzon from 1905 and was sold in 1935 to William Berry, first Viscount Camrose, who acquired the house with part of its contents. The contents were sold by Christie's on 20–22 April 1998.[70]

MacQuoid was also an advisor to White Allom and Co., a decorating company based at 15 George Street, Hanover Square, London, which had the vital credentials of having worked previously at Buckingham Palace, Hampton Court, St James's Palace, Holyrood House and Windsor Castle. Between 1914 and 1920 MacQuoid worked with them on commissions for Parkfield, a house that would later become known as Witanhurst, at 41 Highgate, West Hill. This was the home of Sir Arthur Crosfield, Member of Parliament for Warrington and chairman of a firm of soap manufacturers. MacQuoid had a significant role in re-designing the house in a manner fit for a wealthy member of the nouveau riche, assuming responsibility for the library, music room, drawing room, study, hall and staircase and much of the furniture contained within. As was fashionable, he mixed new designs with significant acquisitions of antique furniture. For example, in the Chinese bedroom, MacQuoid (on behalf of White Allom and Co.) 'strongly' recommended a 'set of four antique Chinese Chippendale elbow chairs and [a] stool for which we quoted the special price of £160', to be combined with a suite of modern Chinese-style furniture that

he had designed himself.[71] Interestingly, in market terms, White Allom and Co. pointed out that 'the price quoted is really no higher than the present day cost of reproductions'.[72] Sir Charles Allom was also called as a witness for the Defence in the 1923 trial. Despite the claim by Ralph Edwards 'that to suggest he was a dealer would be entirely misleading', MacQuoid's work as an advisor 'to rich folk with pretensions to taste . . . [who] collected old furniture to equip their houses' allowed him to effect 'a profitable sale from the abundance of valuable objects he had accumulated'.[73] This 'profitable' side of his business was made very clear in his letters to Sir Arthur Crosfield between 1914 and 1920, where in his attempts to persuade his client to buy he sounded not unlike the dealer, Harry Lawrence:

> Dear Crosfield, I had a very nice but short time with Lady Crosfield in which I deplored the absence of a central chandelier for the Music Room. Strangely enough I lighted on it today in a small shop and exceedingly cheap [at] £75. I think the metal work is beautiful the candles being held in lilies and the crystal pendants are simple . . . and pear shaped and of exactly the same character as the small ones you bought from Harris . . . also in the same shop is an adorable copy of a Louis XVI clock that would look beautiful on the mantelpiece of the French Drawing Room £70.[74]

This was not an isolated incident, as we also find MacQuoid recommending 'a very beautiful Persian old carpet with a great deal of blue in it, the stitch of very finest quality, the wool like velvet – W Allom are asking £175 – I think it worth it as carpets go at the very least £250 and I call it a great "occasion". I have instructed Mr Surgey to send you a small piece . . . I feel it will suit the boudoir à merveille!'[75] At the trial, MacQuoid was depicted as standing apart from 'the other witnesses in that he is not a dealer in furniture. He is a gentleman of artistic tastes who all his life has had these things through his hands, and who advises bodies who exhibit these things'.[76] He was questioned about his 'advice' to clients 'as to the purchase or accepting by them of pieces of furniture which they have bought', and admitted that he had 'taken fees for such a thing', but claimed never to have 'bought furniture for people; I allow them to purchase it. . . . I make remarks upon prices. . . . I very often advise on the subject of the purchase of furniture without any reference to the price at all'.[77] Ironically, some of MacQuoid's publications before the First World War were declared in court to have been published by his 'great friend', Harry Lawrence.[78]

Despite claims to the contrary in court, MacQuoid often acted as a mentor and, as such, a dealer to the nouveaux riches would-be aristocrats. He

was the architect and interior designer for a substantial extension to the home of his friend, Lord Rochdale, Lingholm, in Keswick, in the early 1900s, and photographs of a French credence and a *cacquteuse* chair appear in MacQuoid's *History*.[79] Both pieces are cited as belonging to 'Col. George Kemp', Rochdale's name prior to his knighthood. The first Baron Rochdale had made his money, and secured his social elevation, as the owner and chairman of Kelsall and Kemp, woollen manufacturers in Rochdale. In 1896, he married Lady Beatrice Egerton, and began to collect old furniture, relying on MacQuoid to advise him on the purchases that would eventually fill his four homes – Beechwood in Rochdale, Old Hall in Highgate, Gunnerside in Swaledale and Lingholm, which he bought around 1900. MacQuoid's extension to the Alfred Waterhouse–designed Lingholm took the form of a great stone hall, created specifically to show off the tapestries that Rochdale had bought under the historian's guidance. Rochdale was probably introduced to MacQuoid by his cousin, Harold Peto. When a number of objects from Lingholm were sold through Sotheby's in 1998, 'An oak side table' was provenanced as having been 'illustrated in both MacQuoid and Edwards' and 'formerly in the collection of Sir Ernest George . . . the celebrated 19th century architect of country houses', Peto's architectural partner. It was described as entering Rochdale's collection 'probably' through MacQuoid, 'a close family friend'.[80] At the trial, MacQuoid also made reference to having seen a buffet at Lord Rochdale's house, as evidence of its authenticity. As such, we can see very neatly played out here the circle of social connections that allowed MacQuoid to operate both in the market and to advise as an historian.

His book not only allowed him to publish the objects in friends' houses, but also to make new and important connections with both the new and old monied classes. In a letter from Lever on 6 January 1906 to a Mr D. L. Isaacs, owner of 'Antique Furniture Warehouses' at 44/8 New Oxford Street, another beneficiary of the soap trade and by now a famous collector, enquired whether 'Mr McBott [sic] would like to see the furniture I have at ['The Hill' in] Hampstead? [and have any] . . . photographed for his book on furniture, that is if he thinks them of sufficient interest, I should be very glad for him to do so'.[81] Despite the mistake of misnaming MacQuoid, Lever was already aware of the importance of the book, and understood how that relationship with the expert could work both ways; in return for providing access to an important collection, the objects could be authenticated and provided with prominence and provenance. In reply, Isaacs confirmed that MacQuoid would like to see the collection 'where I am sure there are many things that really ought to be in his book'.[82] MacQuoid's *History* was therefore pivotal, both benefitting from and allowing him further entry into those societies able to pay for 'expert'

advice. As H. Avray Tipping confirmed in his introduction to Volume I of MacQuoid's later *Dictionary of English Furniture* (1924–1927):

Not merely the people of Great Britain, but the whole English speaking world, now takes a keen interest in old English domestic furniture. Yet to get a clear insight into the subject has hitherto needed much time and close attention, as its literature, although large in amount, has been diffuse and sectional in treatment, consisting mostly of monographs on special branches or periods and perhaps airing hazardous theories or personal predilections. Where anything approaching a complete treatment has been attempted there has been a measure of tentativeness and immaturity, arising from the obscurity that surrounded the subject until some score years ago. Mr MacQuoid boldly undertook to dissipate the fog. His *History of English Furniture* was the work of a pioneer. Until then the least ignorant book on the subject attributed chairs at Holyrood Palace to the time of Mary Queen of Scots, forgetting that that building had been altered and refurnished by Charles II, to whose reign these chairs palpably belong. That is merely an example of the entire lack of research that has prevailed and which made the aim of accuracy a toilsome and arduous task. Yet it is accomplished. Mr MacQuoid was the first serious student to bestow time and attention on a comprehensive survey of the field and to give to the public the results of his labours. His volumes have maintained the premier place as a work of reference and instruction on English furniture.[83]

In the book MacQuoid's criteria for assessing authenticity in furniture was that of connoisseur. Looking at a Charles II walnut table at the trial, for example, he remarked:

You see there are certain lines *here* and *there* that are extremely good. You must not judge of these things just by little pieces of wood put in here and the glue pot and varnish ... the thing to look for is the drawing of the piece of furniture and the impression it makes. That is the true artistic way to look at a thing. There is a line *there* that is exceedingly good and there is a sweep *there*. There is something about those lines that is not at all like what a man could do today.[84]

Under cross-examination, he admitted that he was not a cabinetmaker and had 'never been inside a cabinet makers shop or maker of reproduction furniture'.[85] He claimed to know nothing about reproduction furniture, thus seeming to deny his work for the likes of White Allom and Co., although he averred that he could tell old from new despite admitting that he was not interested in

joiners' techniques. When asked how he recognized Chippendale, MacQuoid replied 'by the very curious crisp touch of the carving in the first place so that at times on a rather more intricate piece than this the carving almost amounts to wax modelling of brown wax, by the very beautiful sense of proportion he gives in his furniture, and by the extraordinary exquisite taste of the design'.[86] His approach was an aesthetic one, claiming that 'the thing to look for is the drawing of the piece of furniture and the impression that it makes upon you. That is the true artistic way to look at a thing'.[87] This approach was in direct opposition to that of his fellow witness, Herbert Cescinsky, who after the trial wrote, 'If the [expert] possesses the "eye for the right thing" or have any delusions about this quality, he had better get rid of that "eye" before he starts on the job of the expert. . . . It is the other eye, the one which notices signs of the power saw, the planing machine, and the moulding 'spindle', which really matters'.[88]

Having begun his career as a cabinetmaker, Cescinsky used his knowledge of construction to reject nearly all of the pieces MacQuoid had accepted as authentic in court. Their opposing approaches had already been clear prior to their selection as witnesses on either side of the room when, in 1911, Cescinsky brought out his rival to MacQuoid's *History,* three volumes of *English Furniture of the Eighteenth Century,* in which he wrote, 'so many works on the subject of English furniture have been published of recent years that it would seem that almost the last word on the subject had been said. As I can only hope to excuse the appearance of this book by criticizing others which have already appeared, I prefer to offer no apology'.[89] Reading this comment as implying that 'Mr Cescinsky had to write his own book because he found the books of other writers so bad', R. W. Symonds confirmed that competition with MacQuoid had inspired Cescinsky's publication, concluding that, 'There seems little doubt that Herbert Cescinsky was inspired to write his three volume *English Furniture of the Eighteenth Century* because of the success of Percy MacQuoid's then newly published *History of English Furniture*'.[90] Despite writing 30 years after the trial and over 40 years after the publication of both books, the prejudices of old seemed still to dominate Symond's assessment of Cescinsky, comparing MacQuoid's 'intelligently planned four volumes . . . the first authoritative work on English furniture . . . display[ing] considerable understanding and knowledge of the subject' against Cescinsky's book, damned as 'of little consequence since it showed no research into original sources, very little knowledge about the social life of the eighteenth century, to which period the book was confined, and above all but little understanding of the subject of furniture'.[91] What seemed to annoy the later critic most was the latter's 'ungracious' lack of acknowledgement of MacQuoid's influence. Symonds

went so far as to conclude 'that today *English Furniture of the Eighteenth Century* has become a danger to all students who read it in the initial stages of their learning'.[92] He admitted that 'after fifty years, MacQuoid's work can be criticized, but rather for what it omitted to say than what he did say' but concluded that,

> The information he gave showed a considerable understanding of furniture which he alone must have possessed at that time. . . . On the other hand, reading Cescinsky's book reveals that he has avoided the hard way of writing by neglecting to search for contemporary evidence. He has taken the short cut which has caused him to embark upon theories not based upon research, but upon his own flights of fancy. His book, therefore, lacks the authoritative stamp of MacQuoid's and is highly misleading to all those who refer to it today.[93]

Symonds's critique seems founded in a contemporary annoyance, as Cescinsky's book 'is often consulted by journalists and others who want to write an account on English furniture and therefore, unlike so many other books by incompetent authors, it has not died a natural death, but is still playing an active part as a book of reference after fifty years'.[94] It seems that Cescinsky was an enemy of old as Symonds had criticized the author in print prior to the publication of his 1958 article. In April 1937 in a letter to *Connoisseur* about an article on 'The Development of the English Chair' published two months earlier, Symonds had described Cescinsky's assertion that there were no English-made chairs with upholstered seats before the end of Elizabeth's reign as 'incorrect', 'misleading' and born of 'scant reference', providing archival evidence to the contrary.[95] Cescinsky's response to the criticism, in the same edition, borrows from ideas of historical interpretation which look forward to the post-structuralist responses of the later twentieth century, declaring that 'the case rests upon the interpretation of the words'.[96] He went on to accuse Symonds of 'careless use of the term 'upholstery' and of 'loose thinking as well', concluding in terms familiar to those who had attended the trial, 'Mr Symonds should have asked a practical upholsterer about this'.[97] It was to this defence that Cescinsky would return again and again at the trial and seems ultimately to have condemned him in the Official Referee's eyes. After being sworn in, Cescinsky defined himself as having 'commenced as a cabinet maker'.[98] He began his career as a cabinetmaker working for Brown and Co. of Wilmer Gardens, Kingsland Road, in London, and then, at the age of 20, moved on to become a draftsman and maker of working drawings for Morant and Co. of 91 New Bond Street, 'makers of decorations, panelling and high class furnishings

modern and old', where, ironically, he made up designs for MacQuoid.[99] At 22, Cescinsky became, in his own words, a 'designer of furniture and the restoration and alteration of old buildings'.[100] At the same time he also supplied old furniture to clients at houses such as Helmstead in Kent and Bilsley Manor in Warwickshire. His furniture designs were sold by companies including Hewitson, Milner and Thextons of Tottenham Court Road (which had ceased to trade by 1923); Shoolbred and Maple; and Allen and Menooch of Mount Street.[101] By 1923, Cescinsky was mainly employed on decorative work, furniture and panelling by clients from his business premises at 25 Mortimer Street, London, and he described himself as 'an expert on English furniture and woodwork' with 'an experience of thirty years or more as a practical cabinet maker, and draftsman'.[102] Cescinsky claimed to have advised the Worcester Museum in Boston, Massachusetts and the Chorley Museum, Lancashire, and he described himself as 'an unofficial advisor to the V and A'.[103] He also stated that he had been called upon to advise the Rijksmuseum in Amsterdam on a collection of furniture.[104] By 1923, he had also written articles on furniture for *The Burlington Magazine*, *The Connoisseur* and *The Times*; was joint author of a three-volume book on *English Furniture in the Eighteenth Century*; joint author of a book on English domestic clocks; and the author of the two-volume *Early English Furniture and Woodwork*. Akin to MacQuoid, he also claimed that he had not had to sell goods for a living, 'so have been able to keep my mind reasonably open and unprejudiced. I have had no geese which I have had to strive to promote as swans'.[105] This was despite the fact that, when giving evidence, Frederick Tibbenham claimed that he knew Cescinsky well because he was 'a very large customer' of the firm, mainly for 'contract and decoration work' and also implied that he had purchased 'pieces of furniture that you have made, or made up, altered'.[106] Just as all the other historians at the trial, Cescinsky was at pains to separate himself from the business of dealing, although he was proud to be associated with the manufacture of furniture, claiming that his experience as a cabinetmaker made it possible for him to determine exactly whether furniture was genuine or not.[107]

In his later book, Cescinsky was vehement in his defence of the cabinetmaker and insistent on the need for a full understanding of the manufacturing process to enable the identification of a fake. 'An expert in English furniture and woodwork must be technical. A bench or workshop education does not make an expert necessarily, although I have often seen a 'common workman' point out something of the greatest importance to an "expert". The real expert in furniture MUST begin with a workshop training'.[108] With this he clearly identified the difference between himself and MacQuoid, who had become an 'expert' as a result of his connoisseurial activities. Cescinsky

also provided examples of where this lack of training had let down his rival, claiming that,

> The late Percy MacQuoid certainly accepted the Ockwells credence as Gothic, and gave it coloured plate prominence, as such, in his book. A good workman could have told him that it dated from the latter years of the seventeenth century at the most, and possibly was later still, but workmen cannot be experts – because they are workmen.[109]

Cescinsky's final comment throws light on one of the likely reasons why his evidence, although born of clear knowledge, was rejected in court; he had a significant chip on his shoulder about being undervalued as a result of his background in the trade. Throughout the trial he was compared to MacQuoid and found wanting because MacQuoid had the establishment credentials and the 'right friends' in high places. This was clearly apparent in the summations of both the defence and prosecution lawyers. Pollock, for example, compared Cescinsky's evidence, which he declared 'embroidered', to

> The evidence that has been given by authoritative and well accredited experts, people who stand in the forefront and at the top of their profession, like Mr MacQuoid and Sir Charles Allom, I have no doubt you will be able to say in the case of all these pieces . . . it has been proved and proved to your satisfaction that these pieces are genuine.[110]

Such 'pieces' were judged 'genuine' not on their own merit but on the court's perception of the experts. Even the prosecution team found fault in Cescinsky's presentation of his evidence, calling him a little 'over-zealous in the interests of the person who is employing him, namely, the Plaintiff in this action', but Disturnal, Shrager's lawyer, defended this attitude, saying, 'His evidence is perfectly honest, and it is perfectly independent. His opinion is formed independently upon all the things he saw then'.[111] He critiqued the other experts as providing 'the evidence of a mere dilettante . . . the evidence of a gentleman, who has a kind of auction room knowledge of these particular matters . . . the evidence of a gentleman who is a mere salesman or a buyer'.[112] In comparison, Disturnal stresses that Cescinsky

> [i]s a gentleman who has made it the business of his life, and his knowledge is founded upon the skill of the craftsman, his knowledge is founded on the skill of the cabinet maker, and upon the skill of the man who has made, and is capable of making, these pieces and who knows everything that has to be done for the purpose of making them; in other words he is the craftsman,

and he has got on the top of that skill of the craftsman the broader knowledge which an expert gets in the course of his practice.[113]

The difference between Cescinsky's evidence as a maker, and MacQuoid's as a connoisseur is highlighted if we look at one example of the evidence they provided for the same object, with very different conclusions. A Queen Anne walnut armchair was described first by Cescinsky as having 'arms . . . [with] a spurious appearance of age which has been achieved by rubbing with caustics'. He then indicated that the signs of 'the work of a band saw', clearly identified it as a modern fake.[114] 'That is not old work at all. The wear here is imitating the wear that the hand would give'.[115] When asked to 'give us the secret', Cescinsky relied on evidence based on the technology of the workshop:

> Well, there are two saws in a power shop which are capable of cutting shapes, a fret saw and a band saw. The circular saw serrations are too big. A power driven band saw differs from a hand saw in that it is always going while you are working, and when you are stopping, and when you come to a sharp corner, and you have to pause a little to get your wood round; the saw is running all the time and it is making a series of attempts to go on until you get it round the corner. I said it appeared to have that feel and that led me to believe that it was cut with a power band saw. . . . These signs are unmistakable.[116]

MacQuoid in comparison happily claimed that he did 'not know so much about knives and saws and things of this kind, I look at the furniture, and how it is sawn or cut, I do not really mind'.[117] For him it was all about the line, and an object appearing to be 'right'; the skill to judge such things could only be gained from years of 'looking' at historic furniture. Likewise, MacQuoid soundly rejected Litchfield's historical view that 'there are some old pieces in, but a great deal of the new . . . is not a Queen Anne walnut armchair, it is a William III armchair. It may even be the beginning of the reign of William III'.[118] To both the evidence of the historian and the evidence of the craftsman, MacQuoid, the connoisseur, responded that it is 'a beautiful chair' with 'exceptionally good' carving on the stretcher, and with this he rejected every single one of his fellow experts' criticisms.[119] Pollock reiterated these claims in his summation of the evidence, concluding that,

> By introducing this question of the power-driven saw and the caustics and so on Mr Cescinsky was attempting to add weight and authority to his criticisms which are not justified. He was attempting by this filling up of the chinks, so to speak, to put his criticisms forward as criticisms which were authoritative and justified.[120]

This pattern is followed throughout the case. Each object in turn was brought
into the courtroom, where Cescinsky declared it to be 'a very, very rough mod-
ern copy', or 'a joke . . . it is a perfectly modern sort of thing', or 'a fake, and
another bad one',[121] citing technical aspects as evidence. MacQuoid refuted
each criticism. 'Four William and Mary chairs and four stools' critiqued as
having Dutch frames and new backs 'spiked on to the legs', were declared
'Perfectly genuine', by dint of their 'marks of age, the rich tone of the wood,
the rather rougher treatment of the hind leg', their worm damage and the
almost 'adze treatment on the leg'.[122] MacQuoid points out as 'the indubitable
proof of age' the feet . . . where the darkness has gradually come which the
forger never attempts to do', adding that 'through years of wear, [the feet]
always become a little darker . . . it is very slight but it is quite natural'.[123] He
also rejected Litchfield's evidence that the 'two stools are different from the
others' as they 'are very much better looking walnut', indicating he thought
that 'the dark ones are English walnut and the rest are Dutch'.[124] MacQuoid's
response to this was 'that the lighter stools are cut where the sap is in the
wood and the darker stools are cut where there is no sap in the wood'.[125] Much
of MacQuoid's defence of the objects was based on their aesthetic appear-
ance, sometimes combined with 'quaint' analogies that supported his views,
without any specific recourse to history or practice. For example, a 'Charles II
lacquered armchair' rejected by Cescinsky as a 'modern copy' was declared
'an old chair throughout . . . probably made in the country, and some distance
from a large town. . . . '[126] Although 'the work on the chairs is exceedingly
coarse', the 'beautiful old brown walnut' is compared to 'clothes made in a
country village [which] we should not like to wear . . . very much'.[127] Despite
its admitted crudeness, MacQuoid declared that the lines of the chair, their
flatness, showed 'great age', concluding that 'it has the character of a chair of
that time, and its mere crudity gives an interesting barbarous appearance to
it, which you do not obtain in a forgery. A modern forgery is rough and ill-
proportioned. That is the secret – the proportion'.[128] He frequently referred
to the lines of the objects, declaring them 'good' or 'extremely good' and, in
exact contradiction to Cescinsky, demanded that people did not judge 'things'
by their technical attributes.[129] In giving evidence for a 'Queen Anne marble
wine cooler on carved walnut stand with cabriole legs', judged to be a bad fake
by Cescinsky, MacQuoid stated that he did 'not consider that cabinet makers
are always the best judges of furniture, for they are too much taken up with
their own job which concerns the inside structure'.[130] Despite Cescinsky's
later comment that it 'does not require an expert' to detect an obvious fake,
'a removal man will often be enough for this job; certainly a country carpen-
ter can offer a final opinion', his technical expertise was not accepted by the
court.[131]

We can clearly see this played out in the discussion on one particular piece in the Shrager collection, an 'Elizabethan oak buffet'. In Pollock's summation, his criticisms of Cescinsky, and praise of MacQuoid, are brought to bear on their evidence regarding three of the objects presented in court, the Blue-lac cabinet (which will be discussed in Chapter 5), the Queen Anne walnut armchair cited above and the oak buffet.

> Now, Sir, it falls to my duty to make some criticisms on Mr Cescinsky . . . when you really contrast that evidence [Cescinsky's] does not it reveal intrinsically that the man who is talking as Mr Percy MacQuoid was talking is talking with a knowledge not only of that particular buffet but of a number of buffets, and was able to explain exactly what was meant by the moulding at the top and the like because he was conscious of having seen that in various positions. He is obviously a master of his subject and when you hear and look at what Mr Cescinsky told us, he is seeking to say, with the very imperfect information that he has, something which apparently seems artistic and the like, and not on good grounds which really show that he knows comparatively little of the subject as compared with Mr Percy MacQuoid; and yet he does not hesitate to invite you to believe by the evidence that he gives that it is a fake, and ignorant forgery and that you ought to pay £50 or £60 for it. Mr Percy MacQuoid, Mr Dighton and others have had dealings about that particular piece, and the remarkable thing is, if it was this ignorant forgery and fake, that they should have been content, not once, but more than once, to have bought it and re-bought it at enhanced values during the particular period of time.[132]

In the case of the Elizabethan buffet, Pollock stressed from the off that MacQuoid's former ownership of the object was evidence of its importance as a piece of historic furniture (see Figure 3.1). With this he stressed MacQuoid's 'great advantage' in having many friendships with families that owned such objects and access to their houses. In contrast, Cescinsky's authority and knowledge were dismissed as standing alone in opposition to a great body of opinion, in light of which he asserted over and over again, that he was right and they were wrong.[133]

The buffet also offers us evidence of how closely the historian and the dealers worked together, it having been formerly the property of MacQuoid, as Pollock highlighted this provenance as evidence of its 'rightness'. The fact that it was sold to Shrager demonstrates how MacQuoid profited from his collecting activity without being tarred by the brush of the dealer, ensuring that his practice was not marred by mere commercial gain. It also probably explains why he was so keen to help defend Dighton, who had sold the piece.

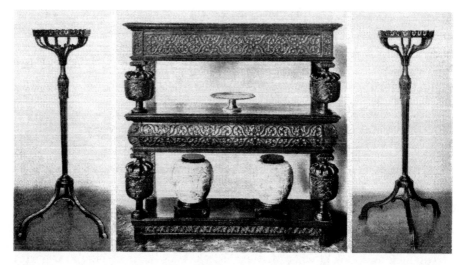

Figure 3.1 'Torcheres from Edgcote Park and the oak buffet, formerly the property of Mr Percy MacQuoid, Three of the pieces questioned during the Trial', *Country Life*, 10 March 1923, p. 322.

MacQuoid had previously bought the buffet from Dighton around 1910 for £350, and sold it in 1920 for £550. Ironically, MacQuoid's former ownership was offered by Lawrence as evidence of the object's desirability. When Shrager visited Dighton's shop on 22 September 1920, the buffet was pointed out by the dealer as being 'probably the most wonderful piece of oak in the kingdom. This has been through our hands four times, of course, with profits'.[134] His sales pitch continued, with the declaration that,

> It belongs to Percy MacQuoid, whom I have told you about, a great pal of mine, and he is selling it because he is doing some repairs to his house in Brighton and he does not want to get other people's cash. He is selling this and you have got your chance, you are a jolly lucky chap to get a chance like this.[135]

With this in mind Shrager had bought it for the then substantial sum of £950.

Cescinsky's view was that the piece incorporated old oak but was in essence 'a very ignorant forgery made about forty years ago'.[136] He thought that the fronts and the ends of the buffet did not match, the bulbs were new and the boards had been planed and not adzed. 'I should buy it', he said, 'for what it is, a fake – I should pay about £50 or £60 for it'.[137] Cross-examined again, Cescinsky denied that the piece was even Elizabethan in style, claiming it

was of 'the Charles I period and made up of old pieces of wood'.[138] Frederick Litchfield agreed with this conclusion, stating that it was, 'more like a glorified dinner wagon of the present day'.[139] MacQuoid produced photographs of similar objects, including one belonging to Lord Rochdale, an example from Sir Edward Berry's collections and one belonging to Lord Mostyn, highlighting the benefit of his access to well-connected collections. He also claimed to have been the first to write on the subject and to have had no doubts that it was a genuine Elizabethan oak buffet as he 'should not have given the very large sum of money' for it if he had'.[140] He also declared that he was 'very, very grieved to part with it'.[141] He then stated that the discrepancy between the front and sides was due to the fact that housemaids had polished the front. His discussion of the structure and mouldings was backed up by the claim that he 'had seen more buffets than anyone else'.[142] MacQuoid's evidence convinced the Official Referee to dismiss the case against the buffet, agreeing with the view that it could not be 'part of the conspiracy extending over ten years . . . it is incredible that any allegation of fraud can be based upon it . . . the only explanation of Mr Cescinsky's evidence is that he must be ignorant'.[143]

Despite applying a cabinetmaker's experience to the objects brought into court, in clear contrast to MacQuoid's lack of technical expertise, Cescinsky was not always right in his assessments, as R. W. Symonds later demonstrated in his critique of his fellow historian. Returning to the evidence of the saw and plane, Symonds declared that 'Cescinsky was still learning his subject, while in the process of writing about it', evidencing this by offering up apparent contractions in his books:

To instance just one, there is the surprising statement that the pit-saw and the smoothing-plane were not in use until the time of William III. Previous to this time, he contends, logs of timber were converted by the English carpenter into uneven boards by splitting with axe and wedge, and the English joiner smoothed his panels by the adze. In order to support this theory that there were no pit-saws for the conversion of timber in medieval England, he tells the reader that furniture made during the first years of William III's reign was of walnut of foreign growth. The reason given is that it was easier to import from Holland sawn planks of walnut wood than to use walnut of English growth, which owing to the absence of pit-saws in England, could not be converted into boards except by splitting... this involved account... receives no mention in the book which he wrote in 1922 in collaboration with Mr. Ernest Gribble, an experienced and knowledgeable craftsman. Here he informs the reader that the English pit-saw was 'a tool used from very early times' ... if only

Mr Cescinsky had done a little more reading of modern books on the mediaeval crafts, of which there are a number, he would have been saved from such blunders at the outset and not have to wait for Mr Gribble to correct him.[144]

Just as Cescinsky took issue with MacQuoid's publication of 'fake' furniture in his *History*, Symonds accused him of an 'enthusiastic appreciation of furniture which is illustrated and described as authentic, but which is the work of a faker' in Volume II of Cescinsky's *English Furniture*, and he described the author's 'complete inability to recognise the genuine from the spurious'.[145] Unfortunately Cescinsky published an illustration in his earlier book of a mahoghany settee (Fig. 67, Vol. II) that he described as 'a beautiful specimen' of about 1730, 'very similar in design to a chair at Nostell Priory but of finer quality' which he then illustrated again in *The Gentle Art of Faking Furniture* as 'merely a commercial product'.[146]

Despite this note of caution about Cescinsky's 'expertise', it seems that his evidence was bound to be rejected, whether false or true, by a court intent on watching the manner by which evidence was given, rather than the evidence itself, and to judge based on the image of the expert rather than on their expertise. Despite clear acknowledgement of Cescinsky's expertise as a craftsman, he was judged in the end on the perception of him in the courtroom.

If there has been a loss of character in this court, that loss of character is Mr Cescinsky's. So far from being the trustworthy and cold, unimpassioned expert witness, we have found him all too ready, all too eager, to add to the evidence which an expert might fairly give something of the zeal and energy which belong to the advocate and also to the person minded to assist, directly, or indirectly, in taking away the honest character of a man he knew well, and in whose sale premises he had declared to us he had always found good stuff. . . .[147]

This perception dogged him throughout his career, even after the publication of *The Gentle Art*, and Symonds's later review found Cescinsky an 'indulgent' author of 'far fetched theories', 'little able . . . to recognise the genuine piece of furniture from the spurious' and 'the cause of many [erroneous] statements', in contrast to MacQuoid's 'discernment and taste'.[148] He seems to have had little hope of being compared favourably with MacQuoid's position as 'the giant upon whose shoulders he, Mr Cescinsky, had travelled a certain distance in the region of antique furniture'.[149] Such a position was ultimately not dependent on MacQuoid's expertise, but on 'his manner and the care with which he has given his evidence'.[150] Perception was everything.

Despite Disturnal pointing out the inconsistencies in his evidence and his lack of workshop experience, MacQuoid was judged a more credible 'expert'. His reputation preceded his entry into the court.

> One heard with a certain amount – I will not say respect, because one has always treated Mr MacQuoid's name with the greatest respect – but one heard with some trepidation that one was going to be met in this matter with the evidence of Mr MacQuoid. Naturally, Mr MacQuoid, when he was put into the box, was produced, and rightly produced by my learned friends with a great flourish as being a gentleman of great experience in this matter.[151]

MacQuoid's evidence was questioned and the contradictions in his use of the word 'genuine' throughout the case were highlighted. Starting with MacQuoid's rather weak definition that '"Genuine" is, shall we call it, what it purports to be', the lawyer critiqued his application of the word to objects described variously as historically right, 'true to its genus', 'restored with modern pieces', 'very much restored', 'made up from a ruin', and 'old', concluding that, 'Now, we know the meaning that Mr MacQuoid attached to the word "genuine" when he used it over and over again during the course of his evidence in this case, that a restored ruin is as valuable as a piece of furniture that was as intact and complete as it was when it left the manufacturers'.[152] The lawyer pinpointed the distinction between the hired experts in his summation that,

> However experienced Mr MacQuoid may be, such evidence must be received with the very greatest caution . . . he is not a craftsman; he says he is not. No doubt he is a person of very large experience; he has written a very beautiful work on antique furniture, beautifully illustrated . . . a work to which we have attached a great deal of importance in this case. But although he has had a large experience of examining pieces and large experiences of examples . . . he has not the special experience of the craftsman, the man who has worked in the shops.[153]

This did not sway the Official Referee's final judgement, however, as he seemed determined to compare the experts and find Cescinsky wanting. Having dismissed Litchfield as 'admittedly a gentleman of very high character and at one time was very well known in business . . . [but] out of the way of this furniture for some little time' and therefore not 'quite so *au fait* with it as the experts on behalf of the defendants'[154] and his evidence, 'honest' but 'a good deal modified' in his later report, the Official Referee saved his harshest

judgement of the prosecution case for Cescinsky. 'Mr Cescinsky made several terrible mistakes'.[155] With this the Referee cites a number of instances, including the oak buffet, which he concluded could not have been a fake because it had been owned by the expert for the defence, MacQuoid! 'That as I say, is conclusive evidence that Mr Cescinsky is not always to be relied upon. Sometimes people are most ignorant when most assured'.[156] In comparison to his praise of Litchfield, Cescinsky was seen to be no gentleman, and his evidence was dismissed by the fact that it contradicted the evidence supplied by the thoroughly establishment MacQuoid, despite the fact that MacQuoid had profited by the sale of his own furniture, and therefore had a vested interest in it being judged 'genuine'.

The role of the expert witness was a tricky one, as the *Manchester Guardian* had declared at the end of the trial. Too often the witnesses themselves were judged, and decisions were founded upon how much their evidence had had 'its effect upon your mind' rather than on the evidence itself. Despite this, there was an active business in experts for hire at the beginning of the century, and the Shrager case was not the first time that MacQuoid had been called upon to offer his considered views. His reputation as an expert, and one experienced in court, preceded him, as Disturnal confirmed when he reflected upon his 'trepidation' on hearing that the expert for the defence would be MacQuoid. Ironically his appearance in an international lawsuit in 1917 was on behalf of the plaintiff, and it was not about furniture, but MacQuoid's first love – art. MacQuoid had been called as a witness in a case brought by Henry E. Huntington about a purchase he had made in 1912 of a portrait reputedly of 'Mrs Siddons and her Sister' by George Romney for $100,000 from the picture dealers Lewis and Simmons. Shortly after the painting arrived at Huntington's Californian estate on 11 December 1912, suspicions about its authenticity were raised by a number of experts, including the historian and art dealer, Joseph Duveen. By the time the case came to court, before Mr Justice Darling in the King's Bench Division in May 1917, it had been established that the painting in question was actually 'Maria and Horatia Waldegrave' by Ozias Humphrey. The trial came to a sensational ending on 23 May 1917, when the original sketch by Humphrey was discovered, thus proving the canvas in question was not by Romney. Unsurprisingly the case attracted much public attention. MacQuoid gave his testimony on 17 May 1917, having declared himself an authority on English eighteenth-century painting by drawing attention to his work as a copyist and restorer of paintings of the period.[157] In his analysis of the disputed canvas, MacQuoid declared that 'it was not painted by George Romney', drawing attention to 'the treatment of the flesh [which] has none of the square breadth of that painter' and 'the drawing of the eyes and their colour'.[158] Ironically, given our case, on

cross-examination MacQuoid, though admitting he was an expert on English furniture, declared that he was fit to give an opinion on the painting given that 'the whole course of my training and life has been that of an artist. . . . My whole life has been connected with English pictures' and that it was 'only within the last ten years' that he had devoted himself to furniture.[159] The case was discussed much in the national press in England, and it was perhaps the positive coverage of his appearance in court that encouraged MacQuoid to offer his services to Dighton's and their legal team. For example, the *Northern Daily Telegraph*, published in Blackburn, and the *Halifax Evening Courier*, both quoted his comment that 'The lady's eyes; Like an Antelope or a Motor Lamp' as their headline, and both papers cited the laughter that greeted his witty evidence.[160] *The Birmingham Post*, the *Yorkshire Evening Post* and *South Wales Echo* also referred to his comments in their coverage of the case.[161] MacQuoid was also involved in other lawsuits, as cited in his letters to the curator at the Lady Lever Art Gallery, where he was working on a catalogue of the collections and preparing the Adam Room. Very soon after the judgment on the Shrager case, in March 1923, he wrote to apologize that, as he had 'to give evidence in a law suit that is coming on soon after the Court's open . . . [he could not] possibly come down till that is over'.[162] In March 1924, MacQuoid was described as having been 'kept at the Law Courts . . . all last week . . . an arbitration case where he is a witness and so could not go to W Alloms'.[163] As we have seen, being an 'approved expert' for hire provided useful employment for historians such as MacQuoid, and was a lucrative way of supporting themselves while ensuring that their 'expertise' was publicized as widely as possible. Hence this role became one of many that brought them into direct contact with the pressures of the market. Unfortunately, as the *Manchester Guardian* so thoughtfully pointed out, 'the possession of voluminous knowledge is not much use unless it is accompanied by a sound grip of the laws of evidence'.[164] As we have seen, however, time and time again, the market did not require 'the laws of evidence', but instead worked within systems of perception, where objects were valued by dint of the fact that an 'expert' declared them important. Once objects and the past are treated as commodities, they are open to systems of valuation and devaluation under the cover of historical rationality. Taxonomies in the market place are not natural or truthful, but responsive and sensitive to contemporary demand.[165] To operate in this market, in the dealer's shop, however, their value has to appear fixed and unquestionable. This is where the experts and their history books became so vital to the system. In fact, as Jean Baudrillard concluded in 'The Art Market' (1981), the discourse, and its representation in reference texts and museums, plays the role of the bank in the market, guaranteeing the validity of the object and, as such, is as pernicious an ascriber of value as the

auction house.[166] Each element in the cycle is carefully and concretely structured in order to permit 'fables and discourse'[167] and the Shrager–Dighton case threatened to reveal (and therefore destroy) this carefully constructed system. This is why Shrager had so much difficulty securing experts to give him advice, as it could damage their own business interests.[168] The links between the experts and the trade can be seen clearly when we turn to the objects that were presented in court.

'Disputed Fragments':
Shrager's Collection of 'Fine Furniture'

The antique furniture case heard at the Law Courts has broken all records for a trial by the Official Referee. For the past few weeks interest has been grow-ing until . . . his court became as crowded as the Valley of the Kings, and Mr Adolpe [sic] Shrager divided the interest of Londoners with Tutankhamen . . . on many occasions articles have been brought into court, and the unusual spectacle of judge, council and experts, pouring over a disputed fragment has been seen.[1]

The furniture case now being tried in the temporary building in the court-yard of the Law Courts promises to eclipse any case now before the courts in general interest . . . the presence of bulky pieces of furniture in the court has introduced an unusual air to the proceedings.[2]

Thus having established the context in which the Shrager–Dighton case came to trial, it is important to turn to the evidence that was presented in the court-room, to explore the 'disputed fragments' that Shrager had purchased and query why he was persuaded time and time again by Lawrence and Dighton to part with significant sums of money. The trial took place at a point when many in Britain were beginning to be interested in objects of the past, encour-aged by the discovery of Tutenkhamun's tomb in 1922. As seen in the reports from *The Sphere* above, this interest also registered internationally, drawing attention to the trial.[3] As each piece of furniture, each 'disputed fragment', was produced as evidence by both the accused and the accuser, it was dis-cussed in turn by the appointed 'expert witnesses', who demonstrated their reasons for maintaining a cabinet was either 'a well known article of com-merce from bogus furniture manufacturers, recently made up in a factory, with brass-work of a well-known Birmingham make' or that it was 'perfectly genuine late Queen Anne'.[4] 'Fine Chippendale lamp-stands' were dubbed by Cescinsky, 'the most impudent fake I ever saw . . . with new legs, a stem prob-ably made from a child's four poster bed and incapable of standing without being wedged'.[5] Allegations were made against some 500 pieces, of which 96 were examined in court. As noted by Sir Edward Marshall Hall during his

unwarranted appearance as the British Antiques Dealers Association (BADA) representative the first day of the trial, the 'great deal of notoriety' that the case had attracted was not just because of the entertaining presentations of the experts, but because so many of the establishment who read about the case in their daily papers owned examples of the objects that were being poured over by the legal teams.[6] Acknowledgement of the suspicions about the products of the dealer's shop that drove the case had already been seen in the establishment of BADA, which aimed to be seen as a badge of protection for the wary customer, and to powerfully represent 'all the best and most reliable dealers'.[7] So important was this case for the dealers' reputation, that two of the Vice Presidents, and two members of the Council of the British Antiques Dealers Association, were engaged professionally on behalf of the defendants, although Hall did not name them.

If the defendants were to be believed, the disputed objects that so interested BADA and the public alike represented all that was good and valuable in the market for old furniture early in the century. They were sold to Shrager by Lawrence on the premise that they would help him 'to form a collection of antique furniture which would consist of fine pieces', as an investment that 'would be worth the same or more money as time went on'.[8] With this in mind, he was advised to only 'purchase stuff which was . . . properly and readily saleable under the description which was sold to him'.[9] The objects as described by the dealers represented all that was considered 'right' at the time, and mainly focused on that which represented the apex of quality in old furniture, namely eighteenth-century English, with some older English and a bit of 'quality' French thrown in for good measure. These periods and places had been established by the literature as significant in the first furniture history publications which developed out of the antiquarian traditions of the nineteenth century. The vast majority of amateur collectors of English furniture by the 1890s were attracted by the eighteenth century.[10] Prior to that, according to Mordaunt Crook, the 'haute-bourgeoisie of mid-nineteenth-century Europe draped itself with the trappings of the *ancien régime*.[11] For example, the fourth Marquess of Hertford's collection, given to the Nation in 1900 as the Wallace Collection, symbolized much of what the aspiring classes desired, with its copies and originals purchased from the denuded palaces of former French kings and its characteristic staircase reclaimed from the *Bibliothèque du Roi*. With typical nationalistic fervour, however, many collectors turned away from France as had so often been the case in the past, and attempted to establish English furniture of the period on an equal footing with the classical ostentation of the French. This can be seen in the public outrage that met Sir George Donaldson's donation of art nouveau furniture from the Paris Exhibition of 1900 to the Victoria and Albert Museum, which had by then

established itself as the arbiter of taste and quality in the decorative arts.[12] The re-focus on *old* English furniture in many collections was also part of a wider turn away from celebrating the new, as represented by the wares for sale at the Great Exhibition of 1851, to a renewed focus on the antique, driven by designer-scholars such as A. W. N. Pugin and William Morris.[13] In 1871, Basil Champneys crystallized the issue in an essay on English eighteenth-century furniture:

> The art of domestic furniture occupies a mean position between those arts which exercise the highest faculties of the producer and intense interest of the recipient, and those others which, being ephemeral in their purpose, are considered unworthy of serious study, and are, apparently at least, relegated to the control of trade interest and social caprice.[14]

Towards the end of the nineteenth century, therefore, there was a growing trend to treat old English furniture as a legitimate subject for 'serious study and conscious criticism' as evidenced by the success of Frederick Litchfield and Percy MacQuoid's books and their role as 'experts' in the trial. MacQuoid's obituary, in *Country Life* in 1925, written by his colleague H. Avray Tipping summed up the mood of the time:

> Up to nearly the close of the nineteenth century, foreign furniture, like foreign architecture and decoration, had been preferred by Englishmen to their own. It was generally the foreign and not the native that was being collected by private connoisseurs and museum authorities. But when the struggle for establishing the merit, and making known the history, of our past cabinetmakers gained strength, Percy MacQuoid (most ably assisted, let it be added, by Mrs MacQuoid) put himself in the forefront, and sought to dispel the obscurity with which indifference had shrouded the whole matter.[15]

Despite Pugin and Ruskin's clear advocacy of the Gothic style, by the '1860s the Georgian Revival began to gather momentum . . . at first the Adam and Sheraton styles were principally favoured, rather than the rococo that was widely condemned for its malign influence on mid–nineteenth-century commercial manufacture'.[16] The growing discipline of furniture history capitalized on this interest, as we can see from the titles of some of the earliest books, such as Kate Warren Clouston's *The Chippendale Period in English Furniture* (1897), Constance Simon's *English Furniture Designers of the Eighteenth Century* (1905) and Robert Scott Clouston's *English Furniture and Furniture Makers of the Eighteenth Century* (1906), all published in London. Much of the

interest focused on the quality of construction of eighteenth-century objects, in line with wider discussions about how to identify an authentic object. For example, in 1874 the execution of eighteenth-century furniture was described as 'first rate' by the *Builder* magazine.[17] It was also felt to fit with the domestic arrangements of the modern home, being delicate and elegant rather than the bulky heaviness of much of the Gothic style, and the eighteenth century was admired as being 'subjected to the conditions with which we are ourselves familiar', with the rise of metropolitan living and the associated town house style.[18] One of the most significant publications for the market in antique furniture of the early twentieth century was established at a time when interest in the eighteenth century was being codified in print. Most of the pioneering scholars of the new academic discipline of furniture history contributed to *Country Life* magazine from its inception in 1897. Its founding editor and proprietor, Edward Hudson, 'emphasised the subject, as an integral part of an unexpressed romantic vision of opening his countryman's eyes to a country house heritage every bit as important as great cathedrals and castles'.[19] In the decade prior to its establishment, the market for early Georgian furniture grew, alongside the republication of key pattern books of the period, such as those by Sheraton and Hepplewhite. The furniture illustrated in the earliest issues of *Country Life* largely ignored any vogue for French pieces, and was clearly mapped onto the developing market for the English eighteenth century. The first article on furniture, published in 1903, featured ten late-seventeenth-century chairs from Levens Hall, Westmorland. Two years later R. Freeman Smith wrote the first article on eighteenth-century furniture, citing the fact that 'today the demand for fine specimens is greater than ever'.[20] Sir Walter Gilbey's pieces at Cambridge House, Regent's Park, formed the first genuine collection, rather than country house accumulation, and were written up in 1910.[21] On 1 April 1911, the magazine announced that 'so great is the present interest in the history of furniture' that it would be taking full advantage of recent advances in colour printing to each week 'present a picture of a piece of furniture so exactly capturing its characteristics . . . that the very thing itself will appear before us'.[22] The first of these colour illustrations was of a William and Mary needlework settee. Thus began a long series of images and articles on 'Furniture of the XVIIth and XVIIIth Centuries', which included in 1911 Percy MacQuoid's article on the 'Stuart Armchair' that featured in the Shrager case (see Figure 1.1).[23] Hudson also engaged MacQuoid to write a four-volume *Dictionary of English Furniture* (1924–7) as the culmination of his life's work (completed posthumously by Theresa and Ralph Edwards).[24] The magazine was at the forefront of the discipline throughout the period running up to Shrager's first purchase, and in it we can see how the distinctions between cabinetmaking and antique dealing, collecting and scholarship were

blurred in the very small world of furniture history, collecting, decorating and designing.[25] Susan Moore demonstrates this in her article on 'Furniture in the Early Years of *Country Life*' using the example of Captain Norman Colville's collection. In the 1920s, Coleville bought Penheale Manor, North Cornwall, which was then remodelled by Edwin Lutyens[26] and decorated by Lenygon and Morant. His furniture collections were recorded in *Country Life* by Margaret Jourdain[27] and included in the Burlington Fine Arts Club exhibition and in MacQuoid's *Dictionary*. The house was then published in the magazine by Ralph Edwards.[28] As early as 1910, *Country Life* was providing information for would-be collectors. In 'How to choose old furniture', for example, it advised, 'It is perhaps as well to make a rule . . . to buy nothing later than the eighteenth century'.[29] Many of *Country Life*'s most frequent contributors on furniture in the early years were involved with the trade in a way that was not disclosed to readers. Margaret Jourdain was retained by Lenygon and Co. from 1911, for example, and her interest in William Kent and his period may well have been stimulated by Colonel Mulliner, who owned the company.[30] Percy MacQuoid, as we have seen, was closely involved with Morant and Co., and their later incarnation as Lenygon and Morant. From the early 1920s, R. W. Symonds was an 'advisor' who helped form many private collections, including the Percival Griffiths collection, as well as a writer.[31] There was a strong sense of discovery in the early years of the magazine, supported by the publication of illustrations of objects such as MacQuoid's 'interesting ruin' (see Figure 1.2). Their articles not only influenced collectors in England, but also reached out to the American market, at a time when English firms of decorators and dealers were opening premises in New York, around 1910.[32] Out of this moment of enthusiasm for old English furniture, in 1914 Hudson began to develop his *Dictionary of Furniture* project, securing MacQuoid's services as author.[33] Frank Green, owner of the Treasurer's House in York and a recognized collector of antique furniture, was said, by family legend, to have suggested the *Dictionary* in the first place.[34] Certainly their connection was close enough for MacQuoid to include a number of pieces from Green's collection in the book, including a Queen Anne secretaire.[35] The restored, upholstered chair from Rushbrooke Hall which MacQuoid wrote about in *Country Life* (1911) was another of Green's antiques (Figure 1.1).[36] MacQuoid used the magazine to extol the virtues of collections with which he had an intimate and professional connection. For example, he wrote about Lord Leverhulme's furniture at his homes and gallery in Cheshire. In 1911, Lever's collection was featured in two parts alongside MacQuoid's claim that:

This well-known collector has been enabled to secure a consecutive variety of examples that are most instructive to the student; and unfortunately

it is only owing to the intelligence of individuals who have informed private collections, and their courtesy in allowing them to be seen, that any definite idea of sequence of evolution in form in English furniture can be obtained. Bequests of pictures, ceramics, plate and foreign furniture have from time to time enriched our national collections, but English eighteenth century furniture . . . has been curiously withheld from our public museums by legacy as well as purchase.[37]

Hudson and his magazine played a modest role in rectifying the situation in 1914 when a George III panelled room from 27 Hatton Garden in the City of London was saved for the nation and deposited in the Victoria and Albert Museum. The following year, H. Clifford Smith, keeper of furniture at the museum, declared in a letter to the editor that 'a debt of gratitude is due to *Country Life* for its pioneer work in revealing to the world this country's wealth of domestic architecture, furniture and interior design'.[38] As John Cornforth pointed out in his article for the centenary edition of *Country Life* (1997), the magazine's involvement with English furniture 'is an elusive topic' as the writers invariably followed dealers or acted as dealers themselves.[39] Certainly the articles on furniture in the magazine in its early years demonstrated how closely the worlds of the historian, the collector, the dealer and the curator were intertwined.

The Victoria and Albert Museum established, and has retained, a central role in the discipline of furniture history and in the market as we can see in the example of the Shrager case. The museum was cited throughout the trial as an indicator of quality, of the 'genuine' rather than the 'spurious', and from the start the museum in South Kensington was seen as the place to learn about the 'right' objects to own. In *Hints on Household Taste in Furniture and Upholstery and other Details* (1868), for example, Charles Eastlake encouraged the 'careful examination of old specimens to be found at the South Kensington Museum and elsewhere . . . [to] enable [ladies] to reform their taste . . . and acquaint themselves with the general principles on which such work should be designed and carried out'.[40] The South Kensington Museum had a central role in dictating good taste. In Hungerford Pollen's introduction to the first catalogue of *Ancient and Modern Furniture in the South Kensington Museum*, published in 1874, he cited a number of key events for the growing popularity of antique furniture in the second half of the nineteenth century: 'We are now, perhaps, returning to a renaissance art in furniture, and it is certain that collections such as those lately exhibited by Sir Richard Wallace; the Exposition Retrospective in Paris in 1865; the loan exhibitions of 1862 in London, and that of Gore House at an earlier period' but 'above all' he concluded, 'the great permanent collection at South Kensington, must contribute to form the public taste'.[41]

From its moment of inception, the museum has been more than a mere historical object. It has been a key driver in the manufacture of an image of history.[42] By collecting artefacts from the past, the museum gives shape to history, in effect inventing it by defining the space of a ritual encounter with the past. All museums participate in the processes of historiography. The South Kensington Museum not only represented what was important, valuable, genuine and historical in its collections, it also helped to define the objects as such and, therefore, became a marker within the wider market. The fact that the furniture dealers and experts were intimately involved in the establishment and continuation of the collections there meant that this relationship remained a dynamic and often problematic one. After all, object choices are historical gestures. They are validated by the moment at which the choice is made, pass judgement upon the past viewed through the present, and are crucial to the processes of valuation and devaluation. History is re-told through the presentation of these objects to the visitor or their removal from the public sphere. As such, museums can be seen to be as much in the business of trading art, objects and history as the antique shop and the auction house. 'Like the antique shop, the museum opens a space where artistic genealogies are bought and histories get a new sticker price. For all its protective nimbus, the museum nonetheless is a vehicle for the uncertainty of historical value'.[43] Such uncertainty was the main reason for the trial. While the same objects could be considered both 'absolutely genuine' and 'spurious and made up', their identification as one or the other relied upon a complex web of historians, museums, price indexes and commercial desirability. The role of the Victoria and Albert Museum (V & A) as a signifier of quality was already in place prior to Shrager's entry into Dighton's shop. MacQuoid's collections at the Yellow House, for example, were declared in *The King* to be so 'rare' and 'beautiful in form' that '[it] is doubtful whether South Kensington can boast of the possession of so fine a piece'.[44] MacQuoid was praised for having made 'a discriminate selection from the best periods of the decorative arts', free from the 'overcrowding with ornaments', 'vulgarly-expensive furniture' and 'superfluous nicknacks' of the typical Edwardian home.[45] Such systems of decoration – representing the 'best periods' of course – were driven by the displays in the museum and, vice versa, the displays in the Museum were influenced by the quality judgements of historians such as MacQuoid. Both MacQuoid and Cescinsky claimed to have been advisors to the V & A, although MacQuoid seemed more established in this role, introducing himself as an advisor to the furniture department of the V & A who had helped the museum purchase English furniture and boasted of recent contact.[46] Cescinsky, on the other hand, described himself as 'an unofficial advisor' to V & A, a rather more tenuous role.[47] Both witnesses needed the credentials provided by advising

the leading museum of decorative arts in England. The fact that MacQuoid's role was rather more established says much about his identity as a connoisseur and gentleman. Likewise the description of an object as 'a museum piece' was one that was much used by Lawrence and Dighton to confirm its authenticity to Shrager, and one that was much debated in the trial. When discussing a William and Mary inlaid mahogany chest of drawers, Cescinsky declared, 'It is certainly not a collector's or a museum piece . . . because if anybody started collecting these pieces he could fill his house with them in a couple of years'.[48] His definition of a 'museum piece', therefore, was predicated on the idea that objects in museums should be unique. This concept of the unique object, as authenticated by the museum, ran throughout the trial. David Lowenthal, reflecting on the 1990 'Fake?' exhibition at the British Museum, said that 'The 1990 exhibition taught me that judgments about authenticity depended as much on where as what things were'.[49] The siting of an object in a museum collection was vital to its authentication. The museum provided an aura of authenticity and, just as Benjamin reminds us in 'The Work of Art in the Age of Mechanical Reproduction', 'The presence of the original is the pre-requisite to the concept of authenticity'.[50] The standard of 'museum piece' is one that is applied throughout the market for decorative arts. For example, when MacQuoid's 'valuable collection of English Seventeenth Century Furniture' from his home at Hoove Lea, Kingsway, Hove, was put up for sale in January 1932, the Jenner and Dell auction catalogue described many of the items as 'being museum pieces, well known to connoisseurs and others'.[51] This definition had to be explored in the courtroom because it had been used so frequently to persuade Shrager to buy from Dighton and Lawrence. Ernest Pollock's defence rested on the idea that '"museum pieces" and "collector's pieces" and so on are all uncertain standards'.[52] Cescinsky came to the conclusion that, 'dealers refer to these specimens as "museum pieces", which is another way of stating that they would be utterly out of place in the home'.[53] The very uncertainty surrounding the expression, however, made it a valuable tool in the dealer's box of tricks when it came to authenticating and selling their wares, and defending their practice. Even Cescinsky was caught out and had to be reminded that he had described a Hepplewhite chair as 'really the first piece, which, from its beauty and rarity, is the first museum piece we have come across. This is worthy of going into a museum . . . from its beauty and rarity'.[54] Pollock then asked, '[C]an you tell me how this came to be placed in the particulars of an action against an antique dealer for fraud?', to which Cescinsky replied, 'I have not got the faintest idea'.[55]

A number of the objects discussed in the trial were authenticated via the Victoria and Albert Museum collections, including an 'elaborately carved Chippendale chest of drawers with carved canted corners and serpentine

front', described as 'a finest quality collector's piece' when it was bought for £350 by Shrager.[56] Shrager accused Lawrence of having claimed that it had been 'exhibited at the South Kensington Museum as part of a loan collection'.[57] He admitted that he had believed this statement, and been convinced by it to buy. His experts had subsequently insisted that its carving was 'not Chippendale's style at all', leading Pollock to mock, 'I dare say the authorities [at the South Kensington Museum] would be glad to hear what you have to say about it being miscarved' having 'exhibited [it] as a very fine specimen', and concluding that 'South Kensington may be wrong and the experts may be wrong, but still it was exhibited as a very fine piece of furniture'.[58] This commode was much discussed by the expert witnesses, specifically because it featured 'a label . . . on the back which shows that it came from the Victoria and Albert Museum'.[59] Despite this Cescinsky stuck to his opinion that a modern brass gallery had been added to it and stated that to describe it as 'a perfect piece of pure English Chippendale' was 'most incorrect'.[60] In response, MacQuoid claimed baldly that 'if I did not like the gallery, I should throw it away', and that he did 'not see that it interferes with the genuineness of the piece'.[61] In the end the commode was judged 'correct' mainly because of its link to the museum. But this was an imprecise marker because, particularly at this point in time, the museum was closely associated with dealers who often donated objects, including George Donaldson's collection in 1900. Attention has subsequently been drawn to this fact, particularly when the new British Galleries were designed, as museums have become more aware of the need to be seen to exhibit 'authentic' objects. Exhibitions such as 'Fake' and the most recent show at the National Gallery on the subject of art fakes and forgeries (2010) have drawn further attention to the need to separate the 'real' from the 'false'. Most interestingly, Scotland Yard recently used the V & A as a site for an exhibition of stolen and faked antiques as a stark warning to would-be purchasers.[62] Susan Pearce has commented that, 'The traditional separation of the aesthetic and economic dimensions . . . confers a "sacred dimension" on cultural objects, versus those objects with commodity status'.[63] This was the role of the museum in the court case and this role has become even more exaggerated in recent times with improvements in scientific methods for dating and authenticating historic objects. As Pearce was later to confirm, there is a 'moral force of the real thing', and it was this moral dimension that the lawyers for the defence employed.[64] It was judged enough that an object resemble one in the V & A for it to be deemed authentic. A 'very properly restored' credence is described by MacQuoid as being similar to one in the museum, which had also been 'altered', unlike the one that MacQuoid claimed to own himself which he described as 'right right through without much alteration'.[65] The credence was authenticated not only via its resemblance to one in the museum

but also to one in the expert's personal collection, just as many objects had
been previously authenticated via the pages of MacQuoid's book.

The utopian space of the museum also helped to codify the language that
was consistently employed by the dealers to help convince Shrager to pur-
chase. Historical terms such as 'William and Mary', 'Charles II', 'Elizabethan',
'Stuart' and 'Louis XVth' were scattered throughout the sales patter, giv-
ing credence to the objects. According to Lawrence, Shrager's first visit to
Dighton's shop saw him purchase a 'Walnut bureau bookcase of early eight-
eenth century', an 'English eighteenth century bracket clock', 'two carved
walnut Charles II chairs', an 'eighteenth century mahogany Carlton House
writing table', a 'silver inkstand by Cripps', an 'elaborate carved Chippendale
chest of drawers', an 'inlaid Adam chest of drawers', 'five chairs and two
settees of the early eighteenth century' and a 'Chippendale jardinière on a
carved stand'.[66] The description of each object in the shop stressed Lawrence's
desire to indicate that each of the objects purchased were 'pieces of the finest
quality which might be true collectors pieces'.[67] Unfortunately, from the off,
each piece did not live up to its billing. The 'Walnut bureau bookcase of early
eighteenth century', examined in court, was described by MacQuoid and the
defence team as 'a very fine piece of antique' and 'quite genuine', and so wor-
thy of its £220 price tag,[68] but Cescinsky deemed it to be 'a made up piece',
'so modern that [it] smel[t] of American oak'.[69] Cescinsky's smell test was
an interesting one, which was challenged in court. MacQuoid declared that
he 'should never judge furniture by its smell,' and Cescinsky was caught out
when asked to smell some drawers produced by Sir Ernest, which he declared
'modern construction'.[70] They turned out to come from a piece owned by
MacQuoid.[71] In his final judgement the Official Referee declared that it 'was
held to be an absolutely good piece'.[72] The label 'Queen Anne' was a popular
one in the courtroom as it had been applied to a great number of objects in
the Shrager collection. *Cornhill Magazine* in 1875 declared that the term con-
tained a 'mysterious sanctity', making it easily applicable to a whole range
of items from widely diverse historical periods and places.[73] The dealers also
used the names of decorative art history as a useful way of indicating quality.
Shrager was encouraged to buy objects described as 'Hepplewhite', 'Tompian',
'Beauvais', 'Wedgwood', 'Sheraton' and 'Adam', a positive roll-call of the key
historic makers and designers. As Muthesius reminds us, one of the reasons
for the popularity of eighteenth-century furniture in the market at the turn
of the century was that 'it could be labelled with the name of a designer'.[74]
Unsurprisingly, the most quoted name at the trial was that of probably the
most famous of English furniture designers, and certainly the most popular
for antique collectors of the time, 'Chippendale', who was deemed so impor-
tant by the late nineteenth century that he was chosen as one of the 'worthies'

to be carved by Albert Hodge for the façade of the Victoria and Albert Museum in 1905 – giving Chippendale a permanent, visible position among the Victorians' favourite artists and designers.[75] One of the major benefits of using his name was that there was a distinct vagueness about the maker's biography and status in the history books. By the time of the trial very few pieces could actually be ascertained to have been made by him, allowing his name to be applied freely.[76] This problem of definition was explored in MacQuoid's cross-examination and Disturnal's summation. MacQuoid was accused of contradicting himself, having declared that 'the use of the term "Chippendale" is generic'.[77] MacQuoid claimed that it was permissible to identify an object as 'Chippendale' even when it was the product of 'the workshops or made by a workman of Chippendale'. When asked, '[D]o you mean to tell us, as a gentleman experienced in this business, that it is honest for a person to sell a piece of furniture and charge a high price for it under the description of Chippendale when it has never been made by one of the Chippendales at all?', he replied, 'Certainly, it is done everyday'.[78] Although he was at pains to remind the court that he did 'not sell furniture', he concluded that, 'it is perfectly honest to sell a piece and call it Chippendale, although it has not been made by the firm of Thomas Chippendale . . . it is not my idea; it is everybody's'.[79] This confirmed that objects labelled as 'Chippendale' would be more valuable than 'a piece of furniture of the period that was not made by Chippendale'.[80] Unsurprisingly, he also declared that he and 'other persons of experience', 'would be able . . . to distinguish it from that of any other craftsman of the particular period'.[81] At this, Disturnal commented that 'Mr MacQuoid is speaking in what I may call the jargon of the trade; it is the language of the trade', and then asked, 'What would become of these people if they posted up in their shops: "When we say 'Chippendale' we do not mean things that are made by Chippendale at all"?' He confirmed that 'trade practice' at the time was to 'sell a thing as Chippendale which was not made by Chippendale, and therefore, I suggest, represent it to a person who does not know as being of the higher value which is placed upon the work of Thomas Chippendale', although he hoped that 'Mr MacQuoid is wrong with respect to this trade'.[82] This hope was unfounded. From the origins of furniture history as an academic discourse in the late-nineteenth-century publications of J. Aldam Heaton and Frederick Litchfield, eighteenth-century furniture has assumed its position at the apex of the historical hierarchy, and Chippendale continues to sit right on the top. At the same time prices for eighteenth-century furniture in the dealer's shop and auction house were rising quickly, with £1,050 being paid for two Chippendale chairs at Christie's in 1902. As we have established, many of the early historians themselves practiced either openly, or as a sideline, as dealers, clearly establishing a link between the commercial market and the writing of

history. This link was often blurred in the pages of the books however, so that Litchfield could (without irony given his own commercial practice) advise potential buyers to 'be prepared to pay a good price to a man of good reputation for a really good article'.[83] Arthur Hayden, likewise, could remind his readers to 'consult old fashioned firms of high standing'.[84] The Official Referee admitted to turning to Litchfield and his co-author Foley when attempting himself to define 'Chippendale'. In *Harmsworth's Household Encyclopaedia*, he found their article on 'Antique Furniture in the Home' where he read that 'Chippendale should be taken merely as a generic term, for it is impossible that a hundredth part of the old furniture of his time and style could have been produced in his workshop'.[85] However vague the term 'Chippendale' was deemed to be, it assumed a particular place in the discourse, as the genius of eighteenth-century furniture-making. Roland Barthes has posited the notion of genius as a distinctly modern one, rising from the 'culmination of capitalist ideology'.[86] Certainly, the name 'Chippendale' needed to be dissected carefully in the trial, as to use it was to imply a certain added value that could run into the hundreds of pounds, or, in today's market, the millions.

From its inception as an academic discipline, furniture history used named eighteenth-century furniture makers as the pivot on which the discourse has been mapped. The dealers followed suit. 'Chippendale' was the supreme example of this. A name is more than a gesture, 'a finger pointed at someone', but rather it is a powerful description.[87] MacQuoid and Litchfield concluded that the name was 'generic'. Unfortunately, the major problem for the court was that 'the link between a proper name and the individual being named and the link between an author's name and that which it names are not isomorphous and do not function in the same way'.[88] This may be fine if it is just a question of historical attribution, but when the attribution meant a fundamental difference in value, it became key to the judgement on whether Shrager had been defrauded. MacQuoid admitted that many of the attributions to Chippendale were based solely on visual analysis and similarity, a thoroughly problematic method of making discriminations, but one nevertheless endorsed not only by the judgement of the Official Referee, but also endorsed by more contemporary furniture historians, such as Christopher Gilbert, who, in his introduction to *The Life and Work of Thomas Chippendale*, proposed that many of his attributions to the cabinetmaker were, 'advanced solely on the grounds of stylistic analogy with proven furniture in other collections'.[89] Many of the problems of attribution came from confusions that had existed since the development of Chippendale's workshop in the mid eighteenth century. As MacQuoid admitted in court, there were potentially 'three' furniture manufacturers 'of the name of Chippendale', although the 'first Thomas' was 'more celebrated than others'.[90] MacQuoid acknowledged that the author function of

the name 'Chippendale' could cause confusion for the layman as it referred to several different makers and was also used as a label to indicate style. Despite this, he declared that the 'furniture of the first Thomas [was] more valuable than the furniture of the other Chippendales' and 'more valuable than furniture that happens to have been made, say, out of London by somebody else in the period of Chippendale'.[91] This very confusion in 1923 was of great value to the dealer.

In an anonymous review of MacQuoid's catalogue of the Lady Lever Art Gallery Collections (1928), he was criticized for being 'always over-inclined to coincide with the views of other early writers on the subject, in giving undue prominence to the supposed Chippendale influence on the work of the first half of the eighteenth century'.[92] In attempting to understand Chippendale's prominence in the literature in the early twentieth century, the reviewer concluded that:

> This may be ascribed largely to the statement by [Richard] Redgrave that Chippendale's father was a cabinet maker of high repute, and that the son worked with him . . . recent investigations have gone far to show that the whole story is apocryphal . . . the results of some of the more recent investigations have only been published since Mr MacQuoid's death. Had he lived, it is probable that he would have modified his assertion that the Chippendale period commenced in 1735, and that various pieces manufactured between that date and 1750 were his work.[93]

This demonstrated the popular mythologies that had been built up by the early historians of eighteenth-century furniture, and also the desire in the literature to constantly use the 'archive' and 'evidence' to refute earlier statements, in a game of Chippendale watching that came to a head with R. S. Symonds's article in *The Country Life Annual* of 1958, 'The Myth Exploded'. Here, for the first time, Chippendale was proposed as the designer of neo-classical furniture, distancing him from the previously all-powerful character of Robert Adam. These debates, and the fact that they were considered so important among the historians, were linked back by Cescinsky to the problems of attribution seen to have been initiated in Chippendale's own publication of the *Director*:

> What constitutes the Chippendale style? Is it the actual work of Chippendale himself, furniture made after the published designs, or the collective work of what is known here as the Chippendale school? . . . If the sum total of the designs in the *Director* be taken as the criterion of the Chippendale style, then we must include many from Ince and Mayhew's *System* and others. Of

these designs very few indeed were ever actually executed in wood, and then only with serious modifications, which suggests that Chippendale himself was not the maker, as these modified pieces, if made by him, would be tantamount to a confession that his designs were impractical. . . . If we take the known and authenticated work of Thomas Chippendale, as at Nostell Priory or Harewood House . . . none of this is in the *Director* manner. . . . Those pieces which are usually regarded as 'Chippendale' bear little or no relation to either the *Director* patterns or the work of the man himself.[94]

The illustrations in the *Director* were a focus for historians attempting to attribute pieces to Chippendale from the moment his worth was recognized but, as Cescinsky indicated, these images were problematic in themselves. They reflected contemporary popular style, as was to be expected in a pattern book produced at a time in the eighteenth century when the commodification of culture was gaining a pace. Engraved by the little-known Mathias Darly, the images were altered according to fashionable taste at the time when they were first produced, hence the rapid succession of editions which mark the move from rococo to neo-classicism. A great number of copies of the *Director* were sold, allowing for the large number of vernacular copies of the designs produced. These copies were included by MacQuoid in his definition of a piece of furniture accurately described as 'Chippendale', although he acknowledged that they were less valuable than those ascribed to the master himself. But how was this to be judged? According to MacQuoid, the piece in question bore 'distinct marks' that he, as an expert and connoisseur, was capable of reading.[95] That said, a 'Small Chippendale love seat with carved legs and underframe', declared by Litchfield to be 'a modern reproduction', was approved by MacQuoid as being 'contemporary with the book. It is copied from the book. It is what Chippendale calls in his "Director" a type of French furniture, and he simply issues that book in order to have things made from it' and was therefore judged to be correct. MacQuoid even went so far as to compare his *History of English Furniture*, called 'the faker's bible' by Cescinsky, to the *Director*, declaring that 'Chippendale's book was the faker's bible in his time'.[96] Without acknowledging the irony of this statement, he added that 'time has gone on and added dignity to the work which was done in his day'.[97]

Pattern books by their very nature are reproducible. Chippendale had shrewdly produced the *Director* when attempting to establish his business in the 1750s, following the architectural tradition of Palladio's *Quattro Libri dell'Architettura* and Campbell's *Vitruvius Britannicus*, and was aware of the power of such texts within the market, allowing his designs and his business to be seen and consumed by a much larger market than his workshops alone could reach. This reproducibility was acknowledged to be a problem for

the furniture historian, especially when asked to judge the value of an object out of the dealer's shop. As Cescinsky asserted in *The Gentle Art of Faking Furniture*:

> The study of English furniture has never been regarded seriously, in the scientific spirit, as it were, and the capacity for sifting and weighing evidences appears to have been totally lacking with many writers. The subject is really far more involved than one would imagine. The fact that a book was published, in which designs of furniture were illustrated, is no more proof that the author – or the one whose name figures on the title-page (which is not always the same thing) – was an actual maker than the present-day catalogue of a firm such as Maple can be regarded as evidence that the late Sir Blundell Maple was either a designer or a cabinet maker. In fact, he was neither. It is so easy when compiling a list of the eighteenth century furniture makers, to take the names from these books, Chippendale, Copeland, Crunden, Darly, Hepplewhite, Ince and Mayhew . . . and to assume, without further evidence, that they were all cabinet makers. As a matter of fact, some were architects, others artists, and a third class only designers, with little or no practical experience of woodwork.[98]

Eighteenth-century documentation in the form of letters, diaries, inventories, and so forth was also cited as vital evidence by the furniture history books. When questioning the use of such evidence in relation to the pieces themselves, Cescinsky also had something to say about this historiographical 'pitfall'. He warned the potential buyer to be wary of paying too much heed to descriptions in inventories as provenance, especially after an object had been sold in the auction house.[99] Despite such warnings, the use of historical material was, and remains, a powerful force in the discipline, and Christopher Gilbert celebrated this in his introduction to *The Life and Work of Thomas Chippendale*:

> Much of the evidence about Chippendale's workshop practice, tradesmen and financial problems has accrued from the systematic study of the firm's business letters, bills and memoranda. This source material is of inestimable value to all students of eighteenth-century furniture, not only for proving Chippendale's authorship of items, but as a record of his industry and commerce.[100]

Yet, 'writing is the destruction of every voice, of every point of origin. Writing is that neutral, composite, oblique space where our subject slips away. . . . As soon as a fact is narrated . . . the voice loses its origin'.[101] The historian is

necessarily selective,[102] but Lawrence, Dighton and their fellow dealers needed to have their customers believe in the 'facts' of the archive, the references to the *Director*, and the evidence of the museum, especially the V & A, in order to convince customers to buy. In this Chippendale was especially helpful as his career and history was surrounded by myths and mystery. Many of the early historians spent a great deal of time trying to fill in gaps in the documentation, and link the son of a carpenter born in Otley, West Yorkshire, with the established metropolitan cabinet-making workshop 23 years later. Such gaps help explain why Chippendale was so popular a subject for the historian, offering a challenge and a chance to play a game of one-upmanship with the archives. This, combined with the growth of fashionable interest in the Chippendale style that developed in the second half of the nineteenth century, led to the significant number of histories of Chippendale published between the 1890s and the 1920s. Within these, the 'facts' of Chippendale's history were beginning to be questioned by historians such as Clouston and Smith, who examined and criticized Redgrave's popularization of the cabinetmaker in his *Dictionary of Artists of the English School* (1874). Oliver Brackett accused Redgrave of using anecdotal comment rather than documented fact, and began his search for tangible evidence with the aim of substantiating authentic furniture. The result was his 1924 publication, *Thomas Chippendale: His Life and Work*. The debates raged throughout the 1920s, coincident with the trial, reaching their height with Fiske Kimball and Edna Donnell's suggestion in 1929 that the designs in the *Director* were not by Chippendale but were instead ghosted.[103]

Cescinsky and MacQuoid were also involved in such debates as can be glimpsed in a letter from Davison, the curator at the Lady Lever Art Gallery, to MacQuoid in December 1923. This letter included a quote from an article written by Cescinsky for the *Burlington Magazine* in May 1917, on 'Furniture in the Port Sunlight Museum'. In the article Cescinsky wrote of Chippendale's sideboard set commissioned by Edwin Lascelles for Gawthorpe (Harewood House) 'which shows Chippendale at his best as a craftsman but as a nonentity as a designer. I am inclined to the opinion that Chippendale was by no means responsible for the whole of the Adam furniture at Harewood'.[104] With this Cescinsky was referring to the ongoing and volatile debates in the literature about the relationship between Robert Adam and Chippendale and the authorship of his designs. Referring to the Chippendale and Haig invoices at Harewood which had become such an important resource for scholars of the period, he concluded that 'Chippendale's work in the Adam style has had always a strangeness of detail and proportion which is absent in his other productions'.[105] This

allowed him to compare the sideboard at Harewood with a sideboard set, ascribed to the makers Seddons and Sons, at Port Sunlight, and to propose that 'Seddon, Sons and Shackleton, of Aldergate St, were equally renowned as makers of fine furniture and were undoubtedly established on a larger scale'.[106] With this, he concluded that it was only because there were so few 'authenticated' pieces of Seddon's work that the firm had been less valued than Chippendale in furniture history, but he was 'inclined to bracket them with Chippendale in point of workmanship, and to rank them much higher as far as details and proportions are concerned'.[107] This is a typical example in the literature on Chippendale at the time, which seemed intent on either proving or disproving Chippendale's worth as a maker and designer. The scant archive was picked over time and time again for evidence that could link his name to certain pieces and, when found wanting, the trade was quick to fill in the gaps and make the links themselves. In the courtroom, the debates focused on attribution. A Chippendale-shaped front sideboard inlaid with mahogany and satinwood was discussed in detail, particularly the application of the description 'Chippendale shaped'. Cescinsky claimed that he did not know of 'any such thing as a Chippendale shape – there is no such thing existing' and that he had 'never heard the term that a front is Chippendale in shape'.[108] Having dismissed the piece as nineteenth century and probably from the 'Wright and Mansfield Period, I should think – 1850 to 1860', Cescinsky went on to offer an analysis of the time period that could be rightly described as 'Chippendale': 'His London life commenced in 1750, and he died in 1779', declaring the 'Chippendale and Haig period [as] the finest period of Chippendale'.[109] He concluded that he had 'never dreamed of associating [the sideboard] with the Chippendale and Haig period'.[110] In opposition, MacQuoid declared, 'I should say it is a work of Chippendale and Haig', and enquired as to whether Cescinsky was 'not acquainted with the fact that Chippendale made some of the most remarkable satinwood pieces in this country'.[111] He cited other examples at Nostell, Harewood and 'many other big houses', providing the Shrager object with the associated status of the Chippendale collections that had been verified in the furniture history books via original accounts and letters.[112] MacQuoid concluded that,

> The very fact of what he calls the clumsiness of it shows to my mind, that Chippendale had something to do with it. There is something about the strength of that leg there which I do not dislike at all, and the whole artistic drawing and design of the piece . . . the date of this satinwood I should say is the end of the eighteenth century. The whole of the table conforms to that date. . . . I am satisfied it is a genuine piece of the Chippendale period.[113]

With this he dismissed Cescinsky's attribution with an establishment flourish,

> I am sure that Wright and Mansfield had nothing to do with it. I remember Wright and Mansfield very well – I do not know whether Mr Cescinsky remembers them – in their full triumph of work. I was only twenty at the time and I used to go all over their shops, and I remember their work. Perhaps Mr Cescinsky remembers them too, as he quotes them.[114]

When asked about another pair of Chippendale side tables, MacQuoid again dismissed Cescinsky's statement that they were a 'copy of a very well known pattern in Chippendale's directory', with the comment that,

> Anyone conversant with Chippendale's work in the great houses will at once recognise his peculiar crisp touch. It is quite unmistakeable when you have seen it and have once read the invoices that exist in many of these houses accompanying the furniture. I have no hesitation in saying that I believe that came from the workshop of Thomas Chippendale.[115]

Yet again, the objects were linked to the archive.

A great deal of court time was spent on a set of 13 single and two elbow mahogany chairs, 'the square shaped backs fluted and carved with acanthus foliage, the centre with interlaced ornament, rosettes and acanthus, square legs, the seats covered with crimson silk damask', bought by Shrager for £1,150 on 10 January 1920. Lawrence had already supplied Shrager with some modern reproductions, but had promised to take them back if they were to subsequently find 'originals'.[116] Shortly afterwards, Lawrence made good his word, declaring that he had found an original set. 'Luckily', Shrager had the previous morning read in The Times that a set of Chippendale chairs had been sold at Christie's for £600. When he inquired why Dighton was selling them for a much higher price, he was informed that the dealers had had to get the chairs 'in the knock-out' and so had paid £1,000 for them.[117] A 'knock-out', which was legal practice at this time, was when a group of dealers agreed to bid together for a piece, so that they could keep the price much lower than if they bid against each other in the auction room. The objects would then be sold on during a later, informal auction among the dealer group. This offered a useful excuse for the price hike. Cescinsky claimed to have been at the original Burghard sale, held on 7 January 1920, where the chairs had been item 65 and he noted the price made on his catalogue.[118] Asked about the method of purchase, Cescinsky declared that a dealer should not buy for a client in the knock-out as 'the knock-out money can never be checked'.[119] In his judgement

the Official Referee referred to these chairs not as a set, but as a 'suite' and then decided that no allowance of any sort should be made as they were in the possession of Shrager for two years before any complaint was made.[120] MacQuoid had also considered the issue of the 'set', which he considered 'absolutely genuine mahogany chairs of the time of Chippendale'. He opined that they were probably not made 'exactly simultaneously as a set', offering the rather neat solution that

> A man had a smaller set which he wished to increase into a larger one. He may have got on in the world and got a larger house. He may have wanted fourteen chairs where eight or ten would have contented him earlier ... and therefore he might have sent to the firm and gave an order for the increase, in which case another man would have made the chairs; but they are all made by the same firm.[121]

The divergence in the set he blamed on 'the touch of another workman', concluding that 'the design is the same, the work of the firm is the same'.[122] On the question of authorship, he fitted the chairs into 'the time of Chippendale ... that is what we generally speak of as Chippendale chairs'.[123] The chairs were subsequently included in the Puttick and Simpson sale of Shrager's collection in 1924 and although, because of the dispute, the auctioneers claimed in the catalogue to have taken particular care with the descriptions, the chairs were offered as a set and fetched 480 guineas. Ironically they were purchased by Frank Partridge, a prominent member of BADA. A Frederick Partridge had given evidence on behalf of the defendants, and a Leonard Partridge became a partner in Dighton's in 1924. A. H. Partridge, ACA, was the first named of Shrager's trustees in bankruptcy.[124]

Another set of 'Chippendale chairs' constituted a significant part of the downfall of Shrager and his subsequent writ. After Shrager fell ill, his wife attempted to attend to his affairs and wrote to Dighton and Co. asking them to 'dispose of the suite of furniture for which my husband paid £3,000 cash', or offering to send the suite up to Christie's for sale.[125] Dighton's response was rapid, and he wrote on 30 December 1921 to say that there was 'little chance of selling your suite of Chippendale furniture as there is practically no business'.[126] At the trial, Disturnal commented that it was just as well that Mr Shrager did not sell the suite of Chippendale furniture or he would probably have had an action brought against him 'for selling as Chippendale furniture something which was not'.[127] The ten Chippendale mahogany chairs and two settees with legs with lion masks and paw feet had been bought by Shrager on 26 October 1920. Lawrence had encouraged him to rush to the shop to see 'something extraordinary', describing the set as 'probably one of the finest

in the kingdom'.[128] Perhaps Shrager should have erred on the side of caution when he was asked to pay cash, and unfortunately the set never made it to his home in Kent. All he got for his £3,000 'was a receipt'.[129] Chippendale lion mask furniture had something of a reputation. As this was a specific type of Chippendale furniture that had been much discussed in the literature, it was subsequently coveted by collectors. Lord Leverhulme, described by Cescinsky as having 'a positive genius for the fashion of the next decade', had many examples in his collections.[130] Cescinsky declared that he 'was the first collector of the lion mahogany of the years between 1725–35, and he bought when this furniture was not understood, and in consequence, not appreciated'.[131] In 1926, when Cescinsky was reflecting on Lever's collecting practice in his catalogue for an auction of Lever's art collections in New York, he confirmed that 'to-day it commands the highest price of all eighteenth-furniture, in the London auction rooms'.[132] Another renowned collector, Percival Griffiths, was credited with having the finest collection of lion mask furniture amassed before the First World War, although he was soon to find that collecting popular furniture left one at the mercy of the faker, when he saw identical objects being manufactured in a London backstreet by a dealer who confirmed that he made 'a large number of such pieces of Chippendale'.[133] The popularity of this type of Chippendale furniture guaranteed that it would be a successful product of the forger's workshop.[134] Despite this, MacQuoid considered the chairs to be 'perfectly genuine' from 'within the period we accept and call Chippendale' but in 'a traditional pattern from a rather early period. You would expect to find those settees about 1730, whereas I think they were made about 1745 or somewhere there'.[135] Reflecting upon the dealer's description of 'mahogany Chippendale chairs with lion masks and paw feet and two settees in the same set', he then went on to articulate why the name 'Chippendale' was such a useful one for the commodification of these objects, stating that it was 'near enough. You do not expect these people to know historically everything in that way; it is impossible for them to do so. . . . You see we do not know the makers before Chippendale. If we knew them we should be glib enough about them.'[136] The name 'Chippendale' was an incredibly important part of the dealer's arsenal. So much so that Lawrence was not adverse to adding it to his labels. The note of purchase for a mahogany Chippendale card table with original needlework cover, written on 20 January 1920 saw the words 'Chippendale with original needlework cover' added in Lawrence's handwriting to the typewritten word 'Card table'.[137] MacQuoid described the table as 'of Chippendale's time absolutely', although he thought it was more likely to be 'made in the country' and it was not very highly finished 'although the claw and ball is extraordinarily good'.[138] Cescinsky, on the other hand, denied that it was Chippendale, and dismissed it as 'a copy of a unique table which exists

in this country'.[139] With this he went on to highlight the usefulness of the illustrations in the burgeoning collections of furniture history books on the eighteenth century, claiming that one known example had spawned numerous copies: 'when a fine or unique example of antique furniture turns up and is illustrated in any recognised papers or books of authority at once curiously enough other examples turn up and it is commonly found that those other examples escaped observation for the simple reason that they did not exist at the time the first discovery took place'.[140]

Michel Foucault has identified 'the naïve and often crude fashion' in which names of authors have been used to identify discourses. While he was looking for an alternative way to read that was not 'tyranically centered on the author', the commercial market for antiques in the early twentieth century clearly benefited from its use of the name 'Chippendale'.[141] This is perhaps why Cescinsky chose a Chippendale invoice as the frontispiece of his novel, *The Antique Dealer: A Novel That Is Not Fiction*, published privately under the pseudonym Frederick Akershall, in about 1930. A satire based on the trial, the novel advised potential collectors to 'DO THE OTHER FELLOW AS HE WILL DO YOU – AND DO HIM FUST'.[142] It was just one of many reflections upon a trial that had captured the public's imagination, and exposed the underbelly of the world of historic furniture to analysis and debate.

'Et tu Brute?' The Verdict

The unfortunate cloud which has been hanging for so many weeks over all connected with old furniture is now happily dispelled. It is probably not too much to say that everybody who had old furniture in their home began to view it uneasily. Even the great majority of people who have old furniture because they like it, not because it is worth so and so, began to look askance at familiar friends, such a veneration for things because they are old is to be sure wicked aesthetically, but it is none the less a human trait. We can make a kingdom for ourselves in a cane bottomed chair and from the opened case of a grandfather clock come forth generations dead and gone, taking shape before our eyes, that is if we feel assured that our veteran is not an impostor, when one of the leading dealers in London was accused of villainous forgery a wave of doubt swept over the country.

Did honour and straight dealing count for nothing with furniture dealers? Good people in parlours stood sadly before some cherished old piece and murmured: 'Et tu Brute?' But the judgment delivered by the Public Referee was a most sweeping vindication of the honour of the defendants. The good faith of Messrs Dighton could not have been more completely proved. The prevailing taste for old furniture, to the exclusion of all other, must inevitably result in a great mass of work being executed in old styles. English cabinet making, moreover, has reached so high a level of craftsmanship that the difference between old and new work is often very difficult of detection. It is not for lack of designers that modern furniture is little known; it is for lack of intelligent demand. The majority of those who buy furniture in old styles do so in order to be in fashion, not for any reasonable preference for it. It is an unhealthy condition of things and one which the true dealer in antique furniture deplores as much as the modern designer; for the best antique furniture will always command high prices, however the fashions change. Moreover, if the highly trained craftsmen were allowed to work on original, instead of copied, designs dealers would be freed from the suspicion of selling reproductions as genuine pieces.[1]

The conclusion of the case was much reported in the contemporary press, as the trial had been since it began in November 1922. The exhaustive legal

proceedings failed to produce a satisfactory verdict on the authenticity of
Shrager's purchases. They had revealed the dubious practices of the trade, the
fragility of leading experts and weaknesses among lawyers and judges, but
whether there had been misrepresentation or faking in any particular case
remained, and still remains, in doubt.[2] As Hussey suggested, the outcome
would have important and long-lasting implications not only for the trade
but also for the many owners of antique furniture up and down the country,
therefore one would have expected the Official Referee's concluding remarks
to provide a reasoned assessment of the conflicting evidence of the expert wit-
nesses. Unfortunately he avoided this difficult task by basing all of his deci-
sions on his view of the respective worthiness of the parties and their experts.
Many of the antiques were not mentioned at all, and, when differing opin-
ions were quoted, they were often incorrectly stated or devised by the Senior
Official Referee himself to support the bias from which he undoubtedly suf-
fered. For example, the judgement on the 'Royston Hall' panelling reads, 'the
only point about it was, was it Elizabethan? Undoubtedly it was Elizabethan',
when even Percy MacQuoid's evidence had questioned this, stating it was
'James I'.[3] His final comment on the Royston Room summed up his general
attitude to the expert's evidence in the courtroom: 'Why it was called Royston
Hall, I do not know; Whatever it was thought to be does not matter the least
in the world!'[4] His judgement on Shrager was even more simplistic: 'In my
opinion he wanted to get out of his bargain, and he thought the best way to do
it was to charge the Defendants with fraud'.[5] As a result, the Official Referee
claimed not to 'believe Mr Shrager's evidence; where he differs in any way
from Mr Dighton and Mr Lawrence I accept the evidence of Mr Dighton and
Mr Lawrence in favour of that of Mr Shrager, because I think Mr Shrager over
and over again showed that his evidence was not to be relied upon'.[6] This was
not altogether a surprising conclusion, given his statement that after days of
hearing evidence in court,

> I know nothing of [Shrager] except that he was a bankrupt in the year 1915,
> that he paid 1s. 3d. in the £, his discharge was suspended for two years
> [and] then, somehow or another he was so fortunate that by the Summer
> or Autumn of the year 1919 he was in the position to want a house, and one
> may judge the sort of house he wanted from the fact that he was then ... in
> a condition to spend something like £110,000 upon furnishing alone.[7]

The way the national newspapers had reported the activities in the courtroom
is very telling as to popular interest in the issues under discussion. The case for
'alleged fraudulent misrepresentation in the purchase of valuable furniture'
was first cited in *The Times* and *The Manchester Guardian* on 15 November

1922 under the headings 'Kings Bench Division. Alleged Antique Furniture Fraud: Claim for £85,000' and the more tabloid-friendly '"New Furniture for Old". Rubber Merchant's Antique Collection'.[8] The articles covered the opening day of the first hearing of the case in the King's Bench Division, a hearing that was ultimately suspended because the judge believed a jury would not be equipped to deal with the scale or detail of the case. Instead the case was referred to an Official Referee to make judgement in the following year. Ironically, as the case 'would involve a long and protracted inquiry in the nature of a scientific character', the Lord Chief Justice felt that it could 'not be put to the jury' but instead referred to one man's judgement. Surprisingly, at no point in the subsequent hearing was Sir Edward Pollock's knowledge as a furniture expert asked for or expected! The newspapers were keen enough on the story to report on all four days of the hearing before the Lord Chief Justice. The jury were told of the 'special relationship' that Shrager thought he had with Lawrence and Dighton, how he was unaware of the fact that Dighton and Co. was a limited company, and a number of the objects were discussed. Shrager declared that,

> I have been induced to put together a very large collection and to pay out very large sums for it. I have been told that I was getting things well worth the money, but have since been advised that they are nothing of the kind. The bulk are frauds, and, therefore, the value of the whole collection is destroyed. I believe a few pieces are correctly described, but I think that they have been enormously over-priced and are not worth anything like what I have been charged.[9]

The following year, *The Manchester Guardian* began reporting the trial from its first day on 23 January 1923. Its headline, 'Rich Man's Investment in Antiques', set the tone for subsequent reports, which often focused on the amount Shrager had spent on furniture.[10] In this first article attention was drawn to the fact that 'The plaintiff . . . was a Jew [who] had a private synagogue at his house'.[11] The second day's headline focused on 'A Chest Exhibited at South Kensington', reporting the statement made in court during the cross-examination of Shrager, 'And so South Kensington may be wrong and the experts wrong'.[12] On 26 January, *The Manchester Guardian* asked in its headline, 'Piece of Window-frame in table?', citing the 'candid expert on rich man's furniture'.[13] Reporting on Cescinsky's evidence, the newspaper reiterated some of his statements on the objects in court, including the two cream lacquer cabinets, dismissed by the witness as 'made by wholesale makers of fakes'.[14] The newspapers tended to focus on the more lurid and exciting reports from the experts, such as Cescinky's discussion of faked worm holes,

under the title 'Long worm that has no turning. Reverse holes in antique furniture', and they enjoyed reporting the laughter in the court.[15] Cescinsky must have been pleased with the reports on his performance. Under the title 'The soothing atmosphere of country houses', the report of 31 January quoted Litchfield's evidence, taking much delight in his comment that 'there is a soothing atmosphere in an old country house which often misleads people (laughter). I have felt it myself, and you don't look at things in that atmosphere with the same alertness that you would in the dealer's shop' in response to Sir Ernest's questions on a pair of Chippendale lamp-stands from Edgcote Park.[16] Percy MacQuoid's definitions of 'genuine' rather than 'genuine but restored' were reported eagerly on 7 February 1923, under the heading 'A Good Word for Mr Shrager's furniture'.[17] They went on to quote MacQuoid's comments on Chippendale, stating his belief that 'the term was generic and could be applied to a piece not necessarily made by Chippendale'.[18] The report concluded with the exchange, 'Do you mean to say it is honest to sell a piece and charge a high price for it, and call it "Chippendale" when it is not made by one of the Chippendales?'[19] MacQuoid's reply must have reassured, and at the same time worried, many readers sitting on their 'Chippendale' chairs. 'Yes, certainly, and it is done every day'.[20] The significance of the case was such that each day events were reported in the national press and one can imagine many a purchaser of antique furniture following it religiously, discussing it with friends at his club and her tea parties. On 8 February, the paper commented on the public interest, declaring that 'the antique furniture case at the High Court goes briskly on, and every day the court is crammed'.[21] MacQuoid and Cescinsky's 'opposite views as to the genuineness of many pieces of furniture' was 'nonplussing' to readers and counsel alike, and MacQuoid was described as 'a weary, wary, elderly man, who is now having his fourth day in the witness box . . . [answering] many twisters'.[22] Both *The Times* and *The Manchester Guardian* gleefully reported on the Official Referee's two-hour-long judgement on 28 February 1923. Shrager was presented as having made the accusation because he would never be able to pay the outstanding bill and therefore 'he thought that the best way out', whereas Mr Dighton was reported to be 'a witness of absolute truth'.[23] Sir Edward Pollock concluded that 'wherever Mr Shrager differed from Mr Dighton and Mr Lawrence he preferred the evidence of Mr Dighton and Mr Lawrence', without giving any clear reasons for this prejudice.[24] As for his expert witnesses, Litchfield was dismissed as 'a gentleman of the highest character, but he had retired seventeen years ago and perhaps was not now quite as *au fait* with these matters as the experts called by the defendants'.[25] Cescinsky was reported to have 'made several terrible mistakes . . . and was not always to be relied on', and the Official Referee concluded that 'sometimes people were most ignorant when they were most

assured'.[26] *The Manchester Guardian* headed their report with the bald title 'Mr Shrager Loses', and under the subheading 'Mr. Shrager's Bankruptcy' (which amounted to a character assassination of Shrager), described him as a man who had had money problems in the past, bringing the case to avoid further problems when he could not pay Dighton's bill. Dighton, on the other hand, was described as 'a well-known dealer in antiques . . . in business for fifteen years'.[27] The costs of the case, which had to be met by Shrager, were estimated to exceed £80,000. *The Manchester Guardian* concluded that:

> The result will be welcomed with heartfelt rejoicing in the antique furniture trade, for business had been almost at a standstill since it began. There is nothing so tender as the confidence in antiques, whether old masters or old furniture. Very few people know anything about either, and business is done by confidence. If buyers are once startled and confidence weakens the enormously swollen prices of antiques – and this case had already shown that 100 per cent is a fairly ordinary profit for dealers – cannot be maintained. As a rule the collector has his opposition in his own household, and whother [sic] Cescinsky the expert for the plaintiff was right or not in his disclosures about the trade, his words are sure to have been brought to the attention of every collector in the land, probably by his nearest and dearest. In the opinion of the art dealers (not with the antique furniture departments) it will be a long time before the trade recovers from this case, although, logically, the verdict ought to restore business. As one of them put it, 'I'm afraid it will be a Versailles victory'.[28]

The paper concluded with its hope that the money diverted from antique furniture would 'go to modern art' as there was a need to support 'the best of our young painters'.[29]

The case warranted much comment after the Official Referee's verdict. *The Manchester Guardian* questioned the influence of 'experts' on the day after the trial under the heading, 'The Specialist and the Public', and the following month it referred back to this when examining the role of 'expert witnesses' in a discussion of the controversial topic of 'Humane Killing',

> The case is in the same class with two others which have in the last few weeks been prominently before the public – the difficult class in which, on the one hand, any number of expert witnesses can be called to say that a thing is so; and on the other hand any number of expert witnesses can be called to say it is not so. In the case of Dr Marie Stopes, the medical witnesses were not less divided than the experts and connoisseurs in the antique furniture case. The layman is left in perplexity.[30]

The Shrager–Dighton case again became the subject of much press discussion when it was referred to the Court of Appeal in June 1923. By this point a bankruptcy notice had been issued against Shrager, and a receiver appointed by the defendants. Shrager had fled abroad, and his furniture had suffered a 'sensational' fall in value.[31] Now housed at Barker's furniture stores, the furniture which had cost some £40,000 was said to be worth less than £20,000.[32] This 'slump in prices' was clearly demonstrated when two carpets, bought by Shrager but not from Dighton and Co., were sold on 26 April at Christie's. Having cost Shrager £4,100, they 'realised £460 and £115 respectively. This showed the way in which prices had "tumbled down"'.[33] The Counsel in the Divisional Court who was discussing a motion by the defendants for security for the costs of Shrager's appeal, mentioned 'that it appeared that if one bought in the boom period and sold by forced sale there would be an astounding difference in value', concluding that 'Mr Shrager is a marked man in the antique world'.[34] Shrager's solicitor, Sir Harold Smith, worried that if the furniture was put up for auction, 'we have great fears lest the furniture ring may so operate that it may fetch infinitely less than it values. . . . If there is a deep feeling of resentment in the antique furniture trade against Mr Shrager that antique trade can undoubtedly make this auction sale a comparative fiasco'.[35] Although it would be in the trade's interest to demonstrate how 'genuine' the objects from the courtroom were, their anger was such that they would rather bankrupt Shrager using a 'ring', than see his furniture reach the prices that the defendants had originally charged him. As such, they fed into the hands of Cescinsky the 'proof' that the objects were fakes, as he claimed the prices subsequently fetched at Puttick and Simpson's demonstrated that the objects were worth no more than bad, second-hand goods. Shrager's costs amounted to more than £70,000. He had spent over £100,000 on the furniture, but it was now thought to be worth less than half that and so would not sell for enough to meet his bills.[36] The actual appeal led to a flurry of comment and report.[37] The appeal was also reported in detail in *The Law Times*, *The Solicitor's Journal and Weekly Reporter* and *The Times Law Reports*.[38]

The Divisional Court decided that the judgement must be set aside and on further appeal the three judges of the court of appeal unanimously agreed with this decision. On 26 July 1923, the written judgements of the Divisional Court of Appeal were delivered: 'There remains only the question whether the order of the Divisional Court directing a completion of the trial by Sir Edward Pollock should be varied by directing a trial before some other referee. Such a course could only be justified upon clear evidence of bias, or anything amounting almost to misconduct on the part of Sir Edward Pollock. No such suggestion has been made . . . under these circumstances the cross-appeal fails and must be dismissed with costs'.[39] They were unanimous in

their decision that Sir Edward Pollock should not have taken the case in the first place and that he had no justification for limiting the plaintiff to the evidence of ninety-six items. Where one Judge, Lord Justice Atkin, differed was in the degree of charity with which they viewed Pollock's mistakes and the activities which led up to his acceptance of the case. 'To obtain by improper means a particular judge may be as bad as so to obtain a particular judgment. It sullies the stream of justice at its source'.[40] Atkin said that he had no doubt that defendant and counsel believed that Pollock was the best fitted to try the case but he pointed out that the defendant's solicitor had by improper means obtained a particular judge and that the Official Referee's desk 'put an endorsement on the certificate which was untrue and which he knew to be untrue, and which if it came to the notice of the senior Official Referee he also in the circumstances must have known it to be untrue'.[41] He said there was grave impropriety on the part of the clerk and of Dighton's solicitors 'in attempting, unfortunately with success, to defeat the open order made after consideration by the Lord Chief Justice and to thwart what was in the circumstances the well-founded objection of the plaintiff to trial before the Senior Official Referee'.[42] Not only was Pollock the wrong judge, and one to whom the plaintiff was not prepared to agree, he was also a near relative of Dighton's leading counsel, Ernest Pollock QC. Atkin's opinion was that a completely new hearing should take place in front of the Official Referee next in rotation, but he was in the minority. Lord Justices Bankes and Younger omitted any reference to the relationship and 'strongly recited' 'there have been no suggestions of bias'.[43] Robert Eggerton points out that the legal profession takes pride in the fact that members of the bar can occasionally appear before a judge who is closely related, but the Shrager case was bound to involve contentious decisions on the evidence and arguments on one side against another. Atkin did agree that 'It seems to me inevitable that in such a case, involving necessarily a protracted trial, the opponents would be embarrassed and their confidence in the tribunal undermined'.[44] Lord Justice Younger finally stated that:

> The conclusion is, I think, inevitable. . . . If any order were made the whole of the twenty-five days proceedings before Sir Edward Pollock would be rendered abortive; the enormous expenditure of time and money made in the prosecution of the enquiry before him would be wasted, and the parties would have to begin the trial of the apparently interminable dispute all over again. For this there is, I think, no justification presented to us. In my judgement therefore the cross-appeal should be dismissed.[45]

Thus, the case was referred back to Sir Edward Pollock. As a result Shrager could never hope to win.[46] In any event, he was now bankrupt, a fact reported

in *The Times* on 25 August 1923 under the heading 'Mr A. Shrager's Affairs'.[47] As his affairs were discussed at the Bankruptcy Buildings in London, Shrager was reportedly in Switzerland, from where he had forwarded medical evidence that he was unfit to travel. His solicitor, Mr C. S. Weir, had travelled to see him there and found him 'living in poor circumstances and too ill to attend to business'.[48] In concluding, Shrager's solicitor said that the debtor had 'already made three fortunes and expected to make another when facilities were given him for resuming business'.[49] Unfortunately Shrager would never have the chance to prove this claim, as he died in Lausanne on 1 November 1923, aged 47. Shrager died owing over £100,000 to his creditors, including Dighton and Co. As such, the immediate story of the Shrager–Dighton case came to its sad end. But the repercussions would continue to be felt.

At the end of the case, after the dealer had triumphed, Christopher Hussey wrote in *Country Life*, 'the unfortunate cloud which has been hanging for so many weeks over all concerned with old furniture is now happily dispelled' with a most sweeping vindication of the defendants.[50] Both Hussey's implicit comments, and Ralph Edwards's explicit comments on the case, describing Shrager as 'a minor plutocrat of mid-European origin',[51] underline that this was not just about furniture, however, but also about class and most probably race and religion. The case represented the establishment closing ranks against outsiders.[52] Adolph Shrager was a European Jew, who, it was insinuated, had profited from rubber estates during the war, a volatile mix in the 1920s. He was seconded by Cescinsky, an 'outspoken maverick with a cabinet-maker's chip on his shoulder', against Dighton, 'an English gentleman dealer' whose business stood or fell on his customers' belief in this identity, backed by Percy MacQuoid.[53] Later Edwards was to describe MacQuoid as 'long-accustomed to a comfortable, even a luxurious, way of life, provided for mainly by the ample resources of his devoted wife, whose family were wealthy, long-established China merchants', and as advising 'rich folk with pretensions to taste'.[54] He also was involved in profiting from the sale of his own collections, although Edwards concluded that 'to suggest he was a dealer would be entirely misleading'.[55] As such, the defendants and their associates had much to lose. There were potentially many other losers among the wealthy families whose fortunes were tied up in their homes and antiques, particularly at a time when these could be used as bargaining chips to secure the more readily available cash of American heiresses. Their image was bound up in the presentation of tradition, breeding and history, and to have the very objects on which such a presentation relied questioned in the Courts was potentially devastating in their quest to appear 'proper' and 'genuine'. Their ownership had often been cited in the courtroom as evidence of the truth of provenance, for example, Lady Northcliffe's Queen Anne walnut long seats from Ashley

Park.[56] The design and decoration of the domestic interior had, and continues to provide, a locus for a dialogue between class, race and gender identities, material culture and the languages of interior decoration. They position the domestic interior as a key factor in the formation of personal and collective identities.[57] The collective identities of the richest homes had been questioned. Time and time again objects were verified through their identity as the property of *someone* of appropriate breeding, and in the judges' decisions these identities were once again confirmed as safe and true, at least in the short term. Sighs of relief must have been heard in drawing rooms and great halls across England.

Unfortunately it was too late for Mr Shrager to benefit when R. W. Symonds mounted an exhibition of 'Genuine and Spurious' seventeenth- and eighteenth-century furniture in 1925 on the first floor of Messrs Finnigans, Ltd of Deansgate, Manchester. In it he allowed the public to compare 'several ingenious forgeries' with the 'genuine' to see how the spurious could be detected.[58] One reviewer wondered if such a display should be seen 'in every town – possibly in the museums' in order to discourage the 'imitation of antiques for dishonest purposes'.[59] The trial reinvigorated the discussion of fake furniture in texts such as Symonds's own *English Furniture from Charles II to George II* (1930), which was reviewed in *The Manchester Guardian* under the heading, 'Old Furniture and the Faker'.[60] The book, which was mainly a catalogue of Perceval Griffiths's collection, included a chapter on 'Faking', which proclaimed that Symonds was the first to 'expose the faker's methods' in print.[61] The anonymous reviewer, who sounds remarkably like Herbert Cescinsky in tone, was unconvinced of Symonds's credentials, arguing that the author 'is evidently not a technical man himself' who had 'dangerously' declared 'that genuine pieces are finely proportioned and fakes crude'.[62] In 1931 Cescinsky himself produced one of the most famous books on the subject, *The Gentle Art of Faking Furniture*, which he dedicated to Shrager. In it he asked:

What of the future of the antique trade? Allowing for circulation, antiques being bought and thrown up again on the market, the time must come when the source will dry up. This day is not far distant. What then? Is it possible that fine forgeries, recognised as such, may become valuable in their turn? Remember it is only while the prices of antiques are high that it pays to make these fine fakes. . . . Here is a possibility of the future: the collecting of fine fakes. It opens up a vivid prospect! Fancy a piece of the furniture being catalogued or described as a 'genuine fake; guaranteed!' Fancy the new school of experts which may arise to meet the new demand! One can visualize some of those white and blue circular plaques being affixed to houses and the ruins of factories. 'Here lived (or died) _____, the noted faker'.[63]

Cescinsky was obviously bitter about the outcome of the trial. This rancour is equally evident in his novel, *The Antique Dealer: A Novel That Is Not Fiction*, where the author described himself as a 'Member of the Fine Art Fakers Guild, Fellow of the Society for the Improvement in the Manufacture of the Genuine Antique'.[64] The novel was published just as Cescinsky left England for New York. The story is a satirical exposé of the events surrounding the trial, featuring all of the main protagonists, thinly disguised by a range of pseudonyms. His most bitter enemy, MacQuoid, was caricatured as Patrick McBride. The case in the novel is presented as a contest between the plaintiff, a collector named Edward Hastings Gunn, and the defendant, the dealer who supplied the goods, Frederick Feasant. Cescinsky features as Axel Sorenson who, unsurprisingly, is described as a fine and experienced connoisseur of furniture, in contrast to the witness for the defence, Patrick McBride, who is cruelly portrayed as a plausible charlatan of whom nobody took any notice 'till he married a woman of twenty thousand a year'.[65] In comparison, Sorenson is a man who 'knows. If he's crabbed anything then that thing's wrong, and on that you can bet your last penny'.[66] As the story unfolds Sorenson is the first to reveal the spurious nature of Gunn's collection, despite being warned off by a minor 'dealer posing as an expert', Pagett.[67] In the courtroom, Gunn is represented by the solicitor, Charles Dixon Lock, and his barrister, Sir Hart Ferguson. On the other side, we have the defendants; Ralph Helmer, potentially standing in for Lawrence and described as a 'pup . . . who runs about for Fred Feasant' and as a 'little rat'. Feasant is most likely Dighton, although his name could suggest a play on Frank Partridge, the other dealer who acted as a witness in the original trial. Patrick McBride, their expert witness, is dismissed as being able to 'sketch a bit, and he's read a bit, and he's written a lot – or someone has for him'.[68] As a result of his successful marriage 'he's the fashionable expert – and the biggest bluffer in the trade'.[69] Cescinsky does not hold back in his criticism of McBride, declaring him to be 'an old man and inclined to wander from the point, and to become exceedingly querulous on cross examination'.[70] When questioned on technical details, 'he frankly confessed his ignorance. "I have never been a workman, thank God" he said "and I do not consort with cabinet-makers"'.[71] Cescinsky's bitterness at being rejected as 'a cabinet-maker without a trade' was still apparent.[72] The other witness for the defence is Sir Julius Knipp, standing in for Sir Charles Allom. The defending barristers included Sir Makepeace Rich, a pointed pseudonym for Pollock, and Mr Rivers-Purse. The judge in the first hearing, Mr Justice Knowles is replaced by Sir Oliver Rich, 'uncle to Sir Makepiece Rich'.[73] Tibbenham features as Nils Ollsen, who is described as the maker of reproductions that were supplied to Gunn as antiques. Cescinsky cannot quite bring himself to criticize the workmen. The trade are represented by the auction houses Veritys (Sotheby's);

Horrocks (Christie's); Parkers (Phillips); Purhams (Bonham's); and Perrick and Allsops (Puttick and Simpson). The narrator of the story is Eli Josephs, an antique dealer from Wimbledon. His son, Rupert Josephs, eventually rises to a respectable position in the trade but only after changing his surname to 'James', implying that he is aware of the implications of a Semitic name on business. Josephs is backed by his friend Michael Heard, who, with his father, Rudolph Hirsch, a banker, is reminiscent of a Rothschild. The other 'big' dealers, Maurice 'Bully' Jacobs, Barnet 'Barney' Issacs and Samuel Bloomer Jr, a dealer of 'lordly eminence' and the 'Prince of dealers', are shown throughout to dominate the market and influence the court. The other collectors, Cyrus W. Harding (The Prince of Collectors) and William B. Dwight are parodied as collecting 'almost everything', in reference, most likely, to the American collectors who entered the English market *en masse*. Cescinsky's conclusion offered a warning to 'the wise and erudite collector' to 'narrow his field as much as possible; there is only one man who collects everything, namely the dustman'.[74]

Cescinsky's determination to lampoon MacQuoid was probably a result of his bitterness that his competitor's reputation as an authority on furniture only increased in the aftermath of the trial. MacQuoid was certainly pleased with his performance in court and commissioned a full, and most likely expensive, copy of the proceedings shortly afterwards. MacQuoid had one of his busiest years after the judgement was announced. He was approached by Lord Leverhulme to produce a catalogue of the furniture at the Lady Lever Art Gallery which he worked on until his death in 1925. He also completed the Adam Room at the Gallery in his final year, basing his designs on the panelling in Adam's Music Room at Harewood House. The work was executed by the firm of his fellow witness, Sir Charles Allom.

MacQuoid was also commissioned in 1923 by Edward Hudson to complete one of the most significant works on the history of furniture, a dictionary based on the material assembled in his *History*. While many of the attributions in the earlier book had been questioned in the trial, and would not be accepted today, his first book on furniture remained the standard work until the publication of the three-volume *Dictionary of English Furniture* between 1924 and 1927. Although an elder statesman of the furniture world by the time Hudson approached him, MacQuoid agreed to produce the *Dictionary* with the proviso that the writing should be done by Ralph Edwards, a staff member at *Country Life* and later the Keeper of Furniture and Woodwork at the Victoria and Albert Museum. This was a lucky decision, as Percy MacQuoid died before the second volume was published. The introduction to Volume II stated that it had been 'far advanced' at the time of his death, although recognized the contribution of his wife, Theresa, who was described as being

'in possession of his notes and material'.[75] Edwards later admitted in *Apollo* (1974) that this was not true; MacQuoid had left no notes and the work was completed by Edwards in collaboration with Theresa. Some of pieces illustrated in the *Dictionary* came from MacQuoid's own collection, as Theresa wrote from Hoove Lea, Hove, on 28 November 1924 that, 'We have had two days of total blankness and fog here and have had a vegetarian insane photographer sent by Mr Hudson to photograph furniture whom we did not know what to do with!'[76] Such illustrations no doubt helped with the sale of MacQuoid's collection after his death. The sale, the subject of a report in *The Times* on 30 June 1925, comprised a 'collection [that] has largely been formed during the last thirty or more years', and MacQuoid was described as 'a frequent visitor and buyer at Christie's, a recognised authority on furniture, and the author of several important books on the subject'.[77] The prices realized reflected this provenance, with a Queen Anne red lacquer cabinet making 2,200 guineas and an Elizabethan walnut buffet £1,260. The former was purchased by MacQuoid's fellow witness for the defence, Frank Partridge, and had been illustrated in the *Dictionary*.[78] Mr Philip Rosenback of New York bought the buffet, no doubt encouraged by its publication in *The Age of Oak* and the *Dictionary*.[79]

These prices were in sharp contrast to those made at the sale of the Shrager collection the previous year. Cescinsky took the massive drop in value at Puttrick and Simpson's 1924 sale as vindication of his opinions, claiming that the furniture had realized prices of 'bad second-hand goods'.[80] *The Connoisseur* of June 1924 claimed that the sale was a 'most noteworthy occasion'.[81] The 'Chippendale' items went for significantly less than Shrager had paid, with the pair of side tables, described in court as being 'formerly at Melchet Court' making 320 guineas and the set of 15 carved chairs, bought for £1,150, realizing less than half that amount and going for 480 guineas; the needlework table fetched £216 and the carved serpentine commode, despite being 'exhibited at South Kensington', only 160 guineas.[82] At a further sale in August 1924, the Elizabethan oak buffet was bought for 500 guineas by Frank Partridge.[83] A witness at the trial, he was aware of the discussions that had taken place on the quality of the piece, but obviously thought it worthy, and it would be interesting to know if he sold it on, once again provenanced by the MacQuoid collection. The remainder of the Shrager collection was finally dispersed through three auctions held that year.[84]

Also for sale in August 1924 was a Queen Anne blue lacquer cabinet and a pair of Queen Anne cream lacquer cabinets (see Figure 5.1). The latter were sold for 140 guineas. Many of the pieces sold at Puttick and Simpson's have now disappeared into private collections, but a few are still traceable, including the pair of cream lacquer cabinets. These were two of a number of pieces

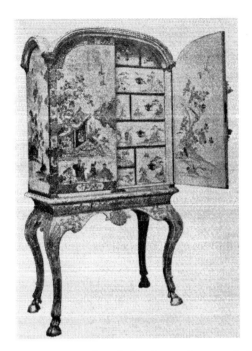

Figure 5.1 'A Famous Lacquer Cabinet', the Cream Lacquer Cabinet, illustrated in Herbert Cescinsky, *The Gentle Art of Faking Furniture* (London: Chapman and Hall Limited, 1931), plate no. 134. Cescinsky claimed that the photograph showed 'one of a pair of yellow lacquer Cabinets from the Shrager case of 1923. They were described by one of the defendant's experts as "utterly genuine" and "fairy-like". The pair were sold to Shrager for £1,250. Evidence was offered . . . that they were bought in Barcelona, but no purchase price was stated, and neither an invoice, nor a bill of lading [sic] was produced. I condemned them as modern fakes (which they were as I saw the stands in the process of making in a kitchen in Charlotte Street, Fitzroy Square) and I valued them at £85 each; £170 the pair. At the subsequent sale at Puttick and Simpson's rooms they fetched £147 the pair, on 2 May 1924. They were bought at this price by the late Lord Leverhulme, and came with his collection to New York in 1927, where I refused to catalogue them. I considered them too "utterly" anything but genuine. They were sold in New York, in separate lots, and one returned to England later.'

purchased by Lord Leverhulme at the sale, even though he was well aware of the risks, and they remain in the collection at Port Sunlight today. Cescinsky published photographs of them in his *Gentle Art of Faking Furniture*, where he credited Lever's 'positive genius for buying fakes'.[85] In the book, Cescinsky claimed that, while writing, he had had before him the catalogue of the Shrager collection, where a pair of cream lacquer cabinets on silvered stands were sold

on 2 May 1924, for £147.[86] He saw this price as absolute vindication of his evidence that they were 'modern, commercial articles, worth at trade prices, £85 each; £170 the pair'.[87] This was significantly less than the £1,250 charged by Dighton to the 'unfortunate Shrager'.[88] Cescinsky's description of the cabinets accompanying their illustration further endorsed his opinion, voiced at the trial, mocking the defendant's experts' claim that they were 'utterly genuine' and 'fairy-like'; Cescinsky claimed that he had seen them in 'the process of making in a kitchen in Charlotte Street, Fitzroy Square'.[89] Litchfield had agreed with this opinion, calling them 'rank duffers'.[90] MacQuoid, on the other hand, had criticized such opinions as 'rather dangerous words to employ', praising their colour as an 'astoundingly charming suggestion of green cream . . . as if a duck had laid a sort of wrong coloured egg', and their 'most delicate and charming decoration'.[91]

While MacQuoid undertook to write the catalogue of furniture at the Lady Lever Gallery, it was Cescinsky who, in 1926, catalogued the furniture sent to sale in New York after Lever's death.[92] Although in his lifetime Cescinsky never received the same recognition as his fellow witness, a fact we have seen as 'largely a social matter', Lucy Wood has suggested that 'with hindsight it seems likely that he was in many ways more distinguished a connoisseur' and 'undoubtedly a perceptive critic of Lever's taste and achievements'.[93] Whereas MacQuoid wasted time trying to induce Lever to add more oak to the collection, Cescinsky realized that 'oak did not appeal to him'.[94] Certainly, Mitchell Kennerley, the Director of the Anderson Galleries who hosted the Lever sale, valued Cescinsky's judgement, calling him a 'well-known authority on English furniture', who was by this date employed as a lecturer at the Metropolitan Museum, New York, and other museums in America.[95] In the same catalogue, Cescinsky claimed a social allegiance with the late Lord Leverhulme, who, he said, 'climbed the ladder of life from the bottom rung, and was not unnaturally proud of the fact, but in no sense with the vanity of the self-made man . . . for riches he had no regard whatsoever. I have never known a man in whose mental make-up there was less snobbery'.[96] Perhaps in Lever he had found some acceptance by the establishment at last, and he praised the collector for his 'passion for acquiring fine things' who 'never bought a thing simply because it was cheap'.[97] At the same time, Cescinsky gently critiqued Lever for collecting 'on his own unaided judgment, without expert advice', thus making mistakes, and he refused to catalogue the cream lacquer cabinets because he 'considered them too "utterly" anything but genuine'.[98] Despite this, they were sold in separate lots, and one returned to the Lever collection in England.[99] The dealer, Moss Harris, who sold the cabinets on to Lever, concluded that they were 'Spanish or Portuguese but old and very decorative for furnishing purposes'.[100]

The exhaustive legal proceedings had failed to produce a satisfactory verdict on the authenticity of Shrager's expensive purchases. They had revealed the dubious practices of the trade, the fragility of leading experts and the weaknesses among lawyers and judges, but whether there had been misrepresentation or faking in any particular case remained (and still remains) in doubt.[101] Above all, the case revealed the prejudices of the period and the powerful role they had to play in law.

The influence of the trial does not end here, however, and ironically it has been used as a source of provenance for objects that have passed through the auction house in recent times. The blue-lac cabinet that sold at Puttick and Simpson's in 1924 came up for sale again, at Christie's, New York, in 1995. Cited as 'the property of a New York Collector', a 'Queen-Anne Blue and Gold Japanned Bureau-cabinet' featured as lot 346. The sale catalogue drew attention to the fact that it had been the 'subject of a large scale lawsuit in 1923', although only quoted the Official Referee's judgement that it was accepted as a 'perfectly genuine article'.[102] Shrager had purchased the cabinet, described by Lawrence as 'a very wonderful blue lac writing bureau, probably unique' on 14 September 1920. It was typical of all the objects purchased at Dighton and Co., in that it came with a resounding and convincing puff from the dealer: 'he said that red lacquer was valuable but blue lacquer was extraordinarily rare. He said "This is absolutely a marvel; you had better have it" and he called it Queen Anne in perfect condition . . . he advised me to have it. I did have it at £850'.[103] This price was later described by Cescinsky as 'simple robbery', and he suggested that it was worth a tenth of that.[104] He also claimed that it was not blue lacquer, but blue paint, and 'certainly not unique, because it is an article which can be acquired from people who make these articles at the present day for such people as like them'.[105] Tibbenham's Ltd was identified as the source of the piece, although the firm claimed not to have sold furniture made in imitation of the antique to Dighton and Co. Under cross-examination, Frederick Tibbenham said that he had worked with the firm for five or six years, had sold about nine pieces of furniture to Basil Dighton Ltd, and that he had also decorated items sent by the dealer Dighton. Two blue-lac cabinets were produced in court, one purchased by Shrager and another from 'a house in Great Russell Street'.[106] Tibbenham admitted that one of the cabinets brought into court had been in his factory at Ipswich, having been 'sent to me to decorate . . . I lacquered it', but he claimed that this was the one from Great Russell Street and that he had only encountered Shrager's cabinet in court.[107] Cescinsky also claimed to have seen the cabinets before, at the Ipswich factory, but Tibbenham claimed not to recollect their encounter. He did admit to having discussed lacquer work with the historian, and Cescinsky claimed to have 'congratulated Mr Tibbenham on his impudence in making

two in blue lacquer'.[108] The company had produced 'eight or ten' blue-lac cabinet during the last three years before the end of 1921, and Tibbenham said that he had never seen a genuine one before.[109] He was questioned about the description as Queen Anne, declaring that it was perfectly honest as long as it was called 'a Queen Anne design', but this would not 'sell it as a queen Anne blue lac cabinet'.[110]

Pollock's team came up with an elaborate story in defence of the cabinet, one that was repeated in the Christie's catalogue in 1995. It was said to have been bought at Christie's on 12 February 1920, where it originated from a Mr Southern-Estcourt of Estcourt, Tetbury. At this point the cabinet was listed in the catalogue as 'an old English lacquer cabinet with folding door, the upper part mounted with panels etc'.[111] At that time, also, the defendants maintained, the exterior of the cabinet was covered in layers of black and gold varnish, although the court was told that the interior retained its vivid blue japanning. It was sold on that day to a Mr Benjamin of the Kent Gallery, buying in association with Dighton, for 60 guineas. Benjamin later claimed that Christie's had missed the fact that it was blue japanned underneath. The bare cabinet, without handles or backplates, was then sent by Dighton to a Mr Herriott of Fitzroy Street who claimed that he had used 'a special thing of my own' which was 'practically composed of petrol' to remove 'three or four coats of old varnish', a process which took three or four weeks and for which he charged Dighton and the Kent Gallery £90.[112] He did not touch the interior at all, he claimed, and from what he could recall, its blue shelves were present and intact at the time of cleaning.[113] MacQuoid admitted knowing little about blue lacquer, having only handled one or two pieces, but nevertheless claimed that the cabinet was 'perfectly genuine' Queen Anne blue japan.[114] His impression was that it was a 'piece of lacquer . . . covered in some other preparation, or dirt, or paint, or more probably filthy varnish that has been removed' and he quite understood 'that something could have been put over this blue that would give it the appearance of black lacquer'.[115] This was the only point in the trial when, unusually, MacQuoid admitted to possessing technical knowledge. Having roundly dismissed the need for an 'expert' to have such knowledge, he now said that he had 'done a good bit of this lacquering' and referred to 'Stalker's book'. Stalker and Parker had mentioned 'Blew Japan' in their 1688 'Treatise of Japanning and Varnishing', although recently Tom Flynn concluded that 'it remains virtually impossible to arrive at a consensus even today on the amount of blue japanned furniture that was actually produced'.[116] MacQuoid had learned to lacquer furniture when he created 'two large cabinets' for the Haymarket Theatre in his days as a designer, and he claimed that 'the dealers used to flock to the stage door to buy them after the performance'.[117] Japanned furniture was particularly popular in the 1920s,

and blue japan was considered very rare. Despite MacQuoid admitting to very limited knowledge of objects of this type, he stated that the cabinet should be described 'as real blue lacquer'.[118] Flynn asked some useful questions of the cabinet in his 1995 article at the time of the Christie's sale: how could the auctioneers at the sale in 1921 have missed its true blue japan nature when its interior was so vividly intact? Why, given the known rarity and value of such objects, would anyone smother a genuine Queen Anne blue japanned cabinet in three quarter coats of black varnish and yet leave the interior intact? How did Herriott manage to remove the varnish (with petrol!) without disturbing the gilt ornament so as to match the exterior so closely with the inside? These questions bothered the witnesses for the prosecution in 1923 and still bothered Flynn over 70 years later. Certainly the cabinet did not fetch its supposed worth at the Puttick and Simpson sale in 1924, where it fetched £400 less than Shrager had paid, although this could be blamed on the public controversy. It was bought by the dealer Moss Harris, who claimed to have known the cabinet before its restoration and could thus vouch for its genuineness. He sold it on to Lord Leverhulme, just as he had the cream lacquer cabinets. In his summation, Pollock used the cabinet in 'his duty' to 'make some criticisms of Mr Cescinsky'. 'It often happens . . . that a piece of furniture is sold at one of the sale rooms, and those who are clever enough see something underneath a possibly unattractive exterior, they buy it, and it is restored, and it is found to be of much greater value than it was originally thought to be at the time of the sale. That is what happened in this case'.[119] At the time of the 1995 sale there were still doubts about the piece. 'Given the controversy', Christie's 'felt it inappropriate to offer a warranty'. Despite this, in 1995 the cabinet once described by Litchfield as 'a glorified wreck after the resurrection',[120] sold to a Connecticut and Ohio buying partnership for $55,000.[121]

What is interesting about this one example of the afterlife of Shrager's collection is that despite the dubious nature of the court case, it is now cited as a provenance to support the sale of an object that was deemed in 1923 to have 'something of an unknown quantity' about it. A trial held 90 years ago is still a valid reminder of the power of the market to alter our perception of an object and determine economic value. The code into which Shrager was attempting to buy – the language of the objects of the antique – was a false one; seemingly transparent, with a long history and provenance, what the case ultimately reveals is that these objects were bound up in a system that masked the real structures of production and social relations rather than made social relations seem achievable and legible.[122]

On 1 November 1923, The Times carried an obituary of Adolphe [sic] Shrager that focused not on his life in general but on the fact that he was 'a plaintiff in the extraordinary dispute about large purchases of antique furniture which

occupied the Courts for many days last year and this year'.[123] The obituary was even headed 'The Old Furniture Case'. A few months earlier, on 24 August, *The Times* had reported on the first meeting of creditors against 'Mr Adolphe [sic] Shrager, of Kent Lodge, Westgate-on-Sea'.[124] It is ironic that, despite having moved to Switzerland – where he was 'found living in poor circumstances and too ill to attend to business' – the address given in *The Times*'s report was the house that Shrager had purchased on moving to England in 1919 to begin his ultimately failed assent through the social ranks.[125] As far as *The Times* obituary was concerned, Shrager was to be remembered only as a 'debtor' who 'alleged that he had been defrauded in purchases of old furniture'.[126] Herbert Cescinsky's frontispiece to *The Gentle Art of Faking Furniture* offered a kinder memorial, dedicating the book 'To the memory of the late Adolph Shrager who acquired a second-hand but first-rate knowledge of both ENGLISH LAW AND ANTIQUE FURNITURE by the simple process of PAYING FOR IT in 1923'. He concluded with a significant warning: 'READER DO THOU NOT LIKEWISE'.[127]

Notes

Notes to Prologue: 'New Furniture for Old'

1 *The Manchester Guardian*, 15 November 1922, p. 3.
2 *The Times*' coverage of the case was often written up under the heading 'alleged antique furniture fraud'.
3 Adele Shrager frequently accompanied Shrager on his buying expeditions. She was often responsible for decisions made on what to buy in Dighton's shop and took over the administration of his business when Shrager fell ill in 1921. Although she was not named in the action, she was often cited in the evidence.
4 'In the Court of appeal; Shrager v. Basil Dighton, Limited and Others, 1923 July 2,3,4,26', *Kings Bench Division*, 1924, p. 274.
5 Ibid., 276–7.
6 *Shrager v. Dighton and Others Trial Manuscript*, transcript published from shorthand notes by Ms Barnett and Barrett, 40, Chancery Lane, London (London: Electric Law Press Ltd, Deed and General Law Printers, 1923), p. 1.
7 Robert Eggerton in 1995 used a multiplier of twenty-one in order to identify the increase in value of money, making the amount equivalent to some £2,335,000, although he acknowledges that the appropriate multiplier to buy properly priced items for 1958–93 should be more than twenty-one, according to John Andrews. For the whole period since 1923, therefore, Eggerton suggests multiplying by a hundred to arrive at present-day value for antiques in general, although for particularly sought-after pieces it is acknowledged that the appreciation can be much higher.
8 Shrager v. Dighton was reported in: Vol. I *Kings Bench Reports*, 1924; Vol. 93 *Law Journal*, Kings Bench, p. 348; Vol. 68 *Solicitors Journal*, p. 166; Vol. 39 *Times Law Reports*, p. 705; Vol. 30 *Law Times*, p. 642. The Shrager case has been cited in three articles on the development of furniture history (Beevers (1984), Muthesius (1988), Flynn (1995)) but has never been subject to an in-depth study.
9 Ralph Edwards, 'Percy MacQuoid and Others', *Apollo*, Vol. XCIX, May 1974, p. 339.
10 Herbert Cescinsky writing as Frederick Akershall, *The Antique Dealer: A Novel That Is Not Fiction*, published c. 1930, quoting William Shakespeare, *The Merchant of Venice*, Act II, vii.

Notes to Chapter 1: *The Emperor's New Clothes: Adolph Shrager*

1 Tom Flynn, 'The Shrager Case', *Antiques Trade Gazette*, 4 March 1995, p. 20.

2 It is vital to understand the class divisions that dominated English society in the 1920s in order to assess the significance of the trial. Therefore it is important to establish from the beginning the way in which class is understood in this book. For this I have turned to Joseph Mordaunt Crook's very useful analysis of class distinctions in *The Rise of the Nouveaux Riches: Style and Status in Victorian and Edwardian Architecture* (London: John Murray, 1999). In his careful consideration of the role of class in the late Victorian and Edwardian periods in England, he distinguishes between the old, landed aristocratic class and the new capitalist class, as yet untitled but significantly monied. Among those individuals comprising this new class, he distinguishes between those who had and those who did not have status within it. To those who had that status he accords the nomenclature 'nouveau riche': they were wealthy enough to display that wealth ostentatiously, and became entitled either as rank or nobility. The old aristocracy, on the other hand, may or may not have had wealth, but they retained their status within the aristocracy by dint of their birth, and their relationship to a specific lineage. There remains a clear distinction between landed, old capital and industrial, new capital. Within both groups there is an elite; the select group with a clear social position in relation to the others in their group. Their status does not rest on financial capital alone, but on the perception of others within their group. The newly monied frequently appropriated the manners and models of the old aristocracy as a model for their own behaviour, and this is where the story of the Shrager Dighton case begins. Adolph Shrager, despite his newly acquired wealth, was unable to obtain the elite status within his class that he so desired. He was a member of the nouveaux riches, but also an *arriviste* from Germany who had made his money in what was perceived to be dubious trading during the First World War. We can also fit Shrager into the class distinctions suggested by Karl Marx in *Capital*. Marx suggests three clear distinctions; the proletariat, who have only their labour to sell; the bourgeoisie, those who have made money through industry and finance, the capitalists who have earned enough to purchase land and status (within this big bourgeoisie there remains a kind of little bourgeoisie, a middle class of shopkeepers, benefiting from the new consumer society); and the aristocracy, whose status is based on land ownership and noble birth. Shrager's money places him in the bourgeoisie, but his race and religion hold him back from obtaining the status he so desires.

3 Mordaunt Crook, 1999, p. 3.

4 Anthony Trollope, *The Way We Live Now* (London: Wordsworth Classics, 2001, first published in 1875), pp. 95–6. Mordaunt Crook quotes Trollope as evidence of social attitudes in the late nineteenth century, p. 3.

5 *Shrager v. Dighton and Others Trial Manuscript*, transcript published from shorthand notes by Ms Barnett and Barrett, 40, Chancery Lane, London (London: Electric Law Press Ltd, Deed and General Law Printers, 1923), pp. 81–2.

6 Ibid., Pollock's directed cross-examination, p. 80.

7 Ibid., p. 399.

8 'The Fascination of Money', *The Spectator*, 23 November 1872, pp. 1486–7, quoted in Mordaunt Crook, 1999, p. 5.

9 Mordaunt Crook, 1999, p. 5.

10 Herbert Cescinsky, *The Gentle Art of Faking Furniture* (London: Chapman and Hall Limited, 1931), p. 13. Mordaunt Crook emphasizes the rise of the nouveaux riches through

the developing terminology of the period; the word 'millionaire' did not exist before the nineteenth century. French in origin, it was soon applied to the new rich of industrial England and America, and *The Spectator* published a list of recent millionaires in England in 1872, under the title 'The Fascination of Money'. Similarly, the term 'nouveaux riches' seems to have been imported from France during the Napoleonic period and by 1813 was used by Maria Edgeworth to describe the commercial magnates of Liverpool and Manchester. See Mordaunt Crook, 1999, p. 7.

11 See, for example, the seminal work of Jean Baudrillard in 'The System of Objects' (1968), in Mark Poster (ed.), *Jean Baudrillard: Selected Writings* (Cambridge: Polity, 1988). Thorstein Veblen had suggested a similar thesis in *The Theory of the Leisure Class* in 1899, reprinted (Amherst, NY: Prometheus Books, 1998).

12 Baudrillard, 'The System of Objects', pp. 13–31.

13 F. Scott Fitzgerald, *The Great Gatsby* (London: Wordsworth Classics, 1993), pp. 6 and 30.

14 See Guy Reynolds, 'Introduction', to F. Scott Fitzgerald, *The Great Gatsby* (London: Wordsworth Classics, 1993), p. xii. See also Thorstein Veblen, *The Theory of the Leisure Class* (1899) (Amherst, NY: Prometheus Books, 1998).

15 Baudrillard's thesis in 'The System of Objects' (1968) is helpful here. However, Shrager's consumer ambitions are located in a time specifically before Baudrillard's world of advertising in a very distinct way. Where Baudrillard sees traditional systems of recognition such as birth status, ritual, language, code of moral values etc. as progressively withdrawing from the system of objects of the later twentieth century, to the advantage of the 'code of social standing' driven in isolation by modern advertising, in 1920s London, the act of buying objects of supposed social recognition does not allow Shrager to break down the barriers of his birth, nationality, religion or race, p. 22. Baudrillard concludes that 'The system of social standing . . . has the advantage of rendering obsolete the rituals of caste or class, and generally, all preceding (and internal) criteria of social discrimination'. Baudrillard, 'The System of Objects', p. 23.

16 Baudrillard goes on to note, 'The code establishes, for the first time in history, a universal system of signs and interpretation. One may regret that it supplants all others. But, conversely, it could be noted that the progressive decline of all other systems (of birth, of class, of positions) – the extension of competition, the largest social migration in history, the ever-increasing differentiation of social groups, and the instability of languages and their proliferation – necessitated the institution of a clear, unambiguous and universal code of recognition. In a world where millions of strangers cross each other daily in the streets the code of "social standing" fulfils an essential social function'. One might argue that in Britain this code of social standing is still not as clear cut as Baudrillard would like to see it. Baudrillard, 'The System of Objects', p. 23.

17 H. G. Wells's *Tono-Bungay* (London: 1909), pp. 306–7.

18 See Mieke Bal, 'Telling Objects: A Narrative Perspective on Collecting', in John Elsner and Roger Cardinal, *The Cultures of Collecting* (London: Reaktion, 1994), pp. 100–1.

19 See J. Bruner, 'Personality Dynamics and the Process of Perceiving', in *Perception: An Approach to Personality*, R. Blake and G. Ramsey (eds), 1951, pp. 121–47, quoted in Russell Belk, *Collecting in a Consumer Society* (London and New York: Routledge, 1995), p. 91.

20 See C. B. MacPherson, 'The Political Theory of Possessive Individualism' (1962), in Charles Harrison and Fred Orton (eds), *Modernism, Criticism, Realism: Alternative Contexts for Art* (London: Longman, 1984), pp. 207–12.

21 James Clifford, 'On Collecting Art and Culture', in *The Predicament of Culture: Twentieth Century Ethnography, Literature and Art* (Cambridge, MA: Harvard University Press, 1988), p. 218.

22 *Punch* of 1843, pp. 40 and 49 quoted in Mordaunt Crook, 1999, p. 3.

23 *Trial Manuscript*, p. 46.

24 Ibid., 85.

25 Between 1895 and 1914, no fewer than thirty men left over two million pounds, and of these, fewer than three came from landed families as the balance of financial power shifted away from the aristocracy. Mordaunt Crook, 1999, pp. 8–9.

26 Mordaunt Crook, 1999, pp. 8–9.

27 Ibid., 9–10.

28 Countess of Cardigan, *My Recollection*, 1911, p. 174, quoted in Mordaunt Crook, 1999, p. 12.

29 *Trial Manuscript*, pp. 81–2.

30 Ibid., 80. Cescinsky commented on the risk of the newly monied from the faker, describing a typical customer as 'William Boggs, who has made a fortune out of "iron rations" for our dear boys at the front?' (1931), p. 3.

31 H. G. Wells, *Tono-Bungay* (London: 1909), pp. 11–13, 77. Gisela Lebzelter, in her excellent account of political anti-Semitism between the wars, offers a useful definition of anti-Semitism as generally meant to describe any hostility against Jews. According to Lebzelter, one should differentiate between an age-old hostility against the Jewish minority, a distinct body of foreigners pleading for political equalization and integration into Christian societies, and the qualitatively new anti-Jewish movement which emerged in the nineteenth century. Gisela C. Lebzelter, *Political Anti-Semitism in England, 1818–39* (London and Basingstoke: Macmillan, 1978), pp. 1–2.

32 *Trial Manuscript*, p. 25. Ironically, Shrager was even overcharged for the symbols of his faith, 'The incense burner was not sold as antique or anything of that sort. I merely mention it because it happens to be one of the Birmingham-made articles which only cost a few shillings. He is charged £16 for that!'

33 Lebzelter, 1978, p. 7.

34 J. Banister, *England under the Jews* (1901), quoted in Lebzelter, 1978, p. 9.

35 See V. D. Lipman, *Social History of the Jews in England, 1850–1950* (London: Watts and Co., 1954), pp. 85–103, quoted in Lebzelter, 1978, p. 7.

36 Lebzelter, 1978, pp. 7–8.

37 Ibid., 8.

38 Ibid., 8–9.

39 Hansard, 4th series, 1905, CIL. 155, quoted in Lebzelter, 1978, p. 13.

40 'Russian Kaleidoscope. Orderly Elements Gaining the Ascendant. The Influence of the Jews', *Morning Post*, 7 August 1917, quoted in Lebzelter, 1978, pp. 14–15.

41 W. S. Churchill to D. Lloyd George, 26 December 1910, quoted in Lebzelter, 1978, p. 9.

42 Board of Deputies of British Jews, *The New Anti-Semitism* (London, 1921), p. 2, quoted in Lebzelter, 1978, p. 10.

43 See Lebzelter, 1978, p. 49.

44 Ibid., 49.

45 See Lebzelter's chapter 'The Britons' for a full discussion of the Society's activities and beliefs, pp. 49-67.

46 The Society's periodical, published from 1920 until 1925, was entitled *The Hidden Hand*, having switched the title from its early incarnation of *Jewry Ueber Alles*, a direct reference to the presumed Judaeo-Germanic conspiracy. In it they claimed in 1921 that 'Jews camouflaged as nationals are the Hidden Hand'. See Lebzelter, 1978, pp. 54-5.

47 Lebzelter, 1978, p. 66.

48 Britons (ed.), 'The Conquering Jew', leaflet, n.d., quoted in Lebzelter, 1978, p. 64.

49 Lebzelter, 1978, p. 67.

50 Letter circulated by Lord Milner, then Secretary of State for War, in 1919 to his Cabinet Collegues, from Mr H. Pearson, Chief Manager of A. Nevsky Cotton Spinning and Weaving Mills, 2 January 1919, quoted in Lebzelter, 1978, p. 18.

51 W. S. Churchill, 'Zionism versus Bolshevism', *Illustrated Sunday Herald*, 8 February 1920, quoted in Lebzelter, 1978, p. 19.

52 Leo Maxse, editor of the *National Review*, LXXII, August 1919, p. 819, quoted in Lebzelter, 1978, p. 20.

53 Recalled by H. Nicholson, *Diaries and Letters, 1930-39* (London, 1966), p. 327; M. Gilbert, *Sir Horace Rumbold* (London, 1967), p. 49; A. Forbes, *Memories and Base Details* (London, 1922), p. 320; all quoted in Lebzelter, 1978, p. 34.

54 A. White, 'The Jews in India' (n.d.), quoted in Lebzelter, 1978, p. 20.

55 Percy MacQuoid in a letter to C. B. Marriot, 25 Berkeley Square, London, W1, 17 November 1924, from Hoove Lea, Beevers' Archive.

56 See Lebzelter, 1978, p. 172. She maps rises in anti-Semitic activity to the two periods of economic decline in the early 1920s and early 1930s, 'What is . . . crucial for the development of anti-Semitism is the combination of socio-economic conditions predisposing large sections of the population towards the reception of propaganda'.

57 Marianne Bertrand and Antoinette Schoar, 'The Role of Family in Family Firms', *The Journal of Economic Perspectives*, Vol. 20, No. 2, Spring 2006, pp. 73-96.

58 Count Conti, *The Rise of the House of Rothschild* (London: Camelot Press, 1928), p. 316.

59 Michael Hall, *Waddesdon Manor: The Heritage of a Rothschild House* (New York: Harry N. Abrams, 2002), p. 22.

60 See Todd Endelman and Tony Kushner (eds), *Disraeli's Jewishness* (London and Portand: Valentine Mitchell, 2002), p. 167.

61 Sir Sydney Lee, *King Edward VII*, 2 vols (London: Macmillan, 1925-7).

62 Robert Blake, *Disraeli* (London: Eyre and Spottiswoode, 1966), p. 10.

63 Ibid., 49.

64 Albert S. Lindemann, *Antisemitism before the Holocaust* (ed. Richard Levy) (Addison-Wesley, 2000), p. 626.

65 V. D. Lipman, *A History of the Jews in Britain since 1858* (New York: Holmes and Meier, 1990), p. 78.

66 See Mark Girouard, *Life in the English Country House* (Harmondsworth: Penguin, 1980).

67 This was eventually published in *Apollo*, July 2007, with an introduction by Michael Hall, pp. 50–77.

68 Ferdinand de Rothschild, 'Bric-a-Brac', 1897, *Apollo*, July 2007, pp. 50–77.

69 Ibid.

70 Ferdinand de Rothschild, 'Bric-a-Brac', published in *Apollo*, July 2007. His reference is to M. Spitzer, a famous Parisian dealer of the period.

71 *The Crawford Papers, 1892–1940*, ed. J. Vincent (Manchester, 1984), 22 July 1939, p. 599, quoted in Mordaunt Crook, 1999, p. 63.

72 *The Crawford Papers, 1892–1940*, 22 July 1939, p. 599, quoted in Mordaunt Crook, 1999, p. 63.

73 T. H. S. Escott, 'King Edward and his Court', 1903, pp. 224–5, quoted in Mordaunt Crook, 1999, p. 155.

74 Mordaunt Crook, 1999, p. 156.

75 *The Crawford Papers, 1892–1940*, 22 July 1939, p. 599, quoted in Mordaunt Crook, 1999, p. 156.

76 Ibid.

77 Mordaunt Crook, 1999, p. 156

78 G. R. Searle, *Corruption in British Politics* (Oxford, 1987), p. 26 and *The Spectator*, 22 May 1897, p. 732, both quoted in Mordaunt Crook, 1999, p. 157.

79 *Trial Manuscript*, pp. 81–2.

80 Ibid., 110.

81 Ibid., 2.

82 Ibid., 3.

83 Ibid., 3.

84 See Susie McKellar and Penny Sparke (eds), *Interior Design and Identity* (Manchester: Manchester University Press, 2004), pp. 3–4.

85 Mark Jones, 'Why Fakes?', in Susan Pearce (ed.), *Interpreting Objects and Collections* (London: Routledge, 1994), p. 94.

86 McKellar and Sparke (eds), 2004, p. 6.

87 See ibid., 79.

88 Louise Ward, 'Chintz, Swags and Bows: the Myth of the English Country House Style, 1930–90', in McKellar and Penny Sparke (eds), 2004, pp. 92–102. Ward cites the example of Nancy Lancaster (1897–1994) and her work for her firm of Colefax and Fowler. She was the American owner of a British firm, settled permanently in England in the 1920s, and provided her clients with an 'authentic English country house interior', as demonstrated by the Yellow Room, her drawing room-cum-library above the premises of Colefax and Fowler in London. Her homes were described as 'an inspiration to those who inherited or acquired houses in the years before or immediately after the war' (John Cornforth, 'Living in her Own Style', obituary of Nancy Lancaster, *The Guardian*, 26 August 1994, quoted in Ward, p. 98).

89 Jones, 1994, p. 92.

90 *Trial Manuscript*, p. 4.

91 Ibid., 4.

92 Ibid., 15.

93 Martin Daunton and Matthew Hilton (eds), *The Politics of Consumption: Material Culture and Citizenship in Europe and America* (Oxford: Berg, 2001), p. 14.

94 See, for example, G. Crossick and S. Jaumain (eds), *Cathedrals of Consumption: The European Department Store, 1850-1939* (Aldershot: Ashgate, 1999); M. B. Miller, *The Bon Marché: Bourgeois Culture and the Department Store, 1869-1920* (Princeton: Princton University Press, 1981) and E.D. Rappaport, *Shopping for Pleasure: Women and the Making of London's West End* (Princeton: Princeton University Press, 2000).

95 Mica Nava, 'Modernity's Disavowal: Women, the city and the department store', in M. Nava and A. O'Shea (eds), *Modern Times: Reflections on a Century of English Modernity* (London: Routledge, 1996), p. 46. See also Margot C. Finn, 'Scotch Drapers and the Politics of Modernity', in Martin Daunton and Matthew Hilton (eds), *The Politics of Consumption: Material Culture and Citizenship in Europe and America* (Oxford: Berg, 2001), pp. 89-107.

96 See E. D. Rappaport, *Shopping for Pleasure: Women and the Making of London's West End* (Princeton: Princeton University Press, 2000), p. 50.

97 John Benson, *The Rise of Consumer Society in Britain, 1880-1980* (London: Longman, 1994), p. 62.

98 *Trial Manuscript*, p. 402.

99 Ibid., 18.

100 Ibid., 46.

101 Ibid., 46-7.

102 Ibid., 48.

103 Ibid., 55-6.

104 Ibid., 3.

105 Ibid.

106 Ibid.

107 Ibid.

108 Ibid., 18.

109 Ibid., 5.

110 Ibid., 4-5.

111 Ibid., 8-9.

112 Jones, 1994, p. 94.

113 Cescinsky, 1931, p. 7.

114 Jones, 1994, p. 94.

115 Cescinsky, 1931, p. 7.

116 Mark Jones, *Why Fakes Matter: An Essay on the Problems of Authenticity* (London: British Museum Press, 1992).

117 Susan Pearce, *On Collecting: An Investigation into Collecting in the European Tradition* (London: Routledge, 1995), p. 154.

118 Baudrillard, 'The System of Objects', p. 27.

119 Cescinsky, 1931, p. vii.

120 David Lowenthal, 'Forging the Past', in Mark Jones (ed.), *Fake, The Art of Deception* (London: British Museum, 1990), p. 19.

121 Stefan Muthesius, 'Why Do We Buy Old Furniture? Aspects of the Authentic Antique in Britain, 1870–1910', *Art History*, Vol. 11, No. 2, June 1988, p. 231.

122 *Trial Manuscript*, p. 346.

123 Cescinsky, 1931, p. 8.

124 Muthesius, 1988, p. 244.

125 Walter Benjamin, 'Unpacking my Library: A Talk about Collecting' (1931), in *Selected Writings*, M. W. Jennings, H. Eiland and G. Smith (eds), Vol. 2, Part 2, 1931–4 (Cambridge, MA: Harvard University Press, 1999), p. 487.

126 Jones, 1990, p. 95.

127 Cescinsky, 1931, pp. 6–7.

128 *Trial Manuscript*, pp. 370–1.

129 Arjun Appadurai (ed.), *The Social Life of Things: Commodities in a Cultural Perspective* (Cambridge: Cambridge University Press, 1986), p. 3.

130 A second layer of meaning is attached to the definition of 'unique' to indicate a level of quality, i.e. 'a uniquely undamaged piece', or 'a uniquely surviving piece', indicating that although the object would not have been unique in its original incarnation, its uniqueness has been created through time. The *Oxford English Dictionary* provides useful examples to support the definition of 'unique' as 'the only one of its kind' in quotes that reference both the collector and the nouveau riche: Firstly it cites a line from *Faust* (1875), II, ii, I, p. 84, 'A thing so totally unique the great collectors would go far to seek', and then a description from Kenneth William's *Wind in the Willows*, of Toad's Hall, 'an eligible self-contained gentleman's residence, very unique' (p. 168).

131 George Simmel, *The Philosophy of Money* (1907) (Translation; London: Routledge and Kegan Paul, 1978), p. 100.

132 Appadurai, 1986, p. 4.

133 *Trial Manuscript*, p. 324.

134 Cescinsky, 1931, p. 7.

135 Appadurai, 1986, p. 4.

136 Jean Baudrillard, 'The Art Auction', in *For a Critique of the Political Economy of a Sign* (St Louis, MO: Telos Press, 1981), p. 121.

137 Baudrillard, 'The Art Auction', p. 117.

138 *Trial Manuscript*, pp. 61–2.

139 Ibid., 48, 60, 61, 63, 64, 66–8.

140 Susan Stewart, *On Longing: Narratives of the Miniature, the Gigantic, the Souvenir, the Collection* (Durham, NC: Duke University Press, 1993), p. ix.

141 *Trial Manuscript*, p. 68.

142 Stewart, 1993, p. 17.

143 'Objects are *categories of objects* which quite tyrannically induce *categories of persons*. They undertake the policing of social meanings, and the significations they engender are controlled. Their proliferation, simultaneously arbitrary and coherent, is the best vehicle for a social order, equally arbitrary and coherent, to materialise itself under the sign of affluence', Baudrillard, 'The System of Objects', p. 20.

144 *Trial Manuscript*, p. 60.

145 Ibid., 72.

146 Baudrillard, 'The System of Objects', p. 20.

147 *Trial Manuscript*, p. 127.

148 Ibid., 127. Dighton's sold the bureau to Shrager for £230 on 19 November 1920. Cescinsky valued it at £21.

149 *Trial Manuscript*, pp. 383–4.

150 Ibid.

151 Ibid.

152 Here Pollock conflates the antique shop and the auction house. Although the spaces are intimately related, they are not the same, but it was a useful conflation for the defence as it implied that the price in the shop was not fixed just as the price in the auction house was not fixed, but went up or down according to the desire of the bidders. The price in the shop, however, is fixed more formally by the use of the price tag, even if these are coded (as in the case of Dighton and Co), and, although there is the opportunity to haggle, the seller has a greater role in fixing the price than he would have in the auction room.

153 *Trial Manuscript*, pp. 383–4.

154 Ibid., 339.

155 Ibid., 353.

156 The word 'genuine' is as debated in the courtroom as 'original'. Samuel Johnson's *Dictionary* defined 'genuine' as 'unadulterated; real; true (as opposed to adulterated; sophisticated; counterfeit; spurious' (*Dictionary of the English Language*, Vol. I, Part II (1882) (London: Longmans), pp. 1050–1). This definition survives today, with the *Oxford English Dictionary* defining it as 'really proceeding from its reputed source . . . not spurious; = authentic . . . not counterfeit'. Ironically the *Oxford English Dictionary* also offers the definition 'natural, not foreign . . . native', which could be seen as the antithesis of the perception of Shrager in the eyes of the courtroom. It is not clear why the prosecution did not use Johnson's definition to their advantage.

157 *Trial Manuscript*, pp. 494–5.

158 Susan Moore, 'Faith and Faultless Choice; Furniture in the Early Years of Country Life', *Country Life*, 8 January 1987, p. 72.

159 'An Upholstered Stuart Armchair', *Country Life*, Vol. XXIX, 29 April 1911, pp. 610–11.

160 Percy MacQuoid, *A History of English Furniture: The Age of Walnut* (London: Lawrence and Bullen, 1904–8), p. 25.

161 Moore, 1987, p. 72.

162 *Trial Manuscript*, pp. 494–5.

163 Percy MacQuoid, 'An Upholstered Stuart Armchair', p. 610; MacQuoid, *A History of English Furniture* (London: Lawrence and Bullen, 1905), p. 25, fig. 26. See also David Beevers, 'Antiquarian Taste and English Furniture from Horace Walpole to Percy MacQuoid', introduction to Percy MacQuoid, *A History of English Furniture*, Volume 1 (Woodbridge: Antique Collectors Club, 1987), p. xvii. 'The armchair here illustrated suggests that its maker must have been the Chippendale of his time . . . the chair was discovered at Rushbrook Hall about 4 years ago in a very dilapidated condition; it stood by the side of a Stuart bed with the tattered remnants of curtains of the same velvet'. In Percy MacQuoid's first article for *Country Life*, the chair in the photograph is described as 'the property of Percy MacQuoid'.

164 *Trial Manuscript*, pp. 493–5.

165 Letter from MacQuoid to Lady Stamford, 4 December 1907, Dunham Massey MSS, John Rylands Library, Manchester, quoted in Beevers, 1987, p. xvii. Unfortunately the prosecution did not make this comparison and one wonders how carefully they had prepared their brief.

166 Kryzsztof Pomian, *Collectionneurs, Amateurs et Curieux* (1987), translated by Elizabeth Wyles-Portier as *Collectors and Curiosities; Paris and Venice, 1500–1800* (Cambridge: Polity, 1990), p. 18.

167 Susan Pearce, *Museums, Objects, Collections* (Leicester: Leicester University Press, 1992), p. 66.

168 *Trial Manuscript*, pp. 98–9.

169 Ibid., 370–1.

170 Ibid., 399–400.

171 Appadurai, 1986, p. 21.

172 *Trial Manuscript*, pp. 15–16.

173 Ibid., Letter of 14 December 1921, p. 386.

174 Ibid., 19.

175 Ibid., 402.

176 Ibid., 59.

177 Ibid., 25.

178 Ibid., Letter from Basil Dighton, 12 December 1921, p. 27.

179 Ibid., 386–7.

180 Ibid., Letter from Mrs Shrager, 14 December 1921, p. 28.

181 Ibid., 28.

182 Ibid., 28–9.

183 Ibid., 28–9.

184 Ibid., 28–9.

185 Ibid., 29.

186 Ibid., 29.

187 Ibid., 33.

188 Ibid., 369–70.

189 Ibid., 403.

190 Ibid., 403.

191 Ibid., 78–9.

192 Ibid., Pollock, pp. 388–9.

Notes to Chapter 2: 'Make us Rich': Dighton and Co and the Market for Furniture

 1 Ferdinand de Rothschild, 'Bric-a-Brac', 1897, *Apollo*, July 2007, pp. 50–77.

 2 *Shrager v. Dighton and Others Trial Manuscript*, transcript published from shorthand notes by Ms Barnett and Barrett, 40, Chancery Lane, London (London: Electric Law Press Ltd, Deed and General Law Printers, 1923), p. 46.

 3 Elizabeth Stillinger, *The Antiquers* (New York: Knopf, 1980).

4 John Cornforth, 'Dealing in History: The Rise of the Taste for English Furniture', Introduction to the *Catalogue of the Grosvenor House Antiques Fair*, 1983, pp. 16–17.

5 *Art History*, Vol. 11, No. 2, June 1988, pp. 231–53.

6 Mark Westgarth, *The Emergence of the Antique and Curiosity Dealer 1815–1850: The Commodification of Historical Objects* (Farnham, Surrey: Ashgate, 2011) (forthcoming) and Mark Westgarth, 'A Biographical Dictionary of 19th Century Antique and Curiosity Dealers', *The Journal of Regional Furniture History*, Vol. MMIX, 2009, pp. 1–204.

7 David Beevers, 'Antiquarian Taste and English Furniture from Horace Walpole to Percy MacQuoid', introduction to Percy MacQuoid, *A History of English Furniture*, Volume 1 (Woodbridge: Antique Collectors Club, 1987), p. vi.

8 Adam Smith, *The Wealth of Nations* (1776), quoted in Beevers (1987), p. vii.

9 Quoted in Beevers, 1987, pp. vii–viii. Also see Simon Jervis, 'The Pryor's Bank, Fulham, Residence of Thomas Baylis Esquire. An Illustration of the Presentation of Ancient Works and their Application to Modern Purposes', *Furniture History*, X, 1974, p. 90.

10 Quoted in Beevers, 1987, p. viii.

11 Cornforth, 1983, p. 16.

12 Ibid.

13 See Mark Westgarth, 'A Cruise through the Brokers: Wardour Street and the London Antique and Curiosity Markets in the mid nineteenth century', paper delivered at AAH, Tate Britain, London, 2008. Aspects of this paper will appear in Mark Westgarth, *The Emergence of the Antique and Curiosity Dealer 1815–1850: The Commodification of Historical Objects* (Farnham, Surrey: Ashgate, 2011) (forthcoming).

14 The South Kensington Museum, which was founded in 1852 at Marlborough House, was renamed, by order of the Queen, the Victoria and Albert Museum in 1899, when she laid the foundation stone of the new building in which it remains today. The new museum was opened in 1909.

15 Gerald Reitlinger, *The Economics of Taste* (London: Barrie and Rockcliff, 1961).

16 Westgarth, 2009, pp. 7–10.

17 Westgarth, 2009, p.23. For a detailed consideration of these literary portrayals of the dealer see Westgarth, 2011.

18 Marjorie Caygill, 'Franks and the British Museum – The Cuckoo in the Nest', in Majorie Caygill and John Cherry (eds.), *A.W.Franks:Nineteenth Century Collecting and the British Museum* (London: British Museum, 1997), p. 98. I am grateful to Mark Westgarth for drawing my attention to this quote.

19 Hungerford Pollen, *Ancient and Modern Furniture in the South Kensington Museum* (London, 1874), p. 114.

20 Cornforth, 1983, p. 16.

21 Charles Eastlake, *Hints on Household Taste in Furniture and Upholstery and Other Details* (London: Longmans, 1868).

22 Ibid., vi–vii.

23 Ibid., vii.

24 Lucy Wood, 'Lever's Objectives in Collecting Old Furniture', *Journal of History of Collections*, Vol. 4, No. 2, 1992, p. 211.

25 *Fortnightly Review*, ed. G. H. Lewes, 15 May 1865, pp. 124–5.

26 Eastlake, 1868, p. 54.

27 Reginald Blomfield quoting from the 'Arts and Crafts Essays by Members of the Arts and Crafts Exhibition Society', 1893, pp. 289–301, quoted in Stefan Muthesius, 'Why Do We Buy Old Furniture? Aspects of the Authentic Antique in Britain, 1870–1910', *Art History*, Vol. 11, No. 2, June 1988, p. 237.

28 Eastlake, 1868, p. 54.

29 Ibid., 58.

30 See Westgarth, 2011.

31 Westgarth, 2009, p. 14.

32 *Trial Manuscript*, p. 472.

33 Ibid.

34 See Westgarth, 2009, Christopher Breward, *Fashioning London, Clothing and the Modern Metropolis* (Oxford: Berg, 2004) and Jane Rendell, *The Pursuit of Pleasure: Gender, Space, and Architecture in Regency London* (London, Athlone, 2002).

35 Westgarth, 2009, pp.12–15.

36 See Westgarth, 2008, 2009, pp. 12–15, and 2011.

37 Cescinsky's cross-examination, *Trial Manuscript*, pp. 350–2.

38 Rhoda and Agnes Garrett, *Suggestions for House Decoration in Painting, Woodwork and Furniture* (London: Macmillan and Co, 1877), p. 11.

39 Ibid., 7.

40 Ibid., 11.

41 Ibid., 13.

42 Muthesius, 1988, pp. 231–53.

43 Ibid., 233.

44 *Cornhill Magazine*, January to June, 1875, p. 535, quoted in Muthesius, p. 239.

45 Eastlake, 1868, p. 59.

46 Muthesius, 1988, pp. 233 and 235.

47 'Of London Houses: The Yellow House, 8 Palace Court, the Residence of Mr Percy MacQuoid, RI', *The King*, 19 April 1902, pp. 258–9.

48 W. Shaw Sparrow, *Hints on House Furnishing*, 1909, p. 60, quoted in Muthesius, 1988, p. 237.

49 Frederick Litchfield, *How to Collect Old Furniture* (London, 1904), p. 68, quoted in Muthesius, 1988, p. 238.

50 Cornforth, 1983, p. 16.

51 Rhoda and Agnes Garrett, 1877, p. 5.

52 *Cornhill Magazine*, January–June 1875, p. 535, quoted in Muthesius, p. 239.

53 'John Bull's New House', *All the Year Round*, second series, Vol. 19, 1877–8, pp. 5–19, quoted in Muthesius, 1988, p. 239.

54 Muthesius, 1988, p. 231.

55 Ibid., 240.

56 Cornforth, 1983, p. 16.

57 Muthesius, 1988, p. 241.

58 R. W. Symonds, *The Present State of English Furniture*, 1921, p. 5, quoted in Muthesius, 1988, p. 242.

59 'Well, there are two saws in a power shop which are capable of cutting shapes, a fret saw and a band saw. The circular saw serrations are too big. A power driven band saw differs from a hand saw in that it is always going while you are working, and when you are stopping, and when you come to a sharp corner, and you have to pause a little to get your wood round; the saw is running all the time and it is making a series of attempts to go on until you get it round the corner. I said it appeared to have that feel and that led me to believe that it was cut with a power band saw . . . (the witness pointed out the indications) here there are two or three things which I submit are tentative cuts, as if the wood had not been pushed against the saw . . . *Here* it is more distinctly shown still. These signs are unmistakable' (*Trial Manuscript*, p. 328). 'The general crudity, the new-ness of the wood, the badness of the detail, the badness of the carving and all the other points which I illustrated here when the genuine and spurious were put together' (*Trial Manuscript*, pp. 326-7).

60 *Trial Manuscript*, p. 50.

61 See Gerald Reitlinger, *The Economics of Taste*, Vol. II, 1961, pp. 152-3.

62 Simon Houfe, 'Percival D. Griffiths Collection: "Intuitively Collected"', *Country Life*, Vol. CLXXXIV, No. 52, 27 December 1990, p. 44.

63 Ibid., 44.

64 Ibid., 44.

65 Ibid., 44-5.

66 Ibid., 45.

67 Ibid., 45.

68 Muthesius, 1988, p. 243.

69 *Trial Manuscript*, p. 2.

70 Herbert Cescinsky, *The Gentle Art of Faking Furniture* (London: Chapman and Hall Limited, 1931), p. 86.

71 Ibid., 2.

72 Christopher Hussey, 'The Furniture Case', *Country Life*, Vol. 53, 10 March 1923, p. 322.

73 Garretts, 1877, p. 6.

74 The firm became Lenygon and Morant in 1912 after merging with Morant and Co.

75 Francis Lenygon, *The Decoration and Furniture of English Mansions during the Seventeenth and Eighteenth Centuries* (London, 1909), p. 57.

76 Cornforth, 1983, p. 17.

77 See Eleanor Dew and Pat Kirkham, 'National Identities and Transnational Antiques: Francis Lenygon and Lenygon and Morant, c. 1904-1943' due to be published in Abigail Harrison Moore and Mark Westgarth (eds), *Dealers and Collectors: The Market for Decorative Arts* (forthcoming).

78 Martin Battersby, *The Decorative Twenties* (London: Studio Vista, 1969), p. 128.

79 Morant and Co was founded in 1884.

80 *Country Life*, 12 June, 1997 p. 138.

81 Ibid., 138-9.

82 Cescinsky, 1931, p. 1.

83 Henry James, *The Outcry* (New York, 1911), p. 17. I am grateful to Eleanor Dew and Pat Kirkham for drawing my attention to this reference.

84 Letter to Crosfield (not signed) from Sir Charles Allom, 12 December 1918, Wittanhurst, Beevers' Archive.

85 Ian Gow, 'Floors Castle, Roxburghshire,' *Country Life*, 7 August 1997, p. 52.

86 Ibid., 52.

87 Ibid., 54.

88 *Country Life*, 25 April and 6 June 1931, cited in Gow, 1997, p. 54.

89 Jeremy Musson, 'Houses for a Superior Person', *Country Life*, 1 January 1998, p. 41.

90 David Beevers in letter to *Country Life*, 12 January 1998, published 5 February 1998. The bed may now be at Hackwood Park, Hampshire. From 1905 Hackwood was let to Lord Curzon, and was sold in 1935 to William Berry, first Viscount Camrose. He acquired the house with part of its contents, which were sold by Christie's on 20–22 April 1998. I am grateful to David Beevers for this information.

91 David Beevers, 'Percy MacQuoid, Artist, Decorator and Historian', 2 parts, *The Antique Collector*, June 1984(a), pp. 70–5, July 1984(b), pp. 48–53. The Morant Archives were destroyed in the war and so the exact connection with Morant and Co and later Lenygon and Morant is uncertain.

92 Beevers, 1984a, pp. 70–5; 1984b, pp. 48–53.

93 Beevers, 1984a, p. 73.

94 Likewise, MacQuoid was involved with the decoration of the Treasurer's House in York, and has been described as a 'friend' of Frank Green, its owner. See Jeremy Musson, 'The Treasurer's House, York', *Country Life*, Vol. CXCIV, No. 23, 8 June 2000, p. 186.

95 *Trial Manuscript*, p. 46. Harry Walton Lawrence was also an executor of Theresa MacQuoid's will, and, therefore, a close friend. I am grateful to David Beevers for bringing this information to my attention.

96 Ibid., 46–7.

97 Ibid., 79–80.

98 Ibid., 82–5.

99 Frederick Litchfield, *How to Collect Old Furniture* (London, George Bell and Sons, 1904), p. 41.

100 Muthesius, p. 241.

101 Ibid., 243.

102 *Trial Manuscript*, p. 383.

103 Pierre Bourdieu, *Outlines of a Theory of Practice* (Cambridge: Cambridge University Press, 1977).

104 See Robert Watts, 'Mellor's "Grotesque Fakes" Row turns Ugly', *The Sunday Times*, 10 January 2010, p. 7. David Mellor lost his case on 31 July 2010.

105 Ibid., 7.

106 *Trial Manuscript*, p. 48.

107 Cescinsky, 1931, p. 2.

108 *Trial Manuscript*, pp. 55–6.

109 See Howard Eiland and Kevin McLaughlin, 'Translators' Foreword' to Walter Benjamin, *The Arcades Project* (written 1927–40, first published 1982) (Cambridge, MA: Harvard University Press, 1999), pp. ix–xi.

110 Walter Benjamin, *The Arcades Project* (written 1927–40, first published in 1982) (Cambridge, MA: Harvard University Press, 1999), p. 3.

111 Ibid., 3.
112 Karl Marx, *Contribution to a Critique of Political Economy* (New York: International Publishers, 1970), p. 87, quoted in Jean Baudrillard, 'Consumer Society' (1968), in Mark Poster (ed.), *Jean Baudrillard: Selected Writings* (Cambridge: Polity, 1988), p. 33.
113 Cescinsky said of Dighton's code, 'The price labels in every case are peculiar . . . the labels are all in code . . . I make these letters to read "Make us rich" . . . those are the labels attached to this particular business'. *Trial Manuscript*, p. 205.
114 14 February 1923, *Trial Manuscript*, p. 15.
115 Ibid., 111.
116 Benjamin, 1927-40, p. 839.
117 *Trial Manuscript*, pp. 66-7.
118 Ibid., 4.
119 Ibid.
120 Jean Baudrillard, 'Consumer Society', p. 34.
121 Ibid.
122 Ibid.
123 See Michel Foucault, 'Of Different Spaces', in J. D. Faubion, *Essential Works of Foucault, 1954-1984* (London: Penguin, 2000), p. 178. 'I am interested in certain ones that have the curious property of being in relation with all the other sites, but in such a way as to suspect, neutralize, or invent the set of relations that they happen to designate, mirror, or reflect. These spaces, as it were, which are linked with all the others, which however contradict all the other sites, are of two main types. First there are the utopias. Utopias are sites with no real place. They are sites that have a general relation of direct or inverted analogy with the real space of Society. They present society itself in a perfected form, or else society turned upside down, but in any case these utopias are fundamentally unreal spaces'.

'There are also, probably in every culture, in every civilization, real places – places that do exist and that are formed in the very founding of society – which are something like counter-sites, a kind of effectively enacted utopia in which the real sites, all the other real sites that can be found within the culture, are simultaneously represented, contested, and inverted. Places of this kind are outside of all places, even though it may be possible to indicate their location in reality. Because these places are absolutely different from all the sites that they reflect and speak about, I shall call them, by way of contrast to utopias, heterotopias. I believe that between utopias and these quite other sites, these heterotopias, there might be a sort of mixed, joint experience, which would be the mirror. The mirror is, after all, a utopia, since it is a placeless place'.
124 Jean Baudrillard, 'Simulacra and Simulations', in Mark Poster (ed.), *Jean Baudrillard: Selected Writings* (Cambridge: Polity, 1988), p. 169.
125 Ibid., 169.
126 Trevor Keeble, in Penny Sparkes (ed.), *The Modern Period Room: The Construction of the Exhibited Interior, 1870-1950* (London: Routledge, 2006), p. 2.
127 See Wood, 1992, pp. 211-26.
128 Lady Dorothy Nevill, quoted in Wood, 1992, p. 216.
129 Byron Webber, *James Orrock RI* (London, 1903), note 15, 1, p. 18. Quoted in Wood, 1992, p. 217.

130 John Marshall to Sir Henry Campbell Bannerman, 23 December 1905 (British Library Add MS 41,226, fol. 80), cited in Wood, 1992, p. 217.

131 Cosmo Monkhouse, 'A Connoisseur and his Surroundings', *Art Journal* (1892), pp. 12–17. See Wood, 1992, p. 217.

132 Constance Simon, *English Furniture Designers* (London, A. H. Bullen, 1905), pp. 200–4. See Wood, 1992.

133 Ibid., 200.

134 Cescinsky, 1931, p. 127.

135 Ibid.

136 Michael Shippobottom, 'The Building of the Lady Lever Art Gallery', *Journal of History of Collections*, Vol. 4, No. 2, 1992, pp. 186–93. William Hesketh Lever was created Baronet in 1911 and was then made Baron Leverhulme in 1917 and Viscount Leverhulme in 1922.

137 Percy MacQuoid, *The Leverhulme Art Collections*, Volume III: *Furniture, Tapestry and Needlework* (London, Batsford, 1928), p. 34. It also featured in *Connoisseur*, 48, 1917, pp. 113–66. See Shippobottom, 1992, pp. 186–93.

138 Shippobottom, 1992, p. 186. The catalogue was completed after MacQuoid's death by Theresa MacQuoid but published under his name.

139 Percy MacQuoid described it as 'in the style of William Kent'. MacQuoid (1928), p. 58.

140 Lady Lever Art Gallery archives, transcript of letter from Lever to Arthur Edwards, 21 December 1921, quoted in Shippobottom, 1992, p. 187.

141 Shippobottom, 1992, p. 186.

142 Eastlake, 1868, pp. 65–6.

143 See Wood, 1992, p. 219.

144 'Of London Houses: The Yellow House', p. 256. The design for the Yellow House was also illustrated in *The British Architect*, Vol. 37, May 1892, p. 379, entitled 'House and Studio, Palace Court Bayswater, for PM esq. Ernest George and Peto architects'. Text by T. Raffles Davison on p. 371: 'Mr Ernest George has given us in Mr Percy MacQuoid's studio a type of house such as that artist has often portrayed with capital effect. A forecourt like this is often a good adjunct for effect.'

 Interestingly, the rooms at the Yellow House, as photographed in *The King*, also resembled the displays in the antique shop, as they were created at Dighton and Co and Lenygon and Co. In 1924 *Connoisseur* magazine illustrated a mock-up of an antiques shop exhibited in the Victoria and Albert Museum and the museum was famed for its period rooms. As such, we can see how there was a clear visual parallel between the domestic interior, commercial display and the period room displays of the museum. This brings to life Benjamin's theories in *The Arcades Project*.

145 *The King*, 19 April 1902, p. 258.

146 Ibid., 258–9.

147 John Cornforth, 'London's Uncrowned King', *Country Life*, Vol. XIV, No. 22, 1 June 2000, p. 136.

148 Bric a Brac (MS 1896), quoted by Geoffrey de Bellaigue in *The James A. de Rothschild Collection at Waddesdon Manor: Furniture, Clocks, and Gilt Bronzes* (Fribourg, 1974), p. 13. Published in *Apollo*, July 2007, pp. 50–77.

149 H. P. Shapland, *Style Schemes in Antique Furnishing* (London, 1909), pp. 29, 36, quoted in Wood, p. 220.

150 Julius Bryant, 'Curating the Georgian Interior', *Journal of Design History*, Vol. 20, No. 4, 2007, pp. 345–50.

151 Jean Baudrillard highlights this drive to recreation and representation, 'When the real is no longer what it used to be, nostalgia assumes its full meaning. There is a proliferation of myths of origin and signs of reality; of second-hand truth, objectivity and authenticity'. 'Simulacra and Simulations', p. 174.

152 John Harris, 'A Cautionary Tale of Two "Period" Rooms', *Apollo*, CXLII, July 1995, pp. 56–7. See also 'The Destruction of the Country House 1875–1975' exhibition at the Victoria and Albert Museum (1974).

153 Ibid., 56.

154 Ibid., 56.

155 Ibid., 56. See also John Harris, 'English Rooms in American Museums' *Country Life*, 8 June 1961; John Harris, 'The Room that Never Was. The Myth of the Kempshott Park Saloon', *Country Life*, Vol. CLXXXII, No. 41, 13 October 1988, p. 260.

156 'Antique Furniture Claim. Damages Awarded', *The Manchester Guardian*, 30 May 1925, p. 14.

157 Michel Foucault, 'Of Different Spaces', in J. D. Faubion (ed.), *Essential Works of Foucault, 1954–1984* (London: Penguin, 2000), p. 179.

158 *Trial Manuscript*, p. 526.

159 Ibid., 420

160 'Utopias are spaces which have no real space, a perfect version or reversion of society', Foucault, 'Of Different Spaces', p. 178.

161 *Trial Manuscript*, pp. 69–70.

162 Ibid.

163 Ibid.

164 Ibid.

165 Ibid., 29–30.

166 Ibid.

167 Didier Maleuvre, *Museum Memories: History, Technology, Art* (Stanford, CA: Stanford University Press, 1999), pp. 119–20.

168 *Trial Manuscript*, pp. 29–30.

169 Ibid., 101–10, 118.

170 Ibid., 31–3.

171 In Jean Baudrillard's 'Simulation and Simulacra' (1988), the concept of authenticity becomes redundant as the simulation bears no connection to the thing it simulates and becomes an entity in itself. But in the courtroom the question of authenticity was key. Unlike Baudrillard's simulation, here the need was to prove that the room had its origin in reality.

172 *Trial Manuscript*, pp. 31–3.

173 Ibid.

174 Ibid.

175 Cescinsky, 1931, p. 7.

176 Ibid., vii.

177 *Trial Manuscript*, p. 400.

178 Roland Barthes, 'Death of the Author', in J. Caughie (ed.), *Theories of Authorship* (London and Boston: Routledge and Kegan Paul, 1981), p. 208.

179 Roland Barthes, 'Myth Today', in Susan Sontag (ed.), *Barthes: A Reader* (London: Fontana, 1983), p. 94.

180 Ibid., 94.

181 Harris, 1995, pp. 56–7. See also John Harris, *Moving Rooms: The Trade in Architectural Salvages* (New Haven and London: Yale University Press, 2007).

182 'Alleged Antique Furniture Fraud', *The Times*, 17 November 1922, p. 5. The Royston Room evidence is also recorded in *The Manchester Guardian* on the same day, and both papers featured the story the previous day, and on 24 January 1923 and 6 February 1923.

183 Three between 1891 and 1912 with a further three between 1936 and 1955. See Bryant, 2007, p. 345.

184 Ibid.

185 *Trial Manuscript*, pp. 118–20.

186 Ibid., 122.

187 Ibid.

188 Ibid., 123.

189 Ibid., 133.

190 Cescinsky, 1931, p. 54.

191 Ibid.

192 Ibid.

193 Ibid., 73–4.

194 *Trial Manuscript*, pp. 361–4.

195 Cescinsky, 1931, p. 76.

196 Keeble, 2006, p. 2.

197 Cescinsky, 1931, p. 75.

198 Ibid., 153.

199 See James Deetz, *In Small Things Forgotten* (Garden City, NY: Doubleday Natural History Press, 1977), p. 7: 'Material Culture is that segment of man's physical environment which is purposefully shaped by him according to a culturally dictated plan'.

200 20 December 1919, *Trial Manuscript*, p. 12.

201 Jones, 'Why Fakes?', p. 92.

202 *Trial Manuscript*, p. 12.

203 Arjun Appadurai, 'Commodities and the Politics of Value', in Susan Pearce (ed.), *Interpreting Objects and Collections* (London: Routledge, 1994), p. 76.

204 George Simmel, *The Philosophy of Money* (1907) (translation; London: Routledge and Kegan Paul, 1978), p. 67.

205 Appadurai, 1994, p. 77.

206 *Trial Manuscript*, p. 21.

207 Walter Benjamin, 'The Work of Art in the Age of Mechanical Reproduction', in Hannah Arendt (ed.), *Illuminations* (London: Pimlico, 1999).

208 *Trial Manuscript*, p. 329.

209 Cescinsky, 1931, p. 39.

210 Kryzsztof Pomian, *Collectionneurs, Amateurs et Curieux* (1987), translated by Elizabeth Wyles-Portier as *Collectors and Curiosities: Paris and Venice, 1500–1800* (Cambridge: Polity, 1990), p. 193.

211 Susan Pearce, *On Collecting: An Investigation into Collecting in the European Tradition* (London: Routledge, 1995), p. 379.

212 Pomian, 1990, p. 39.

213 Ibid., 194.

214 Ralph Edwards, 'Percy MacQuoid and Others', *Apollo*, Vol. XCIX, May 1974, pp. 332–9.

215 *Trial Manuscript*, pp. 453–4.

216 Ibid., 377–8.

217 Frank Herrmann, *The English as Collectors: A Documentary Chrestomathy* (London: Chatto and Windus, 1972), p. 34.

218 E. H. Carr, *What Is History?* (Harmondsworth: Penguin, 1978).

219 Cescinsky, 1931, pp. 119–20.

220 Herrmann, 1972, p. 33.

221 Ibid., 34.

222 *Trial Manuscript*, pp. 55–6.

223 See Michel Foucault, *The Archaeology of Knowledge* (London: Routledge, 1994).

224 Michel Foucault, *Power/Knowledge*, C. Gordon (ed.) (Hemel Hempstead: Harvester Wheatsheaf, 1980), p. 240.

225 Ibid.

226 Pomian, 1990, p. 194.

227 Karl Marx, 'The Labour Theory of Value' from 'Capital', in Maynard Solomon (ed.), *Marxism and Art* (Sussex: Harvester, 1979), p. 24.

228 Pearce, 1995, p. 27.

229 *Trial Manuscript*, pp. 371–2.

230 Ibid., 397–8.

231 Pearce, 1995, p. 285.

232 *Trial Manuscript*, pp. 330–1.

233 Carr, 1978, p. 12.

234 Ibid., 13.

235 *Trial Manuscript*, p. 442.

236 Carr, 1978, p. 21.

237 *Trial Manuscript*, pp. 339–40.

238 Cescinsky, 1931, pp. 154–5.

239 *Trial Manuscript*, pp. 379–80.

240 Ibid., 398.

241 Cescinsky, 1931, p. 54.

Notes to Chapter 3: 'The Faker's Bible': Percy MacQuoid, Herbert Cescinsky and the Role of the 'Expert'

1 'The Specialist and the Public', *The Manchester Guardian*, 28 February 1923, p. 8.

2 Herbert Cescinsky, *The Gentle Art of Faking Furniture* (London: Chapman and Hall Limited, 1931), p. 8.

3 *Shrager v. Dighton and Others Trial Manuscript*, transcript published from shorthand notes by Ms Barnett and Barrett, 40, Chancery Lane, London (London: Electric Law Press Ltd, Deed and General Law Printers, 1923), p. 400.

4 Cescinsky, 1931, pp. 53–4.

5 Ibid., 153.

6 Elizabeth White (ed.), *A Pictorial Dictionary of British Eighteenth Century Furniture Design: Printed Sources* (Woodbridge, Suffolk: Antique Collectors Club, 1990), p. 18.

7 This has been linked by Elizabeth White to the passing of the Engraver's Copyright Act, also known as Hogarth's Act, in 1734, which for the first time protected the designer from illicit copying by others.

8 Ibid.

9 Texts published in the nineteenth century still focused on the practical side of the furniture business. These included J. C. Loudon's *Encyclopedia of Cottage, Farm and Villa Architecture* (1833), Henry Shaw's *Specimens of Ancient Furniture* (1836), T. F. Hunt's *Examples of Tudor Architecture . . . and Furniture of the Tudor Period* (1841), J. Lewis Andre's *Chests, Chairs, Cabinets and Old English Woodwork* (1879), A. E. Chancellor's *Examples of Old Furniture* and W. G. Poulson Townsend's *Measured Drawings of French Furniture from the Collection of South Kensington* (1899). Towards the end of the century, these texts found a new audience among early antique buyers. A. Jacquemart published *A History of Furniture* in 1878. See Stefan Muthesius, 'Why Do We Buy Old Furniture? Aspects of the Authentic Antique in Britain, 1870–1910', *Art History*, Vol. 11, No. 2, June 1988, p. 252.

10 Muthesius, 1988, p. 232.

11 Hungerford Pollen, *Ancient and Modern Furniture in the South Kensington Museum* (London, 1874), p. 1.

12 Ibid., 3.

13 Ibid., 84.

14 *The Builder*, 10 October 1874, pp. 841–2, quoted in Muthesius, 1988, p. 238.

15 *All the Year Round*, second series, Vol. 19, 1877–8, pp. 5–10, quoted in Muthesius, 1988, p. 239.

16 See J. Aldam Heaton, *Furniture and Decoration in England during the Eighteenth Century* (London, 1892) for example.

17 Hermann Muthesius, *Das Englishe Haus*, Vol. III (Berlin, 1905). See Muthesius, 1988, p. 240.

18 By using the phrase 'in the style of . . .' to describe its images, it was still a part of the pattern book genre. See Muthesius, 1988, p. 241.

19 Beevers, 1987, p. x.

20 Frederick Litchfield, *Illustrated History of Furniture* (London, 1892), p. 80, quoted in Beevers, 1987, p. x.

21 Muthesius, 1988, p. 241.

22 Ibid.

23 *Trial Manuscript*, pp. 82–5.

24 Early twentieth century furniture history texts include W. H. Hackett, *Decorative Furniture of the Sixteenth, Seventeenth and Eighteenth Centuries* (1902); F. Roe, *Ancient Coffers and Cupboards* (1902); F. Litchfield, *How to Collect Old Furniture* (1904); P. MacQuoid, *A History of English Furniture* (4 vols, 1904); C. Simon, *English Furniture Designers of the Eighteenth Century* (1905); Fred S. Robinson, *English Furniture* (1905); R. S. Clouston, *English Furniture and Furniture Makers of the Eighteenth Century* (1906); H. Cescinsky, *English Furniture in the Eighteenth Century* (3 vols, 1909–11); E. Foley, *The Book of Decorative Furniture* (2 vols, 1910–11); F. Lenygon, *Furniture in England* (1914); F. Litchfield, *Antiques Genuine and Spurious: An Art Expert's Recollections and Cautions* (1921); and R. W. Symonds, *The Present State of English Furniture* (1921). See Muthesius, 1988, p. 253.

25 See Muthesius, 1988, p. 241.

26 Cescinsky, 1931, p. 153.

27 *Country Life*, 16 April 1910, p. 555. See Muthesius, 1988, p. 241.

28 R. W. Symonds, *The Present State of English Furniture* (1921), p. 5. See Muthesius, 1988, p. 242.

29 '"English Furniture Designers of the Eighteenth Century", By Constance Simon, 1905', *Burlington Magazine for Connoisseurs*, Vol. 7, No. 26, May 1905, p. 167.

30 '"A History of English Furniture", By Percy MacQuoid . . . Vol. I. "The Age of Oak"', *Burlington Magazine for Connoisseurs*, Vol. 7, No. 26, May 1905, pp. 166-7.

31 *Burlington Magazine for Connoisseurs*, 1905, p. 167.

32 Such as the review for '"Chats on Old Furniture", By Arthur Hayden', *Burlington Magazine for Connoisseurs*, Vol. 7, No. 26, May 1905, p. 167, which described it as 'A really popular book – pleasantly written, well illustrated, and remarkably cheap. It is also as trustworthy as can be reasonably expected of any small book that covers so much ground'.

33 F. Litchfield, *How to Collect Old Furniture* (1904); A. Hayden, *Chats on Old Furniture, A Practical Guide to Collectors* (1905); G. O. Wheeler, *Old English Furniture of the Seventeenth and Eighteenth Centuries, A Guide for the Collector* (1907). Later publications in the same vein included F. Litchfield, *Antiques Genuine and Spurious: An Art Expert's Recollections and Cautions* (1921).

34 *Trial Manuscript*, pp. 219 and 503.

35 Ibid., 403 and Beevers, 1987, p. xv.

36 *Trial Manuscript*, p. 403.

37 Beevers, 1984b, p. 48.

38 Ralph Edwards, 'Percy MacQuoid and Others', *Apollo*, Vol. XCIX, May 1974, p. 337.

39 Ibid.

40 Ibid.

41 *Trial Manuscript*, pp. 398, 970, 447, and 552.

42 Ibid., 398-9.

43 Ibid.

44 Ibid., 486.

45 Ibid., 971 and 973.

46 Edwards, 1974, p. 337.

47 An elite British private school.

48 Beevers, 1984a, p. 70. David Beevers's notes made on visit to Mrs L. T. Fairchild, great niece of Theresa MacQuoid, 18 August 1983, state that, 'Percy MacQuoid was first married 7 November 1877 to Charlotte Thom of 8 Westwick Gardens'. Percy MacQuoid's address is given as 8, Coleherne Terrace when first married. A child was apparently born but died aged a few months. Beevers'Archive.

49 Thomas Rohan, *Confessions of a Dealer* (London, 1924), p. 91, quoted in Beevers, 1984a, p. 70.

50 Beevers, 1984a, p. 70.

51 *Trial Manuscript*, pp. 403 and 492.

52 Ibid., 403.

53 The MacQuoids feature in Peto's Visitor's Book, Wiltshire Records Office, from their houses in Heronden, Eastby, Kent (1892), Landford Manor, near Salisbury, Wilts (1895-9) and Ilford Manor, Bradford on Avon (1899-1933), which shows Percy MacQuoid stayed first in 1892 at Peto's first country house and then in 1893, 1894, 1895, 1896, 1897 and

1899; Robin Whalley, letter to David Beevers, 3 March 1999 and Graeme Moore, letters to David Beevers 2 July 1984 and 10 July 1984, Beevers' Archive. When signing the visitor's book MacQuoid liked to do little sketches, particularly of Peto's daschunds.

54 See Beevers, 1984a, pp. 70–2.

55 *The King*, 1902, p. 256.

56 See Beevers, 1984a, pp. 70–5.

57 Gervase Jackson-Stops, 'Dunham Massey, Cheshire I, II and III', *Country Life*, Vol. CLXIX, 4 June 1981, pp. 1562–5.

58 Ibid.

59 See Jane Morrison, 'Percy MacQuoid, Decorator, Historian, Artist; A fresh examination of the decorative work of Percy MacQuoid as seen in the remodelling and redecorations of the state rooms at Dunham Massey Hall, c. 1907–9' unpublished MA dissertation, Department of Museum Studies, Manchester University, 1986, later published in edited form as 'MacQuoid at Dunham Massey, a National Trust Property', *Country Life*, 2 July 1987, Vol. CLXXXI, pp. 156–60.

60 See Morrison, 1986.

61 Percy MacQuoid, 'An Upholstered Stuart Armchair', *Country Life*, 29 April 1911, Vol. XXIX, p. 610; Percy MacQuoid, *A History of English Furniture* (London: Lawrence and Bullen, 1905), p. 25, fig. 26. See also Beevers, 1987, p. xvii.

62 *Trial Manuscript*, pp. 493–5.

63 Letter from Percy MacQuoid to Lady Stamford, 4 December 1907, Dunham Massey MSS, John Rylands Library, Manchester, quoted in Beevers, 1987, p. xvii.

64 Margaret Jourdain, *The Morant Collection of Old Velvets, Damasks, Brocades etc.* (pp. 16–17), quoted in Morrison, 1986, p. 7.

65 Morrison, 1986, p. 18.

66 Ibid., 10.

67 Likewise his employer's business would have been affected by any questions raised about the authenticity of their products. Morant and Co (later Lenygon and Morant) were interior decorators to Edward VII. The Company owned an oak chest which was illustrated in MacQuoid's *History* (fig 53). Their archives survive in the Victoria and Albert Museum; Lenygon and Morant papers, AAD 3–1984.

68 As demonstrated by his letter to Lady Stamford, 27 October 1907, 'I found Lord Harewood's things wonderful, in fact the best of the period in England', Beevers, 1984a, p. 73.

69 Lord Curzon, who also employed McQuoid via Lenygon and Morant, was heir to Kedleston. The estate came to him in 1916. Inside Kedleston he undertook major redecoration, including the painting and gilding of the Marble Hall and the grand saloon, described in correspondence with MacQuoid in 1914. See Jeremy Musson, 'Houses for a Superior Person', *County Life*, 1 January 1998, pp. 38–41.

70 David Beevers, letter to *Country Life*, 12 January 1998, published 5 February 1998.

71 Letter to Lady Crosfield from White Allom, 13 October 1920 from 15 George Street, Hanover Square, Beevers' Archive.

72 Beevers, 1984a, p. 75.

73 Edwards, 1974, pp. 332–9.

74 Undated letter, to Sir Arthur Crosfield from Percy MacQuoid, written at the Yellow House. Beevers' Archive.

75 Note from Percy MacQuoid to Sir Arthur Crosfield, undated and unsigned, Beevers' Archive.

76 *Trial Manuscript*, quoted in Beevers, 1987, p. xx.

77 *Trial Manuscript*, p. 492.

78 Ibid., 46.

79 MacQuoid, 1904–8, pp. 33 and 56. See also letter to David Beevers from Lord Rochdale, 22 April 1987, Beevers' Archive.

80 See Sotheby's: The West Wycombe Park Sale, 22, 23, 24 July 1998, 'The Rochdale Family of Lingholm, Cumbria', pp. 118–33, particularly Lot 364, p. 122, 'an oak side table, English, late c15th'. 'MacQuoid' refers to *A History of English Furniture: The Age of Oak*, p. 4, Fig. 4. and 'Edwards' refers to *A Dictionary of English Furniture* (1924–7), Vol. 3, p. 275, Fig. 2.

81 Letter, 6 January 1906 from D. L. Isaacs to William Hesketh Lever, from 'Antique Furniture Warehouses', 44, 46 and 48 New Oxford Street WC, London to Thornton Manor, Cheshire, Beevers' Archive.

82 Letters; 8 January, 8 February, and 13 February 1906 from D. L. Isaacs to William Hesketh Lever, from 'Antique Furniture Warehouses', 44, 46 and 48 New Oxford Street WC, London to Thornton Manor, Cheshire, Beevers' Archive.

83 Percy MacQuoid, *Dictionary of English Furniture* (London, 1924–7), Vol. I, Introduction by H. A. Tipping, p. xvii.

84 *Trial Manuscript*, 5 Feb 1923, p. 442.

85 Ibid.

86 Ibid.

87 Ibid.

88 Cescinsky, 1931, p. 59.

89 Cescinsky, quoted in R.W. Symonds, 'Herbert Cescinsky and English Eighteenth Century Furniture,' *Connoisseur,* September 1958, p. 18.

90 R.W. Symonds, 'Herbert Cescinsky and English Eighteenth Century Furniture,' pp. 18–23.

91 Ibid., 18.

92 Ibid.

93 Ibid.

94 Ibid.

95 'News and Comments', *Connoisseur,* April 1937, p. 229.

96 Herbert Cescinsky in 'News and Comments', *Connoisseur,* April 1937, p. 230.

97 Cescinsky, 1937, p. 230.

98 *Trial Manuscript*, pp. 206–7.

99 Ibid.

100 Ibid.

101 Ibid.

102 Ibid., 125.

103 Ibid., 206–7.

104 Ibid.
105 Cesincsky, 1931, p. 2.
106 *Trial Manuscript*, p. 432.
107 *Trial Manuscript*, pp. 206-7.
108 Cesincsky, 1931, p. 3.
109 Cesincsky, 1931, p. 50. The Ockwells credence was also illustrated on p. 44 of Frederick Litchfield's *Illustrated History of Furniture* (1892), where it was described as late fifteenth century.
110 *Trial Manuscript*, p. 963.
111 Ibid., 985-6.
112 Ibid.
113 Ibid.
114 Ibid., 328.
115 Ibid.
116 Ibid.
117 Ibid., 447.
118 Ibid., 437-8.
119 Ibid.
120 Ibid., 962.
121 Ibid., 410, 442, 449.
122 Ibid., 404-5.
123 Ibid.
124 Ibid.
125 Ibid.,
126 Ibid., 410.
127 Ibid.
128 Ibid.
129 Ibid., 442.
130 Ibid., 449.
131 Cescinsky, 1931, pp. 53-4.
132 *Trial Manuscript*, pp. 958-61.
133 Ibid., 398-9.
134 Ibid., 64.
135 Ibid.
136 Ibid., 415-16.
137 Ibid.
138 Ibid., 333-6.
139 Ibid., 254.
140 Ibid., 415-16.
141 Ibid.
142 Ibid., 546.
143 Ibid., 972.
144 Symonds, 1958, p. 18.
145 Ibid.

146 Ibid., 19–20.

147 *Trial Manuscript*, p. 963.

148 Symonds, 1958, pp. 18–23.

149 *Trial Manuscript*, p. 958.

150 Ibid., 958.

151 Ibid., 986.

152 Ibid., 987–9.

153 Ibid., 990.

154 Ibid., 1036.

155 Ibid., 1037.

156 Ibid.

157 See Henry E. Huntington Library and Art Gallery, San Marino, California, Manuscripts collection HEH 16/1 Huntington v. Lewis and Simmons. Notes of Proceedings, May 1917 before Justice Darling, p. 81.

158 Huntington v. Lewis and Simmons. Notes of Proceedings, May 1917 before Justice Darling, p. 109. There was also a long discussion with MacQuoid about whether Mrs Siddons was of a 'Semitic type' (p. 115).

159 Ibid., 111–12.

160 *Northern Daily Telegraph*, Blackburn, 18 May 1917; 'Eyes like a motor lamp', *Halifax Evening Courier*, 18 May 1917.

161 'An American's Art Purchase; Doubt cast on authority of a portrait', *Birmingham Post*, 18 May 1917; 'Experts and disputed picture; Strong criticism', *Yorkshire Evening Post*, 17 May 1917; 'Mrs Siddons Eyes', *South Wales Echo*, 18 May 1917.

162 Letter to Davison, curator at the Lady Lever Art Gallery from Percy MacQuoid, 31 March 1923, sent from the Yellow House. He also wrote on 18 April, 1923, 'I have been waiting to answer until I am clear of this silver [sic] case that is coming on in which I have to give evidence'. Theresa MacQuoid wrote on 17 May 1923 from the Yellow House, 'Mr MacQuoid asked me to say that he has been waiting to write to you till he knew about this lawsuit which now has been postponed again', Beevers' Archive.

163 Letters to Davison, curator at the Lady Lever Art Gallery, sent from the Yellow House by Theresa MacQuoid, 2 March 1924, Lady Lever Archives. I am grateful to Lucy Wood for pointing out these archival references in correspondence with David Beevers.

164 'The Specialist and the Public', *The Manchester Guardian*, 28 February 1923, p. 8.

165 Michel Foucault, *The Order of Things* (London: Tavistock, 1985), p. xv.

166 See Baudrillard, 'The Art Auction', pp. 112–21.

167 Foucault, 1985, p. xviii.

168 *Trial Manuscript*, p. 82.

Notes to Chapter 4: 'Disputed Fragments': Shrager's Collection of 'Fine Furniture'

1 *The Sphere*, 3 March 1923, Vol. 92, p. 216b. *The Sphere* was a British newspaper, published weekly from 27 January 1900 until 27 June 1964. It concentrated on news stories of international interest as it was targeted at British Citizens living in the colonies.

2 *The Sphere*, 10 February 1923, Vol. 92, p. ii.

3 *The Sphere*, 3 March 1923, Vol. 92, p. 215b.

4 *Shrager v. Dighton and Others Trial Manuscript*, transcript published from shorthand notes by Ms Barnett and Barrett, 40, Chancery Lane, London (London: Electric Law Press Ltd, Deed and General Law Printers, 1923), pp. 443 and 494.

5 *Trial Manuscript*, quoted in an unpublished article by Robert Eggerton, 'The Furniture Case'.

6 *Trial Manuscript*, p. 2.

7 Christopher Hussey, 'The Furniture Case', *Country Life*, Vol. 53, 10 March 1923, p. 322.

8 *Trial Manuscript*, p. 3.

9 Ibid.

10 See Lucy Wood, 'Lever's Objectives in Collecting Old Furniture', *Journal of History of Collections*, Vol. 4, No. 2, 1992, pp. 211–26.

11 Joseph Mordaunt Crook, *The Rise of the Nouveaux Riches: Style and Status in Victorian and Edwardian Architecture* (London: John Murray, 1999), p. 44.

12 See Wood, 1992, pp. 211–26.

13 See Wood, 1992, pp. 211–26 and Stefan Muthesius, 'Why Do We Buy Old Furniture? Aspects of the Authentic Antique in Britain, 1870–1910', *Art History*, Vol. 11, No. 2, June 1988, pp. 231–53.

14 'The Domestic Furniture of the Eighteenth Century', 1871, pp. 161–2, quoted in Wood, 1992, pp. 214–15.

15 H. Avray Tipping, 'Percy MacQuoid, An Appreciation', *County Life*, 28 March 1925, p. 491.

16 Wood, 1992, p. 215.

17 *The Builder*, 10 October 1874, pp. 841–2, quoted in Muthesius, 1988, p. 238.

18 *Cornhill Magazine*, January–June 1975, p. 546, quoted in Muthesius, 1988, p. 238.

19 Susan Moore, 'Faith and Faultless Choice; Furniture in the Early Years of Country Life', *Country Life*, 8 January 1987, p. 72. See also Roy Strong, *Country Life, 1897–1997: The English Arcadia* (London: Boxtree, 1999).

20 Moore, 1987, p. 72.

21 Ibid., 72–5.

22 Ibid., 72.

23 'Stuart Armchair', *Country Life*, 29 April 1911, pp. 610–11; see also *Trial Manuscript*, p. 494.

24 John Cornforth, 'Hudson's Choice', *Country Life*, Vol. CXCI, No. 2, 12 June 1997, p. 139.

25 Ibid., 138.

26 Hudson employed Lutyens as an architect and writer and regularly championed his work.

27 Jourdain had written for the magazine since 1906 and from 1911 was on a regular retainer from Lenygon and Morant, writing their book on the *Decoration and Furniture of English Mansions during the Seventeenth and Eighteenth Centuries* in 1909, and *Furniture in England, 1660–1760*, a catalogue of the firm's Georgian premises in Burlington Street in 1914.

28 Moore, 1987, p. 71.

29 Ibid., 74

30 Cornforth, 1997, p. 139.

31 Simon Houfe, 'Percival D. Griffiths Collection: "Intuitively Collected"', *Country Life*, Vol. CLXXXIV, No. 52, 27 December 1990, p. 44.

32 Cornforth, 1997, p. 139.

33 Ibid.

34 Jeremy Musson, 'The Treasurer's House, York', *Country Life*, Vol. CXCIV, No. 23, 8 June 2000, p. 186.

35 Ibid. Musson points out that the secretaire has recently been identified as a composite-piece.

36 Ibid., See also 'An Upholstered Stuart Armchair', *Country Life*, 29 April 1911, Vol. XXIX, pp. 610–11.

37 Moore, 1987, pp. 73–4.

38 Ibid., 74

39 Cornforth, 1997 p. 139.

40 Charles Eastlake, *Hints on Household Taste in Furniture and Upholstery and Other Details* (London: Longmans, 1868), p. 89.

41 Hungerford Pollen, *Ancient and Modern Furniture in the South Kensington Museum* (London, 1874), p. 114.

42 Didier Maleuvre, *Museum Memories: History, Technology, Art* (Stanford, CA: Stanford University Press, 1999), p. 1.

43 Ibid., p. 11.

44 *The King*, 19 April 1902, p. 256.

45 Ibid.

46 *Trial Manuscript*, p. 403.

47 Ibid., 206–7.

48 Ibid., 135.

49 Lowenthal, 2008, p. 1.

50 Walter Benjamin, *The Reproduction of a Work of Art* (1936), 1968 edition, p. 222.

51 'A Valuable collection of English Seventeenth Century Furniture', Catalogue, Jenner and Dell Sale, 18 and 19 January 1932.

52 *Trial Manuscript*, pp. 399–400.

53 Herbert Cescinsky, *The Gentle Art of Faking Furniture* (London: Chapman and Hall Limited, 1931), p. 16.

54 *Trial Manuscript*, p. 346.

55 Ibid.

56 Ibid., 86.

57 Ibid., 96–8.

58 Ibid.

59 Ibid., 336.

60 Ibid.

61 Ibid., 454.

62 'Close Examination, Fakes, Mistakes and Discoveries', National Gallery, London, 30 June–12 December 2010; 'The Metropolitan Police Service's Investigation of Fakes and Forgeries', Victoria and Albert Museum, London, 23 January–7 February 2010.

63 Susan Pearce, *Museums, Objects, Collections* (Leicester: Leicester University Press, 1992), p. 66.

64 Susan Pearce, *On Collecting: An Investigation into Collecting in the European Tradition* (London: Routledge, 1995), 154.

65 *Trial Manuscript*, p. 455.

66 Ibid., 4–5.

67 Ibid.

68 Ibid., 48–9 and 445–7.

69 Ibid., 4–5.

70 Ibid., 445–7.

71 Ibid.

72 Ibid., 1037.

73 *Cornhill Magazine*, January–June 1875, p. 535, quoted in Muthesius, 1988, p. 239. See also Mark Girouard, *Sweetness and Light: The Queen Anne Period* (Oxford: Clarendon Press, 1977).

74 Muthesius, 1988, p. 239.

75 Christopher Gilbert, *The Life and Works of Thomas Chippendale* (London: Macmillan, 1978), p. v.

76 Muthesius, 1988, p. 239.

77 *Trial Manuscript*, p. 495.

78 Ibid.

79 Ibid.

80 Ibid.

81 Ibid.

82 Ibid., 989–90.

83 Litchfield, 1904, p. 41.

84 Arthur Hayden, *Chats on Old Furniture* (London, 1906), p. 264.

85 *Trial Manuscript*, p. 1033.

86 Roland Barthes, 'Death of the Author', in J. Caughie (ed.), *Theories of Authorship* (London and Boston: Routledge and Kegan Paul, 1981), p. 208.

87 Michel Foucault identifies the fact that the proper name, an idea first posited by John Searle in *Speech Acts* (1969), has other than indicative functions. 'It is more than a gesture, a finger pointed at someone; it is to a certain extent, the equivalent of a description'. 'What is an Author', in J. Caughie (ed.), *Theories of Authorship* (London and Boston: Routledge and Kegan Paul, 1981), p. 282.

88 Foucault, 'What is an Author', p. 283.

89 Gilbert, 1978, p. ix. For a helpful critique of 'similarity' see Fred Orton and Ian Wood, *Fragments of History: Rethinking the Ruthwell and Bewcastle Monuments* (Manchester: Manchester University Press, 2007), pp. 66–7. Here, Orton and Wood, with reference to Nelson Goodman's essay, 'Seven Strictures on Similarity', discuss this 'thoroughly problematic concept'. As Orton and Wood remind us, if a historian is going to make the statements of similarity that are so necessary for identifying style, then he or she needs to keep in mind that similarity is relative and variable, dependent upon culture, purposes, interests, significance and circumstances.

90 By this MacQuoid is referring to Thomas Chippendale senior and junior, although the identity of the third man remained unclear. 'I do not think we know the other man's name', *Trial Manuscript*, p. 495.

91 Ibid.

92 'Review of the Catalogue, "Lady Lever Art Gallery Collections", 3 vols, BT Batsford Ltd', 'The Lady Lever Art Gallery', *Connoisseur*, December 1928, pp. 245-6.

93 Ibid.

94 Cescinsky, 1931, pp. 120-1.

95 *Trial Manuscript*, p. 495.

96 Ibid., 410-11.

97 Ibid.

98 Cescinsky, 1931, pp. 119-20.

99 Ibid.

100 Gilbert, 1978, p. ix.

101 Barthes, 'Death of the Author', p. 208.

102 'The belief in a hard core of historical facts existing objectively and independently of the interpretation of the historian is a preposterous fallacy, but one which is very hard to eradicate'. E. H. Carr, *What Is History?* (Harmondsworth: Penguin, 1978), p. 12.

103 Fiske Kimball and Edna Donnell, 'The Creators of the Chippendale Style', *Metropolitan Museum Studies*, Vol. 2, 1929-30, pp. 41-59.

104 Herbert Cescinsky, 'Furniture in Port Sunlight Museum', *Burlington Magazine*, May 1917, p. 189.

105 Ibid.

106 Ibid.

107 Ibid.

108 *Trial Manuscript*, pp. 343-5.

109 Ibid.

110 Ibid.

111 Ibid., 479.

112 Ibid.

113 Ibid.

114 Ibid.

115 Ibid., 440.

116 Ibid., 58.

117 Ibid.

118 Ibid., 373.

119 Ibid.

120 Ibid., 1037.

121 Ibid., 477-8.

122 Ibid.

123 Ibid.

124 Robert Eggerton, 'Shrager's Antiques' article for Furniture History Society's newsletter, undated, unpublished manuscripts.

125 *Trial Manuscript*, p. 28.

126 Ibid.

127 Ibid., 28–9.

128 Ibid., 63–4.

129 Ibid.

130 Herbert Cescinsky, Introduction to the exhibition catalogue of *The Art Collections of the late Lord Leverhulme [part 1]* 'to be sold by order of the executors of the right honourable *Wm Hulme, Viscount Leverhulme*', The Anderson Galleries, 489 Park Avenue at 59th Street, New York, 1926.

131 Ibid.

132 Ibid.

133 Houfe, 1990, p. 45.

134 Mark Jones, 'Why Fakes?', in Susan Pearce (ed.), *Interpreting Objects and Collections* (London: Routledge, 1994), p. 13.

135 *Trial Manuscript*, pp. 491–2.

136 Ibid.

137 Ibid., 8–9.

138 Ibid., 486–7.

139 Ibid., 14–15.

140 Ibid.

141 Michel Foucault, 'What is an Author', p. 282.

142 Cescinsky chose to highlight this advice using capital letters.

Notes to Chapter 5: *'Et tu Brute?' The Verdict*

1 Christopher Hussey, 'The Furniture Case', *Country Life*, Vol. 53, 10 March 1923, p. 322.

2 Robert Eggerton, 'Shrager's Antiques', undated, unpublished article for the Furniture History Society's newsletter.

3 Ibid.

4 *Shrager v. Dighton and Others Trial Manuscript*, transcript published from shorthand notes by Ms Barnett and Barrett, 40, Chancery Lane, London (London: Electric Law Press Ltd, Deed and General Law Printers, 1923), p. 1031.

5 Ibid.

6 Ibid., p. 1032.

7 Ibid., 1028.

8 'Kings Bench Division. Alleged Antique Furniture Fraud: Claim for £85,000', *The Times*, 15 November 1922, p. 5; '"New Furniture for Old". Rubber Merchant's Antique Collection', *The Manchester Guardian*, 15 November 1922, p. 3.

9 'Alleged Antique Furniture Fraud', *The Times*, 16 November 1922, p. 5, also reported under the heading '"Decent Victorian" for the Servants. Merchant's furniture deals' in *The Manchester Guardian*, 16 November 1922, p. 7.

10 'Rich Man's Investment in Antiques', *The Manchester Guardian*, 23 January 1923, p. 4.

11 Ibid.

12 'A Chest Exhibited at South Kensington', *The Manchester Guardian*, 25 January 1923, p. 8.

13 'Piece of Window-frame in Table?', *The Manchester Guardian*, 26 January 1923, p. 3.

14 Ibid.

15 'Long Worm that has no Turning, Reverse holes in Antique Furniture', *The Manchester Guardian*, 27 January 1923, p. 14.

16 'The Soothing Atmosphere of Country Houses', *The Manchester Guardian*, 31 January 1923, p. 13.

17 'A Good Word for Mr Shrager's Furniture', *The Manchester Guardian*, 7 February 1923, p. 13.

18 *The Manchester Guardian*, 8 February 1923, p. 6.

19 Ibid.

20 Ibid.

21 Ibid.

22 Ibid.

23 'The Antique Furniture Case; Judgement', *The Times*, 28 February 1923, p. 5.

24 Ibid.

25 Ibid.

26 Ibid.

27 'Mr Shrager Loses', *The Manchester Guardian*, 28 February 1923, p. 10.

28 Ibid.

29 'Our London Correspondence', *The Manchester Guardian*, 28 February 1923, p. 8.

30 'Humane Killing', *The Manchester Guardian*, 7 March 1923, p. 11.

31 'Kings Bench Division. The Antique Furniture Dispute', *The Times*, 25 April 1923, p. 5.

32 'Antique Furniture Case. Security Sought for Costs of Appeal', *The Manchester Guardian*, 25 April 1923, p. 3.

33 'Antique Furniture Case. Carpet Sale Demonstrates Slump in Prices', *The Manchester Guardian*, 27 April 1923, p. 17.

34 Ibid.

35 Ibid.

36 'The Antique Furniture Dispute', *The Times*, 27 April 1923, p. 5.

37 Such as: 'The Furniture Dispute: Alleged Wrong Tribunal', *The Times*, 12 June 1923, p. 5; 'Mr Justice Darling Amazed; The Skill of the Furniture "Faker"', *The Manchester Guardian*, 13 June 1923, p. 15; 'The Furniture Dispute', *The Times*, 12 June 1923, p. 5; 'Antique Furniture Case Appeal. The Objection to Sir Edward Pollock', *The Manchester Guardian*, 14 June 1923, p. 15; 'New Lease of Life for Antiques Case. Official Referee to Try Unheard Claims. The Rota: An Argument with Awful Possibilities', *The Manchester Guardian*, 16 June 1923, p. 12.

38 'Supreme Court of Judicature; Court of Appeal, 2, 3, 4 and 26 July 1923 (before Bankes, Atkin and Younger L.JJ), Shrager v. Basil Dighton Ltd and Others', *The Law Times*, Vol. 130, 24 May 1924, pp. 642-55; 'Cases of Last Sittings. Court of Appeal. Shrager v Dighton and Others', Report by T W Morgan, Barrister at Law', *The Solicitor's Journal and Weekly Reporter*, Vol. 68, 1 December 1923, pp. 167-8; 'Court of Appeal, Bankes, Atkin and Younger LLJ, 26 July 1923, Shrager v Dighton and Others'. The Times Law Reports, Vol. XXXIX, Friday, 17 August 1923, pp. 705-9.

39 LJ Bankes, 'In the Court of Appeal; Shrager v. Basil Dighton, Limited and Others, 1923 July 2, 3, 4, 26', Kings Bench Division, 1924, pp. 282-3.

40 Ibid., 286.

41 Ibid.

42 Ibid.

43 Robert Eggerton, 'The Furniture Case'.

44 LJ Atkin, 1924, p. 286.

45 LJ Younger, 'In the Court of Appeal; Shrager v. Basil Dighton, Limited and Others, 1923 July 2, 3, 4, 26', Kings Bench Division, 1924, p. 294.

46 Robert Eggerton, 'The Furniture Case'. See also 'New Lease of Life for Antiques Case. Official Referee to Try Unheard Claims. The Rota: An Argument with Awful Possibilities', *The Manchester Guardian*, 16 June 1923, p. 12; 'High Court of Justice: The Furniture Dispute: Further Trial Ordered', *The Times*, 16 June 1923, p. 5.

47 'Mr A. Shrager's Affairs', *The Times*, 25 August 1923, p. 5.

48 Ibid.

49 Ibid.

50 Hussey, 1923, p. 322.

51 Ibid.; Ralph Edwards, 'Percy MacQuoid and Others', *Apollo*, Vol. XCIX, May 1974, p. 339.

52 Tom Flynn, 'The Shrager Case', *Antiques Trade Gazette*, 4 March 1995, p. 20.

53 Ibid.

54 Edwards, 1974, pp. 332-3.

55 Ibid.

56 *Trial Manuscript*, p. 329. See Chapter 2 for quote.

57 McKellar and Sparke, 2004, p. 6.

58 'Antique Furniture. Genuine and Spurious', *The Manchester Guardian*, 21 November 1925, p. 9.

59 Ibid.

60 Ibid.

61 Simon Houfe, 'Percival D. Griffiths Collection: "Intuitively Collected"', *Country Life*, Vol. CLXXXIV, No. 52, 27 December 1990, p. 44.

62 *The Manchester Guardian*, 21 November 1925, p. 9.

63 Herbert Cescinsky, *The Gentle Art of Faking Furniture* (London: Chapman and Hall, 1931), p. 156.

64 Herbert Cescinsky writing as Frederick Akershall, *The Antique Dealer: A Novel That Is Not Fiction*, privately published in a limited edition of 100 copies, c. 1930, frontispiece.

65 Ibid.

66 Ibid.

67 Ibid., 83-91, 96-7.

68 Ibid.52.

69 Ibid.

70 Ibid.52 and 114.

71 Ibid.52 and 104.

72 *Trial Manuscript*, pp. 410-11.

73 Akershall, c. 1930, pp. 52 and 104.

74 Ibid., 52 and 124.

75 Percy MacQuoid and Ralph Edwards, *A Dictionary of English Furniture*, 3 vols (London, 1924-7).

76 Letter from Theresa MacQuoid to Miss Alison Bremner, 1 St Petersburg Place, Bayswater, London, originally in the collection of Mrs Anita McFarlane, Beevers' Archive; also published in Beevers, 1984b, p. 51.

77 'The Sale Room', *The Times*, 30 June 1925.

78 MacQuoid, 1924-8, Fig. 15, p. 125.

79 MacQuoid, 1904-8, colour plate 5, p. 62; MacQuoid, 1924-8, Fig. 4, p. 49.

80 Beevers, 1984b., p. 74.

81 'In the Saleroom', *The Connoisseur*, June 1924, p. 105.

82 *The Connoisseur*, June 1924, p. 105.

83 'Furniture, China, and Objets d'Art', *The Connoisseur*, August 1924, p. 234.

84 Eggerton, 'The Furniture Case'.

85 Cescinsky, 1931, p. 127 and p. 96, plate 134.

86 Ibid., 96.

87 *Trial Manuscript*, pp. 443-4.

88 Cescinsky, 1931, p. 96.

89 Cescinsky, 1931, text for plate 134.

90 *Trial Manuscript*, pp. 443-4.

91 Ibid., 443-4.

92 At the Anderson Galleries, New York, 9-13 February and 24-27 February 1926.

93 Lucy Wood, 'Lever's Objectives in Collecting Old Furniture', *Journal of History of Collections,* Vol. 4, No. 2, 1992, p. 222.

94 Ibid.

95 Mitchell Kennerley, Introduction to the exhibition catalogue of *The Art Collections of the late Lord Leverhulme [part 1]* 'to be sold by order of the executors of the right honourable Wm Hulme, Viscount Leverhulme', The Anderson Galleries, 489 Park Ave at 59th Street, New York, 1926'.

96 Herbert Cescinsky, *The Art Collections of the late Lord Leverhulme [part 1]* 'to be sold by order of the executors of the right honourable Wm Hulme, Viscount Leverhulme', The Anderson Galleries, Mitchell Kennerley (president), 489 Park Ave at 59th St, NY, 1926'.

97 Ibid.

98 Ibid.

99 Cescinsky, 1931, text for plate 134.

100 Letter dated 14 April 1924, Lady Lever Art Gallery, Liverpool, Archives.

101 Robert Eggerton, 'Shrager's Antiques'.

102 Christie's, 'Property of a New York Collector: Queen Anne Blue and Gold Japanned Bureau Bookcase', *Fine English Furniture, Objects of Art and Chinese Export Porcelain*, 20 January 1995, lot 346, pp. 104-5.

103 *Trial Manuscript*, pp. 61-2.

104 Ibid., 21-2.

105 Ibid.

106 Ibid., 419-20.

107 Ibid.

108 Ibid.

109 Ibid.

110 Ibid., 420-5.

111 Flynn, 1995, p. 20.

112 Ibid.

113 Ibid.

114 Ibid.

115 *Trial Manuscript*, pp. 420-5.

116 Flynn, 1995, p. 20.

117 *Trial Manuscript*, pp. 406-7.

118 Ibid.

119 Ibid., 958.

120 Ibid., 252.

121 Flynn, 1995, p. 20 and Christie's, 20 January 1995, pp. 104-5.

122 Jean Baudrillard, 'The System of Objects' (1968), in Mark Poster (ed.), *Jean Baudrillard: Selected Writings* (Cambridge: Polity, 1988), p. 24.

123 'Death of Mr Shrager', *The Times*, 1 November 1923, p. 11.

124 *The Times*, 25 August 1923, p. 5. There is a contradiction in the literature on the case as Shrager's home is sometimes described as located at Westgate on Sea and sometimes as at Westcliffe on Sea. A 'Kent Lodge' survives in Westcliffe, although it is now divided into flats.

125 *The Times*, 25 August 1923, p. 5.

126 'Death of Mr Shrager', *The Times*, 1 November 1923, p. 11.

127 Cescinsky, 1931, p. v.

Bibliography

PRIMARY TEXTS

Bankes, Atkin and Younger LJJ, 'In the Court of Appeal; Shrager v. Basil Dighton, Limited and Others, 1923 July 2, 3, 4, 26', Kings Bench Division, 1924.

Cescinsky, Herbert, writing as Frederick Akershall, *The Antique Dealer: A Novel That Is Not Fiction*, private publication, c. 1930.

Christie's, 'Property of a New York Collector; Queen Anne Blue and Gold Japanned Bureau Bookcase', *Fine English Furniture, Objects of Art and Chinese Export Porcelain*, 20 January 1995, lot 346, pp. 104–5.

Eggerton, Robert, 'Shrager's Antiques', unpublished article for Furniture History Society's newsletter, undated.

'Huntington v. Lewis and Simmons. Notes of Proceedings, May 1917 before Justice Darling', Henry E. Huntington Library and Art Gallery, San Marino, California, Manuscripts collection HEH 16/1.

'In the Court of Appeal; Shrager v. Basil Dighton, Limited and Others, 1923 July 2, 3, 4, 26', *Kings Bench Division, Kings Bench Reports*, Vol. I, 1924.

Kennerley, Mitchell and Herbert Cescinsky, 'Introduction', *The Art Collections of the late Lord Leverhulme [part 1] 'to be sold by order of the executors of the right honourable Wm Hulme, Viscount Leverhulme'*, The Anderson Galleries, 489 Park Avenue at 59th Street, New York, 1926.

Shrager v. Dighton and Others Trial Manuscript, transcript published from shorthand notes by Ms Barnett and Barrett, 40, Chancery Lane, London (London: Electric Law Press Ltd, Deed and General Law Printers, 1923).

LETTERS

Letter from D. L. Isaacs to William Hesketh Lever, from 'Antique Furniture Warehouses', 44, 46 and 48 New Oxford Street WC, London, to Thornton Manor, Cheshire, 6 January 1906, Beevers' Archive.

Letter from Lord Rochdale to David Beevers, 22 April 1987, Beevers' Archive.

Letter from Percy MacQuoid to Lady Stamford, 4 December 1907, Dunham Massey MSS, John Rylands Library, Manchester, Beevers' Archive.

Letter from Percy MacQuoid to Sir Arthur Crosfield, written at the Yellow House, undated, Beevers' Archive.

Letter from Theresa MacQuoid to Davison, curator at the Lady Lever Art Gallery, sent from the Yellow House, 2 March 1924, Lady Lever Archives.

Letter from Theresa MacQuoid to Miss Alison Bremner, 1 St Petersburg Place, Bayswater, London, undated, originally in the collection of Mrs Anita McFarlane, Beevers' Archive.

Letter from White Allom to Lady Crosfield, 13 October 1920, Beevers' Archive.

Letter to Davison, curator at the Lady Lever Art Gallery, from Percy MacQuoid, 31 March 1923, Lady Lever Archives.

Letters from D. L. Isaacs to William Hesketh Lever, from 'Antique Furniture Warehouses', 44, 46 and 48 New Oxford Street WC, London, to Thornton Manor, Cheshire, 8 January, 8 February, and 13 February 1906, Beevers' Archive.

NEWSPAPER ARTICLES

'"Decent Victorian" for the Servants. Merchant's furniture deals', *The Manchester Guardian*, 16 November 1922, p. 7.

'"New Furniture for Old". Rubber Merchant's Antique Collection', *The Manchester Guardian*, 15 November 1922, p. 3.

'A Chest Exhibited at South Kensington', *The Manchester Guardian*, 25 January 1923, p. 8.

'A Good Word for Mr Shrager's Furniture', *The Manchester Guardian*, 7 February 1923, p. 13.

'Alleged Antique Furniture Fraud', *The Times*, 16 November 1922, p. 5.

'Alleged Antique Furniture Fraud', *The Times*, 17 November 1922, p. 5.

'An American's Art Purchase; Doubt cast on authority of a portrait', *Birmingham Post*, 18 May 1917.

'Antique Furniture Case Appeal. The Objection to Sir Edward Pollock', *The Manchester Guardian*, 14 June 1923, p. 15.

'Antique Furniture Case. Carpet Sale Demonstrates Slump in Prices', *The Manchester Guardian*, 27 April 1923, p. 17.

'Antique Furniture Case. Security Sought for Costs of Appeal', *The Manchester Guardian*, 25 April 1923, p. 3.

'Antique Furniture Claim. Damages Awarded', *The Manchester Guardian*, 30 May 1925, p. 14.

'Antique Furniture. Genuine and Spurious', *The Manchester Guardian*, 21 November 1925, p. 9.

'Cases of Last Sittings. Court of Appeal. Shrager v Dighton and Others', Report by T. W. Morgan, Barrister at Law, *The Solicitor's Journal and Weekly Reporter*, Vol. 68, 1 December 1923, pp. 167–8.

Churchill, W. S., 'Zionism versus Bolshevism', *Illustrated Sunday Herald*, 8 February 1920.

'Court of Appeal, Bankes, Atkin and Younger LLJ, 26 July 1923, Shrager v Dighton and Others', *The Times Law Reports*, Vol. XXXIX, Friday 17 August 1923, pp. 705–9.

'Death of Mr Shrager', *The Times*, 1 November 1923, p. 11.

'Experts and disputed picture; Strong criticism', *Yorkshire Evening Post*, 17 May 1917.

'Eyes like a motor lamp', *Halifax Evening Courier*, 18 May 1917.

'High Court of Justice: The Furniture Dispute: Further Trial Ordered', *The Times*, 16 June 1923, p. 5.

'Humane Killing', *The Manchester Guardian*, 7 March 1923, p. 11.

'Kings Bench Division. Alleged Antique Furniture Fraud: Claim for £85,000', *The Times*, 15 November 1922, p. 5.

'Kings Bench Division. The Antique Furniture Dispute', *The Times*, 25 April 1923, p. 5.

'Long Worm that has no Turning, Reverse holes in Antique Furniture', *The Manchester Guardian*, 27 January 1923, p. 14.

'Mr A. Shrager's Affairs', *The Times*, 25 August 1923, p. 5.

'Mr Justice Darling Amazed; The Skill of the Furniture "Faker"', *The Manchester Guardian*, 13 June 1923, p. 15.

'Mr Shrager Loses', *The Manchester Guardian*, 28 February 1923, p. 10.

'Mrs Siddon's Eyes', *South Wales Echo*, 18 May 1917.

'New Lease of Life for Antiques Case. Official Referee to Try Unheard Claims. The Rota: An Argument with Awful Possibilities', *The Manchester Guardian*, 16 June 1923, p. 12.

'Our London Correspondence', *The Manchester Guardian*, 28 February 1923, p. 8.

'Piece of Window-frame in Table?', *The Manchester Guardian*, 26 January 1923, p. 3.

'Rich Man's Investment in Antiques', *The Manchester Guardian*, 23 January 1923, p. 4.

'Supreme Court of Judicature; Court of Appeal, 2, 3, 4 and 26 July 1923 (before Bankes, Atkin and Younger L.JJ), Shrager v. Basil Dighton Ltd and Others', *The Law Times*, Vol. 130, 24 May 1924, pp. 642–55.

'The Antique Furniture Case; Judgment', *The Times*, 28 February 1923, p. 5.

'The Antique Furniture Dispute', *The Times*, 27 April 1923, p. 5.

'The Fascination of Money', *The Spectator*, 23 November 1872.

'The Furniture Dispute: Alleged Wrong Tribunal', *The Times*, 12 June 1923, p. 5.

'The Furniture Dispute', *The Times*, 12 June 1923, p. 5.

'The Sale Room', *The Times*, 30 June 1925.

'The Soothing Atmosphere of Country Houses', *The Manchester Guardian*, 31 January 1923, p. 13.

'The Specialist and the Public', *The Manchester Guardian*, 28 February 1923, p. 8.

Northern Daily Telegraph, Blackburn, 18 May 1917.

The Sphere, 10 February 1923, Vol. 92, p. ii.

The Sphere, 3 March 1923, Vol. 92, p. 216b.

Watts, Robert, 'Mellor's "Grotesque Fakes" Row turns Ugly', *The Sunday Times*, 10 January 2010.

SECONDARY TEXTS

Aldam Heaton, J., *Furniture and Decoration in England during the Eighteenth Century* (London, 1892).

André, J. Lewis, *Chests, Chairs, Cabinets and Old English Woodwork* (Horsham: S. Price Printer and Stationer, 1879).

Appadurai, Arjun (ed.), *The Social Life of Things: Commodities in a Cultural Perspective* (Cambridge: Cambridge University Press, 1986).

Bal, Mieke, 'Telling Objects; A Narrative Perspective on Collecting', in John Elsner and Roger Cardinal (eds), *The Cultures of Collecting* (London: Reaktion, 1994).

Banister, J., *England under the Jews* (1901).

Barthes, Roland, 'Death of the Author', in J. Caughie (ed.), *Theories of Authorship* (London and Boston: Routledge and Kegan Paul, 1981).

Barthes, Roland, 'Myth Today', in Susan Sontag (ed.), *Barthes: A Reader* (London: Fontana, 1983).

Battersby, M., *The Decorative Twenties* (London, 1969).

Baudrillard, Jean, 'Consumer Society' (1968), in Mark Poster (ed.), *Jean Baudrillard: Selected Writings* (Cambridge: Polity, 1988).

Baudrillard, Jean, 'Simulacra and Simulations', in Mark Poster (ed.), *Jean Baudrillard: Selected Writings* (Cambridge: Polity, 1988).

Baudrillard, Jean, 'The Art Auction', in *For a Critique of the Political Economy of a Sign* (St Louis, MO: Telos Press, 1981).

Baudrillard, Jean, 'The System of Objects' (1968), in Mark Poster (ed.), *Jean Baudrillard; Selected Writings* (Cambridge: Polity, 1988).

Beevers, David, 'Antiquarian Taste and English Furniture from Horace Walpole to Percy MacQuoid', introduction to Percy MacQuoid, *History of English Furniture*, Vol. I (Woodbridge: Antique Collectors Club, 1987).

Belk, Russell, *Collecting in a Consumer Society* (London and New York: Routledge, 1995).

Bellaigue, Geoffrey de, *The James A. de Rothschild Collection at Waddesdon Manor; Furniture, Clocks, and Gilt Bronzes* (London and Fribourg: Office du Livre, for the National Trust, 1974).

Benjamin, Walter, 'The Work of Art in the Age of Mechanical Reproduction', in Hannah Arendt (ed.), *Illuminations* (London: Pimlico, 1999).

Benjamin, Walter, 'Unpacking my Library: A Talk about Collecting' (1931), in M. W. Jennings, H. Eiland and G. Smith (eds), *Selected Writings*, Vol. 2, Part 2, 1931–4 (Cambridge, MA: Harvard University Press, 1999).

Benjamin, Walter, *The Arcades Project* (written 1927–40, first published in 1982) (Cambridge, MA: Harvard University Press, 1999).

Benson, John, *The Rise of Consumer Society in Britain, 1880–1980* (London: Longman, 1994).

Blake, Robert, *Disraeli* (London: Eyre and Spottiswoode, 1966).

Bourdieu, Pierre, *Outlines of a Theory of Practice* (Cambridge: Cambridge University Press, 1977).

Breward, Christopher, *Fashioning London: Clothing and the Modern Metropolis* (Oxford: Berg, 2004).

Bruner, J., 'Personality Dynamics and the Process of Perceiving', in R. Blake and Ramsey (eds), *Perception: An Approach to Personality* (New York: Ronald Press Co., 1951).

Carr, E. H., *What Is History?* (Harmondsworth: Penguin, 1978).

Caygill, Marjorie and Cherry, John, *A.W.Franks:Nineteenth Century Collecting and the British Museum* (London: British Museum, 1997).

Cescinsky, Herbert, *English Furniture in the Eighteenth Century*, 3 vols (London: The Waverley Book Company, 1909–11).

Cescinsky, Herbert, *The Gentle Art of Faking Furniture* (London: Chapman and Hall, 1931).

Clifford, James, *The Predicament of Culture: Twentieth Century Ethnography, Literature and Art* (Cambridge, MA: Harvard University Press, 1988).

Clouston, R. S., *English Furniture and Furniture Makers of the Eighteenth Century* (London: Hurst and Blackett, 1906).

Conti, Count, *The Rise of the House of Rothschild* (London: Camelot Press, 1928).

Cornforth, John, 'Dealing in History: The Rise of the Taste for English Furniture', Introduction to the Catalogue of the Grosvenor House Antiques Fair, 1983.

Crossick, G. and S. Jaumain (eds), *Cathedrals of Consumption: The European Department Store, 1850–1939* (Aldershot: Ashgate, 1999).

Daunton, Martin and Matthew Hilton (eds), *The Politics of Consumption: Material Culture and Citizenship in Europe and America* (Oxford: Berg, 2001).

Deetz, James, *In Small Things Forgotten* (Garden City, NY: Doubleday Natural History Press, 1977).

Dew, Eleanor and Pat Kirkham, 'National Identities and Transnational Antiques: Francis Lenygon and Lenygon and Morant, c. 1904–1943' due to be published in Abigail Harrison Moore and Mark Westgarth (eds), *Dealers and Collectors: The Market for Decorative Arts* (forthcoming).

Eastlake, Charles, *Hints on Household Taste in Furniture and Upholstery and Other Details* (London: Longmans, 1868).

Endelman, Todd and Tony Kushner (eds), *Disraeli's Jewishness* (London and Portland: Valentine Mitchell, 2002).

Fitzgerald, F. Scott, *The Great Gatsby* (London: Wordsworth Classics, 1993).

Foley, Edward, *The Book of Decorative Furniture*, 2 vols (London, 1910–11).

Foucault, Michel, 'Of Different Spaces', in J. D. Faubion (ed.), *Essential Works of Foucault, 1954–1984* (London: Penguin, 2000).

Foucault, Michel, 'What is an Author', in J. Caughie (ed.), *Theories of Authorship* (London and Boston: Routledge and Kegan Paul, 1981).

Foucault, Michel, *Power/Knowledge* C. Gordon, ed. (Hemel Hempstead: Harvester Wheatsheaf, 1980).

Foucault, Michel, *The Archaeology of Knowledge* (London: Routledge, 1994).

Foucault, Michel, *The Order of Things* (London: Tavistock, 1985).

Garrett, Rhoda and Agnes Garrett, *Suggestions for House Decoration in Painting, Woodwork and Furniture* (London: Macmillan and Co, 1877).

Gilbert, Christopher, *The Life and Works of Thomas Chippendale* (London: Macmillan, 1978).

Girouard, Mark, *Life in the English Country House* (Harmondsworth: Penguin, 1980).

Girouard, Mark, *Sweetness and Light: The Queen Anne Period* (Oxford: Clarendon Press, 1977).

Hackett, W. H., *Decorative Furniture of the Sixteenth, Seventeenth and Eighteenth Centuries* (London: Ecclesiastical, 1902).

Hall, Michael, *Waddesdon Manor: The Heritage of a Rothschild House* (New, York: Harry N. Abrams, 2002).

Harris, John, *Moving Rooms: The Trade in Architectural Salvages* (New Haven and London: Yale University Press, 2007).

Hayden, Arthur, *Chats on Old Furniture, A Practical Guide to Collectors* (London: T. Fisher Unwin, 1905).

Herrmann, Frank, *The English as Collectors: A Documentary Chrestomathy* (London: Chatto and Windus, 1972).

Hunt, T. F., *Examples of Tudor Architecture . . . and Furniture of the Tudor Period* (London: Longman, Rees, Orme, Brown and Green 1830).

James, Henry, *The Outcry* (New, York: Methuen and Co., 1911).

Jones, Mark, 'Why Fakes?', in Susan Pearce (ed.), *Interpreting Objects and Collections* (London: Routledge, 1994).

Jones, Mark, *Why Fakes Matter: An Essay on the Problems of Authenticity* (London: British Museum Press, 1992).

Lebzelter, Gisela C., *Political Anti-Semitism in England, 1818–39* (London and Basingstoke: Macmillan, 1978).

Lee, Sir Sydney, *King Edward VII*, 2 vols (London: Macmillan, 1925–7).

Lenygon, Francis, *Furniture in England* (London: BT Batsford Ltd., 1914).

Lenygon, Francis, *The Decoration and Furniture of English Mansions during the Seventeenth and Eighteenth Centuries* (London: T. Werner Laurie., 1909).

Lindemann, Albert S., *Antisemitism before the Holocaust* (ed. Richard Levy) (Reading, MA: Addison-Wesley, 2000).

Lipman, V. D., *A History of the Jews in Britain since 1858* (New, York: Holmes and Meier, 1990).

Lipman, V. D., *Social History of the Jews in England, 1850–1950* (London: Watts and Co, 1954).

Litchfield, Frederick, *Antiques, Genuine and Spurious: An Art Expert's Recollections and Cautions* (London: G. Bell and Co., 1921).

Litchfield, Frederick, *How to Collect Old Furniture* (London: G. Bell and Co, 1904).

Litchfield, Frederick, *Illustrated History of Furniture* (London: Truslove, Hanson and Comba, 1892).

Loudon, J. C., *Encyclopedia of Cottage, Farm and Villa Architecture* (London: Longman, Orme, Brown, Greene, & Longmans, 1833).

Lowenthal, David, 'Forging the Past', in Mark Jones (ed.), *Fake, The Art of Deception* (London: British Museum, 1990).

MacPherson, C. B., 'The Political Theory of Possessive Individualism' (1962), in Charles Harrison and Fred Orton (eds), *Modernism, Criticism, Realism: Alternative Contexts for Art* (London: Longman, 1984).

MacQuoid, Percy, *A History of English Furniture: The Age of Walnut* (London: Lawrence and Bullen, 1904–8).

MacQuoid, Percy, *Dictionary of English Furniture* (London: Country Life, 1924–7).

MacQuoid, Percy, *The Leverhulme Art Collections, Volume III; Furniture, Tapestry and Needlework* (London: Batsford, 1928).

Maleuvre, Didier, *Museum Memories: History, Technology, Art* (Stanford, CA: Stanford University Press, 1999).

Marx, Karl, 'The Labour Theory of Value' from 'Capital', in Solomon, Maynard (ed.), *Marxism and Art* (Sussex: Harvester, 1979).

Marx, Karl, *Contribution to a Critique of Political Economy* (New, York: International Publishers, 1970).

McKellar, Susie and Penny Sparke (eds), *Interior Design and Identity* (Manchester: Manchester University Press, 2004).

Miller, M. B. *The Bon Marché: Bourgeois Culture and the Department Store, 1869–1920* (Princeton: Princeton University Press, 1981).

Mordaunt Crook, Joseph, *The Rise of the Nouveaux Riches: Style and Status in Victorian and Edwardian Architecture* (London: John Murray, 1999).

Morrison, Jane, 'Percy MacQuoid, Decorator, Historian, Artist: A fresh examination of the decorative work of Percy MacQuoid as seen in the remodelling and redecorations of the state rooms at Dunham Massey Hall, c. 1907–9', unpublished MA dissertation, Department of Museum Studies, Manchester University, 1986.

Muthesius, Hermann, *Das Englische Haus,* Vol. III (Berlin: E. Wasmuth, 1905).

Nava, Mica and A. O'Shea (eds), *Modern Times: Reflections on a Century of English Modernity* (London: Routledge, 1996).

Orton, Fred and Ian Wood, *Fragments of History: Rethinking the Ruthwell and Bewcastle Monuments* (Manchester: Manchester University Press, 2007).

Pearce, Susan, *Museums, Objects, Collections* (Leicester: Leicester University Press, 1992).

Pearce, Susan, *On Collecting: An Investigation into Collecting in the European Tradition* (London: Routledge, 1995).

Pollen, John Hungerford, *Ancient and Modern Furniture in the South Kensington Museum* (London: Chapman and Hall, 1874).

Pomian, Krzysztof, *Collectionneurs, Amateurs et Curieux* (1987), trans. Elizabeth Wyles-Portier as *Collectors and Curiosities: Paris and Venice, 1500–1800* (Cambridge: Polity, 1990).

Poulson Townsend, W. G., *Measured Drawings of French Furniture from the Collection of South Kensington* (London, 1899).

Rappaport, E. D., *Shopping for Pleasure: Women and the Making of London's West End* (Princeton: Princeton University Press, 2000).

Reitlinger, Gerald, *The Economics of Taste* (London: Barrie and Rockcliff, 1961).

Rendell, Jane, *The Pursuit of Pleasure: Gender, Space, and Architecture in Regency London* (London: Athlone, 2002).

Robinson, Fred S., *English Furniture* (London: Methuen and Co., 1905).

Roe, Frederick, *Ancient Coffers and Cupboards* (London: Methuen and Co., 1902).

Rohan, Thomas, *Confessions of a Dealer* (London: Mills and Boon, 1924).

Shapland, H. P., *Style Schemes in Antique Furnishing* (London: Simpson, Marshall Hamilton, Kent, Benn, 1909).

Shaw, Henry, *Specimens of Ancient Furniture* (London: William Pickering, 1836).

Simmel, George, *The Philosophy of Money* (1907), Translation (London: Routledge and Kegan Paul, 1978).

Simon, Constance, *English Furniture Designers of the Eighteenth Century* (London: B.T. Batsford, 1905).

Sparkes, Penny (ed.), *The Modern Period Room: The Construction of the Exhibited Interior, 1870–1950* (London: Routledge, 2006).

Sparrow, W. Shaw, *Hints on House Furnishing* (London: Nash, 1909).

Stewart, Susan, *On Longing: Narratives of the Miniature, the Gigantic, the Souvenir, the Collection* (Durham, NC: Duke University Press, 1993).

Stillinger, Elizabeth, *The Antiquers* (New, York: Knopf, 1980).

Strong, Roy, *Country Life, 1897–1997: The English Arcadia* (London: Boxtree, 1999).

Symonds, R. W., *The Present State of English Furniture* (London: Duckworth, 1921).

Trollope, Anthony, *The Way We Live Now* (London: Wordsworth Classics, 2001), first published in 1875.

Veblen, Thorstein, *The Theory of the Leisure Class* (1899), reprint (Amherst, NY: Prometheus Books, 1998).

Vincent, J. (ed.), *The Crawford Papers, 1892–1940* (Manchester: Manchester University Press, 1984).

Webber, Byron, *James Orrock RI* (London: Chatto and Windus, 1903).

Wells, H. G., *Tono-Bungay* (1909) (London: Penguin Classics, 2005).

Westgarth, Mark, 'A Contest between Two Pairs of Eyes: Dealers and Collectors', paper given at the Stanley and Audrey Burton Gallery, University of Leeds, 2009.

Westgarth, Mark, 'A Cruise through the Brokers: Wardour Street and the London Antique and Curiosity Markets in the mid nineteenth century', paper delivered at AAH, Tate Britain, London, 2008.

Westgarth, Mark, *The Emergence of the Antique and Curiosity Dealer 1815–1850: The Commodification of Historical Objects* (Farnham, Surrey: Ashgate, 2011).

Wheeler, G. O., *Old English Furniture of the Seventeenth and Eighteenth Centuries: A Guide for the Collector* (London: George Newnes, 1907).

White, Elizabeth (ed.), *A Pictorial Dictionary of British Eighteenth Century Furniture Design: Printed Sources* (Woodbridge, Suffolk: Antique Collectors Club, 1990).

JOURNALS

'A Valuable Collection of English Seventeenth Century Furniture', Catalogue, Jenner and Dell Sale, 18 and 19 January 1932.

'An Upholstered Stuart Armchair', *Country Life*, Vol. XXIX, 29 April 1911, pp. 610–11.

Anon., 'A History of English Furniture. By Percy MacQuoid . . . Vol I. The Age of Oak', *Burlington Magazine for Connoisseurs*, Vol. 7, No. 26, May 1905, pp. 166–7.

Anon., '"Chats on Old Furniture" By Arthur Hayden', *Burlington Magazine for Connoisseurs*, Vol. 7, No. 26, May 1905, p. 167.

Anon., '"English Furniture Designers of the Eighteenth Century" By Constance Simon, 1905', *Burlington Magazine for Connoisseurs*, Vol. 7, No. 26, May 1905, p. 167.

Anon., 'Of London Houses: The Yellow House, 8 Palace Court, the Residence of Mr Percy MacQuoid, RI', *The King*, 19 April 1902, pp. 258–9.

Anon., 'Review of the Catalogue, "Lady Lever Art Gallery Collections", 3 vols, BT Batsford Ltd', 'The Lady Lever Art Gallery', *Connoisseur*, December 1928, pp. 245–6.

Beevers, David, 'Percy MacQuoid, Artist, Decorator and Historian', 2 parts, *The Antique Collector*, June 1984(a), pp. 70–5, July 1984(b), pp. 48–53.

Beevers, David, letter to *Country Life*, 12 January 1998, published 5 February 1998.

Bertrand, Marianne and Antoinette Schoar, 'The Role of Family in Family Firms', *The Journal of Economic Perspectives*, Vol. 20, No. 2, Spring 2006, pp. 73–96.

Bryant, Julius, 'Curating the Georgian Interior', *Journal of Design History*, Vol. 20, No. 4, 2007, pp. 345–50.

Cescinsky, Herbert, 'News and Comments', *Connoisseur*, April 1937, p. 230.

Cescinsky, Herbert, 'Furniture in Port Sunlight Museum', *Burlington Magazine*, May 1917, p. 189.

Cornforth, John, 'Hudson's Choice', *Country Life*, Vol. CXCI, No. 2, 12 June 1997, pp. 136–40.

Cornforth, John, 'London's Uncrowned King', *Country Life*, Vol. XIV, No. 22, 1 June 2000, pp. 134–7.

Edwards, Ralph, 'Percy MacQuoid and Others', *Apollo*, Vol. XCIX, May 1974, pp. 332–9.

Flynn, Tom, 'The Shrager Case', *Antiques Trade Gazette*, 4 March 1995, p. 20.

'Furniture, China, and Objets d'Art', *The Connoisseur*, August 1924, p. 234.

Gow, Ian, 'Floors Castle, Roxburghshire', *Country Life*, 7 August 1997, pp. 52–7.

Harris, John, 'A Cautionary Tale of Two "Period" Rooms', *Apollo*, Vol. CXLII, July 1995, pp. 56–7.

Harris, John, 'English Rooms in American Museums', *Country Life*, Vol. 129, 8 June 1961.

Harris, John, 'The Room that Never Was. The Myth of the Kempshott Park Saloon', *Country Life*, Vol. CLXXXII, No. 41, 13 October 1988, p. 260.

Houfe, Simon, 'Percival D. Griffiths Collection: "Intuitively Collected"', *Country Life*, Vol. CLXXXIV, No. 52, 27 December 1990, pp. 44–6.

Hussey, Christopher, 'The Furniture Case', *Country Life*, Vol. 53, 10 March 1923, p. 322.

'In the Saleroom', *The Connoisseur*, June 1924, p. 105.

Jackson-Stops, Gervase, 'Dunham Massey, Cheshire I, II and III', *Country Life*, Vol. CLXIX, 4 June 1981, pp. 1562–5.

Jervis, Simon, 'The Pryor's Bank, Fulham, Residence of Thomas Baylis Esquire. An Illustration of the Presentation of Ancient Works and Their Application to Modern Purposes', *Furniture History*, Vol. X, 1974, p. 90.

Kimball, Fiske and Edna Donnell, 'The Creators of the Chippendale Style', *Metropolitan Museum Studies*, Vol. 2, 1929–30, pp. 41–59.

Laynor, Robert, letter, *Country Life*, 18 September 1997, p. 97.

Lowenthal, David, 'Authenticities Past and Present', *CRM, The Journal of Heritage Stewardship* Vol. 5, No. 1, Winter 2008, pp. 1–25.

Monkhouse, Cosmo, 'A Connoisseur and his Surroundings', *Art Journal*, 1892, pp. 12–17.

Moore, Susan, 'Faith and Faultless Choice: Furniture in the Early Years of Country Life', *Country Life*, 8 January 1987, pp. 72–5.

Morrison, Jane, 'MacQuoid at Dunham Massey, a National Trust Property', *Country Life*, 2 July 1987, Vol. CLXXXI, pp. 156–60.

Musson, Jeremy, 'Houses for a Superior Person', *Country Life*, 1 January 1998, pp. 38–41.

Musson, Jeremy, 'The Treasurer's House, York', *Country Life*, Vol. CXCIV, No. 23, 8 June 2000, pp. 182–9.

Muthesius, Stefan, 'Why Do We Buy Old Furniture? Aspects of the Authentic Antique in Britain, 1870–1910', *Art History*, Vol. 11, No. 2, June 1988, pp. 231–53.

'News and Comments', *Connoisseur*, April 1937, p. 229.

Rothschild, Ferdinand de, 'Bric-a-Brac', 1897, republished in *Apollo*, July 2007, with an introduction by Michael Hall, pp. 50–77.

Shippobottom, Michael, 'The Building of the Lady Lever Art Gallery', *Journal of History of Collections*, Vol. 4, No. 2, 1992, pp. 186–93.

Sotheby's, The West Wycombe Park Sale, 22, 23, 24 July 1998, 'The Rochdale Family of Lingholm, Cumbria', pp. 118–33.

Symonds, R. W., 'Herbert Cescinsky and English Eighteenth Century Furniture', *Connoisseur*, September 1958, pp. 18–23.

Tipping, H. Avray, 'Percy MacQuoid, An Appreciation', *County Life*, 28 March 1925, p. 491.

Westgarth, Mark, 'A Biographical Dictionary of 19th Century Antique and Curiosity Dealers', *The Journal of Regional Furniture History*, Vol. MMIX, 2009, pp. 1–204.

Wood, Lucy, 'Lever's Objectives in Collecting Old Furniture', *Journal of History of Collections*, Vol. 4, No. 2, 1992, pp. 211–26.

Index